# READING VASARI

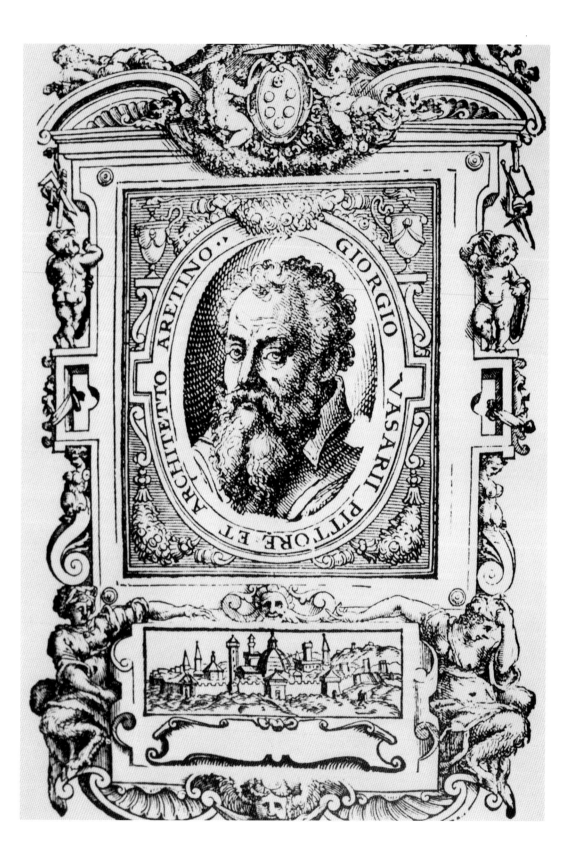

GIORGIO VASARII PITTORE ET ARCHITETTO ARETINO

# READING VASARI

EDITED BY

*Anne B. Barrriault, Andrew Ladis,*
*Norman E. Land, and Jeryldene M. Wood*

Philip Wilson Publishers
and Georgia Museum of Art

Produced by Philip Wilson Publishers Ltd, London, in
association with Georgia Museum of Art.

The University of Georgia
90 Carlton Street
Athens
Georgia 30602-6719
USA

ISBN 0 85667 582 2

Designed by Peter Ling

Printed and bound in Singapore by Craft Print International

First published in 2005 by Philip Wilson Publishers Ltd
109 Drysdale Street
The Timber Yard
London N1 6ND
www.philip-wilson.co.uk

Distributed in the United States and Canada by
Palgrave Macmillan
175 Fifth Avenue
NY 10010

Distributed in Europe and the rest of the world by
I.B. Tauris, 6 Salem Road, London W2 4BU

# Contents

# List of Illustrations

Fig. 3 Titian, *Portrait of Pope Paul III with his grandsons, Cardinal Alessandro Farnese and Duke Ottavio Farnese*, 1545–1546. Museo Nazionale di Capodimonte, Naples. Alinari/Art Resource, NY.

Fig. 4 Titian, *Ecce Homo*. St. Louis Art Museum, St. Louis.

Fig. 5 Titian, *St. Mary Magdalen*, 1567. Museo Nazionale di Capodimonte, Naples. Alinari/Art Resource, NY.

Fig. 6 Titian, *Danaë and Cupid*, 1544–1546. Museo Nazionale di Capodimonte, Naples. Alinari/Art Resource, NY.

Fig. 7 Titian, *Venus and Adonis*, ca. 1560. Widener Collection, 1942.9.84, Image © 2003 Board of Trustees, National Gallery of Art, Washington, D.C.

## LUMI FANTASTICHI AND VASARI'S LANDSCAPES

Fig. 1 Giorgio Vasari, *The Nativity*, Monastero di Camaldoli, Chiesa dei SS Donato e Ilariano.

Fig. 2 Giorgio Vasari, *Burning Landscape*, ceiling roundel from the Palazzo Vecchio, Florence.

Fig. 3 Giorgio Vasari, *Burning Landscape*, fresco from the Chamber of Fortune, Casa Vasari, Arezzo.

Fig. 4 After Correggio, *The Agony in the Garden*, London, The National Gallery.

Fig. 5 Parmigianino, *The Circumcision*, ca. 1523. Gift of Axel Beskow. Photograph © 1986. The Detroit Institute of Arts.

Fig. 6 Giorgio Vasari, *Assault on the Fort of Siena near the Camollia Gate*, from the Salone dei Cinquecento, Palazzo Vecchio, Florence

Fig. 7 Giorgio Vasari, *Pietà*, Private Collection. © Christie's Images, Inc. 2004.

## GIORGIO VASARI'S STUDIO: DILIGENZA E AMOREVOLE FATICA

Fig. 1 Giorgio Vasari, Title Page, woodcut, 1568 edition of the *Vite*, photo by author. Permission from the Gabinetto Disegni e Stampe, Galleria degli Uffizi, Firenze. Su Concessione del Ministerò dei Beni e le Attività Culturali.

Fig. 2 Giorgio Vasari, *Self-Portrait*, woodcut, 1568 edition of the *Vite*, photo by author. Permission from the Gabinetto Disegni e Stampe, Galleria degli Uffizi, Firenze. Su Concessione del Ministcrò dei Beni e le Attività Culturali.

Fig. 3 Giorgio Vasari, *Frontispiece*, woodcut, 1568 edition of the *Vite*, photo by author. Permission from the Gabinetto Disegni e Stampe, Galleria degli Uffizi, Firenze. Su Concessione del Ministerò dei Beni e le Attività Culturali.

Fig. 4 Giorgio Vasari, *Title Page*, woodcut, 1550 edition of the *Vite*, photo by author. Permission from the Gabinetto Disegni e Stampe, Galleria degli Uffizi, Firenze. Su Concessione del Ministerò dei Beni e le Attività Culturali.

Fig. 5 Giorgio Vasari, *Endpiece*, woodcut, 1550 edition of the *Vite*, photo by author. Permission from the Gabinetto Disegni e Stampe, Galleria degli Uffizi, Firenze. Su Concessione del Ministerò dei Beni e le Attività Culturali.

Fig. 6 Giorgio Vasari, *Title Page, Part One and Two*, woodcut, 1550 edition of the *Vite*, photo by author. Permission from the Gabinetto Disegni e Stampe, Galleria degli Uffizi, Firenze. Su Concessione del Ministerò dei Beni e le Attività Culturali.

Fig. 7 Giorgio Vasari, *Title Page, Part Three*, woodcut, 1568 edition of the *Vite*, photo by author. Permission from the Gabinetto Disegni e Stampe, Galleria degli Uffizi, Firenze. Su Concessione del Ministerò dei Beni e le Attività Culturali.

# Foreword

Elsewhere in these prefatory remarks you will find appreciation extended to various entities and individuals for their assistance with this publication, and it is appropriate to let those who benefitted most make those acknowledgments to the publishers Philip Wilson and Cangy Venables of Philip Wilson Publishers; to the staff at the Georgia Museum of Art, who worked on the symposium at which these papers were presented; to the colleagues and friends who offered support and counsel; and to our patron C. L. Morehead, Jr., who graciously and generously helped to underwrite the costs of the symposium and this publication. The Georgia Museum of Art hosts biennial conferences on Italian art, and the one held in 2001 on Vasari and as a tribute to Paul Barolsky served as the impetus for this volume. In addition to the financial gifts of Mr. Morehead, that gathering benefitted from the support of the Vice-President for Research's Office at the University of Georgia; from the Samuel H Kress Foundation; and from the W. Newton Morris Charitable Foundation.

Particularly deserving of gratitude for this volume are the editors Anne B. Barriault, Andrew Ladis, Norman E. Land, and Jeryldene M. Wood. Norman Land suggested the symposium as a tribute to Paul Barolsky, and he along with Andrew Ladis were instrumental in putting together the symposium and in gathering the essays. Above all, Anne Barriault and Jeryldene Wood brought this project to fruition with their indefatigable work on its behalf, and Norman and Andrew join me in appreciation for their belief in the book and for their hard work in realizing its publication.

Either directly through his teaching at the University of Virginia, but just as powerfully, through his work, Paul Barolsky influenced all of the contributors whose papers we are proud to present here. It is a mark of Paul's distinction that he, in some ways, mirrors the artists or chroniclers he studies: whether as advocate or scold, he inspires his students, his readers, to look beyond artifice and illusion to find truth. And he does so with great good cheer; in fact, one could say of Paul what Vasari says of Michelangelo: "Michelagnolo loved his fellow-craftsmen, and held intercourse with them, as with Jacopo Sansovino, Rosso, Pontormo, Daniello da Volterra, and Giorgio Vasari of Arezzo, to which last he showed innumerable kindnesses.... Those who say that he was not willing to teach are wrong, because he was always willing with his intimates and with anyone who asked him for counsel; and I have been present on many such occasions...." In an age of specialization, Paul is both a man of the Renaissance, the entire period from its Gothic beginnings to its Baroque aftermath, and a Renaissance man, even once having served, for instance, as the outside reader of a dissertation on government patronage in mid-nineteenth-century France. The editors and I are pleased and privileged to offer him this tribute, even though, as Vasari said of Michelangelo, among his students, Paul may have "hit upon natures little able to imitate him."

William Underwood Eiland
Director, Georgia Museum of Art

# Preface

Socrates inspired Plato, Virgil guided Dante, Ovid influenced Petrarch, Cimabue cultivated Giotto, Michelangelo inspired Vasari, Vasari and Michelangelo ignited Paul Barolsky's imagination, and Paul sparked the minds of the authors in this book. The relationships may not always be of equal weight, but they represent an animated sequence of exchanges between teacher and student and among successive generations of scholars. To adapt an allegory central to Paul's work from Canto I of the *Paradiso*, as Dante invoked Apollo to imbue him with divine artistic spirit, so every essayist in these pages has been inspired by Paul.

The idea for this book originated with Norman Land as a tribute to Paul Barolsky, a teacher and a scholar—thoughtful and daring, brilliant and impish, disciplined and unconventional—demonstrating with literary artifice the fine art of art historical exegesis. During its gestation, the book has expanded, contracted, and expanded again. As they came to life, the essays revealed that while Paul's influence may at times be veiled, it is pervasive. The essays cover a wide range of topics, and yet each is written in the spirit of Vasari as illuminated by Paul in his series of publications that began with *Michelangelo's Nose*, evolved through *The Faun in the Garden*, and, of course, continues today. While each essay is as unique as its contributor, each study reflects a facet of Paul's intellect as he has slyly chosen to reveal it to the writer. Over the years, not one of us has published without asking Paul first to read a draft or without benefiting from his anonymous critiques as an official (and still secret) reader for a press. He seems to know everyone in the field and, whether as an inspiration or an antagonist, he is a force that has shaped Italian art history of our day in ways that cannot be underestimated.

*Festschrifts*, we are told, have been lost to an Arcadian age. And so, to paraphrase René Magritte, *ceci n'est pas un festschrift*. Some essays originated independently, and then were collected for this volume by Norman Land and Andrew Ladis. Others have been transformed from papers invited by Andrew Ladis and presented at the November 2001 symposium *Reading Vasari* organized by the Georgia Museum of Art at the University of Georgia. That event, indeed, *was* a living *festschrift* in honor of Paul Barolsky.

Hayden Maginnis's Prologue to this volume, in fact, served as the keynote for the 2001 symposium in Athens, Georgia, and we reproduce it here to capture the spirit of that event for the reader. Maginnis's address was, and is, an homage to Paul Barolsky's work. Using Poliziano's quattrocento refrain that "every painter paints himself" as a conceit through which to characterize the nature and extent of Paul's contributions, Maginnis's paper here also serves to introduce a collection of essays by authors of diverse and distinctive sensibilities.

11

Paul Barolsky's *Fear of Fiction: The Fun of Reading Vasari* leads the essays and occupies its own matchless category, as a polemic on Vasari. The essays that follow offer a variety of responses to the question of how to read Vasari, and, in so doing, illustrate aspects of current scholarship in Italian Renaissance, or early modern, art history. The methodologies range from positivist analyses to gender-based studies. The writing is reflective of the archival school as well as the ekphrastic tradition. But therein lies the beauty, for as disparate as they are, the essays share a common thread. Many of us have argued with Paul in private, some have debated with him in print, others have deferred to him, relied gratefully on his help, or hidden at times from his watchful eye. Few would argue Paul Barolsky's role as our *paterfamilias*. Through the years, he has brought to his critiques of our studies a bit of the *terribilità*, much of the *sprezzatura*, and always, the *piacevolissimi inganni* of which he writes. And so, in the spirit of Giorgio Vasari's *Lives of Artists*, and Paul Barolsky's sweeping chronicles of this history of Italian art—the artists, poets, philosophers, and popes; the fathers and sons; the mothers and daughters; the masters and apprentices—we, *della famiglia*, present *Reading Vasari* for the teacher and the student in each of us.

ANNE B. BARRIAULT

# Acknowledgments

We would like to thank the Georgia Museum of Art, University of Georgia, Athens, and Philip Wilson Publishers, London, for making this book possible.

William U. Eiland, Director of the GMA, graciously hosted the 2001 symposium that served as the catalyst for this volume. Under his magnanimous direction and encouragement, Reading Vasari, the book, has come into being. We are grateful to Philip Wilson and Cangy Venables of Philip Wilson Publishers for their enthusiasm for the project, their commitment to fine publishing in the history of art, their respect for academic traditions, and their sense of adventure. It has been an honor and a pleasure from start to finish to work with them. It has also been a joy to work with Peter Ling of Philip Wilson Publishers, and we thank him for his design.

Our thanks also go to Bonnie Ramsey, Editor in Chief of GMA Publications, and Patricia Wright, our communication liaison with GMA's Director's Office. We thank our colleague Claire Farago for suggesting the title, and Sara N. James, Ralph Lieberman, and Liana De Girolami Cheney for heroic assistance with the illustrations.

The University of North Carolina Press, Chapel Hill, generously granted permission to reprint "The Sorcerer's O and the Painter Who Wasn't There" by Andrew Ladis, forthcoming in his book, Fools of Fortune: Victims and Villains in Giorgio Vasari's Lives, published by the University of North Carolina Press.

This book would never have seen print had it not been for the generosity of C. L. Morehead, Jr., of Athens, Georgia. The Georgia Museum of Art, and the editors and contributors of Reading Vasari are indebted to him for his ongoing interest in Italian Renaissance art and scholarship, and for his sponsorship through a most gracious gift.

Finally, we would like to express our appreciation and gratitude to Paul Barolsky and to the authors in this book for their essays, enthusiasm, thoughtfulness, and patience.

AB, AL, NL, JW

# Introduction

Giorgio Vasari's *Le vite de' più eccellenti pittori, scultori ed architettori* (*Lives of the Most Eminent Painters, Sculptors, and Architects,* Florence, 1550; revised edition, 1568) tells the story of Italian art as it unfolds from its first lights in the trecento to its cinquecento radiance in Michelangelo and the art of the *Accademia del Disegno*. The multivalent themes and leitmotifs with which Vasari regales his readers—the major and minor artists, the diligent and delinquent, the inventive and imitative, the mentors and apprentices, the fathers and sons, and the mothers, wives, and daughters—bring the history of Italian Renaissance art to life in his monumental text.

The twenty-one essays in *Reading Vasari* explore the rich literary character of the *Lives*. The contributors propose ways to read Vasari in the light of recent disputes over what is fact and what is fiction, what is history, what is biography, and how Vasari's editions might have been read when they were first published. *Reading Vasari* according concentrates on the lessons and beauty of the text itself—its richness and its color—instead of examining issues of authorship or accuracy that are current or customary in other studies of the *Lives*.

Among the most distinguished of these studies is the massive annotated edition of the *Lives* published by the great archivist Gaetano Milanesi in the nineteenth century, as well as Wolfgang Kallab's groundbreaking *Vasaristudien*, and Paola Barocchi's extraordinary *Studi Vasariani*, published at the beginning and the end of the twentieth century, respectively.[1]

In recent years, Paul Barolsky and Patricia Lee Rubin have directed scholarly attention to the literary qualities and historicity of the *Lives* in their works. Their critiques build upon important predecessors as well: Ernst Kris and Otto Kurz's seminal *Legende vom den Kunstler* (1934); Svetlana Alpers's stimulating "Ekphrasis and Aesthetic Attitudes in Vasari's Lives" (1960); and T. S. R. Boase's memorable *Giorgio Vasari: The Man and the Book* (1979).[2] Rubin's *Giorgio Vasari: Art and History* (1995) has broadened our understanding of Vasari's writing through an analysis of his education, the influence of ancient Roman history, poetry, and philosophy in his work, and the impact of nascent journalism and the art of hearsay on the *Lives*.[3] While Rubin illuminates Vasari's world—his circle of scholars, historians, and antiquarians—Charles Hope has continued to investigate the relationships of this circle to Vasari's text, as he considers the historical place of the *Lives* within the discipline of art history. In "Can You Trust Vasari" (*The New York Review*, October 5, 1995), Hope raises the question of authorship, proposing that several of Vasari's fellow academicians actually wrote sections of the *Lives*, including the Prefaces and sections on Venetian and North Italian artists.[4] Hope cites Paolo

Giovio, Vicenzo Borghini, Cosimo Bartoli, Carlo Lenzoni, and Pierfrancesco Giambullari among Vasari's consultants and possible co-contributors. Recent studies by Richard A. Scorza and Robert Williams have helped to clarify Vicenzo Borghini's advisory role in particular.[5] One profound example of Borghini's influence may be evident in Vasari's emphasis on writing about works of art rather than about the artists themselves, because Borghini believed biography to be a genre reserved for princes.

Our understanding of these intellectual exchanges, collaborative efforts, and cultural complexities of mid-sixteenth-century Florence has been further advanced in *Vasari's Florence*, edited by Philip Jacks (1998).[6] Evolving from a symposium, Jacks's anthology presents papers by Vasari scholars that discuss the genre of biography, the literati and visual artists at the Medici court, Vasari's art collection, and Vasari's concept of history in the narrative frescoes that he painted for the Palazzo Vecchio. The anthology includes "The Trick of Art," by Barolsky, whose literary approach to Vasari has sparked considerable scholarly debate.

Barolsky's comprehensive reevaluation, which asserts that Vasari's book is epic literature rather than solely a source of art historical information, appeared in a succession of volumes published from 1990 to 1994 (*Michelangelo's Nose, Giotto's Father and the Family in Vasari's Lives, Why Mona Lisa Smiles and Other Tales by Vasari*, and *The Faun in the Garden*).[7] Traditionally, the *Lives of the Artists* has been read as a series of biographies in which Vasari attempts to tell the truth about the events and circumstances of each artist's life. While scholars have historically perceived Vasari as an empirical historian and posited his fallacies to his misguided efforts or misinformation, Barolsky has argued that Vasari wrote neither history nor biography, in the modern sense of a more or less truthful narrative of a person's life, but rather a collection of portraits artfully constructed to differentiate artistic types. Vasari's overriding intention is not to tell what really happened or to convey actual circumstances, according to Barolsky, but to paint verbal portraits of artists derived from the character of their works. Although often not literally true, Vasari's anecdotes about artists reveal much about artistic sensibility and personality as befits his typological history of Italian art.

While many still turn to the *Lives* for factual information, Barolsky's provocative re-readings have created a cautious shift in scholarly interpretations. He has shown that while Vasari often bases the *vite* of his artists on verifiable facts, or empirical truth, the historian/biographer/narrator creates unforgettable stories that aspire to myth. The *Lives* has the quality of great literature, carefully constructed to unfold through powerful themes and motifs, major plots and subplots, archetypal heroes, anti-heroes, and villains.

Inspired by Barolsky's innovative approach, the contributors to *Reading Vasari* investigate Vasari's text from the standpoint of its author's literary skills and rhetorical strategies. They share a unity of purpose: to understand the rhetorical framework and operations of the text itself. They examine Vasari's stories in the light of various disciplines and literary genres, as well as art historical evidence and myth. Their essays disclose that Vasari's *Lives* certainly provide the rudiments of history—skeletal facts or information that may be proved or disputed as archival evidence is unearthed—*and* unquestionably serve a larger literary purpose. In essence, the essays in this volume reveal Vasari to be a sly narrator who encourages his reader to believe his history while crafting a work in which fact and fiction are skillfully interwoven.

The book begins with a provocative Prologue "Every Painter Paints Himself"—the keynote address for the symposium *Reading Vasari* given in honor of Paul Barolsky at the Georgia Museum of Art in November 2001. At once an homage to Barolsky, who has described Vasari's *Lives* as "a monumental autobiographical work," Hayden B. J. Maginnis's Prologue eloquently stirs the waters to reflect that every author's work may indeed be innately autobiographical. Maginnis quotes Barolsky's observation on scholarship, the "weaving, unweaving, and reweaving of art and history, and through them, of our very selves." This quotation serves as an appropriate introduction to this book. Each essay in *Reading Vasari* may indeed reveal something of its author under Barolsky's influence, and indeed, something of Barolsky, just as Vasari's descriptions of works of art coalesce into portraits of artists in the *Lives*, which in turn provide insight to the narrator, whom we know as Vasari.

"Fear of Fiction," the premier essay by Paul Barolsky, presents the challenge. Barolsky argues that Vasari's fables, his historical "errors," are indeed fictions "borne of the historical imagination, that faculty essential to one's larger vision of history, which all historians, of all ages, must have if they are going to write history that has the power to capture the imagination of readers, to write history that will endure."

In response to Barolsky's challenge, each essay explores a facet of Vasari's complex text, attending to what is documented evidence and creative license in Vasari's writings. The first section comprises essays that consider select *vite* from each of Vasari's Three Ages of Art: the First Age and the first lights of artistic endeavor; the Second Age, that of invention, which he calls the flowering of youth; and the Third or Golden Age, the Age of Perfection. Vasari's Fine Arts—Painting, Sculpture, and Architecture—are represented in these selections. Andrew Ladis presents the lives of trecento painters Giotto and Buffalmacco, whom Vasari casts as heroic and anti-heroic types. Shelley E. Zuraw explores the life of sculptor Mino da Fiesole—one of the quattrocento "little marble masters"—as a prototype for artistic characteristics that come to fruition in the career of Michelangelo. Arthur F. Iorio presents a fresh approach to Vasari's accounts of the architectural and engineering skills of Francesco di Giorgio, following in the footsteps of Brunelleschi. Sara Nair James discusses Signorelli and the grand manner of painting that led to Michelangelo. Fredrika H. Jacobs examines the *vita* of Bronzino as a paradigmatic artist during the golden age of Vasari's Academy.

In the second section, four essays present a picture of Vasari's view of Rome as a spiritual, political, architectural, and artistic center in the fifteenth and sixteenth centuries. Diane Cole Ahl's and Jack Freiberg's essays examine Vasari's accounts of how the papacy, monastics, and patrons affected the paintings of Fra Angelico and the architecture of Bramante, respectively. Ralph Lieberman details the importance of ancient and Renaissance Roman theater, and Vasari's interpretation of it, to architectural and theatrical design described in the *vita* of Baldassare Peruzzi. Then Maureen Pelta's study of the *vita* of Correggio probes the allure of Rome for artists and the city's importance as a metaphor of artistic excellence for Vasari.

A third section looks at women in Vasari's *Lives*. Vasari's history created "fathers" of Renaissance art. Jeryldene M. Wood elucidates Vasari's treatment of historical and fictional mothers of artists in the *Lives*, as he creates maternal typologies of the good and the bad, the exemplary and the dissolute, which complement his paternal artistic types. Vasari's attention,

or inattention, to artistic women is then revealed by Katherine McIver as she guides readers through Vasari's brief biographies of the few women artists included in the *Vite*.

Vasari's poetic imagination is explored in the fourth section. Anne B. Barriault offers an essay on Vasari and the elegy, a poetic form whose popularity in the sixteenth century is echoed in the Life of Piero di Cosimo, an elegiac painter. April Oettinger looks at fact, fiction, myth, and imagination in Vasari's account of Michelangelo's statue made of snow, while Norman E. Land reveals the compelling nature of Vasari's literary prowess through an historical account of Michelangelo in Venice and Titian in Rome, fashioned in Vasari's own style. Roy Eriksen examines the profound influence of Vasari's Lives of Filippo Lippi and Andrea del Sarto on Robert Browning's poetry and the nineteenth-century understanding of the Italian Renaissance.

Wit and humor inform the fifth section, which presents a refreshing discussion of comic aspects in Vasari's history, and art history in general, which sometimes go missing in academic studies. William E. Wallace looks at laughter and artistic personalities in the Life of Michelangelo, examining amusing anecdotes and themes.

The final section sheds further light on Vasari's perceptions of himself as an author and an artist, within his cyclic view of the history of art. Karen Goodchild examines Vasari's fascination with light-filled landscape as a criterion for artistic excellence and a pervasive theme throughout the *Vite*. Liana de Gerolami Cheney offers conceptual models for Vasari's view of art history within her formal analyses of select woodcuts that illustrate the 1550 and 1568 editions. David Cast reflects upon the joy of reading Vasari illuminated by the sixteenth-century understanding of the classical and academic concepts of *delectatio* or delight.

The essays in *Reading Vasari* isolate and analyze select threads from Vasari's luxurious textual tapestry—from architecture, cosmology, and philosophy to biography, comedy, elegy, and travelogue. The contributors to the volume view this great work through the lens of their respective areas of expertise, the institutions in which they have studied, and their appreciation of Paul Barolsky's contributions to the field. Seeing their varied responses in *Reading Vasari* underscores the vast dimensions of Vasari's *Lives* and the promise that every generation of scholars still has much to learn from this sixteenth-century master of the arts.

ANNE B. BARRIAULT AND JERYLDENE M. WOOD
WITH ANDREW LADIS AND NORMAN E. LAND

NOTES

1. Giorgio Vasari, *Le vite de' più eccellenti pittori, scultori ed architettori*, ed. Gaetano Milanesi, 9 vols. (Florence, 1875–85; reprint, Florence: G. C. Sansoni Editore, 1981); Wolfgang Kallab, *Vasaristudien*, ed. J. von Schlosser, K. Graeser and G. B. Teubner (Leipzig and Vienna, 1908); and Paola Barocchi, *Studi Vasariani*, 3 vols. (Turin: Giulio Einaudi, 1984).

2. Ernst Kris and Otto Kurz, *Legende vom den Kunstler* (Vienna: Krystall-Verlag, 1934); Svetlana Alpers, "Ekphrasis and Aesthetic Attitudes in Vasari's Lives," *Journal of Warburg and Courtauld Institutes* (1960): 190–215; and T. S. R. Boase, *Giorgio Vasari: The Man and the Book* (A. W. Mellon Lectures in the Fine Arts, 1971, The National Gallery of Art, Washington, D.C.), Bolligen Series 35 (Princeton: Princeton University Press, 1979).

3. Patricia Lee Rubin, *Georgio Vasari: Art and History* (New Haven: Yale University Press, 1995). For Paul Barolsky's publications, see n. 7.

4. Charles Hope, "Can You Trust Vasari?" *The New York Review* (5 October 1995): 10–13. See also Paul Barolsky, "What are We Reading When We Read Vasari?" *Source* 22, 1 (Fall, 2002): 33–35.

5. R. A. Scorza, "Vincenzo Borghini (1515–80) as Iconographic Adviser," Ph.D. Thesis, Warburg Institute, University of London, 1987; Robert Williams, "Vincenzo Borghini and Vasari's *Lives*," Ph.D. Thesis, Princeton University, 1988; "Notes by Vicenzo Borgherini on Works of Art in San Gimignano and Volterra: a Source for Vasari's 'Lives,'" *Burlington Magazine*, 127 (January 1985): 17–21; and *Art, Theory, and Culture in Sixteenth-Century Italy: From Techne to Metatechne* (Cambridge: Cambridge University Press, 1997).

6. Philip Jacks, ed. *Vasari's Florence*. (Cambridge: Cambridge University Press, 1998).

7. Paul Barolsky, *Michelangelo's Nose* (University Park, PA: The Pennsylvania State University Press, 1990), *Why Mona Lisa Smiles and Other Tales by Vasari* (University Park, PA: The Pennsylvania State University Press, 1991), *Giotto's Father and the Family in Vasari's Lives* (University Park, PA: The Pennsylvania State University Press, 1992), and *The Faun in the Garden* (University Park, PA: The Pennsylvania State University Press, 1994).

# List of Contributors

Diane Cole Ahl is the Arthur J. '55 and Barbara S. Rothkopf Professor of Art History at Lafayette College in Easton, Pennsylvania.

Paul Barolsky is the Commonwealth Professor of Art History at the University of Virginia in Charlottesville.

Anne B. Barriault is an art historian, writer, and editor for the Virginia Museum of Fine Arts Foundation, Richmond.

David Cast, Professor of the History of Art, Bryn Mawr College, Bryn Mawr, Pennsylvania.

Liana De Girolami Cheney is Professor of Art History at the University of Massachusetts Lowell.

Roy Eriksen is Professor of Renaissance Studies at Agder University College, Kristiansand, Norway.

Jack Freiberg is Associate Professor of Art History at the School of Visual Arts and Dance, Florida State University, Tallahassee.

Karen Hope Goodchild is Assistant Professor of Art History at Wofford College in Spartanburg, South Carolina.

Arthur F. Iorio is Associate Professor of Art History at Illinois State University, Bloomington.

Fredrika H. Jacobs is Professor of Art History at Virginia Commonwealth University, Richmond.

Sara Nair James is Professor of Art History, Mary Baldwin College, Staunton, Virginia.

Andrew Ladis is Franklin Professor of Art at the University of Georgia, Athens.

Norman E. Land is Professor of Italian Renaissance and Baroque Art History at the University of Missouri–Columbia.

Ralph Lieberman is an art historian and photographer in Williamstown, Massachusetts.

Hayden B.J. Maginnis is Professor of the History of Art and Director, School of the Arts, at McMaster University, Hamilton, Ontario.

Katherine A. McIver is Associate Professor of Art History at the University of Alabama at Birmingham.

April Oettinger is Assistant Professor, University of Hartford, Connecticut.

Maureen Pelta is Professor of Art History at Moore College of Art and Design, Philadelphia, Pennsylvania.

William E. Wallace is Professor of Art History at Washington University in St. Louis.

Jeryldene M. Wood is Associate Professor of Art History, University of Illinois, Urbana-Champaign.

Shelley E. Zuraw is Associate Professor of Art History, University of Georgia, Athens.

# PROLOGUE

GIORGIO VASARI PIT. ET
ARCHITET. ARETINO

# Every Painter Paints Himself

## Hayden B. J. Maginnis

It happens but rarely that a scholar attains that to which we all aspire: contributions of such significance that they revolutionize his or her field of study. We gather to honor one who has effected such a revolution. While the rest of us were, rather pedantically, trying to spot Vasari's "errors" and separate them from fact, Paul Barolsky was taking a higher road that led to a panoramic view. He invited us to shift viewpoint, to take his high road, to stand beside him—for the sake of what was to be seen. And it is a sign of the magnitude of his achievement and the justice of his claims that many of us instantly recognized their validity and remarked "of course, so true."

Now, many of you have much to say about Vasari, and I look forward to your papers. But my pleasure today is to reflect on Poliziano's "every painter paints himself," and in so doing to seek the sometimes elusive Barolsky. To do that, I need to take you back, beyond *The Faun*, even beyond the Vasari trilogy, to the crucial moment when, with *Jest*—but not wit—behind him, he turned to Walter Pater.

The conceit behind *Walter Pater's Renaissance* is quite marvellous. It is, to my mind, the wittiest book Barolsky has written. As we pass through its pages, we are carried forward through a series of variations, modulations, and changes in key, in a series of *scherzi* that the inattentive miss, until we come—often all unknowing—to hear Pater's song itself in the ventriloquism of the author. *Pater's Renaissance* is, in fact, a thoroughly Paterian study: both a sensitive reading of its subject *and* its recreation. Barolsky, *travestito* as Pater, offers us discussions of Nabokov and Keats and renewed considerations of Botticelli and Giorgone, and much more. "It is a commonplace in writings on Pater that he becomes all of his subjects," says Barolsky.

Barolsky, for a time, is Pater. But Pater also appears *travestito* as Barolsky. "Pater's own sense of humor is constantly stirred by other artists and writers. . . . *The Renaissance* is permeated by the appreciation of play, wit, and humor," so says the author of *Infinite Jest*.

Such metamorphoses are the very stuff of this new world. For example, when Nietzsche says: "[we] derive such dignity as we have from our status as works of art," he speaks as Michelangelo, verbally claiming the dignity inherent in Michelangelo's having created "his artistic persona in conformity with the art he created."

In the pages of *Pater's Renaissance*, the critic/historian becomes, in turn, the poet, the detective, the biographer, the autobiographer, the novelist, and the artist. And so does Barolsky.

He is Keats or Nabokov, Sherlock Holmes or Conan Doyle, Vasari or Giorgione, and every painter (if not every man).

And do not think that these metamorphoses are confined to Barolsky's work. Let me show you that they are also components of his life. Known to often say: "I'm just a guy who likes looking at pictures," Barolsky appears thinly disguised as Richard Wilbur who said: "what wholly blameless fun . . . to stand and look at pictures."

When he reminds us that, for Pater, all art aspires to the condition of music, we cannot help recalling that music is the aspiration of his household. In his conception of *fraternitas*, not only among artists, but also among art historians, he—in generosity of spirit—becomes St. Paul of the Epistles. And whom do we know more inclined to see humor in our profession and our lives than the author of *Jest*.

"But you don't mean to say that you seriously believe that Life imitates Art, that Life in fact is the mirror, and Art the Reality?"

"Certainly I do," Vivian replies.

There is a phantom in this opera, a presiding genius who, glimpsed in six brief passages, emerges fully on the stage of *Pater's Renaissance* but once.

The critic or historian may, in Oscar Wilde's or for that matter Pater's sense, become himself an artist in order to render the truths of poetical descriptions or interpretations.

Barolsky and Wilde have much more in common. In "The Critic as Artist," Wilde says that the highest form of criticism is really "the record of one's own soul . . . . It is the only civilized form of autobiography." Barolsky describes the *Lives* as "a monumental autobiographical work."

*The Picture of Dorian Gray* is closely tied to the matter of metamorphosis and the nature of art, for it tells of the ultimate transposition: the reversal of the relations between art and life. The portrait becomes Gray's real self, physically manifesting the corruption of his soul, while his body is the never-changing work of art, the "still unravished bride of quietness."

But Barolsky's views, in *Pater's Renaissance* and in later books, have most in common with those in Wilde's essay, "The Decline of Lying." (The connection is signaled, indirectly, only in the section of *The Faun* entitled "The Fine Art of Lying.") "The ancient historians gave us delightful fiction in the form of facts," says Wilde. Barolsky replies with the Vasari trilogy. Wilde says: "Literature always anticipates life." Barolsky says: "The self is the seat of fiction and illusion, of its own poetic beginnings." (Here we all become works of art—not, we hope, in the manner of Dorian Gray.) And he notes that Pater's book is a "weaving, unweaving, and reweaving of art and history, and through them, of our very selves." Wilde remarks: "The final revelation is that Lying, the telling of beautiful untrue things, is the proper aim of art." *Then* we recall that Wilde's and Barolsky's critic/historian is also an artist. And, suddenly, the abyss opens before us. This fiendish duet now has us clutching our throats—and needing a wet towel for our feverish brows. Why? you ask.

Because if fictive biography (such as Vasari's) can elucidate a work of art, cannot fictive criticism elucidate fictive biography? And if the critic/historian is an artist, if his criticism a work of art, must not Barolsky's criticism, that can claim the highest artistic status, be fiction, be a beautiful untrue thing? By the same token, must not my aspiring criticism of Barolsky be a fiction, a lie about a fiction about another fiction addressed to the fictions of art itself? And if the

self is a creation of fiction and illusion, of the fictions of art, and the highest criticism fiction upon fiction, then it may very well be that Barolsky is more than elusive; he may not exist at all. He certainly fits Wilde's definition of a fine lie: "Simply that which is its own evidence." Oh dear! "*What is truth?* said jesting Pilate, and would not stay for an answer."

Now, I hope you will forgive these moments of levity—in tribute to a master of wit—and stay on. For the truth is that they actually cloak some serious and important problems of which art historians generally take little note. Issues of personal identity and notions of self have had a significant place in philosophical discourse of the last half-century. And those matters bear directly on questions of knowledge and certainty—on not only what the past was and we are, but on what the critical and historical enterprise can achieve. With a very light hand, Barolsky places these problems before us.

But it is not just the wit, not just the puzzles, not just the implications for art historical method that determined my choice of *Pater's Renaissance* for reflections today. I chose it because, for me, it best embodies something characteristic of all Barolsky's books and of that great flood of articles we are never sure we have completely found and read, something that is, I think, his most magnificent accomplishment, certainly his most heroic venture. And it is connected to the way I find myself constantly launched on a thousand journeys as I read his work.

I find myself thinking I should reread *Roderick Hudson*, the story of a "modern" sculptor in Rome, or Hawthorne's *Marble Faun*, or Virginia Woolf, or look again at Oscar Wilde. Should I return to Browning's "The Bishop Orders His Tomb"? I wonder if Keats's "Beauty is truth, truth beauty" means that the absence of truth must necessarily put beauty to flight. What does art have to do with truth? What does Proust's comparison of Giotto's *Charity* with the pregnant kitchen-maid at Combray say about the uses of art and the conception of Giotto. Then I think of Swann's abandoned monograph on Vermeer, the artist whose work will cost Bergotte his life. And when Swann, who has crystallized (à la Stendhal) a fictive love of Odette around a reproduction of a painted illusion of Jethro's daughter, realizes that he has wasted years of his life on "a woman who did not please me," I wonder over the fate of Botticelli in Swann's affections—and think about the painter's place in the early twentieth century. Should I look again at the contemporary philosopher, Roger Scruton who, using precisely this last instance from Proust, argues that we all live through successive selves, multiple identities? Thus I am returned to fiction and illusion, and the poetic beginnings of the self.

The marvellous thing is that such thoughts are not necessarily tied to specific passages, specific remarks in Barolsky's work. Rather, they often arise by association, by analogy, and as the result of the mentality in which I am immersed. They arise from the circumstance that, in his work, what we now normally experience as fragments regains, for a time, its wholeness.

It is one of the gentler ironies of scholarship that Barolsky pursues an over-arching objective in a multitude of comparatively short articles and in segmented books. The inattentive or casual reader may mistake such presentations for the fragmentation Barolsky seeks to eliminate. But each contribution is, in fact, a tessera to be laid beside another, and another, and another, until the composition of a grand mosaic emerges.

In *Pater's Renaissance*, Barolsky asks: "How is it possible to maintain universality and historical continuity, built out of the Hellenic and Hebraic traditions, in a modern world, where

such wholeness seems to be dissolving within the flux of experience." And further: "For what is culture—Pater's understanding of culture and our own—if not a vision of such historical continuity." The answer to both questions is his work.

Barolsky's weaving and unweaving and reweaving of criticism, history, painting, poetry, philosophy, fiction, music, and biography seek to make whole again what man and time have put asunder. He reconstitutes our cultural heritage by asserting its interconnectedness and by marrying, or remarrying, art and art, art and ideas that had grown to seem strangers but are, in fact, sometimes acquaintances, sometimes friends, and often more. He leads us to a panoramic view where we see again, in all its glory, the falsely maligned Western tradition and feel once more its unifying power. He asserts that the history of art is part of something much larger and more meaningful. Thus does he restore that vision of historical continuities, synchronic and diachronic, that constitute our culture. And in so doing, I suggest, he paints himself.

For the essence of humanism is that belief of which he seems never to have doubted, that nothing which has ever interested men and women can wholly lose its vitality—no language they have spoken, nor oracle beside which they have hushed their voices, no dream which has once been entertained by actual human minds, nothing about which they have ever been passionate or expended time and zeal.

*Paul:*
*For your work, your achievement, your love of pictures, and your love of words,*
*for your generosity of spirit and your friendship, we, in admiration and appreciation,*
*dedicate this symposium to you.*

# VASARI'S POLEMICS

MORTO DA FELTRO
PITTORE.

# Fear of Fiction: The Fun of Reading Vasari

PAUL BAROLSKY

Although in the art historical scholarship of recent years there has been an increasing awareness of the fictional character of Vasari's *Lives of the Artists*, this fiction has nonetheless been greeted more often than not with discomfort, evasiveness, and condescension, if not with utter disgust, hostility, and ignorance. My purpose here is to explain why this is so, to hint at what lies behind the distaste for Vasari's fiction, to draw our attention to the implications of such contempt for our writing of art history today, to consider what we give up or sacrifice in our various reactions to Vasari's fables. Let us look at a few representative examples of how Vasari is now treated by scholars.

One of the most charming *novelle* in all of Vasari's pages concerns the way in which Giulio Romano was tricked by Andrea del Sarto's copy of Raphael's Portrait of Leo X into believing that he was looking at the original picture which he himself had helped to paint when in fact he was looking at a forgery. The charm of the story lies in the telling. "How can this not be the picture to which I applied my own brush," Giulio protests in amazement when confronted by the revelation of forgery. Vasari's fable is a delightful way of celebrating Sarto's virtuosity, which deceives a fellow artist.

Years ago in a monograph on Sarto, an accomplished scholar referred his readers to Vasari's account of the painter's forgery as if it were a record of what really happened, a matter of fact. Later, however, this same scholar, without mentioning his earlier understanding of the story, changed his position by proclaiming that Vasari, in his tale of Sarto's fake, was spinning a neo-Plinian tale. To speak of a story as neo-Plinian is to see it as formulaic, to ignore the ingenuity of Vasari, who breathed new life into a cliché. Vasari's story may recall the anecdotes of Pliny but as a variation on a theme, the story of how art deceives, it is a novelty, a poetic invention. To call his fable neo-Plinian is to condescend to Vasari, not to adequately appreciate his literary art. Such indifference to literary artifice, to the art of story-telling, is typical of art historians today.

Let us turn to another example of how Vasari's fiction is treated evasively, the tale of how the *Rucellai Madonna* was borne in procession to the sound of trumpets from the home of its author to the church of Santa Maria Novella. It is said in certain records of the old painters, Vasari writes, that while Cimabue (to whom he attributes Duccio's picture) was painting this work, King Charles of Anjou came to Florence and as a sign of welcome was brought to see Cimabue's great image. Vasari tells us the King was the first person to see the painting and adds

that a great crowd of people came to see the work with utmost rejoicing. The picture caused so much joy that this *allegrezza* was the origins of the name of the place where it was first seen, Borgo Allegri.

Acknowledging that Vasari's fable is a fine fiction, the modern scholar is more inclined to dwell on its misattribution than to ponder its full historical implications, its mythic, civic, and theological dimensions. Evoking the visit of a king who in fact came to Florence years before the Rucellai Madonna was painted, Vasari suggests the joyful response to the appearance of baby Jesus who is presented in the picture. Conveying the marvel and wonder associated with the epiphany, Vasari not only renders religious emotion, he also transposes it into aesthetic awe in an epiphany of art. He memorializes the joy of those who behold this double epiphany by pretending that it informs the name of a city street. The advent of Cimabue's painting is thus seen as a great unprecedented event in Florentine history.

Despite Vasari's powerful bias, reflected in his attribution of a Sienese painting to a Florentine painter, we still read in modern scholarship about Vasari's objectivity. Scholars are uncomfortable with Vasari's way of compounding fact and fiction and so they try to isolate the facts in an artist's life, for example, the biography of Piero di Cosimo, from the cement of fiction. To speak of Vasari's Piero di Cosimo as a fictional character is not, however, to deny that he existed, as at least one scholar has ludicrously suggested. It is to acknowledge the extent to which Vasari's deeply fictional portrayal of the painter as a Wild Man was shaped by the sophisticated painter's rendering of a primordial nature. No one would deny that Vasari's Life of Piero is full of facts—facts, which are not the exclusive domain of modern historians. As Eudora Welty once said, "you cannot write fiction without facts." Vasari's fact-filled portrayal of Piero as a quattrocento caveman is such a fiction!

To see Piero as a fictional character in Vasari, it has been claimed, is to reduce the *Lives* to literary exercise. This is a very peculiar way of describing literature, historical literature, and the literary imagination that lies at the heart of Vasari's great and enduring historical work, a masterpiece of literature. For it is the imagination that enabled Vasari to give Piero life over the centuries as a kind of imaginary savage. Piero endures in our imagination, not as a series of facts, however interesting these facts, and they are interesting, but as a character shaped by Vasari in a profoundly fictional way. As a wise man once said, the artist creates the work of art, but the biographer creates the artist.

Let us pursue even further the peremptory and dismissive tone of modern art historians when confronted by Vasari's fables. Rather than refer to one of Vasari's often acknowledged fables of Michelangelo, which concerns a dispute between the artist and his patron, Agnolo Doni, as a fiction, a recent scholar has evasively referred to "Vasari's Michelangelo"—all but admitting what he cannot name, much less appreciate, Vasari's fiction. Another scholar has recently been offended by the suggestion that Vasari's Morto da Feltro, Dead Guy from Feltro, is a fictional character. Scholars who deny this notion insist that he was a real person because Vasari modeled him on a real artist or real artists. Fair enough. But this is a bit like saying that the characters in a historical novel are not fictional because they were inspired by people in real life.

The single most spectacular example of the blatant indifference to Vasari's historical art can be found in the introduction to the Viking Every Man edition of Vasari's *Lives*. No matter

that Vasari's book appears in a series of great masterpieces of Western literature. For the art historian who introduces Vasari to the reader, the Renaissance biographer's relations to Homer, Ovid, and Virgil, to Plato, Aristotle, and Augustine, to Dante, Petrarch, and Boccaccio, to Poliziano, Ficino, and Ariosto, to Castiglione, Bembo, and Aretino are a matter of indifference, as if Vasari's larger imaginative faculties and roots were beside the point. Vasari the writer is here irrelevant.

The resistance to Vasari's fiction reached a peak in a recent discussion of Leonardo's *Mona Lisa*. A distinguished scholar tried to preserve the factuality of Vasari's account of Leonardo employing buffoons and musicians while painting Mona Lisa, as a record of what really happened, even though there is reason to believe the story to be a splendid fiction which conveys a deeper truth. Vasari treats Mona Lisa, entertained by musicians and jesters, as if she were a lady of the court—which she was not—to convey her commanding, if not regal, presence in Leonardo's picture. The story fictively renders an historical truth about the painting. Let us look at the ways in which the modern scholar clings to Vasari's account as a report of fact, as if to water wings on the high seas. Mona Lisa, he speculates, might have been alive when Vasari wrote; she might have spoken to Vasari; and she might have told him about the buffoons and musicians. The scholar builds a house of cards upon a triple subjunctive, scarcely sound historical method.

Why do so many scholars evade, talk around, or scorn Vasari's fictions, even when, in some cases, they acknowledge or pay lip service to them. In order to ponder this question we need to consider how art history has changed since Vasari and the consequences of such changes for our reading of him. After the emergence of historicism, positivism, and the science of art history, *Kunstwissenschaft*, to write history in an avowedly fictional form became unacceptable. We no longer write history as fiction. For us there is a difference between history and the historical fiction of novelists. If Vasari combined documents and *novelle*, fact and fiction, to convey historical truth beyond the limits we define, today fiction about art and art history are two distinct genres. Fiction, as we construe it, is something to resist because it distorts the truth, we fear, especially if we take these stories literally without sufficient attention to their figurative or poetic way of conveying historical truth, a different kind of truth from that conveyed by fact—from our kind of truth.

Our fear and evasion of Vasari's fiction has even deeper roots. Our disquiet stems from the fear that however scrupulous we are in writing factual art history, our own writing will be a form of unwitting fiction. Let me explain. Professional scholars are trained from their first seminars in graduate school onward to eradicate or stamp out errors of interpretation, to replace them with facts, reasonable hypotheses and inferences, since mistakes abound in our field and distort history. Although we do not use the word fiction to describe an historical error, we can, if we stop to think about it, see that errors, given the modern scholar's aversion to them, are like fictions. One scholar objecting to another's improbable historical account might not improperly call such an interpretation, in a manner of speaking contemptuously, a fiction. Consider for a moment a single category of historical exegesis, iconography. Think of the vast literature with its rejected interpretations of Botticelli's *Primavera*, Michelangelo's *Last Judgment*, and Bronzino's *Venus, Cupid, Folly and Time*. A veritable battlefield of hermeneutical corpses.

Consider further that by now there are well over a hundred modern attempts to tell the true story of Giorgione's *Tempesta*, to get to the real facts of its meaning. If one of these interpretations if correct, is the true story, it follows that in a sense there are at least ninety-nine scholarly fictions imposed on Giorgione's picture in the spirit of modern historical reconstruction, not of Vasari's purposeful fables.

We aspire to write history that is true, history grounded in fact, but we are acutely aware of the risk of error, what I call unwitting fiction, and this anxiety leads us back to our fear of Vasari. Deeply conscious of all the errors or unwitting fictions in modern scholarship, despite our best efforts to free ourselves of such error, we wonder whether we have indeed escaped from our own unwitting fables that are inadvertently linked to Vasari's cunning inventions.

Although we no longer aspire to write history as Vasari did by consciously weaving fiction into the fabric of our historical accounts, we misread his great book when we go on search and destroy missions to eradicate, to snuff out his errors or, with a patronizing nod to his fictions, we reduce his book to an accumulation of facts, of which his *Lives* includes many. We fail to reflect adequately upon the deeper significance of Vasari's fictions and what they might tell us. For such fictions are borne of the historical imagination, that faculty essential to one's larger vision of history, which all historians, of all ages, must have if they are going to write history that has the power to capture the imagination of readers, to write history that will endure.

Whereas Vasari wrote a history that is spacious and vivid, filled with living characters, alive still in our imagination, who wrote descriptions of art in a poetic prose that vividly conveys the ways in which art can move the beholder, we, on the other hand, reducing art to a series of problems to be solved in a universally astringent prose, analyzing problems by chopping, dicing, and mincing art and its story, reduce the history of art to voluminous bits of information. The greatest problem that faced modern art history at its inception and that persists, unacknowledged, is that of reconciling the rhetorical traditions of historical narrative, as in Vasari, with the new found rigor of modern historical science, for we have failed to develop compelling historical narratives of our own.

Although we can point to distinguished art historical writers of generations past—for example, Panofsky, Meiss, Freedberg, Chastel, Hetzer, and Longhi, among Renaissance scholars—such distinction is primarily defined within the narrow confines of professional academic art history. Such writers, as much as we admire them, and we do admire them, can scarcely be called great writers when considered in the broader context of literature, that is, of writing that will endure. We need to face the fact that, like all forms of scholarly writing in the present age, art history is a sub-literary genre, too often written in a wooden prose, spoken in a *langue du bois*. There are still art historians who look down their noses at Vasari, as I have suggested, or they try to turn him into a modern squirrel scholar gathering facts like acorns. Let us remember, however, that Vasari's book has endured for almost a half millennium, and it has done so not because it is an archive of facts but because of its literary artifice. How many of our own books, we might ask, will be read in fifty years, much less 500 years from today?

The challenge Vasari poses to art history when we no longer write fiction, at least consciously, is to acknowledge that art history, all art history, is nevertheless fictive in the root sense of *fingere*, molded, shaped, given form. But what are the forms of our historical art? Too often

tedious disquisitions on symbols or technical terms; long historical reviews of what previous scholars have said, unrelenting descriptions of form, lugubrious critiques of ideology; abstract discourses on theory, endless, unshaped, undigested accumulations of facts; lists of data from the archives, all written without historical artifice. Let us not be too negative, for we have developed sophisticated methods for the study of the arts: connoisseurship, stylistic or formal analysis, historical and historicist periodization, various forms of philosophical, psychological, social, political, economic, and institutional analysis; and our discipline has absorbed the lessons of theory, most notably, I believe, semiology and phenomenology.

Given our vast knowledge and our theoretical sophistication, which are formidable, how do we deliver all this, in what form? How do we tell a story, tell a good story, a great story, how do we tell a story well? How does the historical imagination in the modern era give form to a vision of history that is both inspired and inspiring, as Vasari's was in the past and continues to be, both within the precincts of scholarship and in the larger domain of letters? Still not acknowledged at all by art historians, this question is central to the discipline, to its very being, to the further question whether art history can rise from its modest scope, if not parochialism, into the larger domain of the historical imagination to which Vasari belongs.

How does one tell the history of art, the many stories of art, in a lively, enduring way? Not a question asked in our finest journals, our leading universities or schools of higher learning from Paris to Pisa, from Brentwood to New York, from Oxford to Vienna, from Munich to Tokyo, it is still a very basic question. We are satisfied to pick apart the errors in Vasari, to salvage his facts and accumulate others without giving them significant shape or form. We are compliant in the face of passing fashions as we yield to the pressures of the academic market-place, when, at bottom, the questions remain: What is the story we wish to tell? What is the truth to which we aspire? And how might we tell our stories both truthfully and beautifully?

Our own vision of history is at present so devoid of an understanding of the role of art and imagination in the writing, the shaping, of historical narrative, that we fail to grasp adequately the fullness of Vasari's *Lives*, and so we continue, more often that not, to reduce his book to a mass of facts and errors, the mock mirror-image of our own so-called writing of history. But as long as we continue to ignore the fact that the finest historical writing in any age is a form of literary art, as long as we continue to heed insufficiently the fact that Vasari's historical writing depends vitally on the imagination, as long as we continue to pay lip service to the fact that his *Lives* is a work of literary artifice, as long as we leave the study of Vasari's literary art to scholars of literature, who through negligence have failed to do justice to him, as long as we continue to violate Vasari's book by unweaving the facts from the full weave of his fictive, historical tapestry, as long as we continue to correct his errors or dismiss his fictions without paying sufficient attention to the role of his fiction in the articulation of his deeper historical truths, which are not necessarily our own, we will continue to misread, debase, diminish, and trivialize one of the great works of historical art central to our heritage. To be worthy readers and critics of Vasari we need to aspire to write as well as he did. Who among us can say that he or she is worthy of Vasari?

# VASARI'S FIRST LIGHTS,
# FLOWER OF YOUTH,
# AND GOLDEN AGE

LE VITE
DE' PIV ECCELLENTI PITTORI,
SCVLTORI, E ARCHITETTORI

Scritte
DA M. GIORGIO VASARI PITTORE
ET ARCHITETTO ARETINO,
Di Nuouo dal Medesimo Riuiste
Et Ampliate
CON I RITRATTI LORO
Et con l'aggiunta delle Vite de'viui, & de'morti
Dall'anno 1550. infino al 1567.
Prima, e Seconda Parte.
Con le Tauole in ciascun Volume, Delle cose piu Notabili,
De' Ritratti, Delle Vite degli Artefici, Et dei
Luoghi doue sono l'opere loro.

CON LICENZA E PRIVILEGIO DI N. S. PIO V. ET
DEL DVCA DI FIORENZA E SIENA.

In Fiorenza, Appresso i Giunti 1568.

# The Sorcerer's "O"
## and the Painter Who Wasn't There

ANDREW LADIS

Of all the many stories about artists in the literature of the Renaissance, perhaps the most elegant as well as the most famous is the legend of Giotto's "O." Appearing in print for the first time in Giorgio Vasari's *Lives of the Most Excellent Painters, Sculptors, and Architects* of 1568, the story goes that, hearing of Giotto's fame, the Pope sent one of his courtiers to seek him out and "to see what sort of man was Giotto" (fig. 1). After stopping first in Siena to talk to "many masters" in that city, the papal courier at last arrived at Giotto's shop and requested "some little drawing" as a demonstration of his skill. Gracious yet at the same time *dispettoso* or impishly disdainful, Giotto took paper and a brush dipped in red, then, "holding his arm fast against his side in order to make a compass, with a turn of the hand" drew a perfect circle: "'Here is your drawing,'" he said. Confronted with what was after all a zero, the courier began to think ill of Giotto's "little" drawing and indignantly asked if that were all Giotto meant the Holy Father to have, to which the painter replied, "enough and to spare." When this wingless Mercury recounted all to the Pope only to see his master stupefied by Giotto's skill, his exasperation must have curdled to shame. Using a phrase also found in Boccaccio, Vasari says the man was (*di grossa pasta*) "a noodle brain." How right he was to suspect Giotto of tacking a tail to his seat: that "little" mark had the priceless value of rare genius dressed in the most unostentatious modesty. It was an elegant marriage of form and meaning, at once a dexterous gesture of manual skill as well as a deft characterization of the fool who ran the errand.

FIG. 1 *Giotto*, woodcut, 1568 edition of Vasari's *Le vite de' più eccellenti pittori, scultori ed architetti*.

According to Vasari, the incident gave rise to a "beautiful" proverb used to describe a simpleton: "*Tu sei più tondo che l' O di Giotto!*" (You're rounder than Giotto's "O"), because *tondo* not only means round or in relief but also stupid or empty-headed, like the English words thick or dense. By means of this anecdote about a seemingly pointless nothing, Vasari not only illustrated the difference between sophistication and ignorance but also demonstrated Giotto's quickness and sage understanding of the human comedy as well as his genius for depicting it.[1]

Although the story of Giotto's "O" is a tale in the tradition of Boccaccio, Sacchetti, and the *novellieri*, it describes an *esprit* so exquisite as to transcend the witty retort or the *bon mot*, for the explanatory punchline lets us in on a pun so elegant as to be silent, so cunning as to leave the victim oblivious, so satisfying as to reward the observer with the compliment of sophistication. Above all, one marvels at the swift, near invisibility of the gesture and the seeming insubstantiality of the result: a paradoxical nothing that is everything, a reticence that says it all. The painter, who in the inscriptions to two of his paintings styled himself *magister* (master), demonstrates a mastery that is magisterial and, in the root sense of the word *magus*, also wise. Indeed, *magister* Giotto is almost a magician, because in effect Vasari has him transform himself into a compass. After so brilliant a show of manual skill, wit, and perspicacity, is it any wonder that Giotto should conquer his world and achieve a decisive position in Vasari's *Lives*? His art is so subtle as to be effortless, and his genius constitutes that perfect marriage of hand, eye, and mind, a masterful manifestation of unique powers of sight and insight.

The story of Giotto's "O" raises the immediate question of whether it actually happened, and, if so, what is the nature of its truth. Athough the story of the "O" sounds like a tall tale in the tradition of the *Decameron*, it makes much the same point as a passage in Petrarch's testament, whose credibility we hardly question. The poet mentions a treasured *Madonna* by Giotto, a painting whose beauty, he says, the ignorant failed to comprehend, though the initiated could only marvel. Such, however, is the power of the frame that despite the fact that both Petrarch and Vasari say much the same thing, we tend to take Petrarch seriously but discount Vasari, whom we imagine to have invented a story out of whole cloth, but Petrarch's testament, which Vasari knew and quoted, was merely one of a variety of sources that the sixteenth-century writer exploited, including the tales of Boccaccio and Sacchetti. In the context of the *Decameron* and the *Trecentonovelle* one reads stories such as Giotto's "O" as fictions, perhaps about real persons but fictions just the same, whereas in the context of Vasari's *Lives* we tend to approach such stories with the evidentiary expectations of modern historical enquiry, but stories such as the "O" occupied a middle space at the intersection of history, art, and fable. While we ought not to accept them as literally true, to dismiss them is to miss the truth that they contain. It is to misread Vasari and to ignore the shrewder part of his creative accomplishment as a critic and historian.

Giorgio Vasari's *Lives* is universally acknowledged as a key work in the history of western art. First published in 1550, it reappeared in 1568 in a much-expanded, much-embellished second edition, which exchanged the crisp structure of the first for a more sprawling but more mature and far more subtle vision. Vasari's epic story traces the reawakening of the arts in Italy from Cimabue and what he calls "the first lights" (*i primi lumi*), to the full sun that was Michelangelo. Conceived as a continuous development in three parts roughly corresponding to

the fourteenth, fifteenth, and sixteenth centuries, the structure of the *Lives* not only projects the notion of an organic development, but understands it as anthropomorphic, mirroring the human experience of growth from infancy, youth, to maturity as personified by its heroes, above all Giotto in the First Part, Brunelleschi, Masaccio, Donatello in the Second, and the "divine" Michelangelo in the Third. For Vasari the story of art's triumph in Italy, above all, Tuscany and Florence is a story of rebirth, of ascent, and of absolute victory. It is a history told through its actors from Giotto to Michelangelo, a history filled with drama between darkness and light, good and evil, heroism and villainy. Much has been written about the heroes, for they prevail in Vasari's *Commedia*, but surely Vasari's story of famous men would hardly have been as compelling without its antiheroes, his *uomini infamosi*. As a literary strategy, such counterpoint brought tension and energy to Vasari's work, and it is present from the beginning of the *Lives*, as when, evoking Dante's famous lines on Giotto from the *Purgatorio* and even adopting the poet's portentous solar imagery, he says in the Life of Cimabue that Giotto eclipsed the older master's name "not otherwise than as a great light does the splendor of one much less."[2] Besides acting as foils, Vasari's antiheroes also make his story more compelling and real, for most heroes, whatever high ideals we may have of them, are not divine. On the contrary, we are all as God made us and many of us much worse: Even so, let us be half-grateful and admit that had Adam not had a taste for apples, there would be no one to hear the story. For Vasari, as for many an author, the dark side was an abiding natural force and essential to his scheme, because a history without error could hardly hold interest, much less be true. To put it in the dead-on words of Mae West: "Virtue has its own reward but no sale at the box office."

A conception involving heroes and antiheroes implies a literary fabrication that is at odds with the positivist ideal of history as an interpretative recollection of facts and events, but in truth all history implies a self, a point of view from which subjectivity is ultimately inescapable. By intelligence, training, and inclination, Vasari was capable of the kind of literary performance that we should understand the *Lives* to be. Although we do not know precisely what kind of education he got, we do know that after entering the Medici household in his teens, he studied with the same tutors as the Medici princes, Cosimo and Ippolito, and in accordance with princely schooling, the *Lives* are fraught with references to classical and Italian poets, writers, and historians. One may conclude that Vasari had an absorbing mind, but, as he himself says in the Preface to the Second Part, he aimed at being more than a mere cataloguer. Instead, his goal was writing of a more interpretative and creative kind. Thanks to Paul Barolsky, Patricia Rubin, and others, we know much more about what went into the *Lives* and are better able to appreciate the author's fictive strategies. One tactic was to appropriate words and thoughts of earlier and contemporary voices; yet, even if Vasari quoted from Boccaccio and Sacchetti, even if he incorporated passages written by contemporaries, such as Don Silvano Razzi and Cosimo Bartoli, one cannot deny his decisive authorial role. The totality of the *Lives* is due to Vasari, and surely no one after the century of the ready-made should think to discredit him.

The story of Giotto's "O" is an example of Vasarian appropriation, because its fame derives from Vasari but not its invention. Four biting lines attributed to the fifteenth-century poet Burchiello already have the tenor of proverb: "*Al tuo goffo buffon darò del macco,/ Che più che l'O di Giotto mi par tondo,/ E da qui innanzi più non gli rispondo/ Per non gittar le margarite al ciacco . . .*"

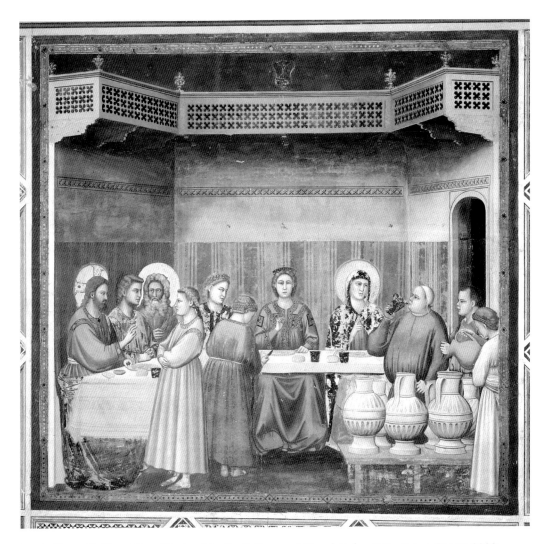

FIG. 2 Giotto, *Wedding at Cana (Master of the Feast)*, Scrovegni Chapel, Padua.© Quattrone, Firenze 2000.

("I'll serve mere mush to that doltish buffoon, who's more *tondo* than Giotto's "O"; and from now on I'll pay him no mind: why throw pearls before swine?"). Adding the flesh of anecdote to the bones of aphorism, Vasari apparently fashioned a paradigmatic narrative that vividly sums up his conception of Giotto as *magister*, magus, and magician, the consummate genius of the Trecento and the inevitable predecessor to Masaccio and Michelangelo. If not true, then the story of Giotto's "O" is well found.

Although the "O" is a story whose authenticity one may never confirm as fact, it is hardly a story without a purpose or without historical or critical value. Giotto's surviving work offers tantalizing parallels to the story of the "O" and suggests that the tale's particulars embrace a core of truth that gives credence to Vasari's vision of him as the ancestor to the heroes of the fifteenth and sixteenth centuries. The most obvious is Giotto's *Wedding at Cana* in the Arena

Chapel in Padua, which illustrates the proverb exactly (fig. 2). Following on the heels of another epiphany at the *Baptism*, the *Wedding at Cana* illustrates the moment of Christ's first miracle and the earliest revelation of his awesome power. Even in the face of prodigy, the master of the feast is unable to get it into his granitoid head that what was once water is now wine. His unwillingness to acknowledge the miraculous is nothing but foolish stupidity, which Giotto encourages us to see in moral terms thanks to a parallel he makes between the steward and the allegorical representation of the vice, *Folly*, an equally swollen creature equally weighed down by matter, namely, a belt of stones hanging from his waist (fig. 3). The master of the feast is, to borrow a phrase from Vasari and Boccaccio, a noodle-brain. This fat zero is *tondo*, not only round but thick: he is *più tondo che l' O di Giotto*. Above all, *tondezza* is not merely a characteristic of his looks but also of his intelligence and behavior. It is at once the defining feature of the figure's outward appearance and an assessment of his inner being, which one understands to mean both his mental capacity as well as his moral shape: It is truly "significant form."

For Vasari, the witty trickster of the "O" is a man of profound insight, who, as a creative figure, anticipates Masaccio and Michelangelo, and, however simplistic this notion may seem as an historical proposition, it is worth noting the confirming evidence of *tondezza* in Giotto's art. One of the most powerful scenes in the Arena Chapel is the *Arrest of Christ*: a tight circle of helmets tightens round Christ's head like a metal cuff, even as He is drawn into the enclosing circle of Judas' embrace (fig. 4). As a phalanx of men and raised weapons to the right block escape, time is compressed to a blurred instant, and action is forced into the illogical condition of instantaneity: The trumpet's blast, John's flight, Peter's crime, that severed ear, and the priest's pointing hand, the latter afloat in a lake of brilliant red, are separate incidents that somehow hang suspended in mid-air, like the kiss that triggers them all. A faceless hood in steely blue snatches the fleeing John the Evangelist's identifying mantle of pink, as if divesting him of his momentarily abandoned apostleship, but in their separate and conflicting ways both John and Peter desert the ideals of their teacher. Thus, in contrast

Fig. 3 Giotto, *Folly*, Scrovegni Chapel, Padua.

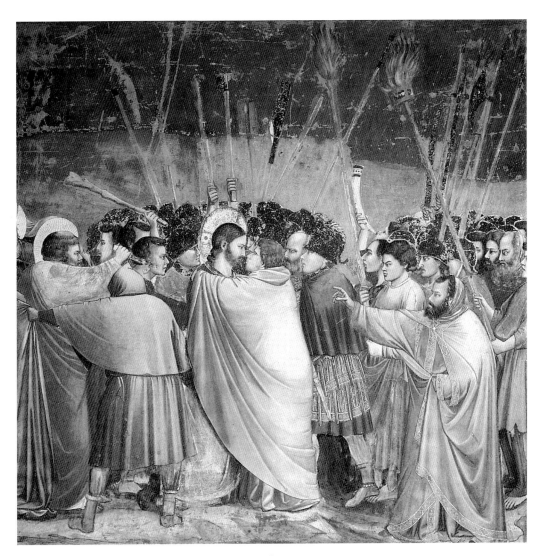

FIG. 4  Giotto, *The Arrest of Christ*, Scrovegni Chapel, Padua.

to the wall of weapons and men who block escape to the right, confusion shatters the action at Christ's back, where two powerful arms, one that of a faceless henchman and the other Peter's, move in forcefully opposing directions behind Christ and seem to sprout a jumbled assortment of heads, some fragmentary, some faceless, some turned one way, and some the opposite. Above all, Giotto captures the kinetics of conflict, whose essence is disarray. Anchoring it all is a faceless figure in blue (to the left of Christ), whose shrunken form and masked anonymity make him all the more sinister. As if playing on the double meaning of *tondo* as solid and empty and using the two senses as paired metaphors of entrapment and abandonment, Giotto contrasts the solid, spherical mass of metal encasing Christ's head with the action at his back, which is reduced to its metaphorical essence in the space between the faceless hood's legs: through this mediating window of legs we see an astonishing choreography of feet, some stepping one way, some

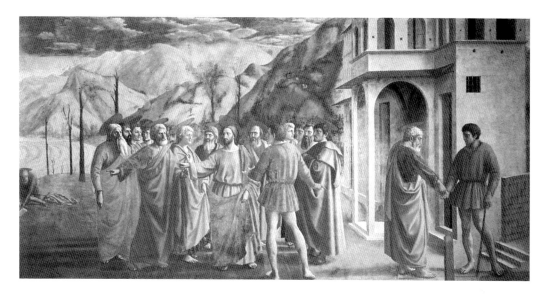

Fɪɢ. 5 Masaccio, *The Tribute Money*, Brancacci Chapel, Sta. Maria del Carmine, Florence.

another, the whole arranged in a vacant *tondo*. Viewed through the rectilinear opening of the figure's legs and the edge of his garment, this empty ring of feet, which evokes the classic geometrical combination of a circle and square, is an uncanny anticipation of the extraordinary and justly famous figure of the tax collector from Masaccio's *Tribute Money* in the Brancacci Chapel, whose magnificently rendered legs frame a vista of carefully positioned cast shadows and feet envisioned according to the principles of a later century and another kind of perspective (fig. 5).

Yet, Giotto's understanding of the multiple meanings of *tondezza* even looks ahead to Michelangelo and lends support to Vasari's historical conception. In Giotto's *Last Judgment* in Padua the colossal figure of the judge sits on a bank formed by a rainbow of clouds and the symbols of the four evangelists (fig. 6). Over the centuries the blue of the figure's mantle has fallen away to reveal something Giotto never intended the viewer to see, namely, the drawing made by the painter directly on the *intonaco*. Amidst the webbing of red lines that give volume and shape, that is, *tondezza* to the mantle and its folds, are a few brief and almost unnoticeable marks that give us insight into the painter's creative process. Three long, fluid lines define the figure's lower legs, hinting with astonishing sensitivity at the differences in musculature of each leg and even indicating the protruding bone of the ankle: while underscoring the notion of Christ's human, bodily nature, these indications of anatomy also suggest—at least in this figure—that the painter conceived the position and forms of the body before covering them. How can one fail to compare Giotto's Judge in Padua with Michelangelo's powerfully sculptural figure from the *Last Judgment* in the Sistine Chapel?

In the end, the story of Giotto's "O" is a paradigmatic summation of Vasari's portrayal of Giotto, but it also speaks to two of the great themes of the *Lives*: the painter as illusionist and visual trickery as a metaphor of both fool-the-eye naturalism and the artist's near-magical powers. The story of the "O" speaks to the nature of Giotto's genius, but another story, told only in

FIG. 6  Giotto, *Last Judgment*, Scrovegni Chapel, Padua.

the 1568 edition of the *Lives*, reduces the painter's gift to something even more essential: "It is said," Vasari writes, "that Giotto, while working in his boyhood under Cimabue, once painted a fly on the nose of a figure that Cimabue himself had made, so true to nature that his master, returning to continue the work, set himself more than once to drive it away with his hand, thinking that it was real, before he perceived his mistake." By means of this extraordinary, life-

giving mimetic gesture, Giotto demonstrated the difference between his art and that of the past. Vasari tells the story of Giotto's fly not at the beginning but at the end of his life of Giotto, immediately before speaking of the painter's monument in the Cathedral of Florence (fig. 7), so that the story of the fly, in effect, itself becomes a kind of literary memorial. Using imagery of almost emblematic brevity, Vasari fashions a verbal illustration of the central point of his life of Giotto: Cimabue stands for an old vision, for an old way of seeing, and Giotto for a new.

In Giotto play and tricks are metaphors of visual performance, but what play and trickery mean in the case of Giotto may be better gauged by comparing him with another painter and contemporary, Buonamico Buffalmacco (fig. 8). Above all remembered for his playfulness, Buffalmacco, like Giotto, inhabits the fictional worlds of Boccaccio and Sacchetti, where he romps from prank to prank and joke to joke through the pages of the *Decameron* and the *Trecentonovelle*, but unlike Giotto, he remains, despite the best efforts of modern historians, little more than a name on a page, hardly more substantial than his legendary friends Bruno and Calandrino. Despite scholars' recent attempts to identify him as the painter of the *Triumph of Death* in the Camposanto of Pisa, his works remain debatable, if not virtually unknowable, so that as a painter he plays a minor role in histories of the period and remains largely a literary curiosity. Such, apparently, was the condition of his legacy even in Vasari's day, and Buffalmacco's historical fate is perhaps reflected by the marginal position that his life occupies in the *Lives*. It is notable that the Life of Buffalmacco is embedded among the biographies of foreigners, among them Andrea Pisano, who, according to Vasari, "changed countries" and was, therefore, Florentine only by adoption. Even more notable is the fact that after the Life of Giotto,

FIG. 8 *Buffalmacco*, woodcut, 1568 edition of
Vasari's *Le vite de' più eccellenti pittori, scultori ed
architetti*.

Vasari's Life of Buffalmacco is the longest in the First Part of the *Lives*. Vastly expanded from the 1550 edition, its enlarged scale in 1568 has nothing to do with a sudden windfall of new information; rather, its prominence is due to the addition of a veritable anthology of tales that Vasari tells about him.[3] One may well ask why Vasari should have focused on a painter who, even in the Cinquecento, was as vaguely real as Buffalmacco, but anonymity conveniently allowed Vasari to exploit the painter's life for the sake of a larger thematic purpose. In the end, Vasari's Life of Buffalmacco may be understood as an extended counter-demonstration of what it takes to be a true artist, a cautionary example of how *not* to lead one's life, and a poignant illustration of the difference between success and *succès d'estime*.

Vasari's Buffalmacco is an easygoing trickster who uses his cleverness to live life in the way of *Ferris Bueller's Day Off*. It is a characterization sanctified by earlier sources, not only the tales of Boccaccio and Sacchetti but also by Ghiberti's *Commentaries*, written ca. 1450. Although Ghiberti was little given to telling tales, he nevertheless reinforced the literary tradition about Buffalmacco. The notion that Buffalmacco never tried very hard, first articulated by Boccaccio and Sacchetti, is validated by Ghiberti. When Buffalmacco put his heart into his work, Ghiberti says, he surpassed all other painters of his day, but that conditional praise allows the implication that Buffalmacco did not always try. Indeed, laziness, as well as brilliance, is also the hinted pejorative behind Ghiberti's applause for the effortlessness of Buffalmacco's work: "*durò poco fatica*." Depending on the accent one gives it, effortlessness could be a virtue not unlike grace, but it might also be a failing. Building on two very different kinds of sources, the *novellieri* and Ghiberti, Vasari makes brilliance and indolence, talent and frivolity the paired— and ultimately dooming—themes of his Life of Buffalmacco.

Two stories, both retold from Sacchetti, strike the keynote of the Life. The first concerns Buffalmacco's experience in the workshop of his teacher, Andrea Tafo. As Vasari tells it, both Buffalmacco's talent and his character were clear even in his youth during his apprenticeship with Tafo. Of Giotto the student we are told the story of a magically *trompe l'oeil* fly; of Buffalmacco we are told a story about beetles, but the respective insects say very different things about the two painters. Following Sacchetti, Vasari relates that even when a mere boy in Tafo's shop, Buffalmacco used his wits to outsmart his master and to avoid inconvenient work. Tafo, it seems, was annoyingly diligent and had the habit of calling his young assistant to work before dawn. Bad Luck. But even as a boy, Buffalmacco was nothing if not sly subversive, so he resolved

to out-maneuver Tafo by teaching the old dog a new lifestyle. He took "thirty large cockroaches, or rather blackbeetles" from a badly swept cellar, and by means of "certain fine and short needles," he ingeniously affixed a little candle on the back of each one. Now, it is ironic that Buffalmacco's intricate ploy implies a great deal of trouble and more than a little of the very thing he was trying to avoid: work. Nevertheless, such work was all play. Just before Tafo was to rise, Buffalmacco lit the cockroaches and, "through a chink in the door," set them loose in his master's bedroom. The latter, "awaking at the very hour when he was wont to call Buffalmacco" and confronted by "those little lights," was more than terrified, believing them to be, as Vasari says with comic exaggeration, "more than a thousand demons." Instead of calling Buffalmacco to work, the old man "all full of fear began to tremble and in great terror to recommend himself under his breath to God, like the old gaffer that he was, and to say his prayers or psalms." Finally, in the classic slapstick retreat, Vasari even has the old man pulling the sheets over his head to hide under the covers: in effect, forcing him to take the kind of *longue levée* that young Buffalmacco wished for every morning. Needless to say, that morning Buffalmacco enjoyed nothing but the sweetest beauty sleep, because Tafo, of course, "made no attempt for that night to call Buffalmacco, but stayed as he was, ever trembling with fear, up to daylight." Although the next night Buffalmacco sent only three beetles into the old man's room, the memory of the first haunting was enough, and in the morning he rushed from the house, meaning never to return. At that point, Buffalmacco the pupil adopts the pose of a tutor and, in terms that recall the well-known miracles of the Madonna, reasons with Tafo, saying that demons, which are the greatest enemies of God, also especially hate painters, who are always painting saints in order to make "men more devout and upright thereby." And because these demons have greater power at night, they "play us these tricks, and worse tricks will they play if this use of rising for night-work is not given up completely." With a delighted anticlericalism that reverberates elsewhere in the Life, Buffalmacco even brings in the parish priest, gulling him into lending his phony authority to the trick. In the end, Buffalmacco and his unwitting accomplice, "Sir Priest," as Vasari derisively calls him, convince the credulous Tafo to lay off night work for good, which he did, "being above all advised to do this by the priest," who for all his presumed expertise with the supernatural, hardly knew the difference between the devil and a bug.

According to Vasari, Buffalmacco's performance not only forced Tafo to abandon working at night but even caused all painters in the city to stop night work and, in other words, to paint in the light instead of in the dark. But what kind of painter, one might ask, tries to work in the dark? The story tells of the simplicity of the older master, who succumbs to a visual trick—*faux*-witchcraft involving true art—that demonstrates Buffalmacco's talent for manipulating reality, but at the same time, in the context of Vasari's book, this story, though appropriated from Sacchetti, becomes a droll play on the defining image of the first part of the *Lives*: in a sense, the flickering "devils" that that Tafo could not bear to see are "*i primi lumi*" that precede dawn, and old Tafo is one who sees the light but comprehends it not.

Inspired by the Bible and the *Divine Comedy* but also by antique sources, light imagery as a metaphor of artistic reawakening informs the *Lives* from the very start. Thus, Tafo's contemporary, Cimabue, whom Vasari calls John, is the voice crying in the darkness: He is not the true light but one who points to the true light of Giotto, who was to paint by the light of day. In truth,

the notion of art produced by day as opposed to night is a topos. According to Benvenuto da Imola, in his commentary on Dante's *Comedy*, Dante is said to have posed the same question to Giotto that Petrarch, writing earlier in the century, had ascribed to the ancient painter Mallius: How was it that he could paint such beautiful figures and produce such ugly children? Because, the painter replied, I produce figures by day but reproduce at night (*quia pingo de die, sed fingo de nocte*), a pithy remark that makes a pun on the words *fingere* and *pingere*. Playing on the difference between appearance and reality and on the theme of the painter as illusionist, the remark is related to the legend of Giotto's physical ugliness, but it also speaks to the broader theme of an outward appearance that belies the true beauty within, a difference between outward appearance and hidden reality, between seems and is.

For all his cleverness, Buffalmacco is not Giotto, and the story of the fiery beetles reinforces the notion of Buffalmacco as unwilling to work hard. Unlike Giotto, his light and talent are put to frivolous use. Both Buffalmacco's cleverness and his love of creature comforts are illustrated by the next story, which Vasari again freely adapted from Sacchetti. The story concerns a problematic neighbor of Buffalmacco's, "a passing rich woolworker" by the name of Capodoca or "Goosehead," who makes the mistake of putting his wife to work at night and thereby interfering with Buffalmacco's sacred sleep. This Capodoca is a character in the appellative tradition of Boccaccio's seedy Fra Cipolla or Brother Onion, who always smelled decidedly too impious for a man of the cloth. In the fifteenth century, we see his type in Giovanni Sabadino degli Arienti's Fra Puzzo or "Friar Stink," another reprobate whose name tells us all we need to know.[4] Likewise, by way of his name alone, we know that Capodoca is destined for well-deserved abuse.

As Vasari tells it, instead of being content with the natural profits of a day, greed got the better of Goosehead. This Capodoca was, as Vasari puts it, *un nuovo uccello*, literally a "new bird" or a birdbrain, who apparently believed the old adage about the early bird and the worm. He hatched a scheme to make more money by forcing his wife to commence work at her spinning wheel well before dawn, that is, by night as well as by day. Thus, this unhappy daughter of Eve, whose ultimate mother was also condemned to spin, rose to her work just when Buffalmacco went "to lie down." Needless to say, the noise of the wheel, hour after hour, night after night kept Buffalmacco from his much-loved rest. After a few nights of staring at the walls, Buffalmacco discovered a crack in the partition between the two houses, precisely behind the fireplace where the woman cooked. Seeing that the wife was used to leaving the pot over the fire while she worked, Buffalmacco "thought of a new trick," as Vasari says, cooking up a plan that might not only put an end to the disturbance but would even avoid a confrontation. After boring a hole in the wall, he took a hollow cane and, filling it with salt, passed it through the aperture until it reached the pot cooking over the fire. At that point, with a mere puff of air or, as one might say in Italian, *una buffata*, Buffalmacco was able to salt the pot so much that when Goosehead eventually sat down to dinner his food was inedible. *Pazienza*. At first the unsuspecting Goosehead let the matter go with a few salty words, but mere remonstration got him nowhere, and after several days of spitting out his food, he took to blows. For her part, the poor wife thought that she had always been more than careful with the salt, but in the face of an inarguably ruined pot, her excuses only drove Goosehead crazier with rage. In the end, all the yelling and screaming created enough of a stew to rouse the whole neighborhood, including

our unruly hero, Buffalmacco. After calming his neighbor, Buffalmacco strikes the familiar and ironic pose of one directed by cool logic. Telling Goosehead that the problem "calls for a little reason," he says, "[you] complain that the pot, morning and evening, is too much salted, and I marvel that this good woman of thine can do anything well. I, for my part, know not how, by day, she keeps on her feet, considering that the whole night she sits up over that wheel of hers, and sleeps not, to my belief, an hour. Make her give up this rising at midnight, and thou wilt see that, having her fill of sleep, she will have her wits about her by day and will not fall into such blunders." With reinforcement from the equally unwitting neighbors, Buffalmacco convinces Goosehead to suspend the night shift. Thereafter, when once or twice Goosehead was lulled in to thinking that she might safely start up again, Buffalmacco simply resorted to his stealthy remedy, until Goosehead had to give up the idea altogether.

As far as Goosehead could see, working at night was demonstrably unrewarding, but of course Goosehead only sees what Buffalmacco wants him to see, for the painter's power is the power of sight. What Buffalmacco sees, he controls by subjecting it to his vision, his way of seeing things. The hole in the wall, like the chink in Tafo's door, functions as both a scope and a portal, through which the clever painter penetrates, alters, and masters an adjoining reality. And while he subjects his environment to the power of his hand, he himself remains invisible, for by hands unseen do such painter-magicians as Buffalmacco create their illusions.[5] In the end, both the story of the fiery beetles and the story of the oversalted pot are stories about Buffalmacco's self-indulgence, but they are also stories about power and control.

Painters like Giotto and Buffalmacco are powerful because above all they have the ability to see and to make others see, and vision is a rare gift indeed, because things, including painters, are not always what they seem. It is not easy for ordinary mortals to recognize the true painter's power, and this is the point of Vasari's next story, which concerns Buffalmacco's work for the nuns of Faenza. "Of this work," Vasari says, "that convent being to-day in ruins, there is to be seen nothing...," but the considerable cycle that once filled "the whole of the church" had been attributed to Buffalmacco in the fifteenth century by Ghiberti, who, unlike Vasari, may well have seen it.[6] Whether these murals were actually painted by Buffalmacco remains impossible to confirm, but notable it is how with one hand Vasari takes away and with the other he restores. Despite saying that all of the work is lost, he nevertheless praises one scene in particular, the *Massacre of the Innocents*, as though it were alive before him, saying Buffalmacco "expressed very vividly the emotions both of the murderers and of the other figures; for in some nurses and mothers who are snatching the infants from the hands of the murderers and are seeking all the assistance that they can from their hands, their nails, their teeth, and every movement of the body, there is shown on the surface a heart no less full of rage and fury than of woe." Although one may wonder why Vasari chose to describe a work no one (including himself) could see, this, of all the stories of the life of Christ, allowed Vasari to stress how Buffalmacco, like Giotto, understood the movements of the heart and mind. He thereby suggests an unexpected depth and substance to our heretofore shallow and insubstantial hero. Indeed, how like Giotto this unseeable Buffalmacco seems to be.

Vasari's assertion of Buffalmacco's *gravitas* frames a story, surely a Vasarian invention, that inverts the point and turns what was solid into air. According to the story, the same nuns

of Faenza mistook Buffalmacco for a gofer instead of the CEO, though his art should have been business card enough. Because, Vasari claims, Buffalmacco was a person careless in his dress and in his habits (*una persona molto stratta ed a caso*), he did not always dress his part, so that the nuns, "seeing him once through the screen that he had caused to be made," began to doubt that he was the master but rather "some knavish boy for grinding colours." In an un-nunlike manner that is far from the female monastic ideal of *clausura*, Vasari's nuns actually become voyeurs, not only peeping through the painter's enclosure but peeping at a man. Their behavior justifies what they get, for unlike the painter, who played the voyeur earlier in the life with the story of Goosehead, the nuns misapprehend what they see and, far from gaining control, earn nothing but embarrassment. At length the holy sisters have the abbess complain "that they would have liked to see the master at work, and not always him." To this, Buonamico, who took cognizance of how little faith the nuns took in him and his work, answered as amiably as his name, "Good Fellow" or, as we might say in the South, "Good Ol' Boy." Promising to apprise them "as soon as the master was there," he of course does no such thing. Instead, he contrives to give them both what they want and nothing: Stacking two stools one atop the other and a pitcher atop both, he proceeded to transform those humble things into a splendid personage, draping a fancy coat around the stools and crowning the pitcher with a cap that hung over the handle as if against the nape of a neck. And finally, the *pièce de resistance*: he put a brush through the spout, so that viewed from the back it seemed as though the painter, brush to his mouth, were scrutinizing his work. Then, Vasari says, "he went off," that is, he vanished, leaving the nuns to search through the hole and discover his latest illusion. Vasari conjures up the drolly comic picture, worthy of opera buffa—or rather opera buffalmacco, of nuns peering from their world onto the deliciously deceptive realm of the painter, who in turn seems to be contemplating the imagined reality of his paintings: an illusion within an illusion within an illusion. Besting even Harry Potter and his famous "invisibility coat," Buffalmacco makes a sham painter who is nothing more than a coat without a body by means of a "visibility cloak" that magically simulates his presence. In the story, Buffalmacco, who, in any case never needed much prompting to leave work, takes a vacation and is gone for a fortnight, leaving the unsuspecting nuns hanging on a painter who isn't there. All three tales—Tafo's demon-beetles, Goosehead's oversalted pot, and the nun's absent painter—are about power but also about perceptions or, as Vasari says, the difference "between men and pitchers," to which he adds a wryly ironic moral: "it is not always by their clothes that the works of men should be judged."

The unperceptive nuns try to control the painter, but they end up becoming his playthings. They get their just desserts, but perhaps because they are women as well as nuns, Vasari has them gulled not once but twice, though the second time only we the readers and Buffalmacco are in on the joke. When the paradoxically credulous and faithless nuns, who believe in the dummy but not in the painter, discover that the painter had absented himself a fortnight, they remained, Vasari says, "all confused and blushing" at their error. Buffalmacco, "with the greatest laughter and delight" finished the job to their satisfaction, except—for clearly they fail to learn their lesson—that the figures appeared to them "rather wan and pallid than otherwise in the flesh-tints." In other words, the recently red-faced nuns fancy redder faces! Naturally, the amenable Buffalmacco grants them what their eyes desire—for a price. Knowing that the abbess

had an especially fine Vernaccia wine—"the best in Florence"—that she piously saved for the holy mass, Buonamico decided, despite the hint of sacrilege, that such nectar should go to him and not to the Lord, so he tells the silly sisters, as though revealing a professional secret, that the only way to make the flesh of his figures rosier is to temper the colors with some good Vernaccia. Needless to say, the good nuns kept him in the best they had to offer for as long as the work continued, while Buffalmacco, "rejoicing in it," from then on merely used his usual colors to give his figures fresher, rosier flesh. Not only are the witless but believing nuns cheerfully fooled a second time, they are secretly punished. After all, is not their interest in seductive flesh vaguely sinful? Thus the red-faced nuns, who delight in the sensuous rubicundity of flesh, expose themselves to ridicule: they are unable to tell the difference between wine and paint, that is, between *Vernaccia* and *verniccia*, and the artful painter, playing on deception and belief, handles them with the sly deftness of a magician.

Linking one episode to another and contributing to the larger portrait of the painter, both the paired imagery of painted and real flesh as well as the paired notions of technical mastery and ignorance recur in the very next paragraph and in the very next story, where they are turned around and redirected against the painter himself. The flesh-savoring but gullible and ultimately embarrassed nuns are juxtaposed with an account that is likewise about a failure of intelligence, but in this story, which concerns Buffalmacco's still-extant murals in the Badia a Settimo, it is the painter who falters, precisely because of the way he painted flesh. "And because Buonamico was wont, in order to make his flesh-colour better, as is seen in this work, to make a ground of purple, which in time produces a salt that becomes corroded and eats away the white and other colours (*per tutto di pavonazzo di sale, il quale fa col tempo una salsedine che si mangia e consuma il bianco e gl'altri colori*), it is no marvel if this work is spoilt and eaten away, whereas many others that were made long before have been very well preserved." Arguing with himself in a way that reassures the reader of the painter-author's expertise, Vasari says: "And I, who thought formerly that these pictures had received injury from the damp, have since proved by experience, studying other works of the same man, that it is not from the damp but from this particular use of Buffalmacco's that they have become spoilt so completely that there is not seen in them either design or anything else, and that where the flesh-colours were there has remained nothing else but the purple. This method of working should be used by no one who is anxious that his pictures should have long life." In truth, although the painter at the Badia a Settimo did use a reddish ground, the figures are blackened because of the lead white, employed especially for the flesh, but in a striking coincidence, Vasari criticizes Buffalmacco's technique in terms that recall the image of salt that was at the center of the earlier story about Goosehead and his wife: indeed, as in the case of Goosehead's artfully oversalted pot, too much salt passes through the wall, but, here, one might say that, rather than Buffalmacco's artfulness working to his advantage, it is his artlessness that ruins his own bread and butter. Committing a kind of symbolic suicide, Buffalmacco does himself in at his own hand by creating works that die, and once again, because his paintings vanish, so does he in effect, negating himself as he did in the story of the pitcher that became a painter.

Buffalmacco's experience at the Badia a Settimo is the beginning of Vasari's subtly negative *giudizio* against Buffalmacco and a journey toward the painter's ultimate judgment.

Increasingly the Life turns toward defeat and loss. Buffalmacco has wit and inventiveness: indeed, as Ghiberti said, when he tried, he could surpass all others, but all too often he worked without craft or industry. Reprising the notion that a painter who follows this path only denies himself life, Vasari sustains and darkens this sad judgment in the very next paragraph, where he claims that Buffalmacco painted a chapel in the Badia of Florence. Of this cycle, which survives in part, he mentions only one chilling scene: the suicide of Judas. Is it a coincidence that this subject should appear twice in the Life of Buffalmacco but nowhere else in Vasari's vast work? The suicide of Judas is an image of self-destruction that bolsters Vasari's portrayal of Buffalmacco as an artist who annuls himself, no matter that the damaged and fragmentary frescoes in the Florentine Badia, including the hanged Judas, are now securely attributable to Nardo di Cione and not to Buffalmacco. Although it is possible that Vasari was simply wrong about the attribution, the name of the chapel in question, the Giochi e Bastari, is too telling, for *giochi* means games and *bastare* means to suffice. This pun is, in fact, the essence of Vasari's portrayal of Buffalmacco: echoing Ghiberti and the *novellieri*, Vasari's Life of Buffalmacco asserts that when Buffalmacco applied himself he was good,[7] but usually, alas, he merely went through the motions: he was games and just enough.

As Buffalmacco's life proceeds toward its close, the premonitory theme of self-destruction expands. Echoing Ghiberti, Vasari rehearses an itinerary that takes the painter to Bologna, but instead of many works made in that city, he claims Buffalmacco undertook a project (the one he names cannot have been by Buffalmacco) that went unfinished because of some "accident." With the image of the hanged Judas still fresh in the memory, Buffalmacco's unnamed but defeating accident in Bologna frames the subsequent story of his work in Arezzo for Bishop Guido. Taken openly from Sacchetti, the *novella* continues the leitmotif of games and just enough, but increasingly the amusing games resemble mishaps. The bishop, it seems, had an especially mischievous ape, who observed Buffalmacco painting a chapel in the Vescovado at the behest of their common master: "This animal, standing once on the scaffolding to watch Buonamico at work, had given attention to everything, and had never taken his eyes off him when he was mixing the colors, handling the flasks, beating the eggs for making the distempers, and in short when he was doing anything else whatsoever." After the painter left one night, the ape went to work, turning everything upside down, mixing up the colors, and finally repainting the whole thing "with his own hand." When Buonamico eventually returned and confronted chaos, he suspected sabotage in the form of some local motivated by envy. Hearing the tale and the painter's suspicions, the bishop was much troubled but desired that Buffalmacco start again and put the work to right, and as a safety against further vandalism, he placed six of his soldiers on guard with orders, in the event of a sniper, to "cut him to pieces without mercy." The figures having been repainted and the guards at watch, a rumbling in the church one hour signalled the return of the ape, who came up the scaffolding dragging a wooden weight that hardly cramped his style. Returning to work in the same way as before, "the new master" began to rework the saints of Buffalmacco, to the amusement of the soldiers and, later, Buffalmacco himself. They "were all like to burst with laughter; and Buonamico in particular, for all that he was vexed thereby, could not keep from laughing till the tears came." The ape had made a monkey of the greatest trickster of all. After this, Buffalmacco went to the bishop and said, "My lord, you

wish the painting to be done in one fashion, and your ape wishes it done in another." Then, relating the affair, he added: "There was no need for you to send for painters from elsewhere, if you had the true master at home. But he, perhaps, knew not so well how to make the mixtures; now that he knows, let him do it by himself, since I am no more good here. And his talent being revealed, I am content that there should be nothing given to me for my work, save leave to return to Florence."

Like the story of the pitcher, the story of the ape is also about what it takes to be a painter, for now Buffalmacco contends with a sham painter who is merely a mimicking ape. The theme of the painter as nature's ape is an old one; indeed, one of Giotto's pupils, Stefano, was crowned with the honorific: *scimmia della natura*. In a figurative sense the ape in this tale is an image of Buffalmacco himself, because when the latter worked without craft, he was no better than a creature who copied without comprehending. Vasari even describes the ape in terms that could also apply to Buffalmacco: *sollazzevole* and *cattivo*. In being *cattivo*, the ape, unlike the true painter, lacks judgment, because he cannot tell the difference between right and wrong, and to underscore this point Sacchetti and Vasari have the animal committing what in a human being would be blasphemy: the ape does his worst on a Sunday, but, of course, as Italians sometimes say about their pets: *non sono cristiani*, by which we are to understand that cats and dogs and apes cannot be held to the Commandments or to the teachings of either Testament. Though he might ape the painter, an ape and a painter were as different as a painter and a pitcher. However much Buffalmacco might be given to monkeyshine, he, unlike the animal, in fact possessed judgment and understanding. What he lacked, as his life had already begun to show, was seriousness of purpose and the drive to make his actions, namely, his works, mean something. Like the ape in the story, Buffalmacco in the Giochi e Bastari chapel merely went through the motions, with the consequence that time and fate had punished him by devouring his works, in effect, killing him. Vasari suggests the parallel by means of his language. In the end the guilty ape is caged, that is, punished and condemned to watch Buffalmacco finish the work, and, Vasari says, one could hardly imagine "the contortions which that creature kept making in this cage with his face, his body, and his hands, seeing others working and himself unable to take part." Vasari evokes the echoed presence of the Giochi e Bastari chapel, as well as the one who painted it, when he uses the phrase: "*i giuochi che quella bestiaccia faceva*." From *Giochi* and *Bastari* to *giuochi* and *bestiaccia*, the tragedy of Buffalmacco—for ultimately it is a comic tragedy—is underscored by the very fact that, unlike an ape, who only knew to make certain gestures, the human painter possessed talent and wit, that is, judgment. All too often, however, Buffalmacco was himself no better than the ape, aping a painter, for in misdirecting his talent he sacrificed his judgment.

The uncomical point of the Life is driven home by the coda, for the story of the ape, like the creature itself, has a narrative tail. Preserving the setting and characters of the first story as well as its animal imagery, the second episode is a demonstration of the painter's power, for it tells how Buffalmacco, as in Sacchetti's version, teaches the same high bishop of Arezzo his true place and shows how *virtu* can invert the given order of society. Unlike Sacchetti, however, Vasari frames this addendum in terms that justify Buffalmacco's actions and forestall all blame. After the ape was found out and the chapel finished, the bishop "commanded" another work

from Buffalmacco, but Vasari also says that the bishop did so "either in jest or for some other reason known only to himself." In other words, the patron acted on caprice, that is, a want of judgment that made him no better than his creature. What the bishop desired was "that Buffalmacco should paint him, on one wall of his palace, an eagle on the back of a lion which it had killed." This was a transparent political statement, like a cartoon, in which the Ghibelline eagle triumphed over the Guelph lion, and in reality Bishop Guido is known to have been a fierce Ghibelline. "The crafty painter, having promised to do all that the Bishop wished, had a good scaffolding made of planks, saying that he refused to be seen painting such a thing. This made, shutting himself alone inside it, he painted, contrary to what the Bishop wished, a lion that is tearing to pieces an eagle . . . ." The "crafty" painter follows one ruse with another. Pretending that the allegory remained unfinished, although it was, he invents an excuse to go home to Florence, in short, to disappear. Besting the bishop and enacting a symbolic Guelph victory over the rival Ghibellines, the Florentine goes to his *patria*, Florence, city of the lion, before the bishop can find out. Inverting the expected order of power, the one supposedly without power disarms his better, forcing him to make peace and to treat his supposed inferior as his *familiare*. This variation on the theme of servant and master is a cunning follow up to the tale of an animal and its keeper, for it shows that, unlike the "bad" ape who does not know right from wrong, the painter's contrariness has purpose and meaning as a demonstration of his moral judgment. One cannot help but recall two stories involving Giotto, the first, which Vasari quoted verbatim from Sacchetti, concerns Giotto and a coat of arms that he painted for a pretentious rube; the second has to do with an allegory that puts the king of Naples in his place. These analogous stories starring Giotto and Buffalmacco invite comparison between the two.

Having evoked Florence, Vasari returns Buffalmacco to his native city and to his ultimate fate, and no sooner is Buffalmacco home than Vasari introduces the catastrophic image of judgment day, weaving together the themes of death, living by one's wits, and judgment, both in the sense of punishment and in the sense of discernment or even wisdom. *Scrivono alcuni*: with this vague "some writers tell" Vasari imaginatively connects Buffalmacco to a real event: the terrible collapse of the Ponte alla Carraia that took place on May Day 1305. The entire bridge had become a stage for a vast representation of hell with figures dressed as demons and souls suspended in boats, a hell that came to pass when the bridge fell into the river. As Vasari would have it, the wily Buffalmacco might sing *vissi d'arte*, for he lived or, rather, escaped by his art. On that terrible day he was away getting some things for the festival and eluded God's wrathful judgment, even as he had cleverly eluded the wrath of the bishop of Arezzo. But what of his works?

Having brought Buonamico so close to judgment, Vasari continues with an account of works that reveal a dooming dichotomy between Buffalmacco's mind and his hand, between wit and craft. According to Vasari, Buffalmacco's work in Pisa, which some have tried to link to surviving mural fragments at S. Paolo a Ripa d'Arno as well as to the Camposanto, conveyed the fine "conceptions of his mind," but at the same time, Vasari says, these works are mostly ruined and show little design. To better understand the nature of Buffalmacco's work, which in turn sets off Giotto's, another painter traditionally linked to the artist now appears as his foil: Bruno. Mentioned at the start of the Life, Bruno is a character taken from Boccaccio and Sacchetti, where he and his companion Calandrino, whom Vasari does not mention, are Buffalmacco's

friends. In the *novelle* of Boccaccio and Sacchetti they are tricksters and buffoons, especially the hapless Calandrino, who once believed, thanks to Buffalmacco and Bruno, that he had disappeared from plain sight and no longer existed. Clearly, Calandrino was more *tondo* than Giotto's "O," and, in fact, "*far calandrino*" entered the language as "to sell someone the Brooklyn Bridge." In Vasari's Life of Buffalmacco, Calandrino remains an unspoken presence, the fool of fools, more fool than Bruno, who is less than Buffalmacco, who cannot compare to Giotto.

The silliness of Bruno was evident in his work. Vasari describes a still-extant painting that he wrongly attributes to Bruno. The description emphasizes discrepancies of scale, odd juxtapositions, and physically contorted figures so as to recast the picture in comic terms: the painting, he says, shows St. Ursula, who in one hand carries the banner of Pisa, while she offers "the other hand to a woman who, rising between two mountains and touching the sea with one of her feet, is stretching both her hands to her in the act of supplication. . . . ." To the reader, the spatial incongruities suggested by figures who stretch from mountains to sea conjures something of the illogical and worse. How can one not laugh, when Bruno then complains that his figures "had not the same life as those of Buonamico"? His friend treats him as he did others of dull wit, telling him that his figures would surely be speaking likenesses if only Bruno were to give them speech by way of speech bubbles. This device, which it suited Vasari to praise in his Life of Cimabue,[8] now becomes an object of ridicule: "This expedient," he writes, "even as it pleased Bruno and the other thick-witted men of those times, in like manner pleases certain boors to-day, who are served therein by craftsmen as vulgar as themselves." How, he adds, could anyone make use of a device that started as merely a joke, yet the inability to tell a legitimate pictorial device from a jest is the reason why, for Vasari, so many of the murals in the Camposanto of Pisa are to be condemned. Unlike Buffalmacco's bizarre allegory for the bishop of Arezzo, in which the painter's wit and understanding allow him to manipulate nature and master his patron, Bruno's work is merely foolish.

Bruno's failure of perspective and his silly juxtaposition of words and images are set beside Buffalmacco's solutions to the same problems. Praising a colossal figure of God the Father that he incorrectly claims Buffalmacco painted in the Camposanto, he says that the painter appended at the foot of this image a sonnet written "with his own hand." Unlike Bruno, Buonamico separated and distinguished the painted figure from the voice of the sonnet, which begins with a direct address, "you who see this painting. . . ." Whereas Buffalmacco possessed judgment, poor Bruno was hopelessly witless, and Vasari accentuates the point by saying that Buffalmacco supplied Bruno with designs for certain works in S. Maria Novella in Florence, because he recognized that "Bruno had not much design or invention."

In contrast to Bruno, who was blind to his own faults, Buffalmacco's goofiness reveals a knowing intellect, such that when he played with scale, perspective, and the natural order of things, it was to make a point. Vasari tells the story of a peasant (another prejudicial casting) who wanted an image of St. Christopher twelve *braccie* high or about twenty-four feet, in keeping with a saint who was traditionally depicted as a giant. After measuring the church where the figure was to be painted, it became apparent to Buffalmacco that the rube's arithmetic, as well as his judgment, were off, because the little church was not nine *braccie* in either height or length. Since he could not squeeze the figure in upright, he hit upon the perfect solution: he

would paint it lying down. Even so, he had to bend the figure at the knees from one wall to another to reach the full twelve *braccie*. Naturally, the peasant protested that he had been duped and refused to pay, but when the case wound up in court, Buffalmacco won, it being agreed that he had completely fulfilled the terms of the agreement. In Buffalmacco's hands the comical makes sense, but the St. Christopher may also be understood as a kind of a self-portrait of the painter: after all, though surviving documents refute it, Vasari claims that Buffalmacco's middle name was Cristofano, but more to the point, from his earliest days Buonamico was wont to take life lying down.

As Vasari brings Buonamico's career to an end, he speaks of countless works, including many throughout the Marche, all lost, and in this final census he mentions, for the second time in the life, a terrible subject and the image of another lost soul: Buffalmacco's painting of "Judas hanging from a tree." This dark note jolts us into the realization that silliness, no matter how shrewd, ultimately will not last, as indeed few of Buffalmacco's works survived. It is perhaps no coincidence at this point that the works Vasari specifies evoke the partnered notions of wisdom and foolishness: the learned St. Ivo, St. Catherine confounding the philosophers, but then, in Perugia, the perfect job for "Good Ol' Boy" Buffalmacco: the chapel of the Buontempi, literally, "good times."

As the good times come to an end, Buonamico performs two more tricks, both very nearly sacrilegious, that recall his escapades with the nuns of Faenza. In the first story, which is taken from Sacchetti, the people of Perugia commission him to paint an image of their patron, St. Ercolano, in the town square. He set to work behind "a screen of planks and matting, to the end that the master might not be seen painting. . . ." But within a fortnight the locals began pestering him about the work and urging him to finish, "as though such works were cast in moulds." Disgusted that these importunate people knew nothing of what it took to create such a figure, Buffalmacco "determined within himself to take a gentle vengeance." When the work was completed but before unveiling it, he let them see it, to their delight, but what they were to learn soon enough is that the painter-magician can make something disappear as well as appear and that he can make something ugly as easily as he can make something beautiful. When the Perugians moved to remove the screen, he stalled, saying they should leave it up for two days more; then, withdrawing behind the scaffolding, the painter decided that the patron saint of fools could hardly wear a crown of gold, so he removed the splendid diadem of gilded pastiglia work that adorned the saint's head and replaced it with something more appropriate: a slimy tiara of fish. Then quietly leaving town, that is, vanishing into thin air, he left the Perugians to discover the insult, and when they did, "they said all the evil that can be imagined about Buonamico and the rest of the Florentines."

Buffalmacco's last trick is also about the painter's power of illusion. Having to paint a *Madonna and Child* for another unworthy patron in a church at Calcinaia, when the one who ordered it gave him words instead of cash, he asked to be punished, because, Vasari says in an understatement, Buonamico "was not used to being trifled with or being fooled. . . ." Transforming the infant Christ Child into a baby bear, he produced a monstrous, almost satanic, Madonna. One can well imagine that having one's name and money attached to such a work might give the Lord, not to mention the neighbors, the wrong impression. Well might the peas-

ant be terrified, and in due course, far from refusing, he was begging the painter to take his money and to put the image right. This the painter was able to do merely with a sponge dipped in water, because he had painted the bear in watercolor in the first place. Thus, with a mere wave of his hand, the crafty painter was able to make the monster vanish.

The bear is merely the last in a surprisingly long list of animals mentioned in this life: cockroaches, Goosehead the birdbrain, an ape, an eagle, a lion, fish, and finally the bear; moreover, Vasari uses the verb *uccellare* or to gull, which is derived from *uccello* or bird. Thus the Life of Buffalmacco conjures the teeming vitality of much trecento painting and at the same time evokes the tradition of the *fabliaux*, for the Life of Buffalmacco is a life of fables, and as with fables there are victims and morals. Long is the list of Buffalmacco's victims: his master Tafo, Goosehead, the silly nuns of Faenza, the bishop of Arezzo, his friend Bruno, the peasant who wanted a St. Christopher, and the peasant who got a bear: all are unseeing, dull, or ignorant. Yet in the end Buffalmacco is also a victim, because he cannot see beyond today, beyond the here and now. Perspective was the Renaissance painter's vehicle into infinity and lasting fame, but Vasari's Buffalmacco is limited: he does not go far. The intelligence behind his trickery allows him to get by in his own day but to what end? What is left? Most of the works that Vasari describes, by his own account, are either lost or spoiled, hardly surviving but a day. Likewise, Vasari's Buffalmacco, like Giotto's *Folly*, could not see past the moment. Of the fortune he made in Pisa, Vasari claims that he spent everything, for he was, Vasari says, "careless of today" and a spendthrift, who died a pauper. Self-defeating in spite of his wits, Buffalmacco cannot see beyond the present. Too often he merely goes through the motions, like a comical monkey, willing to use his art to get what he wants and to victimize those around him without thinking that his works should be more than jokes and barbs but things that last beyond the circumstances of their creation. Ultimately his buffoonry is self-annihilating, the saddening folly of an artist with talent but no prudence, which, as in Giotto's Arena Chapel, is folly's opposite. In the end, Buffalmacco amounts to a big amusing zero, a *tondo*. As Burchiello says of one more *tondo* than Giotto's "O": "*al tuo goffo buffon darò del macco*": and for Vasari it is as if *buffon* and *macco* add up to Buffalmacco, because Vasari's Buffalmacco is no more than what his name proclaims: silly mush. In this there is a moral: it is important to know the difference between a true artist like Giotto and one like Buffalmacco, who for all his cleverness fails. Vasari's Life of Buffalmacco is a prolonged parable of wasted talent, and in this regard it is noteworthy that it immediately precedes that of Ambrogio Lorenzetti, whom Vasari, inspired no doubt by the painter's murals in the Sala della Pace in Siena, portrays as learned, wise, and philosophical.

Above all, Buffalmacco is less than Giotto, and Vasari's Buffalmacco allows us to better appreciate Giotto's accomplishment and to gain perspective on a loftier breed of artist. Giotto, Buffalmacco, Bruno, and Calandrino are like the reflected images of a mirror within a mirror, in which each successive reflection of the artist is progressively diminished with each remove from the source. If Calandrino is a fool and Bruno a trickster without ingenuity, Buffalmacco is a talented deceiver with judgment he fails to use. But Giotto is a sorcerer, a conqueror, a true painter. Giotto possesses judgment, wit, skill, and seriousness of purpose. Unlike Buffalmacco, he is never absent, and as a result the world falls at this feet. So must every artist do who hopes to succeed. If Buffalmacco's name hints at who he is, so too is Giotto's very name an audible

reminder of that magical "O," for the "O," as if doubled for emphasis, hangs on the lips every time we speak his name. Whereas Buffalmacco's works perish, in Vasari's account, Giotto *vincit omnia*, for Vasari's Life of Giotto is a record of imperial conquest. It is a conception that still underlies and bedevils modern assessments of Giotto's career, and it is key to the structure of the First Part of the *Lives*. Within the sweep of a linear development, Vasari also fashioned a circular configuration, in which the entire cast of the first age revolves around the virtuous hero, Giotto. Giotto's conquests include the arts of painting, sculpture, and architecture; princes and prelates; the Sienese and, indeed, all Italy. By contrast, Buffalmacco is the poignant personification of unmet potential. He is a painter too clever for his own good, a wizard without a destiny, a sorcerer without a stone. Whereas Buffalmacco's delightful tricks are as ephemeral as a soap bubble, Giotto's conquest of nature and the realm of appearances is a legacy with substance, a legacy that anticipates the victories of Brunelleschi and heroes of the Second Part, as well as the ultimate triumph of Michelangelo: *tutto tondo*.

NOTES

*This essay is forthcoming in* Fools of Fortune: Victims and Villains *in* Giorgio Vasari's Lives *by Andrew Ladis.* © *by The University of North Carolina Press. Used by permission of the publisher.*

1. See Giotto's Life in *Le Vite de' più eccellenti pittori, scultor ed architettori, scritte da Giorgio Vasari pitttore aretino con nuove annotazioni ed commenti di Gaetano Milanesi*, Firenze: G.C. Sansoni, Editore, [1906] 1981, vol. 1, 369–409. Hereafter referred to as Vasari-Milanesi.

2. Life of Cimabue in Giorgio Vasari's *Lives of the Most Eminent Painters, Sculptors and Architects*, trans. Gaston du C. de Vere (New York: Alfred A. Knopf, 1996), vol. 1, 57. Hereafter, Vasari-De Vere.

3. Life of Buffalmacco in Vasari-Milanesi, vol. 1, 499–520.

4. Fra Puzzo, about whom Lauro Martines says, "Whether purely imagined or partly real, he is the type of the carnal, pushy, pleasure-loving, hypocritical, fifteenth-century cleric, and the head of his convent to boot." See Lauro Martines, *An Italian Renaissance Sextet* (New York: Marsilio Publishers, 1994), 84.

5. This anticipates Botticelli and the noisy neighbor with the loom. Botticelli gets his way via a solution worthy of the painter who illustrated Dante's Inferno. Adopting an approach that threatens his nemesis with destruction in the way that the threats of hell deter every erring soul, he balances a colossal stone on the ledge over the neighbor's house, so that any shaking threatened to cause it to fall on the helpless neighbor. See Vasari-Milanesi, vol. 3, 320.

6. *Commentarii,* 26. The passage reads: "Buonamico fu eccellentissimo maestro: ebbe l'arte da natura, durava poca fatica nelle sue opere. Dipinse nel monastero delle donne di Faenza: è tutto egregiamente di sua mano dipinto con moltissime istorie molto mirabili. Quando metteva l'animo nelle sue opere, passava tutti gli altri pictori. Fu gentilissimo maestro. Colorì freschissimamente. Fece in Pisa moltissimi lavorii. Dipinse in Campo santo a Pisa moltissime istorie. Dipinse a Sancto Pagolo a Ripa d'Arno istorie del testamento vecchio et molte istorie di vergini. Fu prontissimo nell'arte; fu uomo molto godente . . . . Fiorì in Etruria molto egregiamente; fece moltissimi lavorii nella città di Bologna. Fu doctissimo in tutta l'arte; dipinse nella Badia di Settimo le storie di Sa[n]cto Jacopo et molte altre cose." See Lorenzo Ghiberti, *I Commentarii*, ed. O. Morisani, (Naples, 1947).

7. To underscore the point, Vasari ends by praising some murals in the church of Ognissanti, which he attributes to Buffalmacco: they "were wrought," he says of these lost works, "with so much diligence and with so many precautions, that the water which has rained over them for so many years has not been able to spoil them or to prevent their excellence from being recognized, and that they have been preserved very well, because they were wrought purely on the fresh plaster."

8. It suited Vasari to see the device in a negative light here, but in the Life of Cimabue, he sees it otherwise in talking about a panel by Cimabue in Pisa, where words accompanied the figures: "Wherein it is to be observed that Cimabue began to give light and to open the way to invention, assisting art with words in order to express his conception; which was certainly something whimsical and new." See Vasari-De Vere, vol. 1, 56.

MINO DA FIESOLE SCVLTORE

# Vasari's Sculptors of the Second Period: Mino da Fiesole

SHELLEY E. ZURAW, UNIVERSITY OF GEORGIA

One cannot read the Life of Giotto, Painter, Sculptor, and Architect of Florence without recalling that of Michelangelo Buonarroti, Painter, Sculptor, and Architect of Florence [1] because the earlier biography was conceived, at least in part, as a foreshadowing of the latter. In a sense, the whole of the *Lives* serves to introduce its climactic biography, that of Michelangelo, "a spirit with universal ability in every art and every profession."[2] This typological program affects biographies throughout the *Lives*, even ones not ostensibly afforded the attention given to the great masters. Among the *Lives* often overlooked are those devoted to the marble carvers of the mid-quattrocento. Physically separated from the more famous sculptors of the fifteenth century, the biographies of Antonio Rossellino, Desiderio da Settignano, and Mino da Fiesole seem almost incidental to the great sweep of Florentine art. Yet Michelangelo, who for Vasari embodied the ideal representative of all the arts, was—at least in his own estimation—first and foremost a sculptor of marble. And the lives of Michelangelo's immediate predecessors in that field, the men once known as the little marble masters, demonstrate the author's careful use of these sculptors as prototypes, exemplifying single virtues and even vices that would ultimately come to fruition in Michelangelo.

The generation of Florentine sculptors that fell between Ghiberti and Donatello at the beginning of the quattrocento and Verrocchio and Pollaiuolo at the end is represented in the *Lives* by three biographies—Antonio Rossellino, Desiderio da Settignano, and Mino da Fiesole.[3] In this order they appear together in the 1568 edition sandwiched between two Ferrarese painters—Galasso Ferrarese and Lorenzo Costa.[4] This grouping of sculptors suggests that Vasari understood that the three had important biographical, formal, and presumably chronological connections. Yet it is remarkable how diverse these lives are; there are striking differences in tone and, arguably, intent between the first two and the last. Vasari wrote the three biographies to be instructive, not as accounts of the artists' careers or production.[5] His praise of Antonio Rossellino and Desiderio da Settignano assured their future reputations, modern historiographical analysis being capable of sidestepping the prescriptive bias of their lives. But what of Mino who, as he appears in Vasari's tale, had no place in the history of Renaissance sculpture leading to Michelangelo? In this instance, the moralizing tenor has egregiously affected our understanding of the development of Renaissance sculpture. If Desiderio and Antonio

Fig. 1 *Antonio Rossellino, scultore Fior*, woodcut, 1568 edition of Vasari's *Le vite de 'più eccellenti pittori, scultori ed architetti*, photo by author.

represent aspects of the ideal sculptor whose noble grace and divine genius foreshadow Michelangelo, then Mino stands for their opposite, the craftsman whose training and methods represent the end of an outmoded tradition.

The biography of Antonio Rossellino (fig. 1) narrates both the career of the eponymous sculptor and that of his brother, Bernardo Rossellino. Antonio's greater importance is made clear in the phrasing of the biography's heading: "Antonio Rossellino e Bernardo, Suo Fratello." Primarily about Antonio Rossellino, it is only secondarily about Bernardo, his brother. This hierarchy is reinforced in the biography itself. Vasari begins with a panegyric to Antonio, addressing Bernardo's life after his brother's has been reviewed. Yet, even so, Antonio's career is dealt with swiftly. Vasari lists Antonio's works including the Nori Monument in S. Croce and a series of reliefs of the Madonna and Child. He pauses to admire the Chapel of the Cardinal of Portugal, noting that "it appears not merely difficult but impossible for it to have been executed so well." The climactic superlative refers to the angels who seem "not merely made of marble, but absolutely alive." Dating the erection of the tomb to 1459, Vasari goes on to explain that a version of the tomb was made for the Duke of Malfi, Antonio Piccolomini.[6] Here, again, Vasari tells us that Antonio's sculptures seem almost to breathe and that "iron tools and man's intelligence could effect nothing more in marble." Reinforcing this statement, Vasari concludes with the ultimate approbation—that Antonio's works were much esteemed by Michelangelo.

Bernardo's portion of the biography follows immediately and Vasari manages to say even less about Bernardo than he did about his brother.[7] We learn that Bernardo, an architect and sculptor, made the tomb for Leonardo Bruni in S. Croce. The longest passage in the entire biography addresses a different aspect of Bernardo's career altogether; it is essentially a list of works undertaken or planned by Pope Nicholas V in Rome. Vasari acknowledges his source to be Giannozzo Manetti and then goes on to describe works designed by Bernardo. This apparently factual recording of Bernardo's projects for the pope rapidly dissolves into fantastic descriptions of plans invented by the pope himself.[8] It is almost impossible to recognize in this treatment of the brothers what modern art historians tend to emphasize.[9] No mention is made of Bernardo's status as the elder brother and, therefore, his presumed role in Antonio's training. Nor is Bernardo's not inconsiderable career as a sculptor outlined.[10] And while several of Antonio's

most important sculptures are mentioned by Vasari, his famous portrait busts have no place in this account. Vasari concludes the biography by returning self-consciously—he refers to the discussion of Nicholas V's projects as a digression—to Antonio, his ostensible subject. He adds one unexpected and, indeed, incorrect, detail to the life. According to the author, "Antonio wrought his sculptures about the year 1490." While the sole previously mentioned date of 1459 that Vasari provides for the Chapel of the Cardinal of Portugal roughly marks the beginning of that project, Antonio (b. 1427 or 1428) probably died of the plague in 1479.[11]

This same willful prolongation of a career occurs in the life of Desiderio da Settignano (fig. 2). Noting that death took him prematurely, Vasari again includes the curiously vague statement that "the

Fig. 2 *Desiderio da Settignano, scultore*, woodcut, 1568 edition of Vasari's *Le vite de' più eccellenti pittori, scultori ed architetti*, photo by author.

sculptures of Desiderio date about 1485." Desiderio was born, like Antonio Rossellino and Mino da Fiesole, around 1430. He died, however, in 1464, twenty years before Vasari implies. Like the Life of Antonio Rossellino, Desiderio's too begins with an encomium, followed by a brief list of works. Vasari is careful to note at the outset that even though the artist was from Settignano, the town is so close to Florence that "this matters nothing." Identified as an imitator of Donatello, his first work is described as the marble base for the bronze David. The early works that follow are an odd compendium: lost works, important works mistakenly described (most famously the confusion about the marble sacrament tabernacles in S. Lorenzo and S. Pier Maggiore), and incorrect attributions (the tomb of the Blessed Villana in Santa Maria Novella is by Bernardo Rossellino).[12] Vasari then devotes a long passage to the tomb of Carlo Marsuppini in S. Croce, describing it, as he did the Chapel of the Cardinal of Portugal, as a work that "still fills with marvel all who see it."

With both artists Vasari is at pains to explain that their work is admired by his own contemporaries. Not only that, both Antonio and Desiderio are characterized by their nobility and grace. Indeed, the biography of Desiderio da Settignano begins with a striking explanation for his skill as a sculptor. It was a "celestial gift" that allowed the sculptor to bring such grace and beauty to his creations that they seemed to marry Heaven and Nature. This statement echoes in advance the famous introductory passage in the Life of Michelangelo—that the "most benign Ruler of Heaven . . . became minded to send down to earth a spirit . . . who might be able, by himself alone, to show what manner of thing is the perfection of the art of design. . . ."[13] Thus

the reader alert to the climactic nature of the divine Michelangelo's role in Vasari's *Lives* understands Desiderio's divine gift as a prefiguration of that later heavenly "clemency." In praise of Antonio's work Vasari directly quotes Michelangelo's assessment of the sculptor. Further conjuring Michelangelo's status, Vasari says of Antonio that "he was esteemed by all who knew him as something more than a man, and adored almost as a saint." Antonio is almost divine by virtue of his saintly character, Desiderio is the celestial genius, "a spirit who worked . . . nobly." While their factual careers are sharply truncated in Vasari's biographies, each allowed one glorious work, the focus of both lives is on their ideal character traits. And with both we are offered a foretaste of Vasari's idealized Michelangelo.

And it is surely for this reason that both sculptors' dates are so erroneously recorded. In the grand sweep of the quattrocento, marble carving had been brought to an unsurpassable level by Donatello, "for not only did no craftsman in this period ever surpass him, but no one even in our own age has equaled him."[14] Lest we mistake the author's meaning, the last lines in the Life of Donatello are a quote from Borghini: "Either the spirit of Donato works in Buonarroto, or that of Buonarroto began by working in Donato."[15] Michelangelo is Donatello reborn, in other words, his true heir. But how would this work practically? Vasari was famously unwilling to accept Michelangelo's own myth that he learned to be a painter without a master.[16] With marble, the explanations become even more convoluted. Michelangelo himself explained that he took in marble dust with his nurse's milk in Settignano. In the Medici Garden, overseen by Bertoldo, Michelangelo could learn about antique statues, bronze casting, even marble polishing from Donatello's last assistant, but not about carving itself. So when he came to carve a faun's head, his success was doubly admirable because he "had never yet touched marble or chisels."[17] Since there was no one in Florence from whom the young man could learn, Vasari extends the lives of Desiderio and Rossellino, allowing them to be, at least implicitly, the marble masters who provide the link between Michelangelo's genius as a marble carver and the earlier triumphs of Donatello.[18]

How different is the third Life in this series of three. Desiderio and Antonio Rossellino, graced by heaven with divine skills and saintly personae, are in every way distinguished from their compatriot, Mino da Fiesole. Instead of praise, Mino's life begins with a cautionary tale. Mino is Vasari's model for the artist so trapped in admiration for his master that he cannot break free to form his own, independent style.[19] The "master" is Desiderio da Settignano and, according to Vasari, Mino:

> having an intelligence capable of achieving whatsoever he wished, was so captivated by the manner of his master, Desiderio da Settignano, by reason of the beautiful grace that he gave to the heads of women, children and every other kind of figure, which appeared to Mino's judgment to be superior to nature, that he practiced and studied it alone, abandoning natural objects and thinking them useless, wherefore he had more grace than solid grounding in his art.

This explanation for Mino's development is as fantastic a tale as any other told in the *Lives*. Mino da Fiesole (fig. 3) was born in 1429; his first known work is the portrait bust of Piero de' Medici, signed and dated 1453 (Bargello, Florence). Admittedly, no documentary or stylistic evidence

allows for a secure identification of Mino's teacher, but it was not likely to have been Desiderio. Almost Mino's exact contemporary, Desiderio only matriculated in the *Arte della Pietra e del Legname* in 1453. Scholars most often associated both Desiderio and Antonio Rossellino with the workshop of Bernardo Rossellino.[20] Yet in Vasari's biographies neither sculptor has a master; instead they spring fully formed onto the stage. In contrast, the identity of Mino's master, who plays such an essential role in Vasari's biography, has not been satisfactorily identified. Linked to Bernardo or to Michelozzo by some, the most likely candidate may be Luca della Robbia.[21] Of all these possibilities Desiderio da Settignano is the least likely. The dates alone suggest that Vasari's designation of Mino's master can have little basis in fact. But the story underlines Desiderio's

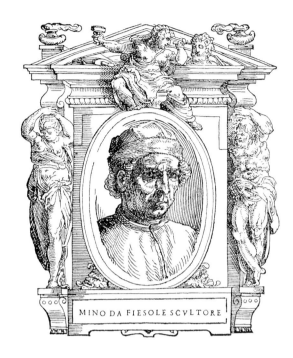

Fig. 3 *Mino da Fiesole, scultore*, woodcut, 1568 edition of Vasari's *Le vite de'più eccellenti pittori, scultori ed architetti*, photo by author.

"celestial gifts," since Mino's inability to master the rules of nature and his dependence on the model of another is deliberately opposed to Desiderio's divinely given facility.

Mino's biography is also distinguished from that of his peers by its length. Vasari carefully describes Mino's works in Florence, Rome, Volterra, Perugia, and Fiesole. The sense one has that this is a well-researched biography is made explicit when Vasari provides the exact price paid for the tomb of Count Hugo of Tuscany in the Florentine Badia, L.1600.[22] Reading the Life of Mino da Fiesole one gets glimpses of a personality—Mino takes a wife, he is a hard worker, determined and professional in his trade, who step by step makes a career for himself; even his death has a specific cause.[23] Mino da Fiesole made a good name for himself through his work; it was not the glory of genius that attracted his patrons, but the consistency of his product. Vasari's Mino, like the works he carves, is steady, reliable, responsive to his patrons, and uninspiring. Oddly, personalities are exactly what Desiderio and Antonio lack in Vasari's biographies of them.

But Mino's own life was not enough. Vasari, in essence, provides the sculptor with two biographies and both serve to dramatize artistic failures, both of skill and of character. The story of Mino da Fiesole, the career artist, is mirrored in that of his alter-ego, another artist who attempted to improve himself and his reputation, but who was destroyed by his own malevolent personality—Mino del Reame. This second Mino is not afforded his own Life. He shares it with another sculptor, Paolo Romano.[24] One Roman and the other apparently Neapolitan—Vasari also uses del Regno to identify Mino as from the kingdom of Naples—their biography is set between those of two Florentine painters of the second manner, Fra Filippo Lippi and Andrea

del Castagno. Like the Life of Mino da Fiesole, the purpose of the lives of these two obscure, foreign sculptors is to serve as exempla, models for the proper and improper behavior of the artist.

The shared life of Paolo Romano (fig. 4) and "Maestro Mino" opens with the infamous story of their competition. According to Vasari, the artists were involved in a competition for two marble figures of Sts. Peter and Paul to flank the entrance to the Basilica of St. Peter. Paolo Romano, whose work pleased Pope Pius II greatly, was asked to make a figure, presumably the extant St. Paul today on the Ponte Sant' Angelo. Mino, a "presumptuous and arrogant" character, so importuned the pope for its pendant that he, too, was awarded a statue to carve. Vasari's language in this story is notable for its dramatic intensity. Paolo Romano is described as "modest and quite able," whereas the sculptor Mino is "so overbearing . . . with his speech [that he] exalted his own works beyond all due measure." Mino persecuted Paolo out of envy and falling into a rage, bet Paolo a thousand ducats that he could do a better figure assuming, apparently, that Paolo was too placid a personality to accept the challenge. Paolo, however, did agree to the competition. In a panic Mino, knowing his true worth, reduced the bet to a mere hundred ducats. The moral of this story is virtually predetermined; the rare and excellent master's work was judged the finer and "Mino was scorned as the sort of craftsman whose words were worth more than his works."

It is not Vasari's moral tale that traditionally has concerned art historians but, rather, the problematic facts that lie behind the story. In other words what, if anything, about this story, is true? Regarding the actual sculptures, Paolo Romano's St. Paul is documented, and its history since 1534 when Clement VII had it placed before the south side of the Ponte Sant'Angelo, is well known.[25] The sixteenth-century pope commissioned a pendant to the St. Paul; this sculpture of St. Peter, by Lorenzetto and also documented, has stood with the St. Paul since its creation.[26] The question that Vasari's story leaves unanswered is the history of Mino's sculpture, another statue of St. Peter.

Vasari's "Maestro Mino" or "Mino del Regno" or "Mino del Reame" was the focus of extraordinarily convoluted art historical controversy for almost a century.[27] From the meager facts available it was argued that a Neapolitan named Mino did, indeed, work in Rome in the middle of the fifteenth century. What he actually did and what of that survived was the second question. The problem was, of course, the overlapping presence of another Mino in Rome during this same period—Mino da Fiesole. Vasari seemed to have been describing two sculptors—one from Naples and one from Florence. He even goes so far as to acknowledge their intersection:

> And although some believe that this tomb [the Tomb of Paul II, d. 1471] is by the hand of Mino del Reame, yet, notwithstanding that these two masters lived at almost the same time, it is without doubt by the hand of Mino da Fiesole. It is true, indeed, that the said Mino del Reame made some little figures on the base, which can be recognized; if in truth his name was Mino, and not, as some maintain, Dino.[28]

Vasari here seems to suggest that he is uncertain about Mino del Reame's real name. But, in fact, he is further confusing the problematic distinction between the two Minos because it is Mino da Fiesole who appears in Filarete's list of sculptors as Dino and, again, it is Mino da Fiesole who is

mentioned by Gauricus as Nino.[29] In a modern attempt to differentiate the work of the two Minos a case was made for the distinctive quality of a series of works produced in Rome in the 1450s and early 1460s, most signed "Opus Mini." There was, however, nothing on the Tomb of Paul II that could be connected with this otherwise unknown master sculptor from Naples. The ingenious explanations for the apparent contradictions in Vasari's account make fascinating reading on their own. They are vivid records of the historic tendency to assume that what Vasari said must be true because his work was intended as a historical and, therefore, factual account.[30]

In this case the presumption of factual accuracy was continually undermined by what was generally believed to be the false, or allegorical, story of the statues of Sts. Peter and Paul.[31] Recently

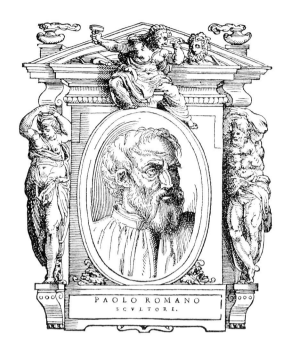

Fig. 4 *Paolo Romano, scultore*, woodcut, 1568 edition of Vasari's *Le vite de' più eccellenti pittori, scultori ed architetti*, photo by author.

discovered documents have revealed, however, that two statues were, in fact, commissioned by the Pope from Paolo Romano and Mino da Fiesole.[32] Mino never completed the statue of St. Peter; yet, according to Poliziano, the great architect Alberti described this ruined work as "the best thing Mino ever did." The implicit joke was that Mino's completed works were so poor that an unfinished one could only be an improvement.[33] It is worth recalling that the pendant to this sculpture, Paolo Romano's St. Paul, is one of the great, large-scale marble statues of the quattrocento. Fortunately for us, Alberti's negative appraisal of the St. Peter can now be compared to the actual work, the statue of St. Peter begun by Mino da Fiesole, but finished by Niccolo Longhi.[34] Although considerably altered, the work still unmistakably reveals Mino da Fiesole's hand; indeed, it appears as if one of his relief figures has been blown up and set free in space.

These two extraordinary sculptures were transformed by Vasari into emblems of jealousy and arrogance. How different is his description of this competition from the other great sculptural competition of the fifteenth century, that for the bronze doors for the Florentine Baptistery. That event, described by Brunelleschi's biographer as acrimonious—at least at the end—is used by Vasari to represent the paradigm of public-spirited competition.[35] In the Life of Ghiberti, Vasari tells us that Brunelleschi and Donato, "seeing the diligence that Lorenzo had used in his work, drew aside, and, conferring together, they resolved that the work should be given to Lorenzo, it appearing to them that thus both the public and the private interest would be best served." For Vasari, competition held between artists who are equally good and talented should inspire greater achievements. As he says in the Life of Brunelleschi: "Happy spirits! Who, while

they are assisting one another, took delight in praising the labors of others." And he continues in the next breath: "How unhappy are those of our own day who, not sated with injuring each other, burst with envy while rending others."[36]

Vasari's determination to make this essential point about artistic collaboration—its ideal functioning with the Baptistery commission and its opposite, the debacle at St. Peter's—is reinforced in the biography that follows that of the Roman sculptor and his Neapolitan rival. Paolo Romano and Mino del Reame appear not with Antonio, Desiderio, and Mino da Fiesole, but before the double life of two painters, Andrea dal Castagno and Domenico Veneziano, who replay the same theme of competition between a "cruel and devilish" artist, one "notable for the rancor and envy that he bore towards other painters," and the "good and affectionate" friend.[37] In this case the "vice of envy" led inexorably to murder; Andrea attacked and killed his friend and teacher in order to "remove him from his path" to fame and glory.[38] Thus in these paired double lives of sculptors and painters Vasari states and restates his opinion about deplorable competitors and competitions.[39]

Implicit in the story of Domenico Veneziano and Castagno is another theme—xenophobia. Andrea del Castagno is carefully identified as having been born in the Mugello, "in the territory of Florence," while his rival, Domenico Veneziano, was easily identified by name as an alien. Domenico had been summoned to Florence because he knew the new method of oil painting and Vasari explains that Castagno was jealous because "the Venetian, although a foreigner, should be welcomed and entertained by the citizens." And while the story of Mino's failure ends in utter humiliation, even though Castagno murders the foreign Venetian artist, he still achieves glory because of his boldness and "*terribilità*." Andrea, for all his poisoned spirit, is described as a Florentine draftsman and painter who, in his art, anticipates the third era of Michelangelo.

If Andrea dal Castagno foreshadows some of his fellow Florentine painter's *terribilità*, neither of the two foreign sculptors are afforded a similar role. That potential is, not surprisingly, awarded to Florentine sculptors.[40] The marble carvers of Castagno's generation, who, in their facility and beauty, anticipate Michelangelo are Desiderio and Antonio Rossellino. If they embody both the ideal style and personality, then their opposite, Mino da Fiesole, is Vasari's model for the artist whose style never achieves true independence and, therefore, beauty.[41] In turn, the Florentine's alter-ego "Mino del Reame" illustrates the failure of personality, the evils of envy and self-centered competitiveness.

If Mino's life (or, better, his dual lives) illustrates the pitfalls of artistic and personal vice and weakness, Desiderio and Antonio Rossellino's lives set the stage for the heroic, divinely sanctioned career of Michelangelo. The difference between these lives is not merely anecdotal, it is also formulaic. About both Minos, specific stories are told that recount and define problematic personal and artistic behaviors: Mino del Reame's competition with Paolo Romano reveals his true character, Mino da Fiesole's excessive devotion to his master led to his despair at Desiderio's death and his subsequent departure for Rome. Desiderio and Antonio, on the other hand, are emblematic figures. They represent ideals, but these ideals are merely listed, not illustrated. Their characters are embodiments of their works; their lives tell us nothing about the sculptors other than to reveal Vasari's calculating reaction to their sculptures. For as Vasari says, Antonio's "supreme virtues . . . were united to his talents." His carvings:

display diligence and difficulty . . . and these two characteristics are particularly noticeable in Antonio's work; [thus] he deserves fame and honor as a most illustrious example from which modern sculptors have been able to learn.

The same approach is evident in the Life of Desiderio—his "grace and simplicity" refers both to his person and to his sculpture. But still unanswered is the question—why does Vasari treat Mino da Fiesole so differently? Not only does he make Mino into a schizophrenic, dividing him into two different personalities, but both of these Minos are described as fully formed individuals, not two-dimensional ciphers identified with the works they made. Personalities are exactly what Desiderio and Antonio seem to lack in Vasari's biographies of them. It is, after all, always easier to describe sinners than saints and what Vasari seems to have wanted here was the contrast between two types.

That these biographies represent types is further underscored by the actual portraits that Vasari includes with his text. Desiderio's portrait, based, he tells us, on a portrait obtained from some of Desiderio's relatives in Settignano, depicts a shockingly youthful man, almost a boy, whose capless head is engulfed in curls and who apparently lacks facial hair (fig. 2). Like his sculptures of children, "there is seen a delicate, sweet and charming manner." Desiderio is again not an individual but a type whose virtues are illustrated by, even derived from, his own eternally youthful and idealized sculptures. For Antonio Rossellino, too, Vasari is at pains to document the face, explaining that he has a portrait drawing in "our book" done by Antonio himself. Antonio's image shows an aged and bearded man, whose upturned eyes and open mouth have all the vivacity and depth of some of Antonio's own sculptures that "reveal such grace, beauty, and art in their expressions . . .that they appear not merely made of marble but absolutely alive" (fig. 1). Here, too, Antonio's art explains his appearance. Mino's portrait, based on one that Vasari owned but could not attribute to anyone, shows neither the heroic vivacity of Antonio nor the youthful purity of Desiderio. Mino is, instead, merely a middle-aged man, wearing a cap (fig. 3). He looks out of the frame directly at the viewer, without any special attributes. He is, as Vasari characterizes him, both visually and textually, a craftsman who works with diligence. His evil twin, Mino del Reame, has no portrait at all, as if to emphasize his rather murky status.[42]

Desiderio and Antonio, though certainly real, are emblematic figures. Just like their portraits, their characters are embodiments of their works. Together Desiderio and Antonio anticipate Michelangelo's appearance. They foreshadow the heavenly intervention that was required to produce Michelangelo, but also through their art, they provide the transition between the generation of Donatello and the glorious era announced by Michelangelo's arrival.

In Vasari's *Lives* Mino da Fiesole's dull and plodding life and equally unremarkable portrait cannot be compared to those of Michelangelo. Yet, strangely, of the three Florentine sculptors, it is Mino da Fiesole whose career most closely foreshadows the arch traced by Michelangelo's—both began working for the Medici, both had extensive experience in Rome, both produced papal tombs, and both were involved in large-scale architectural projects.[43] But for Vasari Mino lacks the spark of divine genius, of *terribilità*, of creative *sprezzatura* that so completely defines Michelangelo. How better to demonstrate Michelangelo's truly unique gifts than to show their flip slide in the seemingly pedestrian career of Mino da Fiesole?

NOTES

1. For general discussions of the *Lives* see Paul Barolsky, *Why Mona Lisa Smiles and other Tales by Vasari* (University Park, PA: The Pennsylvania State University Press, 1991) and Patricia Lee Rubin, *Giorgio Vasari: Art and History* (New Haven and London: Yale University Press, 1995).

2. Unless otherwise noted, all English quotations are taken from Giorgio Vasari, *Lives of the Painters, Sculptors and Architects*, trans. Gaston du C. de Vere, intro. and notes, David Ekserdjian (New York and Toronto: Alfred A. Knopf 1999), 2 vols. The quotation cited above from the *Life of Michelangelo* appears in vol. 2, 642.

3. Vasari also includes a biography of Benedetto da Maiano but his Life is placed later in the collection, after Botticelli and just before Verrocchio (Vasari, vol. 1, 542–-47). The three Lives under consideration here appear in the Ekserdjian edition, vol. 1 on pages 468–73 (Antonio and Bernardo Rossellino), 473–75 (Desiderio da Settignano), and 475–80 (Mino da Fiesole). All English quotations from their lives in this article are from these thirteen pages.

4. Vasari, vol. 1, 467–68 (Galasso Ferrarese) and 480–83 (Lorenzo Costa). In the 1550 edition, the Life of Francesco di Giorgio appears between those of Antonio Rossellino and Desiderio da Settignano; see Giorgio Vasari, *Le Vite de' più eccellenti architetti, pittori ed sculptroi italiani, da Cimabue, insino a' tempi nostri*, Nell'edizione per i tipi di Lorenzo Torrentino, Firenze, 1550, eds. Luciano Bellosi and Aldo Rossi, 2 vols. (Turin: Einaudi, 1986), vol. 1, 411–21. In the 1568 edition, Vasari joins the Lives of Francesco di Giorgio and Lorenzo Vecchietta, placing them together before Galazzo Ferrarese's Life (Vasari, vol. 1, 464–66).

5. On Vasari''s use of *exempla* to illustrate ideas and proper modes of behavior, see T.S.R. Boase, *Giorgio Vasari, The Man and the Book*, Bollingen Series XXXV (Princeton: Princeton University Press, 1979), 51.

6. George L. Hersey, Alfonso II and the Artistic Renewal of Naples 1485–1495 (New Haven and London: Yale University Press, 1969), 111–18.

7. There is an almost willful disregard of chronology here. Antonio is described by Vasari as dying in Florence at the age of forty-eight but neither his birth or death date is provided. Bernardo is described as the surviving brother, even though Bernardo, the elder brothcr, was born in 1409 and died in 1464. Following this statement about the remaining brother, Vasari then begins his discussion of the plans of Nicholas V (who reigned from 1447–1455). While one can appreciate that Vasari may not have been able to discover precise documents for the dates of artists dead almost one hundred years when he was writing, the chronology of the popes was more readily available. See Francesco Caglioti, "Bernardo Rossellino a Roma: 1. Stralci del carteggio mediceo (con qualche briciola sul Filarete)," Prospettiva 64 (1991): 49–59 and "2. Tra Giannozzo Manetti e Giorgio Vasari," Prospettiva 65 (1992): 31–43. For another instance of the "restructuring of the history of art" see Lorenzo Bartoli, "Rewriting history: Vasari's Life of Lorenzo Ghiberti," in Word and Image 13, 3 (1997): 245–52.

8. For a discussion of Martin V's projects, see Carroll William Westfall, *In This Most Perfect Paradise. Alberti, Nicholas V, and the Invention of Conscious Urban Planning in Rome, 1447–1455* (University Park: The Pennsylvania State University Press, 1974), esp. 167–84.

9. See, for example, John Pope-Hennessy, *Italian Renaissance Sculpture, Introduction to Italian Sculpture*, II, 4th ed. (London: Phaidon Press, 1996) 369–74. For a consideration of some of Antonio Rossellino's major projects, see Eric C. Apfelstadt, "The later sculpture of Antonio Rossellino," Ph.D. diss., Princeton University, 1987, where he also reviews the contemporary literature on Antonio Rossellino, up to and including Vasari's biography (15–19).

10. It is worth noting that of the sculptors under discussion here only Bernardo has been afforded a modern English monograph: Anne Markham Schulz, *The Sculpture of Bernardo Rossellino and his Workshop* (Princeton, NJ: Princeton University Press, 1977). It, however, addresses only Bernardo's career as a sculptor.

11. James H. Beck, "An Effigy Tomb-slab by Antonio Rossellino," *Gazette des Beaux-Arts*, ser. 6, 95 (1980): 213–17; Doris Carl, "A Document for the Death of Antonio Rossellino," *Burlington Magazine* 125 (1983): 612–14. This is a change from the first edition of the Life; according to Apfelstadt, 1987, 19, the addition of ca. thirty years to Antonio's life span may have been made to more clearly distinguish his career from that of Donatello.

12. For the problems mentioned above see Alessandro Parronchi, "Un tabernacolo brunelleschiano," in Filippo Brunelleschi. *La sua opera e il suo tempo*, 2 vols. (Florence: Centro Di, 1980), vol. 1, 239–55; and Pope-Hennessy, 1996, 373. For a review of the major works of Desiderio's career, see ibid, 375–78; see also the article by Caroline Elam and Andrew Butterfield, "Desiderio's Tabernacle of the Sacrament," Mitteilungen des Kunsthistorischen Institutes in Florenz 43 (1999): 333–38.

13. Vasari, vol. 2, 642.

14. Vasari, vol. 1, 363

15. Vasari, vol. 1, 378.

16. See, of course, the famous attempt to document Michelangelo's presence in the workshop of Domenico

Ghirlandaio. Vasari, vol. 2, 644.

17. Vasari, 2, 647; see Kathleen Weil-Garris Brandt, "'The Nurse of Settignano:' Michelangelo's Beginnings as a Sculptor," in *The Genius of the Sculptor in Michelangelo's Work*, exh. cat., The Montreal Museum of Fine Arts, 1992, 21–43.

18. Vasari explicitly links Antonio's progress in the art of sculpture to that outlined earlier by Donatello and, thus, by implication to the coming triumph of the third generation (Vasari, vol. 1, 473). And, as noted above, he also reminds us not only that Desiderio's first work was the base for Donatello's David, but also describes his relief of the Madonna and Child on the Marsuppini tomb as "wrought after the manner of Donatello" (Vasari, vol. 1, 474).

19. See Shelley E. Zuraw, "The Sculpture of Mino da Fiesole (1429–1484)," Ph.D. diss. Institute of Fine Arts, New York University, 1993, 51–53, and Francesco Caglioti, "Mino da Fiesole, Mino del Reame, Mino da Montemignanaio: un caso chiarito di sdoppiamento d'identità artistica," Bollettino d'arte LXXVI, no. 67 (1991): 50–53, esp. paragraphs 2 and 3; and most recently, Rubin, 1995, 246–47.

20. See Anne Markham Schulz, "Desiderio da Settignano and the Workshop of Bernardo Rossellino," Art Bulletin 45 (1963): 35–45; idem., 1977, 11; the assumption that Antonio developed in his brother's shop is repeated in the useful introduction to his career provided by Francesca Petrucci, *Introduzione alla mostra fotographica di Antonio Rossellino*, exh., Florence: Misericordia di Settignano, 25 October – 8 December, 1980. See also Ida Cardellini, Desiderio da Settignano (Milan: Edizioni di Comunità, 1962), 5–6.

21. For Bernardo see Charles Seymour, Jr., *Sculpture in Italy: 1400–1500, The Pelican History of Art* (Harmondsworth: Penguin Books, 1966), 140; Schulz, 1977, 11. This opinion is supported by Caglioti, 1991, 50–53. For Michelozzo see L. Carrara, "Nota sulla formazione di Mino da Fiesole," *Critica d'arte* 3 (1956): 76–83; this argument is implicitly accepted, although with reservation, by Pope-Hennessy, 1996, 378. According to Gian Carlo Sciolla, *La scultura di Mino da Fiesole* (Turin: G. Giappichelli, 1970), 5–9, Mino's style echoes the broad stylistic currents developed under the Medici by both Michelozzo and Luca dell Robbia. See also Zuraw, 1993, 51—60, for a discussion of these theories and especially of the connection between Mino and Luca della Robbia.

22. The agreed upon price of L. 1600 is recorded in the 1471 contract; see Giovanni Poggi, "Mino da Fiesole e la Badia Fiorentina," in *Miscellanea d'Arte* 1 (1903): 98–103.

23. One interesting error that Vasari does make in

Mino's life is the date of his death. According to Vasari Mino died in 1486, but Mino wrote his will on July 10, 1484 and died on July 11, 1484; see Cornelius de Fabriczy, "Appunti d'Archivio: Alcuni documenti su Mino da Fiesole," *Rivista d'arte 2* (1904): 43–45. The difference of two years is not as dramatic as the mistakes made in the lives of Antonio Rossellino and Desiderio da Settignano, but it does push Mino's death beyond the "about 1485" citation for Desiderio's work as given by Vasari.

24. Vasari, vol.1, 444–46; the chapter in the 1568 edition concerns three artists—Paolo Romano, Maestro Mino, and Chimenti Camicia, an architect.

25. André Chastel, "Two Roman Statues: Saints Peter and Paul," in *Collaboration in Italian Renaissance Art*, eds. Wendy Stedman Sheard and John Paoletti (New Haven and London: Yale University Press, 1978), 59–63; Carlo La Bella, "Scultori nella Roma di Pio II (1458–1464): Considerazioni su Isaia da Pisa, Mino da Fiesole e Paolo Romano," *Studi Romani*, 43, nos. 1–2 (1995): 26–42, esp. 40–41.

26. Maria Grazia Tolomeo Speranza, "La decorazione del ponte," in *La Via degli Angeli: Il restauro della decorazione scultorea di Ponte Sant'Angelo*, eds. Luisa Cardilli Alloisi and Maria Grazia Tolomeo Speranza (Rome: De Luca Edizione d'Arte, 1988), 43–47.

27. For a review of the history of literature on Mino del Reame, see Zuraw, 1993, 118–28.

28. Vasari, "Life of Mino da Fiesole," vol. 1, 477–78. While the use of Dino may come as a surprise it was the name mentioned by Filarete in his 1464 treatise, when listing the best sculptors active in Florence; presumably in this case Filarete was referring to Mino da Fiesole. Filarete's *Treatise on Architecture*, being the Treatise by Antonio di Piero Averlino, known as Filarete, trans. with intro., J. Spencer, 2 vols. (New Haven and London: Yale University Press, 1965) vol. 1, 76–77: "The names of the masters were these. They are the following: Donatello, Luca, an Agostino and his brother Ottaviano. There was also another worthy master called Desiderio and another called Dino." (Book VI, fol. 44v).

29. Pomponius Gauricus, *De Sculptura*, 1504, eds. André Chastel and Robert Klein (Geneva: Droz, 1969), 245–46: "Nostris uero scalpendo marmore insignes habiti, Ninus, cuias nescio, Nam semper hoc tantum usus est inscriptionis titulo, Nini opus." The problem of Mino's name is an especially painful one: neither the first nor the second name are without problems. In Florentine documents, Mino appears as Mino di Giovanni, referring to his father Giovanni who was known, in turn, as Giovanni di Mino. Thus, Mino's first name seems sanctioned by family tradition. It is, however, worth noting that Mino was not a common name and seems to bring with it associations of

"minore," minor or little. Vasari's use of "da Fiesole" is even more problematic. He seems to be the first to do so, suggesting that he made the name up whole cloth. It is interesting that he chose to imply that Mino's origins were outside the city of Florence, in Fiesole (incorrectly, in fact, since Mino was born in Poppi), but not in the place traditionally associated with marble carving, Settignano. Desiderio, the exemplar for Michelangelo, is from Settignano. Mino, on the other hand, is neither a Florentine (like Antonio Rossellino) nor a marble carver from the "right side of town" Settignano. For a discussion of Mino's name, see Zuraw, 1993, 47–51.

30. See note 27. For perhaps one of the most extreme examples of the attempts to parcel out the work between two different artists, see Alberto Riccoboni, *Roma nell'Arte; La scultura nell'evo moderno dal Quattrocento ad oggi* (Rome: Casa Editrice Mediterranea, 1942), 15–19; idem., "Nuovi apporti alli' arte di Mino del Regno a Roma," L'Urbe 29 (1966): 16–23. Sciollo, 1970, 21, attempts to assign the Neapolitan works to yet a third sculptor, Jacopo della Pila. For a more recent review of this issue, as reflected in a single monument, see Shelley E. Zuraw, "Reliefs from the Altar of St. Jerome, Catalogue Entries 1–4," in *Masterpieces of Renaissance and Baroque Sculpture from the Palazzo Venezia*, exh. cat., Georgia Museum of Art, Athens, GA, 1996, 40–47.

31. See Caglioti, 1991, 62–68.

32. The documents that record the payments linked to the St. Peter are preserved in the Archivio dello Stato in Florence. They were apparently discovered, more or less simultaneously, by Margaret Haines and Rolf Bagamilel. The latter generously shared them with me and they were duly cited and transcribed in my dissertation, Zuraw, 1993, 564–66. They were also published as previously unknown documents by Francesco Caglioti in his article "Ancora sulle traversie vaticane del giovane Mino, sulla committenza statuaria di Pio II e su Leon Battista Alberti," Dialoghi di storia dell'arte 1 (1995): 126–31.

33. Angelo Poliziano, in a fifteenth-century ms. published by Creighton Gilbert, *L'Arte del Quattrocento nelle testimonianza coeve* (Florence: IRSA, 1988), 193–94: "Mino schultore haveva tolto a rachonciare una statua di sancto Pagholo a papa Pagholo, la quale assotigliò tanto, che la guastò. Il papa se ne dolse con messer Batista Alberti, peritissimo in architettura. Alla cui santità messer Batista rispuose: Mino non ha errato, chè questa è la miglior cosa che facessi mai." Poliziano's anecdote was repeated in the middle of the sixteenth century by Lodovico Domenichi in his Facezie, ed. Giovanni Fabris (Rome: A.F. Formiggioni, 1923), 78: no. 179 – "Mino scultore, lavorando una statua di S.

Paolo a papa Paolo secondo, la assotigliò tanto, che gliela guastò. Ora, sendo sdegnato il papa e contando ciò a messer Leon Battista Alberti, disse detto messere che Mino non aveva errato, ché questa era la miglior cosa che facesse mai."

34. Francesco Caglioti, "Da Alberti a Ligorio, da Maderno a Bernini e a Marchionni: il ritrovamento del 'San Pietro' vaticano di Mino da Fiesole (e di Niccolò Longhi da Viaggìu)," *Prospettiva* 86 (1997): 37–70. According to Caglioti, the statue was in Borgo Vecchio from 1463 until 1565 when the head, hands and parts of the feet were added by Niccolò Longhi da Viaggìu and his assistants. Vasari had long since departed from Rome and it is likely that he never saw the unfinished work, but may well have heard about the outcome.

35. For Brunelleschi's version of events, see *The Life of Brunelleschi* by Antonio di Tuccio Manetti, ed. Howard Saalman (University Park and London: The Pennsylvania State University Press, 1970), 47–51. For a discussion of this competition, see Rubin, 1995, 346.

36. Vasari, in the Life of Lorenzo Ghiberti, 1, 293, and in the Life of Filippo Brunelleschi, 1, 330.

37. Vasari, vol. 1, 447–54.

38. Boase, 1971, 222–25; Rubin, 1995, 175–77; and, most recently, James Clifton, "Vasari on Competition," Sixteenth Century Journal, 27/1 (1996): 26–28.

39. For an example of a more positive competition, see Rubin's description of the genesis of Donatello and Brunelleschi's wooden crucifixes (1995, 343–44).

40. After Donatello, the great master sculptor of his narrative is Verrocchio, who like Giotto and Michelangelo, is announced as a painter, sculptor, and architect. Yet Verrocchio "had a manner somewhat hard and crude." Vasari, vol. 1, 549.

41. Rubin, 1995, 246–47.

42. Bernardo Rossellino, the minor character in Antonio Rossellino's life, too, is without a portrait. Paolo Romano has a portrait; it is his visage that graces the biography devoted to him and to Mino del Reame (fig. 4). He is characterized as another aging, bearded figure with eyes upturned. But rather than resembling Antonio, this head and the straight, forked beard recall the famous statue of St. Paul that is the subject of the central narrative in the Life of this artist, also named Paul. The identification between artist and sculpture is based on their shared name and their shared city, Rome.

43. My previous attempt to link Mino and Michelangelo's careers is found in Shelley E. Zuraw, "Mino da Fiesole's Lost Design for the Facade of Santa Maria del Fiore," in *Santa Maria del Fiore. The Cathedral and Its Sculpture* [Acts of the International Symposium for the VII Centenary of the Cathedral of Florence, Florence, Villa I Tatti, 5–6 June 1997], ed. Margaret Haines (Fiesole: Cadmo, 2001), 79–93, esp. 92.

# Vasari on Signorelli:
# The Origins of the 'Grand Manner of Painting'

SARA NAIR JAMES

A giant in his own time, Luca Signorelli inspired Michelangelo, Raphael, and others; however, as Dante reminds us in Book XI of his *Purgatorio* when speaking of Cimabue and Giotto, successors often overshadow the foundational contributions of giants who precede them. Even before Signorelli's death in 1523, his successors had so completely eclipsed his art and that of his late fifteenth-century contemporaries that today their value in their own time is unjustly overlooked. However, a careful reading of Signorelli's biography as recorded by Giorgio Vasari in his *Lives of the Most Eminent Painters, Sculptors, and Architects* (fig. 1), noting both prose and structure, reveals that Vasari recognizes Signorelli's stature in his own time and for posterity. Vasari understands not only Signorelli's stylistic contributions, but also the theoretical issues he raises, observations that scholars have virtually ignored since. In his 1568 edition of the *Lives*, calling him an innovator and a pioneer, Vasari subtly credits Signorelli with shaping the foundation for the High Renaissance style, or the "Grand Manner" of painting, as he calls it.[1] Vasari recounts Signorelli's career and builds toward his monumental masterwork, the frescoes of the Apocalypse and Last Judgment in the Cappella Nuova of the cathedral at Orvieto, which give the most compelling evidence of the artist's innovations (figs. 2–5). For Vasari, they mark a turning point in Renaissance painting.

Innovative in subject, ambitious in scope, and frequently heavyhanded in opinion, Vasari is surprisingly subtle in his use of literary conventions—so subtle, in fact, that his literary skills usually go unrecognized. However, Vasari's organization and skillful

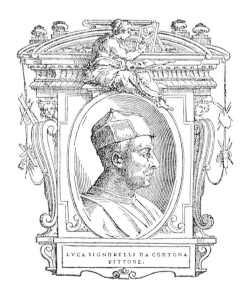

FIG. 1 Giorgio Vasari. *Portrait of Luca Signorelli,* woodcut, 1568 edition of the *Lives of the Most Eminent Painters, Sculptors and Architects.*

75

rhetoric in the *Lives* frequently convey as much information to the reader as do his carefully chosen words. The arrangement of the *Lives* follows the traditional, biblically based, medieval and Renaissance perception of history as linear and progressive according to a divine plan. Vasari, like his predecessors, divides history into three eras in which the first two parts prefigure the third: before the Law of Moses, under the Law, and under the Grace of Christ. Thus, in Part One of his three parts, Vasari praises the earliest Renaissance artists, such as Cimabue and Giotto, as the "first lights." These artists, he says, abandoned the "rude manner of the Greeks," as he calls the Italo-Byzantine style, and, in the manner of classical artists, looked to nature for a model. He regards the "prophetic" artists in the second part, such as Piero della Francesca and Botticelli, as those who struggled to master the rules governing perspective, depth, proportion, and the handling of figures, as well as the difficulties of ornamentation and grace, and built a foundation for the "Grand Manner" of painting in the final part. For Vasari, the developments in Part Two culminate in Signorelli's frescoes at Orvieto, which in turn bridge the transition to the Grand Manner. He supports his case through a subtle literary device; he dramatically ends Part Two of his 1568 edition of the *Lives* with Luca Signorelli:

> And so, with the end of the life of this master . . . we will end the second part of these lives; concluding with Luca as the person, who with profound mastery of drawing and of nudes in particular, and with the grace of invention and composition of the scenes, opened to most of the inventive artists the way to ultimate perfection of the arts, by which way they later were able to follow to the summit.[2]

In the introduction to Part Three of the *Lives*, Vasari reiterates his admiration for Signorelli. Here he lists him last among those artists of the late *Maniera Seconda*, including Piero della Francesca, Lazzaro Vasari, Ghirlandaio, and Botticelli, painters who, Vasari says, had limited knowledge of the antique works found in Rome around 1500, " . . . which causes their styles to be rather dry, lacking liveliness, perfect design, and inspired grace."[3] Signorelli's position at the end of the list implies not only the highest achievement, but also indicates a beacon to guide those who follow. Part Three begins with Leonardo da Vinci and peaks with Michelangelo, whom Vasari calls "divine." The final part continues with Michelangelo's followers, or "disciples," and their acts, and concludes with Vasari's own art.

For Vasari, the Grand Manner, with its grace, subtlety, harmony, and perfection, represents the pinnacle of artistic achievement. He equates grandeur in painting with the highest forms of literature and oratorical rhetoric, and borrows the term Grand Manner from ancient literary theory. In oratory, the Grand Manner meant an ornate, spontaneous style; in literature, it meant epic poetry.[4] Following the directive of the ancient orator Horace, "as painting, so poetry," Renaissance artists sought literary models in oratorical rhetoric and in poetics. Cennino Cennini, writing in the late fourteenth century, aligns the painter and the poet, giving the painter the license or freedom to compose creatures of fantasy and to discover new things as a labor of love or for embellishment:

> . . . this is an occupation known as painting, which calls for imagination, skill of hand, in order to discover things not seen...And it justly deserves to be enthroned

next to theory, and to be crowned with poetry. The justice lies in this: that the poet, with his theory, though he have but one, it makes him worthy, is free to compose and bind together, or not, as he pleases, according to his inclination. In the same way the painter is given freedom to compose a figure standing, seated, half-man, half-horse, as he pleases, according to his imagination. So then, either as a labor of love for all those who feel a desire to understand; or as a means of embellishing....[5]

Mid-fifteenth-century architect and author Leon Battista Alberti also associates painting and poetry, though more for literary form than to be evocative. He advocates that the artist not only emulate ancient writers, but also seek instruction and then apply the values and the forms of literature to painting:

Therefore I advise that each painter should make himself familiar with poets, rhetoricians, and others equally well learned in letters. They will give new inventions or at least aid in beautifully composing the *istoria* through which the painter will surely acquire much praise and renown in his painting. Phidias, more famous than other painters, confessed that he had learned more from Homer, the poet, how to paint Jove with much divine majesty. Thus we who are more eager to learn than to acquire wealth will learn from our poets more and more things useful to painting.[6]

Recalling Horace, Alberti further states that, "The *istoria* [history] will move the soul of the beholder when each man painted there clearly shows the movement of his own soul."[7] In addition, Leonardo da Vinci, a contemporary of Signorelli's, discusses painting as poetry at some length in his treatise on painting.[8] Thus, by the end of the fifteenth century, the emulation of the poet by the artist had become customary. Vasari admires the license that the poetic model gives to artists and sees the seeds of this new grandeur in the epic scale, subject, design, and handling of the figures in Signorelli's paintings at Orvieto. Signorelli, then, was not out of step with his contemporaries in his emulation of the poet; he was simply bolder and more evocative.

Vasari shows further admiration for Signorelli by associating himself with the artist, proudly claiming him as a relative whom he met as a youth. He recounts that when he served as an apprentice to Piero della Francesca, Signorelli had lived with his uncle Lazzaro Vasari, who was Giorgio Vasari's grandfather. When the artist returned to Arezzo as an elderly man, the author says that Signorelli commended his work, telling his father to encourage little Giorgio to draw.[9] To demonstrate his admiration for Signorelli, Vasari included his portrait, one of seven— along with those of Michelangelo and himself—in the decoration of his study in his house in Arezzo.

Vasari emphasizes Signorelli's relationship with Piero della Francesca, one of the most intellectual painters of the fifteenth century, and notes his prodigious mastery of the figure. He recounts that as Piero's *creato* (or leading apprentice), he imitated his master so well that their styles were indistinguishable. He supports his claim with a fresco he attributes to the young Signorelli of the Annunciation in S. Francesco in Arezzo.[10]

Moreover, in praising Signorelli's drawings and paintings as possessing good composition, grace, and invention, Vasari calls him "Luca" rather than by his family name, another subtle

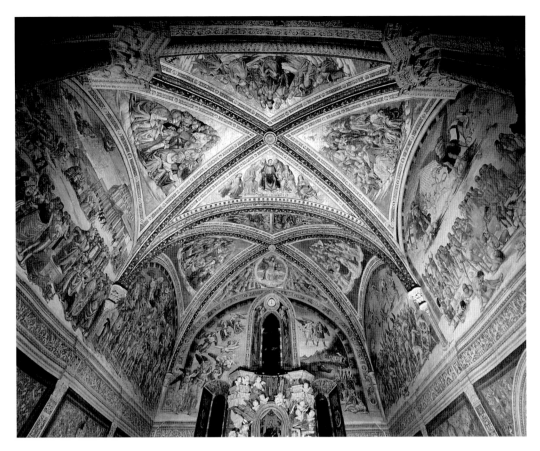

FIG. 2 Luca Signorelli. Cappella Nuova, Orvieto. Panorama of the ceiling and walls of the Cappella Nuova facing the altar (south): *Last Judgment, Rule of the Antichrist, Resurrection of the Dead,* and parts of the socle, 1499–1504.

but noteworthy detail. Vasari frequently elaborates upon artists' names in his *Lives*, finding special meaning that relates to the artist's oeuvre or personality. Not coincidentally, legend holds that S. Luca, evangelist and patron saint of the artists, painted the first portrait of the Virgin and Child, presumably through his grace, good composition, and his mastery of drawing—skills valued by Florentine artists and Vasari, and ones that Vasari admired in Signorelli.

The author's praise fits the artist's reputation among his contemporaries. Prestigious patrons, including distinguished civic leaders and high-level churchmen, sought after Signorelli. Vasari recounts a portion of Signorelli's early career, listing the artist's principal commissions, not necessarily in chronological order. He builds from Signorelli's apprenticeship to his work for Lorenzo de'Medici and culminates with his masterwork at Orvieto. Vasari states that Signorelli was the highest paid artist of his time because he excelled at painting nudes, such as those in his lost *School of Pan* (fig. 7), painted in the early 1490s for Lorenzo de'Medici, who said these figures would never be surpassed.[11] Later in the text, Vasari mentions others of Signorelli's noteworthy paintings that precede those at Orvieto, including the sacristy at Loreto, his contribution to the walls of the Sistine Chapel for Pope Sixtus IV, and the eight murals in the Great Cloister of the Benedictine monastery of Monte Oliveto Maggiore depicting the miracles

of St. Benedict as narrated by St. Gregory the Great, done just a year before he began work at Orvieto. All of these works concur with the progressive style of selected late fifteenth-century contemporaries of Signorelli's, such as the frescoes of Filippino Lippi in the Carafa Chapel in Rome and those of Pinturicchio in Rome and Spello, which fall into the late period of Vasari's Second Manner. Each program consists of a multi-episodic, high-minded history that praises the life and deeds of a saint. Rather than stack paintings of individual scenes, these artists enlarged the compositions and used continuous narrative, often placing figures and the action deep in the space that new expanded picture-fields afforded. Unlike his contemporaries, however, Signorelli emphasized the figures by enlarging them, bringing them close to the picture plane, and diminishing landscape detail.

In April of 1499, Signorelli left Monte Oliveto Maggiore for Orvieto, where his style underwent a remarkable metamorphosis. The epic subject, complex iconography, monumental proportions, emphasis on the figure, especially the nude, the working procedure, and the new poetic models that inspired Signorelli in creating this complex fresco program indicate changing paradigms in painting and confirm Vasari's astute observations concerning the artist's leading role in the development of the High Renaissance style. Vasari proclaims that Signorelli, with *audacia* (boldness) and *invenzione* (invention), introduced *cose nuove* (new ideas) heretofore unknown and notes that Signorelli painted the end of the world "*con bizzarra e capricciosa invenzione*"—with bizarre and fantastic invention. He describes ". . . angels, demons, ruins, earthquakes, fires, miracles of the Antichrist, and many similar things besides, such as nudes, foreshortenings, and many beautiful figures; imagining the terror that there shall be on that last and awful day."[12]

A half century earlier, Fra Angelico had begun a traditional Last Judgment in the chapel, but he left no specific plans beyond the vaults of the south bay. Once Signorelli proved himself in the vaults, where he painted groups of heavenly hosts to complement the Christ in Judgment and Prophets left by Angelico, he apparently had a certain measure of freedom.[13] As he turned to the program of the walls, Signorelli, for the first time in monumental history painting, joined the Last Judgment with selected events from the Apocalypse.[14] Below Christ and above the altar in the south bay, Signorelli filled half-lunettes with *The Ascent of the Blessed to Heaven* and *The Damned Led to Hell*, which adjoined facing lunettes on the side walls of *The Blessed in Paradise* and *The Punishment of the Damned* (fig. 2). In the corresponding upper wall spaces in the facing north bay, the artist placed events from the Apocalypse: *The Rule of the Antichrist*, *The Destruction of the World at Doomsday*, and *The Resurrection of the Dead* (figs. 3–4).

Four compositions in the Cappella Nuova—*The Blessed in Paradise*, *The Blessed Transported to Heaven*, *The Punishment of the Damned* and *The Resurrection of the Dead*—focus on the figure. The latter two paintings boldly concentrate on the monumental nude. Many of Signorelli's figures engage in tumultuous, seemingly uncontrolled, motion, indeed "bizarre and fantastic innovations." The work at Orvieto probably would have been regarded skeptically, if not contemptuously, by some of Signorelli's more conservative contemporaries, who would have disapproved of the lack of restraint. Vasari, on the other hand, admires such complex, evocative art that expresses the aim of the poet. He marvels at figures that have life, breath, and pulse, and invokes the ancient sculptural model of the *Laocoön*. As Horace had said of poetry, Vasari

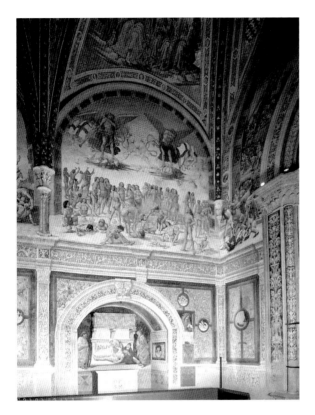

FIG. 3 Luca Signorelli. Cappella Nuova, Orvieto. View to north-west: with the *Resurrection of the Dead* and the *Cappellina della Pietà* and entrance with *Doomsday*, 1499–1504.

advocates that the movement of the figures should stir the soul of the viewer. In his eyes, Signorelli not only surpasses his contemporaries with the handling of the figure, but also he succeeds in moving the soul.

Even Signorelli's contract of 1499 specifies the importance of the figures, which illustrates the major change of emphasis from materials to artistic mastery. Fra Angelico's contract at Orvieto of May 11, 1447, makes no mention of figures or the master's involvement but discusses expensive materials, specifying the quality of gold and blue pigments.[15] In contrast, Signorelli's contract, regarding pigments, states simply that the master must be present when the colors are mixed. The valuable colors are not singled out; instead, Signorelli himself is required to paint the faces and the figures from the waist up and always be present to supervise the painting.[16] The value of the number, beauty, and variety of figures supersedes the rich ornamental use of expensive materials. The new emphasis on mastery and the figure means that the art is not so much a monument to valuable material as it is to the new Renaissance value of painter and artifice. The work of a great master, a progressive idea articulated by Leon Battista Alberti and internalized by his successors, surpasses all else.[17] Vasari reiterates this value for exceptional artistic skill almost verbatim in reference to a damaged work by Signorelli at Volterra that was restored by Sodoma: "And, in truth, it would sometimes be better to leave works half spoilt, when they had been made by men of excellence, rather than to have them retouched by inferior masters."[18]

Signorelli's mastery of the figure is also supported by his adroit working technique. From Piero, Signorelli had learned drawing, panel and fresco techniques, as well as methods of trans-ferring drawings to painting surfaces. Throughout his monumental frescoes in S. Francesco, Piero used the tedious tracing method of *spolveri* (charcoal dust pounced through the pricked drawings), still visible there at close range. At Orvieto, telltale dots in the vault frescoes reveal that Signorelli first transferred his drawings conservatively, using *spolveri*, in the manner of his master. Then, on the walls, he traced drawings into the damp plaster with a stylus, evident in the rounded indentations. As he became increasingly bold, strokes outlining some of the mon-umental figures, especially in the *Punishment of the Damned*, appear sharp and of uneven depth,

so freely rendered that Signorelli obviously took the method one step further and sketched freehand, sometimes making changes as he proceeded. Finally, in the half lunette of *The Damned Led to Hell*, Signorelli confidently painted *alla prima* on the plaster.

Signorelli's paintings and drawings often show *pentimenti*, or alterations. The Cappella Nuova has many of them. One such instance is an empty halo beside that of the Virgin Mary in the *vela* of the Apostles. Although he changed the position of a figure, he saw no need to eliminate the halo. In a similar fashion, Signorelli, thinking ahead to what would follow, sketched ideas in carbon directly on the walls, still visible at close range in *The Resurrection of the Dead*. He did not obscure alterations for several reasons. First, and most pragmatic, fresco is an unforgiving medium that demands precision and speed; correction means re-plastering, which is costly and time-consum-

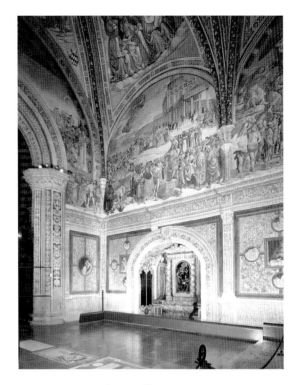

FIG. 4 Luca Signorelli. Cappella Nuova, Orvieto. View to northeast: vault, entrance with *Doomsday*, *The Rule of the Antichrist* and *Cappellina della Magdalena* (now destroyed), 1499–1504.

ing. Second, in an age before optical lenses, such minor alterations so high above the viewer would not have been visible. Most importantly, however, alterations and pentimenti demonstrated *audacia* and *invenzione*: the actual thought process of creative genius. Following the directives of Horace, in the Grand Manner, error is permissible in things seen at a distance, for it is the whole effect, rather than detail, that is important.[19]

Signorelli's innovations at Orvieto extended beyond the handling of the figure. On the lower walls of the Cappella Nuova, rather than follow tradition and imitate marble revetment, Signorelli extended the artistic program into those spaces with elaborate fields of gilded *grotteschi* (ornamental decoration), which hold portraits of animated authors flanked by literary scenes. To support the message of the monumental subject in the upper walls and vaults, Signorelli illustrated allegories from both Christian and pagan literary works, told in the more accessible medium of poetry. Signorelli, therefore, did not simply recount a narrative or a theological truth, but, in the poetic tradition, he included deeper levels of meaning.

Eleven scenes from Dante's *Purgatorio* (fig. 5) continue the message of salvation through penance. The remaining scenes come from classical literature, most by way of moralized sources. Initially the classical scenes might seem out of place in a Christian setting. Both Dante and Boccaccio, however, speak of veiling truth in the guise of fiction, suggesting that it can edify, functioning much as the parables of Christ. The use of allegory, the foundation of textural

FIG. 5 Luca Signorelli. Cappella Nuova, Orvieto. Southeast socle, left panel: Dante with *Canti* I–IV of *Il Purgatorio*, 1499–1504.

interpretation, especially in sermons and poetry, carries over into art. Following the poetic model, Signorelli silently folded in familiar, moralized classical stories as exemplars of the faith. The poetic scenes comment allegorically on the theology of his principal narratives, reinforcing the message of punishment for evil, the triumph of good, and the promise of salvation implicit in the eschatological scenes above. Thus, Signorelli's invention and his reliance on poetic models extend beyond issues of style.

At Orvieto, Signorelli's emulation of the poet brought painting to a new level, incorporating poetic values such as *audacia*, *invenzione*, *fantasia*, and *capricciosa* that previous artists had not dared to do, thereby creating novel inventions. In this context, *audacia* and confidence on the part of the artist challenged the artist to excel, to improve upon nature by making things more beautiful than they appear naturally. Signorelli constructed his nudes according to the same canon laid forth in Leonardo's drawing *The Vitruvian Man*;[20] in doing so, he exceeded nature not only in perfection, but also in beauty. Moreover, the boldness of the program itself in scale, style, and epic subject reflects *invenzione*, for, in addition to referring to decorous composition, *invenzione* also means inspired handling of the subject matter, skill with depicting the figure in motion, and the freedom to invent and to use one's *fantasia* indicates the use of the imagination; *capricciosa* evokes the unexpected, brilliant, and ingenious. These *cose nuove* demonstrate not only novel solutions to artistic challenges, but also include poetic metaphor and epideictic rhetoric, or veiled meanings, that, as in poetry, would captivate both the learned and unlearned and move their souls to higher understanding.[21] Signorelli's murals at Orvieto, like mute epic poems, portray more than historical narrative; they present timeless truths in ascending layers of theological meaning. These accomplishments distinguish Signorelli from his contemporaries and set the stage for Vasari's Third Manner.

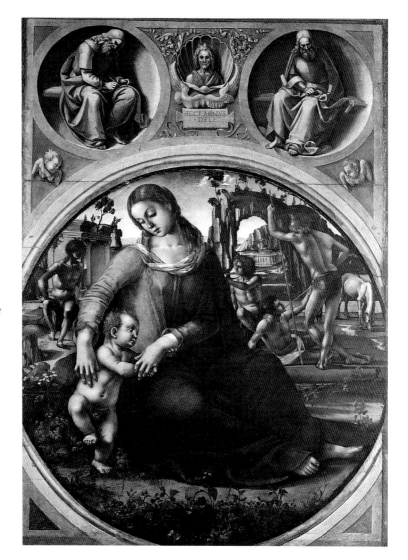

FIG. 6 Luca Signorelli.
*Madonna and Child with Male
Nudes, St. John the Baptist,
and two Prophets,*
1499–1504.

At Orvieto, Signorelli set the precedent for the over life-size, energetic figure. Nowhere previously had an artist portrayed such enormous figures or incorporated so many nudes in a religious setting; rarely before had an artist used figures as vehicles of expression or handled them with such skill. With these monumental figures and more complex action, Signorelli's fresco program assumes an epic proportion. No theme is more suited to the model of epic poetry, and therefore to the Grand Manner, than events from the Apocalypse combined with the Last Judgment. With these murals, Signorelli's depiction of narrative, told by figures in action, departed from the decorum and restraint advocated by Alberti, values that dominated the art of Vasari's second part, and daringly moved in a new, more poetic direction. Aristotelian literary convention held that historians recounted what had happened while poets told what might happen, and that while history recounted facts, poetry presented truths.[22] Whereas his contemporaries methodically illustrated traditional histories by starting at the beginning, Signorelli, in

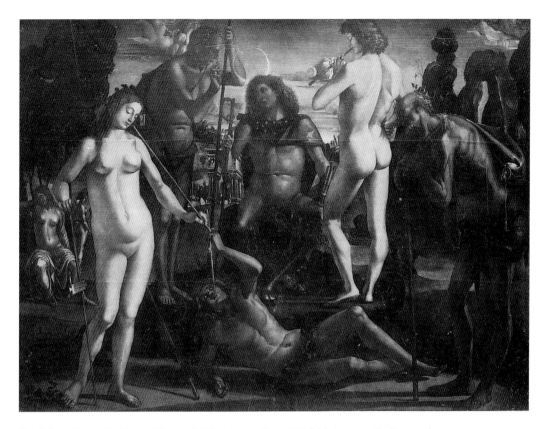

FIG. 7  Luca Signorelli. *School of Pan*, ca. 1490. Formerly Kaiser Friedrich Museum, Berlin; now lost.

the convention of epic poets, launched his story *in medias res*; at the same time, he presented a vision of the future and subtly imparted several meaningful levels of theological truths.[23] Narrative art, like epic poetry, was valued not only for style, but also for the faculty of integrating deeper meaning into the story. In the manner of a well-crafted sermon, Signorelli's paintings combine narrative, theology, wisdom, and eloquence to move, instruct, and inspire the viewer.

Vasari reports that Signorelli inspired subsequent artists and especially singles out Michelangelo as revering his methods, which he says is evident in the young artist's work. The *Doni Tondo*, an early work by Michelangelo, resembles two of Signorelli's paintings done while both artists resided in the Medici household in Florence: a tondo of the *Holy Family* and a panel of the *Madonna and Child* (fig. 6).[24] Like the *Holy Family*, the *Doni Tondo* depicts the holy parents engaged with the Christ Child as a toddler, an unusual iconography. As with Signorelli's panel of the *Madonna and Child*, the *Doni Tondo* contains a group of enigmatic male nudes in the midground, figures that engage with one another but that have no apparent relationship to the principal figures in the composition. The function of these similar figure groups has never been satisfactorily explained in either painting.

Art historians, moreover, have speculated that Michelangelo, en route between Florence and Rome, visited Signorelli in Orvieto. The monumental figures, working procedure, epic sub-

ject, and complex iconography in the Sistine Chapel ceiling frescoes, which Michelangelo began just four years after Signorelli finished his master work, confirm this hypothesis, suggesting first-hand scrutiny of the Cappella Nuova. Like Signorelli, Michelangelo reduced background detail in his final scenes from the Creation so that gigantic figures—even larger than those of Signorelli—dominate the compositions and stand out against only sky. Michelangelo also first used *spolveri* and later the stylus to transfer his large drawings to the ceiling, and like Signorelli, he frequently altered the figures as he painted, leaving behind telltale incisions in the plaster. Finally, in the lunettes, he emulated his mentor's method by painting the ancestors of Christ freehand directly on the damp plaster.

Vasari additionally credits Signorelli with being the artist whose method of handling nudes and composition at Orvieto was worthy of being imitated by Michelangelo in his *Last Judgment* in the Sistine Chapel:

> By means of this he encouraged all those who have lived after him, insomuch that since then they have found easy the difficulties of that manner; wherefore I do not marvel that the works of Luca were ever very highly extolled by Michelagnolo [sic] nor that certain parts of his divine Judgment, which he made in the chapel, should have deigned to avail himself in some measure to the inventions of Luca, as he did in the angels, demons, and the divisions of the Heavens, and other things, in which Michelagnolo [sic] himself imitated Luca's method, as all may see.[25]

Although Vasari speaks most directly to compositional and stylistic issues, conceptually and theologically Michelangelo's *Last Judgment* also owes much to Signorelli. Like Signorelli, Michelangelo worked on a monumental scale, crowding energetic nudes close to the picture plane. Regarding the compositional divisions, Signorelli, in an unusual interpretation, joined *The Ascent of the Blessed into Heaven* with *The Damned Led to Hell* over the altar. The union is no longer immediately apparent, for the large, eighteenth-century altar now hides the composition below the windows.[26] Michelangelo's subsequent *Last Judgment* composition shares the ominous proximity of Damned and Blessed. By placing the mouth of Hell directly over the altar, both artists stressed the accountability of each individual, reminding celebrant and communicant alike of the precarious state of each soul as it inescapably stands for eternal judgment and that the final pronouncement rests not on earthly position, but on faith, worthiness, and purity of heart. In addition, both artists balanced the traditional foreboding judgment with the promise of hope. Each includes the intercessory Virgin Mary closest to Christ. Both artists also emphasize the wonder of the Blessed as they ascend to Heaven, and leave the eternal torture of the Damned in Hell to the imagination of the viewer.

The contemporary mural decoration in the Stanza della Segnatura in the Vatican by Raphael, frescoes that replaced ones painted by Signorelli and others a decade before, also owes a debt to the older master. When compared to Signorelli's lunettes of the *Resurrection of the Body* and *The Blessed in Paradise*, Raphael's *Disputà* especially bears Signorelli's mark in the grand theme, the monumental figures, the reduced emphasis on background and the use of gestures, and glances upward to tie together the two levels of action. Following Signorelli's innovation, Raphael also used *pastiglia*—bits of wax in which gold leaf has been suspended—in the upper

reaches of the heavens to increase the depth of field and for decorative effect. Although *pastiglia* appears in panel paintings, especially in Sienese works of the fourteenth century, artists before Signorelli seldom used it to embellish frescoes.

Signorelli's stylistic inventiveness and iconographic complexity, therefore, not only distinguish his art from that of his contemporaries, but also bridge the transition between Vasari's second and third styles. The *cose nuove* that he introduced confirm Vasari's astute observation of Signorelli's key role in forming the foundation of the Grand Manner of painting. Signorelli introduced a new vision of the artist as one with poetic license, free to be bold, inventive and expressive. Indeed, "Luca ...with profound mastery of drawing . . . and with the grace of invention and composition...opened to most of the inventive artists the way to ultimate perfection of the arts, by which way they later were able to follow to the summit."[27] Upon Signorelli's giant shoulders rests the cornerstone of the High Renaissance style.

NOTES

1. I wish to extend my deepest thanks to Paul Barolsky, teacher, mentor, and friend, for opening my eyes to the richness of Vasari, a journey that began for me in the fall of 1989 at the University of Virginia. I am grateful to the editors of this book for their vision and perseverance and to many colleagues for suggestions and assistance.

Giorgio Vasari, "Luca Signorelli da Cortona Pittore nella redazione del 1550," in Corrado Gizzi, ed., *Signorelli e Dante* (Milan, 1991), 111–17; G. Vasari, *Le Vite de' più eccellenti pittori, scultori ed architettori,* ed. by Enrico Bianchi, 7 vols. (Florence, 1930), vol. III, pp. 358–70; G. Vasari, *Lives of the Painters, Sculptors and Architects,* 2 vols., trans. Gaston de C. du Vere, intro. and notes by David Ekserdjran (New York, 1996), vol. I, pp. 609–14. Vasari places Perugino at the end of Part II in the first edition (1550) of the *Lives,* and Signorelli in Part III. Part II of the second edition (1568) ends more dramatically with Signorelli, who Vasari calls an innovator and a pioneer.

2. Vasari-Bianchi (1930) vol. III, 370; Vasari (1996) vol. II, 614. Author's translation with the assistance of Giuliana Fazzion.

3. Vasari-Bianchi (1930) vol. III, 377–80; Vasari (1996) vol. I, 618–19.

4. Bernadine Barnes, *Michelangelo's Last Judgment: The Renaissance Response* (Berkeley, 1998), 73–75.

5. Cennino Cennini, *The Craftsman's Handbook: Il Libro Dell'Arte,* trans. by Daniel Thompson (New York, 1960), 1–2.

6. Leon Battista Alberti, *On Painting,* ed. and trans. by

John Spencer (New Haven, 1966), 91. Whereas Signorelli may not have read Alberti, many late fifteenth-century artists shared his values. Vasari, on the other hand, would have had access to Alberti's published works.

7. Horace, *De arte poetica,* lines 101–03, quoted by Spencer on Alberti, 25 and 38.

8. Although Leonardo da Vinci"s writings remained unpublished until c.1550, they largely concur with the mainstream of late fifteenth-century thought. Martin Kemp and Margaret Walker, ed. and trans., *Leonardo On Painting,* (New Haven, 1989) Part I, 22–34.

9. Vasari-Bianchi (1930), vol. III, 60, 367–68; Vasari (1996), vol. I, 609 and 613.

10 Vasari-Bianchi (1930), vol. III, 359–60; Vasari (1996), vol. I, p. 609–10.

11. Vasari-Bianchi (1930), vol. III, 363; Vasari (1996) vol. II, 611.

12. Vasari-Bianchi (1930), vol. III, 365 and Vasari (1996) vol. II, 611–12; Alberti, 75–77.

13. Cathedral documents record three contracts for Signorelli. The first, for the south vault, requires that he follow Fra Angelico's designs. The second, for the north vault, notes that local theologians would assist with the theologies.

Signorelli's final contract, which is for the walls, indicates that the Opera del Duomo (the governing board) showed greater confidence in him; it also implies greater freedom, for it is based on drawings that Signorelli presented.For the first contract and two other preliminary documents of the same date, see Archivo Opera del Duomo, Orvieto, *Riformanze* 12

(1484–1526), 5 April 1499, c.344r.–345r., in Laura Andreani, (ed.), 'I documenti', Appendix I, in *La Cappella Nova o di San Brizio nel Duomo di Orvieto*, edited by Giusi Testa, Milan, 1996, pp. 219–20, docs. 218–20, 434; for the second contract, see AODO *Rif.* 12, 25 November, 1499, c.360r., Andreani in Testa, doc. 223, p. 434–35; and for the final contract, see AODO, *Rif.* 12, 6 January, 1500, 363v.–64r., in Andreani in Testa, doc. 224, 435.

14. Heretofore in mural and mosaic decoration, the two subjects appeared separately; only recently had Hartmann Schedel and Albrecht Dürer combined them in German block books.

15. AODO *Rif.* 9 (1443–48), c.288v.–290r., 2 June 1447 and 14 June 1447, in Andreani in Testa, docs. 46 and 49, 424–25.

16. AODO *Rif.* 12 (1484–1526), 5 April 1499, 344r.–45r. in Andreani Testa docs. 218–20, 434.

17. Alberti in Spencer, 64: "Gold worked by the art of painting outweighs an equal amount of gold unworked. If the figures were made by the hand of Phidias or Praxitiles from lead itself—the lowest of the metals—they would be valued more than silver."

18. Vasari-Bianchi (1930), vol. III, 361; Vasari (1996), vol. I, 610.

19. David Summers, *Michelangelo and the Language of Art*, (Princeton, 1981), 44.

20. Pen, ink, watercolor and metalpoint on paper, ca. 1492, Gallerie dell'Accademia, Venice.

21. Summers, 73–74, 164–67, and 406–09.

22. Thus, poetry was considered more scientific and serious than history. S. H. Butcher, *Aristotle's Theory of Poetics and Fine Arts* (London, 1911) vol. VIII: 9-X: 3, 35–39; Charles Osgood, *Boccaccio on Poetry* (Princeton, 1930) vol. XIV, 67–68.

23. For details on the complex meaning of Signorelli's frescoes, see Sara N. James, *Signorelli and Fra Angelico at Orvieto: Liturgy, Poetry, and a Vision of the End Time* (Aldershot, 2003), *ad passim*, especially Chapter 9.

24. Michelangelo's *Doni Tondo* (ca. 1506) and Signorelli's *Holy Family* and *Madonna and Child* (ca. 1490) are in the Galleria degli Uffizi, Florence.

25. Vasari-Bianchi (1930), vol. III, 365; Vasari (1996) vol. I, 612.

26. Parts of the composition were visible, however, during the restoration of the Cappella Nuova in the 1990s, confirming that the two areas were once joined into one large composition.

27. Vasari-Bianchi (1930), vol. III, 370; Vasari (1996) vol. II, 614.

FRANCESCO SANESE SCVLT.
ET ARCHITETTO

# Francesco di Giorgio and Brunelleschi

### Arthur F. Iorio

By the time he published the second edition of his *Lives of the Most Eminent Painters, Sculptors, and Architects* (1568), Giorgio Vasari had acquired enough new information about Francesco di Giorgio to assign him a position of undeniable stature in the architectural renewal of the fifteenth century, the Second Age in his paradigm of artistic development. He was an "excellent sculptor and architect," the biographer wrote, a "very great engineer, particularly in the design of war engines" and, still more significantly, he "facilitated (*facilitò*) and improved the art of architecture more than anyone else from the time of Filippo di Ser Brunellesco to his own."[1]

While his contention that Brunelleschi was the first "to bring back to light sound architectural practice" is well known, Vasari's remarkable assertion that Francesco di Giorgio was his worthiest fifteenth-century heir has been largely overlooked.[2] And so has the fact that he is praised more highly than Leon Battista Alberti in the *Lives*.[3] Even though Vasari does not really explain how Francesco di Giorgio "facilitated (*facilitò*) and improved the art of architecture," his recollection of Brunelleschi's name in this context is hardly fortuitous. According to Vasari, Filippo Brunelleschi deserved high praise for his work as an architect, and just as much credit for his innovations as an engineer. Gifted with rare ingenuity and equipped with a wealth of practical experience, Vasari's Brunelleschi is the antithesis of his Alberti, whose theoretical preparation proves to be an inadequate substitute for skills honed in person on the job site. For Vasari, Francesco di Giorgio was more like Brunelleschi than Alberti. Apparently unaware of his architectural treatises, the biographer praises him as a practicing architect and sculptor, and above all else as a great engineer. This essay argues that shared interest in applied technology, more than any perceived architectural relationships, led Vasari to compare Francesco di Giorgio to Filippo Brunelleschi.

Both editions of Vasari's Life of Francesco di Giorgio strike a similarly laudatory tone. In 1550 his praiseworthiness was linked principally to the pair of bronze angels he cast for the high altar of the Duomo in Siena and to the *modello* as well as the execution of the Ducal Palace at Urbino. By 1568, however, this list of attributions had swelled to include "all the designs and models for the Palace and Vescovado of Pienza," the "general form and the fortifications of the said city, together with the palace and loggia," a frieze of military engines "painted with his own hand in the said palace at Urbino," some "books filled with designs of such instruments," and portraits of Federico da Montefeltro "both on medals and in painting."[4]

As is often the case, Vasari's attributions warrant some clarification. Contrary to what he believed, Francesco di Giorgio did not provide the *disegni* and *modelli* for Pius II's Pienza, nor was he entirely responsible for the Ducal Palace at Urbino, even though he did play a significant role in its execution. The frieze of war engines at the Palace of Urbino is in low relief, though it may once have been painted, and the "truly beautifully cast" bronze angels for high altar of the Sienese Duomo were not actually "chased with the greatest diligence imaginable by the artist himself." Moreover, Vasari's casual reference to some books filled with drawings of war engines by Francesco that "Duke Cosimo de'Medici counts among his most cherished possessions" makes it hard to identify which manuscript he might have seen.[5]

It has seldom been noted that Francesco di Giorgio is also mentioned in the Preface to Part Two of the *Lives*, where Vasari establishes the broader context for the architectural renewal he discerns in the fifteenth century. Here too, Francesco is paired with Brunelleschi, although less specifically, for having designed exemplary buildings. After crediting him once again with the palace in Urbino, Vasari adds that he was also responsible for the cathedral in that city, as well as for "the strong and rich castle of Naples, and the impregnable castle of Milan, not to mention many other notable buildings of that time."[6] Although there is no evidence that Francesco was ever employed as a military architect in Milan, modern scholarship does attribute him with the design of the Duomo in Urbino and acknowledges his role in the defenses of the Castelnuovo in Naples.

What is most striking about this Preface is that Vasari cites only Brunelleschi and Francesco di Giorgio to exemplify the architectural accomplishments of the fifteenth century. His omission, of course, is a glaring one: what about Leon Battista Alberti? Even in the first edition (1550) of the *Lives*, where he is celebrated in epitaph as a Florentine Vitruvius, Alberti is not cited in the Preface.[7] Considering that the renewal of ancient forms is an important *topos* in the *Lives*, and the fact that Vasari had even provided his friend Cosimo Bartoli with a design for the frontispiece of his 1550 translation of Alberti's *De re aedificatoria*, his peremptory dismissal of a Florentine architect in favor of a Sienese one seems all the more surprising.[8] This is certainly not the point of view taken by modern scholarship, where Leon Battista Alberti inevitably assumes the mantle as the second great architect of the fifteenth century. Why did Vasari see things so differently?

Brunelleschi casts a long shadow in the *Lives*, one that stretches into the sixteenth century, when all of the arts—at least according to Vasari—attained perfection. Brunelleschi's "genius" (*ingegno*) we are told, "was so lofty that it might well be said he was sent by heaven to give new form to architecture, which had languished for hundreds of years." While in Rome, "he made drawings of every kind of building: both round and square temples, as well as octagonal ones, basilicas, aqueducts, baths, arches, colosseums, amphitheaters, and every brick temple....He also distinguished the Doric, Ionic, and Corinthian orders from one another, and conducted his studies so thoroughly that he could visualize in his mind's eye how Rome looked before it fell into ruins." It was to his credit, Vasari maintains, "that architecture once again found the measure and proportion of the ancients." This encomium is taken up again in the Life of Bramante where he adds that Brunelleschi "imitated (*contrafatto*) and brought back to light the excellent works of the most learned and admirable ancients," and that his "new method of practice

(*moderno operare*) was truly of very great benefit to architecture." As Brunelleschi's worthiest heir, Bramante followed in his footsteps (*seguitando le vestigie di Filippo*), and established a clear path (*strada sicura*) for the profession, which he could do because he was "not only a theorist (*teorico*), but a highly experienced practicing architect (*pratico ed esercitato sommamente*)."[9] Like Brunelleschi, Bramante also imitated ancient architecture, but he did so "with new imagination (*invenzione*)," increasing the beauty and subtlety (*difficultà*) of this art, "which was much improved by him, as we can see today."[10] Brunelleschi and antiquity, either in combination or separately, set the standard by which Vasari assesses the progress of architecture into the early sixteenth century. "After Brunelleschi, Michelozzo was reputed to be the most methodical architect of his times"; Giuliano and Antonio da Sangallo instilled "the Doric order with a better sense of measure and proportion" in the manner of Vitruvius than their predecessors had; and Cronaca "was an accomplished imitator of ancient things," as can be seen in his works, which disclose how well he observed "the rules of Vitruvius and the works of Filippo di Ser Brunellesco."[11]

Even this sketchy summary suggests how the architectural past evolves into the present in the *Lives*. Brunelleschi reintroduced classical forms and from these beginnings Bramante forged a new style that can truly take its place alongside the architecture of antiquity. Vasari's definition of this renewal emphasizes the recovery of ancient architectural vocabulary and attendant concepts of measure, symmetry, and proportion, as well as the example of Vitruvius. As the author of the first architectural treatise since antiquity, Leon Battista Alberti might well be expected to play a prominent role in the *Lives*, especially in the first edition, where he is praised for having a masterful command of Vitruvius (*intese Vitruvio benissimo*) and is hailed as the Florentine Vitruvius.[12] Yet in Vasari's estimation, Alberti's theoretical knowledge was insufficient to compensate for his inadequate grounding in architectural practice, and he said so even in the 1550 edition of the *Lives*. This perceived lack of technical knowledge is emphasized still more explicitly in the revised biography of 1568, where both references to Vitruvius are dropped. Speaking at greater length than earlier about Alberti's Rucellai Loggia, Vasari criticized the solution of the vaulting as evidence that "he lacked judgment and design, making it clear that theory (*scienza*) must be accompanied by practical experience." He then turned his attention to the still more disconcerting arches of the chapels in the choir at Santissima Annunziata. These, he claimed, appeared to be falling backwards: "perhaps Leon Battista would not have done this if he had practical experience along with theoretical knowledge."[13]

Vasari's criticism of Alberti exemplifies his premise that architectural theory separated from practice is of little value. Yet it is fair to add that his dismissive assessment of this architect was also almost certainly conditioned by a differing attitude toward antiquity. Vasari saw in Brunelleschi, the Sangallo, Bramante, and Cronaca the seeds of an archeologically motivated interest in the past that accelerated as the sixteenth century progressed. This interest is chronicled intermittently in the *Lives*, which recounts that Peruzzi began a book on Roman antiquities and a commentary on Vitruvius, that Vignola set out to measure the ruins of the ancient city in their entirety, that Serlio produced illustrations for two books on architecture, and that Caporali and Cesarino, as well as Daniele Barbaro commented on Vitruvius.[14] By the mid-sixteenth century Roman antiquity had become the subject of an increasing number of historical

and topographical studies; and this archeologically minded climate naturally spurred an interest in Vitruvius as a source for understanding the architectural traditions of the past. It is consequently not surprising that Alberti's *De re aedificatoria*, which proposes a model for how architecture should be done in the future, lagged behind Vitruvius's *De architectura* in popularity during the sixteenth century.[15] Vasari implicitly acknowledges as much, citing several commentaries on Vitruvius, including the annotated translation by Daniele Barbaro, published in 1551 and reissued in 1556, but notes only his friend Cosimo Bartoli's 1550 translation of Alberti's architectural treatise.[16]

While Vasari does offer some justification for his negative appraisal of Alberti, the reasons that motivated him to assign Francesco di Giorgio a prominent role in the *Lives* are less specific and therefore more difficult to assess. The study of Roman antiquity, which is a defining feature of the biographer's concept of architectural progress, is mentioned only briefly in the 1568 version of Francesco's Life. Apparently, Vasari knew little about his extensive corpus of drawings after antiquity and nothing at all about his studies of Vitruvius. All he could report was that Francesco "investigated the construction (*modo*) of ancient amphitheaters and other similar buildings."[17] This is certainly much too vague an observation to suggest that Vasari considered Francesco an important heir of the archeological tradition putatively inaugurated by Brunelleschi during his Roman sojourn. Yet the basis of his esteem for Francesco di Giorgio as an architect is not hard to find. In contrast to Alberti, Vasari considered him to be a skilled practitioner who "showed the greatest judgment in architecture and demonstrated that he understood that profession very well." This claim most likely depends on his conviction that Francesco was responsible for the Ducal Palace of Urbino, a building which he deemed to be "as beautiful and well made a palazzo as any ever built." His purported drawings and *modelli* for the palace of Pius II and the Bishop's residence at Pienza may also have contributed to Vasari's assessment, though to a lesser extent, since these buildings were merely "as magnificent and well adorned as they could be for that place." None of these, nor any of the other architectural works cited in Francesco's biography, however, help to explain what Vasari meant when he credited this architect with having "facilitated (*facilitò*) and improved the art of architecture more than anyone else from the time of Filippo di Ser Brunellesco to his own."[18]

This unexpected statement is arguably the most compelling emendation that Vasari brought to the 1568 Life of Francesco di Giorgio. But what does it mean? On their own, neither Brunelleschi's nor Francesco's biography offers a clear answer to this question. But if their lives are considered together, it is possible to establish a plausible context for understanding what the biographer might have intended. According to Vasari's story, Brunelleschi set himself two of the greatest goals he could conceive (*due concetti grandissimi*): "first to bring back to light sound architectural practice, believing that in so doing he would leave posterity no less of a memory of himself than Cimabue and Giotto had; and secondly, to find the way—if he could—to vault the cupola of Santa Maria del Fiore in Florence, so difficult a task . . . that no one had sufficient courage to attempt it without great expenditures for wooden armatures."[19] Vasari's Brunelleschi begins to prepare himself to meet this daunting engineering challenge even as a boy, when he was "constantly pursuing ingenious problems pertaining to art and devices made by hand." As the narrative progresses, he becomes acquainted with certain scholarly individuals, and "begins

to speculate (*entrar colla fantasia*) about the problems of time and motion, about weights and wheels, and how they can be made to turn and move." He then learns geometry from Paolo Toscanelli, and though unschooled in letters, is able to reason and discourse so skillfully by virtue of his practical experience that he astonished his teacher. Vasari informs us further that Brunelleschi thought almost continuously about devising and solving "ingenious and difficult problems," and that while studying the ruins of ancient Rome rediscovered the *ulivella*, a device used to hoist large stones.[20]

Armed with a great intellect (*virtù dell'intelletto*) that revelled in transposing speculative thought into solutions to practical engineering problems, Brunelleschi eventually secures the commission for the dome of Florence Cathedral, and diligently oversees every possible aspect of its construction. "Filippo was continually making designs and models for every slightest thing," Vasari writes, including "scaffolding for the masons and machines to lift weights." There was "nothing, however difficult and arduous which he could not make easy and simple; he demonstrated this by hoisting weights with counter-weights and wheels, making it possible for a single ox to raise what six pairs [of oxen] would have barely been able to lift." It "made one tremble and shudder to think that a single mind (*ingegno*) was capable of so much." The Life's account of the skillful inventiveness and technical ingenuity that Brunelleschi demonstrated in solving the daunting structural and mechanical problems posed by the cupola thus has more to do with engineering than with antiquity. And it is no accident that Vasari draws this part of the story to a close by remarking that Brunelleschi "greatly facilitated (*facilitò*) architecture."[21]

Although it may be going too far to suggest that Vasari deliberately intended to characterize the great structure of the cupola in mechanical terms by referring to it as a "stupendous machine" (*stupendissima machina*), his metaphor was certainly well-chosen, for the dome's skeletal form is aesthetically comparable to the timber framework of the mechanical devices (*machine*) Brunelleschi invented to facilitate its construction.[22] While Vasari praises Brunelleschi highly for his contribution to the recovery of the forms and rules of ancient architecture, it is the dome of the cathedral which earns his highest tribute. According to the *Lives*, in fact, Brunelleschi succeeded only in counterfeiting (*avendo egli contrafatto*) ancient architecture; the credit for genuine and inventive imitation (*imitazione*) goes to Bramante instead. As the architect-engineer who designed and raised the cupola of Santa Maria del Fiore, however, Brunelleschi not only surpassed the ancients, he set an authoritative standard of his own: "and the heavens ordained . . . that Filippo should leave the world a greater, higher, more beautiful structure ever made either in modern times or in antiquity."[23]

Vasari was hardly the first writer to cast the dome as an unprecedented feat of architectural and mechanical engineering that showcased the technological prowess of the Florentine state. Alberti had said as much, still more eloquently, in the Italian text of his treatise *On Painting*, which he dedicated to Brunelleschi in 1436:

> What man, however hard of heart or jealous, would not praise Filippo the architect when he sees here such an enormous construction towering above the skies, vast enough to cover the entire Tuscan population with its shadow, and done without the aid of beams or elaborate wooden supports? Surely a feat of engineering

(*artificio*) . . . that people did not believe possible these days and was probably equally unknown and unimaginable among the ancients.[24]

As Smith has noted, Alberti was not the only contemporary humanist to extol Brunelleschi's originality and inventiveness in the field of mechanical engineering. Recalling the consecration ceremony of 1436, Sozomeno of Pistoia records the amazement caused by the fact that the cupola had been built without wooden armature, and proclaims Brunelleschi's hoisting devices as something wonderful to behold (*etiam miribilius*). Alberti himself lauds Brunelleschi's origi- nality as a mechanical engineer in the *Profugiorum*, of 1441 or 1442, citing his invention of "unheard of machines for moving and lifting" weights. Carlo Marsuppini, the Florentine chan- cellor, strikes a still more laudatory note in the epitaph he composed for the architect's tomb in 1446, evoking the precedent of Daedalus and the image of a divinely inspired inventiveness: "How Filippo the architect excelled in the art of Daedalus can be shown not only by the admirable dome of the most famous temple but also by many machines which he invented with his divine genius." Giannozzo Manetti's treatise on human dignity, completed in 1453, once again cites the "many, great remarkable instruments or machines marvellously invented and comprehended," as does Alamanno Rinuccini's dedicatory epistle of 1473, addressed to Federico da Montefeltro, which casts both war engines and weight-lifting machines among the achievements of modern times.[25] And according to Battisti, one proposal for Brunelleschi's tomb called for marble reliefs representing his projects for the cupola, and presumably his machines as well.[26]

Like Alberti, whose treatise on painting he knew, Vasari casts Brunelleschi as the harbin- ger of a new interest in engineering and his cupola, which surpasses antiquity itself, as a visible expression of the ethos of the Florentine state. While it is hard to say how familiar Vasari may have been with various other fifteenth-century humanist texts that praise Brunelleschi and the dome besides Alberti's dedication letter and Marsuppini's epitaph, his career as a court artist eventually required him to develop an expertise of his own in the field of applied mechanics. In fact, between the two editions of the *Lives*, he was engaged in the invention of machines of his own design for a theatrical performance staged in the Palazzo Vecchio.

The literary consequences of this experience are reflected in the revised Life of Brunelleschi, which is expanded to include a detailed description of the theatrical machinery he devised for the performance of the Annunciation play at San Felice in Piazza, and in the second version of the Life of Il Cecca, where he engages in a broad discourse on Florentine festivals and theatrical engineering. To be sure, these revisions add substance to Brunelleschi's reputation as an innovative engineer, but as Patricia Lee Rubin has observed, they are also intended to call attention to the author himself, who can now claim a celebrated precedent for his own work with theatrical machines.[27]

Vasari's reappraisal of Francesco di Giorgio in the second edition of the *Lives* probably also has more to do with engineering than with architecture itself. Even so, it is important to keep in mind that Renaissance engineering was closely allied to architecture; that it furnished as Scaglia aptly put it, the "machines for architecture."[28] Brunelleschi's talent for inventing devices designed to hoist and move weights is amply lauded in his Life. But the role of the engineer was

just as valuable in the battlefield as on the construction site. Vasari implies as much in the second edition of Francesco di Giorgio's Life, by characterizing him as a "very great engineer, particularly in the design of war engines."

Fiore was the first to suggest that Vasari's reappraisal of Francesco di Giorgio should be understood in terms of his engineering accomplishments, but he remained perplexed by his use of the verb *facilitare* to denote a substantive accomplishment.[29] By definition, *facilitare* means to make easier or more accessible. It does not normally connote conceptual originality; yet this is precisely how Vasari used the expression on several noteworthy occasions. Taddeo Gaddi, for instance, having seen and learned the new pictorial concepts that Giotto had made understandable (*quello che aveva facilitato Giotto*), followed in his manner, but did not improve upon it, except in his "fresher and livelier use of color." In sculpture, Donatello breaks new ground, "having explained the difficulties of art (*facilitatare le difficultà dell'arte*) in his copious works." Brunelleschi plays a similar exemplary role by solving the structural and mechanical problems posed by raising the cupola of Santa Maria del Fiore with such originality that he "greatly advanced the art of architecture" (*facilitò molto l'architettura*). Prior to winning the commission, however, he had to endure the ridicule of an audience that remained skeptical no matter how hard he tried to "explain his concept" (*facilitare il concetto suo*) in terms they could understand.[30] In all of these instances, the verb *facilitare* is used within a contextual framework that makes its meaning clear. This is not so in Francesco di Giorgio's case, where this expression appears as a summary appraisal appended as a conclusion to the Life. Yet when his biography is read in conjunction with Brunelleschi's, Vasari's meaning comes through clearly enough. To him, Francesco di Giorgio was Brunelleschi's worthiest fifteenth-century heir, not by virtue of his work as an architect, but because of his accomplishments as an engineer.

Vasari's recovery of Francesco di Giorgio's reputation in this field, and the conclusion that he was a "very great engineer, particularly in the design of war engines," is linked to two notable works: the so-called *Frieze of the Art of War* at the Ducal Palace of Urbino, and "some books of drawings filled with these kinds of instruments, the best of which "Lord Duke Cosimo de'Medici counts among his most cherished possessions." Vasari would certainly have seen this frieze when he traveled to Urbino in 1566 to gather information for the second edition of the *Lives*.[31] Originally located on the exterior of the Ducal Palace, it functioned as a *spalliera* to the long stone bench that runs along the base of the facade. The fact that he remembered it as a painting rather than as a relief might simply suggest that the seventy-two carved panels that formed the back of the bench were once colored. His characterization of its subject is also somewhat misleading, since it calls attention only to the illustration of military machines (*machine da guerra*), while ignoring the broad range of technological devices actually represented on the *spalliera*. These include, among other things, illustrations of siege ladders, stockades, various stone hurling engines, and cannon, as well as hoists, mills, hydraulic machines, clock and bell mechanisms, a pyramid raising device, and even musical instruments. Taken as a whole, the frieze is an impressive visual compendium of medieval and Renaissance military and civil technology, but it was also much more than that. As Dal Poggetto observed, it was literally the "business card" which Federico da Montefeltro presented to anyone who approached his palace.[32] Displayed in the city's most important public space, it served above all as an

ideologically charged demonstration of the formidable technological resources through which the duke had forged his military and political power.[33]

Vasari's recollection that Francesco di Giorgio had illustrated "some books" filled with devices like those represented in the Urbino frieze makes it hard to know which of the many copies of his illustrated works available in the sixteenth century he actually may have consulted, since they all commingle civil and military architecture with technological devices appropriate to both of these fields. But once again it was the military technology which impressed him most and led him to conclude that Francesco was "so taken with trying to understand the machines and war engines of the ancients, and so engaged with investigating the manner of ancient theaters and other similar things," that these pursuits left him less time for sculpture. Even so, he adds, these studies "have earned him and continue to bring him no less honor than sculptures could have."[34]

Vasari's estimation of Francesco di Giorgio's engineering accomplishments, however, may not depend solely on his recollection of the Urbino frieze and on the manuscript in the ducal library. It might also have been fostered by his friendship with Cosimo Bartoli (1503–72), who assisted him in collecting new information for the second edition of the *Lives*. A prolific author in his own right, Bartoli owned Buonaccorso Ghiberti's *Zibaldone* (1490s), one of the most significant surviving sources of technological information produced in the fifteenth century.[35] Some of the most notable drawings recorded in this workshop notebook are the hoists and cranes invented by Brunelleschi to raise the cupola of Santa Maria del Fiore and the theatrical machinery he conceived for staging the Annunciation at San Felice in Piazza. Significantly, it also contains illustrations of machines drawn from Francesco di Giorgio's work.[36] Bartoli's interest in technological studies is also reflected in an engineering sketchbook of his own (Florence, Biblioteca Nazionale, Ms. Palatino E. B. 16.5, vol.2). Probably compiled in Venice, where he served as Duke Cosimo's agent for a decade (1562–72), Bartoli's compendium depends largely on Francesco di Giorgio's work.[37] Although it is hard to know for certain, Bartoli may well have communicated his admiration for the Sienese artist to his friend Vasari, thereby contributing to his rediscovery of Francesco di Giorgio's engineering accomplishment in the *Lives*, and promoting the flattering comparison with Brunelleschi's more famous endeavors in this field.

NOTES

1 Giorgio Vasari, *Le vite de' più eccellenti pittori, scultori ed architettori*, 9 vols. ed. G. Milanesi, Florence, 1878–1885, (1906; reprint, Florence: G. C. Sansoni, 1973), 3: 69–74 [hereafter Vasari-Milanesi]. Unless otherwise noted the translations of Vasari are mine. "Fu [Francesco di Giorgio] scultore ed architetto eccellente...grandissimo ingenere, e massimamente di macchine da guerra; come mostrò in un fregio che dipinse di mano sua mano nel detto palazzo d'Urbino, il quale è tutto pieno di simili cose rare appartenenti alla guerra. Disegnò anco alcuni libri tutti pieni di di così fatti instrumenti; il miglior de'quali ha il signor duca Cosimo de'Medici fra le sue cose più care . . . Fu il medesimo tanto curioso in cercar d'intender le macchine ed istrumenti bellici degli antichi, e tanto andò investigando il modo degli antichi anfiteatri e d'altre cose somiglianti, ch'elleno furono cagione che mise manco studio nella scultura; ma non però gli furono nè sono state di manco onore, che le sculture gli potessino essere state. . . . Fece per Papa Pio II tutti i disegni e modelli del palazzo e vescovado di Pienza...e così la forma e la fortificazione di detta città; ed insieme il palazzo e la loggia pel medesimo pontefice . . . Il quale Francesco merita che gli sia avuto grande obligo per aver facilitato le cose d'architettura e recatole più giovamento che alcun altro avesse fatto da Filippo di ser Brunellesco insino al tempo suo." Except as noted, the quotations from the Life of Francesco di Giorgio cited in this essay are drawn from the text cited above. I am grateful to Richard Betts for sharing his thoughts on Francesco di Giorgio with me on many occasions.

2. For Vasari's Life of Brunelleschi, which draws on Manetti's earlier biography (Antonio di Tuccio Manetti, *The Life of Brunelleschi*, Introduction, Notes, Critical Text Edition by Howard Saalman, translated by Catherine Engass [University Park, PA: The Pennsylvania State University Press, 1992]), see Vasari-Milanesi, 2: 327–87. The quotation cited in the text is from Vasari-Milanesi, 2: 337.

3. For Vasari's Life of Alberti, see Vasari-Milanesi, 2: 535–48.

4. Giorgio Vasari, *Lives of the Painters, Sculptors and Architects*, 2 vols., translated by Gaston C. de Vere, ed. D. Ekserdjian, New York and Toronto: Alfred A. Knopf, 1999, 1: 465 [slightly altered; hereafter Vasari-de Vere]. See Vasari-Milanesi, 3: 70 and 73–74. For the 1550 edition of Francesco di Giorgio's Life see Giorgio Vasari, *Le vite de' più eccellenti pittori, scultori ed architettori, da Cimabue insino a' tempi nostri*, 2 vols. Florence, 1550 (reprint ed. L. Bellosi and A. Rossi [Turin: Einaudi, 1991] 2 : 415–17 [hereafter Vasari-Bellosi].

5.The angels were cast under the direction of Francesco's lifelong associate Giacomo Cozzarelli. See Francesca Fumi, "Nuovi documenti per gli angeli dell'altar maggiore del Duomo di Siena," *Prospettiva* 26 (1981): 9–25. See note n. 34 below on Francesco's manuscripts.

6. Vasari-de Vere, 1: 252 and Vasari-Milanesi, 2: 103–04. Francesco di Giorgio is also mentioned in the Life of Duccio (Vasari-Milanesi, 1: 655–56). See Flavia Cantatore. "Francesco di Giorgio nella trattistica rinascimentale, in *Francesco di Giorgio architetto*, ed. L. Bellosi and M. Tafuri, exh. cat, Milan: Electa 1993, 382–83.

7. For the 1550 edition of Alberti's Life see Vasari-Bellosi, 1: 354–58; especially the epitaph on page 358.

8. Rubin, Patricia Lee, *Giorgio Vasari. Art and History*, Yale University Press: New Haven and London, 1995, 167.

9. Vasari-Milanesi, 2: 328, 338, 104; and 4: 145 on Brunelleschi and Bramante.

10. Vasari-Milanesi, 4: 145–46.

11. Vasari-Milanesi, 4: 432 (Life of Michelozzo); 4: 290–91 (Lives of Giuliano and Antonio da Sangallo); 4: 442 (Life of Il Cronaca).

12. Vasari-Bellosi, 1: 356 and 358.

13. Vasari-Milanesi, 2: 535, 542, and 544 "Il che forse non avrebbe fatto Leon Battista, se con la scienza e la teorica avesse avuto la pratica e la sperienza nell'operare." On Vasari's architectural criticism, see Leon Satkowski *Giorgio Vasari, Architect and Courtier*. Princeton University Press. Princeton, N.J. 1994, 117–19.

14. Vasari-Milanesi, 4: 604 (Life of Peruzzi); 4: 149 (Cesarino, in the Life of Bramante); 3: 597–98 (Caporali, in the Life of Perugino); 7: 106 (Vignola, in the Life of Zucchero); 5: 431 (Serlio, in the Life of Marcantonio Bolognese); 7: 530 (Barbaro, in the Life of Jacopo Sansovino).

15. Giuseppe Zander, "Il Vasari, gli studiosi del suo tempo e l'Architettura antica," in *Il Vasari storiografo e artista*, Atti del Congresso Internazionale nel IV Centenario della Morte. Arezzo-Firenze: 2–8 September 1974. Istituto Nazionale di Studi sul Rinascimento. Palazzo Strozzi. Firenze, 1974, 333–50, especially pages 334–35. The different premises underlying Alberti's and Vitruvius' architectural treatises are noted by Joseph Rykwert in Leon Battista Alberti, *On the Art of Building in Ten Books*, translated by. J. Rykwert, N. Leach, and R. Tavernor, London and Cambridge: MIT Press, 1988, ix–x. On the pre-eminence of Vitruvius over Alberti during the sixteenth century see Alina Payne, *The Architectural Treatise in the Italian Renaissance. Architectural Invention, Ornament, and Literary Culture*, Cambridge and New York: Cambridge

University Press, 1999, 71–73 and 263–64, notes 1–5.

16. Vasari-Milanesi 2: 537, and 7: 530.

17. Vasari-Milanesi, 3: 72. On Francesco di Giorgio's drawings after antiquity see Howard Burns, "I disegni di Francesco di Giorgio agli Uffizi di Firenze,"in *Francesco di Giorgio architetto*, 330–57. See also the drawings of ancient monuments collected in Codex Salluzziano 141, in Francesco di Giorgio Martini, *Trattati di architettura, ingegneria, e arte militare*, edited by Corrado Maltese and transcribed by Livia Maltese Degrassi, 2 vols., Milan: Il Polifilo, 1967, 1: 278–279; 283–84, with accompanying facsimile reproductions. For Francesco di Giorgio's translation of Vitruvius see Gustina Scaglia, ed., *Francesco di Giorgio. Traduzione di Vitruvio (Vitruvio Magliabechiano)*. Documenti inediti di cultura Toscana 6. Florence: L. Gonnelli, 1986.

18. Vasari-Milanesi, 3: 70 and 73–74.

19. Vasari-Milanesi, 2: 337.

20. Vasari-Milanesi, 2: 330, 333, and 338.

21. Vasari-Milanesi, 2: 359–61. On the meaning of *ingegno* and its relation to engineering see, most recently, Christine Smith, *Architecture in the Culture of Early Humanism: Ethics, Aesthetics and Eloquence, 1400-1470*, New York and Oxford: Oxford University Press, 1992, 28–34, and Anthony Grafton, *Leon Battista Alberti, Master Builder of the Italian Renaissance*, New York: Hill and Wang, 79 and 99.

22. Vasari-Milanesi, 2:104. See also Vasari-Milanesi, 6: 347 (Life of Michele Sanmicheli) where the fortress at the Lido in Venice is described as a *machina*. According to Cosimo Bartoli (*L'architettura di Leon Battista Alberti. Tradotta in lingua Fiorentina da Cosimo Bartoli*, Florence: Torrentino, 1550, 47.44) "di cosa assai voluminosa dicesi che e' una gran machina."

23. Vasari-Milanesi, 2: 328 (Life of Brunelleschi) and 4: 145–46 (Life of Bramante). See Rubin, 257–58, for distinctions between *contrafare* and *imitare*.

24. Leon Battista Alberti, *On Painting*, translated by C. Grayson, London: Penguin Books, 1991, 35.

25. The translations of these literary sources are from Smith, 27–28. For Rinuccini's observations on modern engineering accomplishments see the excerpts of the Latin text reprinted in Ernest H. Gombrich, *Norm and Form: Studies in the Art of the Renaissance*, London and New York: Phaidon, 1971, 139–40.

26. Eugenio Battisti, *Filippo Brunelleschi*, Milan: Electa, 1975, 16.

27. On theatrical machinery in the Lives, see Vasari-Milanesi, 2: 375–78 (Life of Brunelleschi) and 3: 196–203 (Life of Il Cecca). See also Rubin, 224–25. On Brunelleshi see also Götz Pochat, "Brunelleschi and the 'Ascension' of 1422, *Art Bulletin* 60 (1978): 232–34.

28. Gustina Scaglia, "Drawings of Machines for

Architecture from the Early Quattrocento in Italy," *Journal of the Society of Architectural Historians*, 25 (1966): 90–114.

29. Francesco Paolo Fiore, *Città e macchine nei disegni di Francesco di Giorgio Martini*, Accademia Toscana di Scienze e Lettere "La Colombaria," Studi 49, Florence: Leo S. Olschki, 1978, 9–14.

30. Vasari-Milanesi, 1: 585 (Life of Taddeo Gaddi); 2: 425 (Life of Donatello); and 2: 345–46, 361 (Life of Brunelleschi).

31. For this visit see Rubin, 364.

32. See Paolo dal Poggetto, who likens the frieze to a "biglietto da visita" in the Preface to Grazia Bernini Pezzini, *Il fregio dell'arte della guerra nel palazzo ducale di Urbino*, Rome, 1985, 5. On the iconography of the frieze and the extent of Francesco di Giorgio's role in its execution see Pezzini, 23–47.

33. The hoists, mills, saws, hydraulic devices, and other apparently civil machines illustrated on several of these panels had as much of a role in prolonged siege campaigns as the trebuchets, scaling ladders, and artillery with which they are combined. The broader issue of mechanical technology itself, however, is still more significant. If Brunelleschi's dome stood as a testament to the advanced state of Florentine architectural engineering and mechanical technology, the Urbino frieze did much the same for Federico da Montefeltro, who greeted visitors to his palace with a visual encyclopedia of the formidable technological resources at his disposal. For the use of engineering as an expression of individual or state power see Pamela O. Long, "Power, Patronage and the Authorship of *Ars*. From Mechanical Know-How to Mechanical Knowledge in the Last Scribal Age," *Isis* 88 (1977): 1–41, and Grafton, 71–109. For a broad discussion of Renaissance engineering see *Prima di Leonardo. Cultura delle macchine a Siena nel Rinascimento*, ed. Paolo Galluzzi, Milan: Electa, 1991.

34. The most frequently copied of Francesco di Giorgio's illustrated works is a sumptuous copybook of drawings without text, the so-called *Opusculum de architectura* (London, British Museum, Harley Ms. 3281, Cod. 197 *b* 21) dedicated to Federico da Montefeltro. There are also various copies and adaptations of both an early and a later version of his treatise on civil and military architecture, each of which is known in two principal drafts (*Trattato* I: Florence, Biblioteca Medicea-Laurenziana, Ms. Ashburnham 361 and Turin, Biblioteca Reale, Ms. Salluzziano 148; *Trattato* II: Siena, Biblioteca Comunale Ms. S.IV.4 and Florence, Biblioteca Nazionale, Ms. Magliabechiano II.I.141). For a comprehensive survey of Francesco di Giorgio's manuscript production and its influence see Gustina Scaglia, *Francesco di Giorgio*.

*Checklist and History of Manuscripts and Drawings in Autographs and Copies from ca. 1470 to 1687 and Renewed Copies (1764–1839)*, London and Toronto: Associated University Presses, 1992. On the influence of Francesco di Giorgio's drawings of machines see Daniela Lamberini, " La fortuna delle macchine senesi nel Cinquecento," in *Prima di Leonardo*, 135–46. For a summary on the state of the research on Francesco di Giorgio's Treatises, see Massimo Mussini, "La trattistica di Francesco di Giorgio: un problema critico aperto," in *Francesco di Giorgio architetto*, 358–81. According to Fiore, 10, the manuscript Vasari saw in Duke Cosimo's collection was the late version of the treatise now in the Florentine National Library (Magliabechiano II.I.141). But the provenance of this manuscript prior to 1670 is uncertain. See Scaglia, *Checklist*, 221–24, who points out that the military illustrations in this late version of the treatise are limited to a single folio of cannons. There are no drawings of the "macchine da guerra" nor of the amphitheaters and other antiquities to which Vasari refers in Francesco's Life. There is a still larger issue: if Vasari had seen this copy of Francesco di Giorgio's treatise, how could he have failed to comment on its theoretical content, as he did in the Lives of Alberti and Filarete, both of whose treatises were in Duke Cosimo's library?

35. On Bartoli and Vasari see Rubin, 51, 167, 215–16, and Judith Bryce, *Cosimo Bartoli (1503–1572). The Career of a Florentine Polymath*, Travaux d'Humanisme et Renaissance, 191, Geneva: Librairie Droz, 1983, 131–44. Bartoli inherited Buonaccorso Ghiberti's *Zibaldone* from his father, Matteo, in 1525, see Rubin, 115.

36. On the *Zibaldone* see Gustina Scaglia, *"Drawings of Machines,"* 90–114, and Scaglia, Checklist, 120–21.

37. For Bartoli's engineering sketchbook see Daniela Lamberini, in *Prima di Leonardo, 223*, and Gustina Scaglia, *Checklist*, 78–82.

F. GIO. AGNOLO MONTORSOLI
SCVLTORE.

# Vasari's Bronzino:
# The Paradigmatic Academician

### FREDRIKA H. JACOBS

A gnolo Bronzino (1503–72) was sixty-five years old when the second edition of Giorgio Vasari's *Lives of the Most Eminent Painters, Sculptors and Architects* was published in 1568. Florence's Accademia e Compagnia del Disegno, having been formally inaugurated on January 31, 1563, had been in existence but five years. The publication of the revised and significantly expanded *Lives* and the founding of the Accademia are, as has frequently been noted, closely related events, with the *Lives* simultaneously reflecting and reinforcing recently instituted academic principles while promoting and celebrating the aesthetic ideals—and *perfezione*—of *la bella maniera*. Two additions to the *Lives* speak with special eloquence to this inter-reliance of text and institution. The first was the inclusion of four theoretical prefaces, one introducing the book as a whole, the other three demarcating and defining three distinctive phases in a progressive history of art that reviews the lives and works of more than one hundred and sixty artists and architects. The second was the insertion near the end of this voluminous biographical history of art of a section devoted specifically to selected members of the newly established academy.[1] By reason of its placement as the premier life in *Degli Accademici del Disegno* and by right of its content, Vasari's Life of Bronzino is something of a linchpin. Not only does it securely fasten the lives of academicians to the Preface to Part Three, it binds both to Vasari's discussion of *disegno* in his technical treatise *Della pittura*. Read in light of academy rules and regulations, the aesthetic values set forth in the *Proemio alla parte terza* of the *Lives*, "which we wish to call *la moderna*," and Bronzino's oeuvre, this life stands as a primer to academicism, its subject paradigmatic of all that inheres in that term.

The relationships between the *Proemio alla parte terza*, *Degli Accademici del Disegno*, and the discourse on *disegno* reflect the thoughtful nature of Vasari's book as an edifying compilation of parts. These sections of the book also go a long way in explaining the enduring impact of the *Lives*, which, despite its Tuscan bias, factual errors, and hyperbolic indulgencies, is by consensus counted among the most influential texts of the sixteenth century. Much of the importance of Vasari's history of Renaissance art resides in its structure and organizing principles. The four prefaces are key components of this critical frame, as is the order of the Lives within each of the three sequential phases. Logically, the artist's Life that immediately follows a preface is both demonstrative and prescriptive. Whatever is said about this principal artist, his life, works, and

*maniera* is intended to illustrate the critical truths of the theoretical precepts propounded in the preface. In Part Three of the *Lives* Leonardo da Vinci holds this esteemed position, with both his personal and artistic manners exemplifying the themes of *grazia, vivezza,* and *perfezione* that are the hallmarks of *la bella maniera.*

As a discreet section within this era of perfection, *Degli Accademici del Disegno* subscribes to this same organizational system.[2] It does so, however, in a unique way. In contrast to the cluster of Lives that come near the ends of Parts One and Two of Vasari's *Lives,* those included in *Degli Accademici del Disegno* do not provide a stylistic contrast aimed at underscoring deficiencies of one era in order to praise the advancements of another. Hence, there is no suggestion of a shift in style, nor can there be, since there was as yet no fourth era on which to reflect. Accordingly and of necessity, the collected biographies in the concluding section of the modern period operate differently from those situated similarly in the first and second phases of Vasari's history of art.[3] Rather than attest advances while pointing to inadequacies, this cluster of lives acts as a summation of the five *cose,* or governing formal qualities—"rule," "order," "proportion," "disegno," and "*maniera*"—that distinguish and define the *perfezione* of modern art.[4] As such, these biographies relate directly to the Preface to Part Three as well as to Vasari's discussion of *disegno,* which reflects the *corso di perfezionamento* established by academy statutes. Seen in this way, the Life of Bronzino holds a special place. While it is true that this life is not distinguished by detailed ekphrases, and therefore lacks the in-depth critical analysis that is the critical component of this form of rhetoric, Vasari's Life of Bronzino reads like a panegyric to the values of academicism, echoing the precepts institutionally codified by the Accademia, celebrated in the Preface to Part Three, and detailed in the author's ruminations on *l'arte del disegno.*

It has recently been argued that Vasari's decision to place the Life of Bronzino with those of other academicians, thereby rupturing the chronological sequence otherwise ordering the *Lives,* "effectively disassociated" this painter from his master. Not only are the Lives of Bronzino and Pontormo "separated by some thirty other career stories," they are distinctive in tone and distinguished by their contents. In contrast to the Life of Pontormo, which has been described as "lengthy," "characterized by recurrent themes, anecdotes, and psychologically geared observations," that of Bronzino has been represented as being "rather miserly," "brief and sterile," and described as one that has "no themes, no intriguing innuendos, and no revealing character notes."[5] This assessment cannot stand. The assertion that Bronzino's life lacks a theme is contradicted by the argument that the segregation of master from disciple was intended to signal the end of the age of the independent *bottega* in order to announce the advent of that of the *Accademia.* If this is the case, then Bronzino's life, as the first in *Degli Accademici del Disegno,* should convey the values of this new order. It does and in so doing adheres to the instructional structure of Vasari's book.[6]

As Filippo Villani had done in celebrating such *uomini illustri* as Giotto and Taddeo Gaddi in *De origine civitatis et eiusdem famosis civibus,* written about 1381–82, and as Cristoforo Landino had subsequently done in his brief history of modern art in the Preface to his Commentary to the *Divine Comedy,* 1481, Vasari had to make a case for the preeminence of Florentine art and, at this particular point in the history of Florence, do so within the framework of Cosimo I de' Medici's vision of a renewed Tuscan *imperium.*[7] The practicality of economic well-spring, to say nothing of the preservation of status within the Medici court,

demanded he do so. Since December 15, 1554, Vasari had been in the service of the Duke, receiving initially an annual stipend of three hundred ducats. The addition of biographies of contemporary artists to the *Lives*, especially those of some of the more distinguished seventy-five members of the newly founded Accademia del Disegno, of which Cosimo was one of two nominal heads, was the first step in this process. The second was to present a paradigm of academic excellence, to paint a verbal portrait of an academician whose works and working practice advanced the intellective doctrine of *disegno* and the aesthetic values of *maniera* as it was defined within the cultural politics of Cosimo's Florence. Bronzino's pedigree of patronage, which included both Cosimo and his wife Eleonora di Toledo, as well as his association with Pontormo, whose reburial on the Feast of the Trinity in 1562—complete with a stone marker adorned with carvings of the instruments of the three arts of *disegno*—was inextricably tied to plans to reinvigorate the Compagnia di San Luca as the Compagnia del Disegno, made him the logical choice. So selected, Bronzino is presented as an academician *par excellence*, a master whose multifaceted proficiency and work ethic should be emulated.

Within his relatively short Life of Bronzino, Vasari presents a litany of works that point to remarkable and admirable versatility. Bronzino is celebrated as a painter of portraits of the living and a master at portraying the dead. He is commended for rendering figures "so natural that they seem truly alive...and wanting of nothing save breath," and others, such as a Christ on the Cross, as clearly dead, having surely been "copied from a real dead body fixed on a cross."[8] He is praised for having painted monumental altarpieces, such as that for the Altar of the Graces in the Cathedral of Pisa, and for being able to work in miniature, as he did for Cosimo's son, Francesco. He is lauded for making the mythic seem real, as evinced by the "Venus with a satyr . . . so beautiful as to appear in truth Venus Goddess of Beauty," which he painted for Alamanno Salviati, and for depicting the real when it seemed mythic, as happened when he painted the double portrait of "the bizarre and monstrous" dwarf Morgante.[9] He could paint devotional pictures and prospect views for comedies. He was equally adept at painting chapel walls in fresco and secular and sacred images in oil on tin as well as on wood panel. His excellence did not wane with the years. In fact, his mature works were "even better" than those executed "in the flower of his manhood," something Vasari emphasizes by stating it near the beginning of Bronzino's *vita* and reiterating the observation near its end. Vasari credits much of this to Bronzino's diligence, a word that appears more than ten times in the artist's life, often accentuated with modifying terms like "incredible" and "greatest." Vasari's decision to stress *diligenza* in the premier life of *Accademici del Disegno* was one weighted with significance, implicitly acknowledging the work ethic required of those pursuing the academic *corso di perfezionamento*.

### The Accademia del Disegno

The impetus for founding an art academy in Florence came from Fra Giovanni Angelo Montorsoli, together with the Prior of the Servite church of SS. Annunziata, Father Zaccaria Faldossi. It began with the idea of establishing a proper sepulchral site for Montorsoli and other Florentine painters, sculptors, and architects and was propelled by the re-entombment of Pontormo.[10] Vasari was quickly brought into the discussions. So, too, was Bronzino. The initial

deliberations soon expanded to include the consideration of establishing an academy, the purpose of which was both to teach beginners and improve the works of those already established. Within three years what had begun as an effort to memorialize artists evolved into a state-sponsored institution endowed with ducal privileges and accorded a status commensurate with that of a professional faculty. The mission of the Accademia del Disegno, which reflects the technical essays of the three sister arts introducing the *Lives,* was made clear by its statutes, sponsored activities, and, subsequently, by the *Proemio alla parte terza*. Artists were enjoined to master the replication of the human form, rendering it with the utmost grace and without betraying the difficulty of the task. Drawing was crucial in this process, for it was through the act of drawing that an artist progressed from copying (*ritrarre*) to imitating (*imitare*). The distinction between the two is best explained by Vincenzo Danti in *Trattato delle perfette proporzioni*, 1567.

> By the term *ritrarre*, I mean to make something exactly as another thing is seen to be; and by the term *imitare* I similarly understand that it is to make a thing not only as another has seen the thing to be (when that thing is imperfect) but to make it as it would have to be in order to be of complete perfection.[11]

According to Vasari, the act of drawing resulted in a practiced hand ready to visualize all that the mind conceives. "We may conclude that *disegno* is nothing other than a visible expression and declaration of our inner concepts."

> Hence, whoever understands and manages these lines well will, with the help of practice and judgment, excel in each of these arts. Therefore, he who would learn thoroughly to express in drawing the conceptions of the mind and anything else that pleases him, must . . . exercise [his hand] in copying figures in relief either in marble or stone, or else plaster casts taken from life, or from some beautiful antique statue, or even from clay models, which may be either nude or clothed. . . . When he has trained his hand by steady practice in drawing such objects, let him begin to copy from nature . . . with all possible labor and diligence (*opera e diligenza*), for the things studied from nature are really those things that do honor to him who strives to master them, since they have in themselves, besides a certain grace and liveliness, that simple and easy sweetness which is nature's own.[12]

Vasari's directive reflects Academy practice and the resources it possessed to realize such practice. By 1568, Accademia holdings of collected art works were already considerable with more to follow, including drawings and paintings by Academy members for the catafalque erected on July 14, 1563 to honor Michelangelo, drawings and engravings after the works by this most revered of masters, and donations willed to the Academy by its members. In his *Memoriale*, ca. 1578, Federico Zuccaro voiced his pleasure at seeing an Academy volume in which many drawings were kept, advising all proper means be taken to preserve such treasures. Capitolo XXI of Academy statutes speaks to this need, noting the construction of "una libreria" for the "disegni, modelli di statue, piante di edifizii, ingegni da fabbricare," and any other things associated with

the arts.[13] Prints and drawings, such as Cornelius Cort's *Academy of Art*, 1578, engraved after a drawing by the academician Giovanni Stradano, and, later, Pietro Francesco Alberti's *Academy of Painters*, ca. 1600, verify in image all that is prescribed statutorily for artists engaged in a *corso di perfezionamento*.

If Capitolo XXI addressed the importance of "exercising [the hand] in copying figures in relief," including those of "some beautiful antique statue," then Capitolo II, which was appended to Academy statutes six months after the institution's founding, took into consideration the critical role played by the natural model. While archival records documenting the teaching of life drawing have yet to be found, studying the dead is certified. Capitolo II mandated all Academy members attend annually a dissection at the hospital of Santa Maria Novella.[14] Despite Vasari's repeated recommendation to study the antique and emulate the works by great Renaissance masters, it was ultimately nature that was the key, providing artists access to "that certain grace (*grazia*) and liveliness (*vivezza*) . . . which is nature's own."[15] As his own practices make clear, "nature" included the anatomized body. Moreover, as both Stradano's and Alberti's allegorized images of the Academy indicate, understanding the fabric of the human body was fundamental to academic training.[16] Not only are dissections pictured, so are articulated skeletons of the sort devised by Andreas Vesalius in the 1530s. But beyond the specifics of studying the graphic works of others, drawing after casts of hands, feet, and ancient and modern works, and witnessing the taking apart of the body so that, to quote Benvenuto Cellini, one will know how to "make one without errors," these allegorical views of academic study stress the *diligenza* required of "him who strives to master" *l'arte del disegno*. As evinced by dozens of mid-to-late sixteenth-century drawings, such as Alessandro Allori's *Studies of Arms and Legs* (The British Museum), Giovanni Battista Naldini's *Study of Michelangelo's Statue of Lorenzo de'Medici* (The Art Museum, Princeton University), and Jacopo da Empoli's *Studies of an Antique Statue of Venus* (The Cleveland Museum of Art), the message of *diligenza* was taken seriously.

### Academicism and Bronzino's Oeuvre

It has been asserted that Bronzino, one of the most revered and influential members of the Accademia del Disegno, was Vasari's equal, "wield[ing] as much power [as the author of the *Lives*] in the artistic community in the period between the founding of the Academy in 1563 and Bronzino's death in 1572."[17] He has also been credited with advancing the importance of drawing and "promot[ing], verbally and by example, the Pontormo revival that took place in the last four decades of the century."[18] These two things are, of course, interrelated. After beginning his artistic training with Raffaellino del Garbo, Bronzino became an apprentice to Pontormo, mastering his teacher's style so well, says Vasari, "that their pictures have often been taken one for the other, so similar were they for a time."[19] It was Bronzino's personal experience and the heavy emphasis Pontormo placed on drawing that formed the basis of Bronzino's own advocacy of the efficacy of the practice to the younger members of the Academy. Supporting Bronzino's verbal advice was an oeuvre that spoke volumes about the ideals of *la bella maniera* and the newly instituted practices that were issued to ensure its attainment.

As noted, the Accademia prescribed a course of study that was progressively ordered.

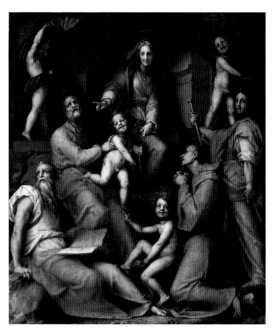

Fig. 1 Agnolo Bronzino, *Pygmalion and Galatea*, ca. 1530–1532, Galleria degli Uffizi, Florence.

Fig. 2 Jacopo Pontormo, *Madonna and Child with Saints (Pala Pucci)*, 1518, San Michele Visdomini, Florence.

Copying the works of "masters of the greatest reputation," which could be a Renaissance painting or a classical statue, comes first. Frequently this was achieved through the dissemination and reuse of drawing and *bozzetti*.[20] The second step, says Vasari, is to study the creations of nature, since such things are characterized by "grace, liveliness, and that simplicity of ease and sweetness."[21] At this point, one was entitled to engage in the art of creative imitation (*imitazione*). The distinction between *ritrarre* and *imitare* was at once easily comprehensible and theoretically complex, turning on the all important authorial designation "*di mano di*." Bronzino's *Study of a Nude* (Uffizi, no. 6704F) for the *Crossing of the Red Sea* fresco in the Chapel of Cosimo's wife, Eleonora di Toledo, 1540–1545, is a demonstration of these principles.[22] Derived from the *Idolino* unearthed on land adjacent to the Villa Imperiale just outside of Pesaro and known to the artist since the early 1530s, *Study of a Nude* transforms an easy, classical *contrapposto* into a mannerist configuration through the forcing of the pelvis forward and the rendering of the rest of the body in conformity with the exaggerated posture. Another example is seen in the figure of Pygmalion on the panel Bronzino painted sometime around 1530–1532 as a cover for Pontormo's *Portrait of a Halberdier*[23] (fig. 1). The kneeling Pygmalion, his hands clasped in thanksgiving for the benefice of bringing to life his vision of female ideality, clearly depends on the praying St. Francis in the *Pala Pucci* for San Michele Visdomini, Florence, 1518 (fig. 2). There can be no doubt that this borrowing is a student's homage to his master. By the same token, it cannot be questioned that this quotation bears the unmistakable mark of Bronzino's hand. This is how it should be since, in the context of sixteenth-century critical writings on art, the hand of the maker should always be indexed by what remains visibly and materially made about a work of art, despite its sublimation, as image. *La mano di artista* is, after all, that which reveals

agency and imbues a picture with inner depth, which, in turn, is a testament to the artist's advancement from replicating a model to imitating a source.

Any number of theorists, including Vasari, Vincenzo Danti, and Giovanni Battista Armenini, are clear on this issue. Artists, says Vasari, should imitate "pictures by excellent masters and ancient statues in relief." But not, says Danti, without emendation. He suggests altering the sex of the model. Armenini, the author of *De' veri precetti della pittura*, 1587, proposes other solutions; "reversing members, changing the head slightly, raising an arm, or by taking away or adding drapery."[24] Clearly, Bronzino employed these figural strategies in fashioning his Pontormesque Pygmalion. And obviously, as documented by the dates of Vasari's, Danti's, and Armenini's texts; respectively 1568, 1567, and 1587, theory followed practice. It is fitting that a painting of the story of Pygmalion and Galatea is a demonstration of what would become academic prescriptive since both the ancient tale told by Ovid and Bronzino's rendering of it are about and masterfully demonstrate transformative artifice. In the case of the former, an inanimate ivory statue is metamorphosed into a living woman, who, in turn, bears her maker a child.[25] In the case of the latter, images made by one artist are transfigured into those of another, creating something new. If, as has been claimed, "the Pygmalion story stands . . . as a rare example of the triumph of both love and art," then Bronzino's Pygmalion can be viewed as a triumph of both the admiration accorded one artist by another and the artifice of *imitazione*.[26]

Curiously, Vasari fails to mention the *Pygmalion and Galatea* in Bronzino's Life, referencing it only in passing in the *vita* of Pontormo.[27] It is impossible to know the motivation behind this omission. Perhaps because Pontormo's portrait and Bronzino's portrait cover are, in essence, pendants, Vasari opted to keep the works together textually. There is, however, an alternative possibility. Maybe Bronzino's *Pygmalion* reflected *too* much dependency of the student on the teacher. Despite a revived interest in the works of the older master by such young academicians as Mirabello Cavalori (ca. 1530–1570) and Francesco Morandini, called Il Poppi (1544–1597), Vasari judged Pontormo to be "rather strange."[28] He registers this evaluation in two closely related ways in his review of Bronzino's work. The first is to note the considerable number of works begun by Pontormo but completed by Bronzino. While death prohibited the older artist from bringing many commissions to finish, the intervention of the younger painter is laden with innuendo. Although Pontormo was the master and Bronzino the disciple, the former was dependent on the latter, and not simply because he had more work than he could handle. The reliance, in Vasari's mind, was one of transforming a good but incomplete work of art into one that was excellent in its finished form. For example,

> Pontormo, having left unfinished at his death the chapel of San Lorenzo, and the Lord Duke having determined that Bronzino should complete it, he [Bronzino] finished the section of the Deluge . . .and gave perfection (*perfezione*) to that part, and in the other, where at the base of the Resurrection of the Dead many figures were needed, he painted them in the manner wherein they may be seen, as very beautiful. . . . In the space that remained he painted a St. Lawrence upon a gridiron, with some little angels about him. In that whole work he demonstrated that he had executed his work with judgment superior to (*molto migliore giudizio*) that of Pontormo, his master.[29]

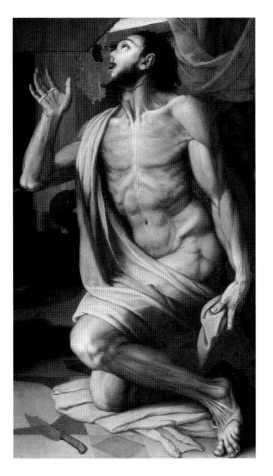

Fig. 3 Agnolo Bronzino, *Saint Bartholomew*, 1554–1556, Accademia di S. Luca, Rome.

Vasari underscores this evaluation by noting that the juxtaposition of style was not lost on Duke Cosimo I, "who then gave orders [in 1565] to Bronzino that he should execute two large altarpieces, one containing a Deposition of Christ from the Cross with a good number of figures for sending to Porto Ferraio on the Island of Elba . . . and another . . . of the Nativity of Out Lord Jesus Christ, for the new Church of the Knights of Stephen, which has since been built in Pisa."[30]

What follows next is, in the context of Bronzino's *vita*, a rare instance of Vasari advancing a truly substantive critical assessment. These altarpieces have it all. They "have been finished with such art, diligence, design, invention, and supreme loveliness of color" (*tanta arte, diligenzia, disegno, invenzione, e soma vaghezza di colorito*) that "it would not be possible to do more" (*che non si può far più*) As the narrative continues, Vasari makes clear that rewards are given to those who produce in a timely manner works of this caliber. Bronzino is entrusted with portraying "all the great men of the House of the Medici," including the duke's children.[31]

Before making this point, Vasari describes two paintings that secure his right to designate Bronzino a paradigm of academicism. The first is a "Christ on the Cross, and about Him many saints," 1554–56, destined for the Altar of the Graces in the Duomo of Pisa but now existing as two fragments, one of St. Andrew, the other of St. Bartholomew. We are fortunate to have the second of these two fragments, given the fact that Vasari essentially restricted his cursory remarks to the figure of Bartholomew (fig. 3). The partially flayed saint "has the appearance of a true anatomical subject and of a man flayed in reality, so natural is it and imitated with such diligence (*diligenza*) from an anatomical subject."[32] Artists had, of course, long engaged in anatomical dissection. According to chapters nine and eleven of Danti's *Treatise on Perfect Proportions*, anatomizing a body enabled an artist to acquire an understanding of the composition of the human form, the knowledge of which would permit "diligent speculation" on the members of the body and allow the making of "a man of complete perfection."[33] In the reasoning of Benvenuto Cellini set forth in his *Sopra i principii e 'l modo d'imparare l'arte del disegno*:

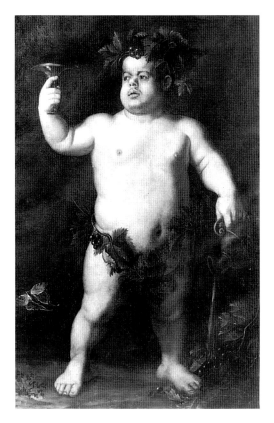

FIG. 4  Agnolo Bronzino, *Double Portrait of the Dwarf Morgante*, recto, before 1553, currently undergoing restoration, Florence.

FIG. 5  Agnolo Bronzino, *Double Portrait of the Dwarf Morgante*, verso, before 1553, currently undergoing restoration, Florence.

> Once you have put well to mind a bone structure, you can never make a figure, either naked or clothed, with errors; and that is surely a great accomplishment. I am not saying that you can be sure, because of that, to make your figures with more or less *grazia*; but only that it may suffice to make them without errors; and of this I assure you.[34]

Undoubtedly with the goal of achieving the proportional perfection of Danti and the errorless figures of Cellini, the Accademia del Disegno appended its regulations in July of 1563 to include a provision requiring members to attend an annual dissection. Once again, Bronzino's work provides an exemplary case study of practice preceding theory. Certainly and in accordance with Cellini's arguments, it can be said that Bronzino's *St. Bartholomew* has "no errors." It can also be said that it is not lacking in *grazia*. Indeed, those areas of the partially flayed figure that shift from muscles and veins stripped bare to those masked by skin, as can be seen, for example, in the masterful handling of Bartholomew's left foot and the area of the saint's neck, visualize the very essence of *grazia* as it is defined by Vasari in the Preface to Part Three of the *Lives*. The body's structure is "revealed with that sweetness and facile grace which hovers mid-way between the seen and the unseen, as is the case with the flesh of living figures" (*che apparisce fra 'l vedi e non vedi, come fanno la carne e le cose vive*).[35]

It has been argued, correctly I believe, that in imaging the flayed *St. Bartholomew*, "Bronzino placed his virtuosity in the service of one of the best-known effects of Aristotelian *mimesis*: the paradoxical pleasure derived from the detailed portrayal of objects for which, in reality, one feels only repulsion."[36] The same argument has been applied to Bronzino's portrayal of the misshaped body of the dwarf Morgante (figs. 4 and 5). Here, however, there is an added twist rendering the image of deformity more palatable. Morgante, whose name parodies the giant Morgante Maggiore of Luigi Pulci's mock-epic of 1481, or rather Bronzino's double-sided portrait of this member of the ducal court, is a readily comprehensible counterpoint to the effete formality distinguishing Bronzino's portraits of a number of other, albeit noble, Medici favorites. Painted in the early 1550s and subjected to considerable over-painting in the next century, *Double Portrait of the Dwarf Morgante* has in recent years been discussed in the context of Bronzino's *rime in burla* and also within the ambient culture of the ducal court in which dwarfs were weighed on the Pitti Palace's large kitchen scales to the amusement of all. Pointing to Morgante's pose, which mimics that of the noble ruler "compromised by his ripples of fat [and] awkwardly turned-out feet," Barry Wind describes the picture as "resonat[ing] with a studied derision," as an example of "artistic mockery," and as a portrait of "sexual impulses . . . and the absurd instability of social life."[37] Deborah Parker has further noted that the owl (*uccello*) perched on the dwarf's shoulder is "among the most common euphemisms in burlesque poetry for the phallus" and, as seen here, suggests "that not all of Morgante's appendages are small!"[38] Currently, Bronzino's painting is undergoing restoration. It is a process that is stripping the seventeenth-century Bacchic details from the image and revealing a flock of birds, each one depicted with precision so as to make their positive identification possible. The revelation is forcing an interpretative re-reading of the picture, moving it away from derisive humor and sexual innuendo and toward didactic function. The painting, it now appears, was something of a visual lexicon of birds, a primer on hawking.[39]

Long before restoration efforts were initiated and Wind and Parker advanced their readings of the *Double Portrait of the Dwarf Morgante*, James Holderbaum viewed the double-sided portrait with a focus on aesthetic issues rather than iconographic detail. He judged the portrait, as a composite image of front and back views, to be "remarkable" and "extraordinary." It is a painting, he argued, "not to be dismissed as just another extravagant mannerist caprice."[40] We would do well to consider Holderbaum's discussion, especially in light of the fact that Vasari says nothing about ribaldry, noting instead that Bronzino's rendering of Morgante is commendable as a picture "of its kind" (*in quell genere*), one that is both "beautiful and marvelous" (*bella e maravigliosa*).[41] There are two ways of understanding Vasari's remark. One is in the context of content, the other is within the framework of Bronzino's presentation of it. Both are *maravigliosa*.[42]

Like Vasari, Bronzino was one of the eight artists, four painters, and four sculptors, who responded to Benedetto Varchi's *richiesta* for an evaluation of the arts concerning which art—painting or sculpture—garnered the laurels of superiority. Bronzino began his argument in a surprising manner. He lists and explains aspects of sculpture (seven in all) that suggest its primacy over painting.[43] Unfortunately, he never completed his response, which surely would have been a refutation of the pro-sculpture arguments he advanced, thereby leaving his advocacy of the art of painting unarticulated. But if Bronzino failed to verbalize his theoretical stance, he did

visualize it. Not only does the *Double Portrait of the Dwarf Morgante* portray the subject from the front and, on the canvas's reverse, the back, it also depicts the dwarf positioned so that the slightly angled Morgante reveals oblique as well as frontal views of himself. This was not the only sixteenth-century work of it kind, nor was it Bronzino's sole demonstration of the capacity of painting to best (through the addition of color and *chiaroscuro*) the multiplicity but one-ness of a piece of sculpture, or what Francesco da Sangallo described in his letter to Varchi as the "*molti in un sol*" of a statue. In the uppermost part of *Christ in Limbo*, 1552, Bronzino employed all of the pictorial devices accorded the painter and repeatedly praised by Vasari: diminution, perspective, foreshortening, and chiastic configuration. An almost *écorché* flying demon is a *tour de force* of *scorcio*, a figure arrayed like a spiraling spooked wheel, a hideous and exaggerated counterpoint to the Blessed Christ. The very nature of this creature points to the second aspect of *maravigliosa*, namely that of presentation, and raises the issue of determining what Vasari meant when he described Bronzino's portrait of Morgante as a picture, which "of its kind, is beautiful and marvelous."

The best way to determine what Vasari implied by the phrase "of its kind" is to find other examples of images placed in this category. One such picture is Piero di Cosimo's St. Margaret issuing from the belly of a "beast so foul and deformed that I do not think there is anything bet-ter of its kind."[44] These two references suggest that the category "of its kind" includes depictions of the "bizarre and monstrous," or *meraviglie*.[45] If this is the case, then an image "of [this] kind" is a synecdoche for the miraculous nature of the subject *and* the artist's marvelous rendering of it. Yet, as Bronzino's Morgante and Piero's "beast" make clear, there are divisions within this grouping. One images fact, the other fiction. One is made with reference to nature, the other a *fantasia* inspired perhaps by Piero's contemplation of the markings on "a wall at which sick peo-ple had for ages aimed their spittle." Accordingly, that which is *miracoloso* is, in the first case, the witty and double-sided format of an image of nature gone wrong and, in the second, the cre-ative invention of a fabled creature. Whatever Bronzino's *Double Portrait of the Dwarf Morgante* might be—and surely it is many things—it should be seen as evidence of the artist's long-stand-ing interest in the natural model and proximate causes, which, no less than Piero's "beast so foul and deformed," is intricately bound to issues surrounding creativity.

In his *Lezione Della Generazione de'Mostri* of 1548, Varchi, who maintained a close friend-ship with Bronzino, recounts an event that purportedly took place in the gardens of the Rucellai Palace in 1536. A physical examination of a "monstrous birth" was performed.[46] This event needs to be seen in context. Prior to the early modern period "monsters" were deemed failures in the purposive efforts of nature (Aristotle), recognized as prodigies and portents (Cicero, Livy, and Tactitus), or appreciated as wonders of nature and God's creative intent (Pliny and St. Augustine). During the course of the sixteenth century interest in the study of so-called "monsters" shifted from final to proximate causes and, hence, to the potentialities that inhere in material and form. This interest was of concern to natural philosophers in pursuit of tax-onomies, to physicians desiring to know the causes of congenital conditions and diseases, and artists seeking to understand the creative process of the *Deus Artifex* by literally taking apart His ultimate creations: man and woman. Thus, joining Varchi in the Rucellai Gardens was an assortment of natural philosophers, physicians, and at least one artist. That artist was

Bronzino, who, according to Varchi, made a "distinguished portrait [of the] monster." He describes the subject under examination as follows:

> Two females [were] joined and stuck together, one toward the other in such a way that half the chest of one along with that of the other made up a single chest, and thus they formed two chests, one joining up with the other; their backs were not shared but each had its own; it had its head turned directly toward one of the chests, and on the other side, in place of a face it had two ears that were joined one to the other...[nonetheless] the face was very beautiful . . . [one] was very well proportioned; the other girl, from mid-back down was twisted, especially her legs . . . both of their arms, and their hands were very beautiful and well proportioned.

When the bodies of the conjoined twins were cut in half and the insides examined,

> . . . they found two hearts, two livers, and finally everything doubled for two bodies, but the windpipes coming from the hearts were joined around the base of the throat, and became one."[47]

Although the whereabouts of Bronzino's portrait of the "monster" is not known, his double-sided portrait of the gnomish *Morgantaccio nudo* can serve as a visual counter-point.

As Zakiya Hanafi has observed, "it is difficult not to be struck, in this prose passage...by [Varchi's] insistence on parallel structures of unequal elements . . . as if the monster's body alone were able to contradict the principle of non-contradiction. By being described, the double-bodied [girl] was in a way transferred from the category of *naturalia* into that of *artificialia*."[48] By the same token, in being presented in a double-sided portrait in which the front is both the same and different from the back, Bronzino's *Morgante* plays with the same aesthetic of paradox seen in the partially revealed, partially concealed *St. Bartholomew*. The subject is ugly in his deformity, the painting is *bella* in its rendering. Ultimately, however, both are *miracoloso*, one extraordinary as an example of *naturalia*, the other exceptional as a fabricated object, that is, as an example of *artificialia*.

As noted, Vasari's Life of Bronzino contains almost no protracted critical analyses yet it is filled with acknowledgments of completed works of art, some said to evince "much better judgment than his master Pontormo," others, like *Christ in Limbo*, noted for their *varietà* "wherefore there are...most beautiful nudes, men, women, and children, young and old, with different features and attitudes," many, like the portraits "of the illustrious men of the House of the Medici" praised for their "vivacious, and most faithful likenesses" (*vivaci, e somigliantissimi al vero*), and virtually all said to be the result of *diligenza*. Reading this *vita* reveals a *modus operandai*. Vasari's many references to works of art coupled with his strategic use of words loaded with aesthetic import direct the reader to the works themselves. Omnipresent throughout Florence, Bronzino's paintings function like the Accademia del Disegno's repository of works of art by great masters while evincing the work ethic implicit in the *corso di perfezionamento* laid out in Academy statutes.

**Bronzino, an exemplary artist**

Vasari's biographies belong to the genre of epideictic rhetoric. Consequently, the concern is with the "exemplary and universal [more] than with the individual."[49] This said, Vasari's composite portrait of the exemplary artist is simultaneously composed of singular, distinguishing qualities and reflected in individual character traits. In other words, while the image of *the* exemplary artist is extracted from the characterizations of many, it also underscores singularity by noting individual excellences. Some are indifferent to worldly goods, like Masaccio and Fra Bartolommeo; others, such as Leonardo, are refined in their sensibilities, the very ideal of the courtier; still others, like Michelangelo, are noted for their generosity to artists less masterful than themselves. They are precocious, kind, magnanimous, timely in completing commissions, and deserving of the privileges of patronage. Education is, of course, important, but not in and of itself. Often Vasari reviews the relationship of teacher to pupil in order to acknowledge a youthful excellence that surpasses the eminence of an older master. More important still is personal effort, or *diligenza*.

Vasari's Life of Bronzino fits easily within this scheme. Indeed, it holds a particularly important place within it by reason of its position within the voluminous text. As the first biography in the section devoted to members of the newly instituted Accademia del Disegno, it both reflects the values of the older system of *botteghe* and speaks to the new order of fellowship among academicians. Concerning the former, Bronzino is not said to have superseded Pontormo early on in his career, as happened with Michelangelo and Ghirlandaio, but he is commended for exhibiting "better judgment" than his master, with whom he was always "patient and loving." Regarding the latter, Vasari, whose personal relationship with Bronzino began, he says, in 1524 while both were at work at the Certosa, concludes Bronzino's *vita* with a personality sketch:

> Bronzino has been and still is most gentle and . . . very courteous . . . agreeable in his conversation and in all affairs, and much honored; and as loving and liberal with his possessions as a noble craftsman such as one can be . . . he has never done injury to any man, and he has always loved all able men in his profession.[50]

The final point made in this passage functions as a brief introduction to the opening statement to Alessandro Allori's Life. "Many have been the pupils and disciples of Bronzino, but the first (to speak now of our Academicians) is Alessandro Allori, who has always been loved by his master."[51] The reference to "able men in his profession" at the end of Bronzino's Life is clarified by that to "Accademici nostri" at the beginning of Allori's. The placement of Bronzino's *vita*, textually separated from that of Pontormo and at the beginning of a wholly new section in which artists are defined by institutional affiliation rather than identified by individual association, speaks to the new era of the academy. Although the aesthetic values that are prized and the personal characteristics that are admired remain the same, Bronzino's Life is exemplary in the same way that those of Cimbue, Jacopo della Quercia, and Leonardo da Vinci, which are respectively the first Lives following the prefaces introducing the three successive stages in the history of Renaissance art, are laudable. In different ways and to varying degrees Vasari

fashioned these lives to announce the technical advances, theoretical concerns, and aesthetic goals of their respective eras. He could do this with the acuity of hindsight. The time between the publication of the second edition of the *Lives* and the founding of the Accademia del Disegno did not afford Vasari this possibility in composing Bronzino's Life in relationship to those "accademici del disegno" who succeeded him. It is only logical, therefore, that he continue to stress the values of *la bella maniera* and the merit of those living and working in that age of artistic *perfezione* as set forth in the *proemio* to Part Three of the *Lives*. Still, the repeated referencing of Bronzino's *diligenza* demands consideration. In fact, the term also appears with frequency in the lives of Bronzino's pupils and disciples, "our Academicians." For example, the second sentence of Allori's Life claims, "he is seeking by *diligenza* and continual study to arrive at that rarest perfection which is desired by beautiful and exalted intellects." Similarly, the fourth sentence praises Allori's paintings on the vault of the Chapel of the Montaguti in SS. Annunziata as having been "executed with great pains, study, and *diligenza*, he having sought in the nudes to imitate Michelangelo."[52] This was something Bronzino did as well. It is impossible not to see the impact of Michelangelo's Sistine Chapel ceiling *ignudi* in Bronzino's *Adoration of the Shepherds*, 1565, Santo Stefano dei Cavalieri, Pisa, or the great master's *Doni Tondo* in the Pushkin Museum's *Madonna and Child with the Infant John the Baptist*, a collaborative work of Bronzino and Allori. Vasari's mention of Michelangelo and Bronzino's quotations from his works completes the academic circle. In myriad ways, the founding and governing statutes of Florence's Accademia reflect efforts to advance the belief that Michelangelo's incomparability both defined and mirrored the city's own artistic preeminence. To imitate, rather than simply replicate, the works of Michelangelo implies by the very nature of the term a process of stylistic progression, an advancement requiring *diligenza*. Vasari's Life of Bronzino stresses this point, proffering the example of this "most important" of academicians as a model for younger Academy members to heed and reminding them of the need to be diligent.

NOTES

1. Giorgio Vasari, *Le Opere*, ed. Gaetano Milanesi (Florence, 1906), 7: 593.

2. Ibid, 4: 11.

3. The only life following those of Florence's academicians is that of Vasari, who, as one of the founders of the academy and one of Duke Cosimo I's favored artists, upholds the same stylistic values of Medicean taste. For a discussion of the importance of the Duke, who was one of the two *capi*, or nominal heads, of the Academy, see, Karen-edis Barzman, *The Florentine Academy and the Early Modern State: The Discipline of "Disegno"* (Cambridge, 2000).

4. For a discussion of these *cose* see, Philip Sohm, *Style in the Art Theory of Early Modern Italy* (Cambridge, 2001), 99–103.

5. Elizabeth Pilliod, *Pontormo, Bronzino, Allori: A*

*Genealogy of Florentine Art* (New Haven, Ct, 2001), 5.

6. In the Preface to Part Two of the *Lives* Vasari notes that this is the function of a history;" . . . the true spirit of history...is that which truly teaches men how to live and makes them wise." Vasari, 2: 94.

7. See Larry J. Feinberg, with Karen-edis Barzman, *From Studio to Studiolo: Florentine Draughtsmanship Under the First Medici Grand Dukes* (Allen Memorial Art Museum, Oberlin College and Seattle, 1991).

8. Vasari, 7: 595.

9. Ibid, 7: 600 and 601.

10. Ibid, 6: 655ff. Also see, among others, C.I. Cavallucci, *Notizie storiche intorno alla R. Accademia delle Arti del Disegno in Firenze* (Florence, 1873); G. Ticciati, "Storia della Accademia del Disegno," *Spigolatura Michelangiolesca*, ed. P. Fanfani (Pistoia, 1876), 193–307; Karl Frey, *Der literarische Nachlass Giorgio*

*Vasaris*, 1 (Munich, 1923), 708ff; Carl Goldstein, "Vasari and the Florentine Accademia del Disegno," *Zeitschrift für Kunstgeschichte*, XXXVIII (1975), 145–52; M. A. Jack, "The Accademia del Disegno in Late Renaissance Florence," *The Sixteenth Century Journal*, 7 (1976): 3–20; Charles Dempsey, "Some Observations on the Education of Artists in Florence and Bologna During the Later Sixteenth Century," *Art Bulletin* 62 (1980), 552–69; and Zygmunt Wazbinski, *L'Accademia Medicea del Disegno a Firenze nel Cinquecento*, 2 vols. (Florence, 1987).

11. Vincenzo Danti, in *Trattati d'arte del cinquecento fra manierismo e controriforma*, ed. Paola Barocchi (Bari, 1960), 1: 241.

12. Vasari, 1: 169, 170–71 (*Della Pittura*).

13. Wazbinski, as in n. 10, 1: 281.

14. Fredrika Jacobs, "(Dis)assembling: Marsyas, Michelangelo, and the Accademia del Disegno," *Art Bulletin* 84 (2002), 436–38.

15. Vasari, 1: 170–71.

16. For an overview of the subject see, Ludwig Choulant, *History and Bibliography of Anatomic Illustration* (Chicago, 1920); and Bernard Schultz, *Art and Anatomy in Renaissance Culture*, Studies in the Fine Arts, Art Theory, no. 12 (Ann Arbor, 1985).

17. Feinberg, as in n. 7, 75.

18. Ibid.

19. Vasari, 7: 593.

20. Alessandro Nova, "Salviati, Vasari, and the Reuse of Drawings in their Working Practice," *Master Drawings* 30 (1992), 83–108; and Leatrice Mendelsohn, "The Sum of the Parts: Recycling Antiquities in the *Maniera* Workshops of Salviati and His Colleagues" in *Francesco Salviati et la Bella Maniera: Actes des colloques de Rome et de Paris (1998)* (Rome, 2001), 107–48.

21. Vasari, 1: 171.

22. Craig Hugh Smyth, *Bronzino as Draughtsman: An Introduction* (Locust Valley, New York, 1971), 5–7.

23. The most complete discussion of Bronzino's *Pygmalion* is found in Elizabeth Cropper, *Pontormo, Portrait of a Halberdier* (Los Angeles, 1997), 92–98; and Maurice Brock, *Bronzino*, translated by David Poole Radzinowicz and Christine Schultze-Touge (Paris, 2002), 52–58.

24. Vasari, 1: 172; Danti, as in n. 11, 1:240; and Giovanni Battista Armenini, *De' veri precetti della pittura* (Ravenna, 1587), 1, ix, 78.

25. Ovid, *Metamorphoses*, 2 vols., ed. G. P. Goold (Cambridge, Ma. and London, 1984), 2: 80–84.

26. Leonard Barkan, "'Living Sculptures': Ovid,

Michelangelo and *The Winter's Tale*," *ELH* 48 (1981), 646.

27. Vasari, 6:275.

28. Pilliod, as in n. 5, discusses this thoroughly, but perhaps too harshly, in the first chapter of her book. Her discussion is, nonetheless, very insightful.

29. Vasari, 7: 602.

30. Ibid, 7: 602–03.

31. Ibid, 7: 603.

32. Ibid, 7: 601.

33. Danti, as in n. 11, 231 and 239. Also see, Bernard Schultz, *Art and Anatomy in Renaissance Italy* (Ann Arbor, Michigan, 1985).

34. Benvenuto Cellini, *Sopra i principii e 'l modo d'imparare l'arte del disegno*, in *La Vita di Benvenuto Cellini*, ed. A. Rusconi and Valeri (Rome, 1901), 802.

35. Vasari, 4: 9.

36. Brock, as in note 23, 302.

37. Barry Wind, *A Foul and Pestilent Congregation: Images of "Freaks" in Baroque Art* (Aldershot,1998), 27; Brock, as in n. 23, 177.

38. Deborah Parker, *Bronzino: Renaissance Painter as Poet* (Cambridge, 2000), 157–58.

39. I am grateful to Bruce Edelstein for bringing this to my attention.

40. James Holderbaum, "A Bronze by Giovanni Bologna and a Painting by Bronzino," *Burlington* 98 (1956), 441.

41. Vasari, 7: 601.

42. For a discussion of wonder see, Caroline Walker Bynum, "Wonder," *The American Historical Review* 102 (1997), 1–26.

43. See, Leatrice Mendelsohn, *Paragoni: Benedetto Varchi's "Due Lezzioni" and Cinquecento Art Theory* (Ann Arbor, Michigan, 1982), esp. 150–52 for Bronzino's letter.

44. Vasari, 4: 138.

45. Ibid, 7: 601.

46. Benedetto Varchi, *Della Generazione de'Mostri in Opere*, 2 vols. (Trieste, 1859), 2: 665.

47. Ibid.

48. Zakiya Hanafi, *The Monster in the Machine: Magic, Medicine, and the Marvelous in the Time of the Scientific Revolution* (Durham, NC and London, 2000), 20.

49. Carl Goldstein, "Rhetoric and Art History in the Italian Renaissance and Baroque," *Art Bulletin* 73 (1991): 646.

50. Vasari, 7: 605.

51. Ibid, 7: 606.

52. Ibid, 7: 606–07.

# VASARI'S ROME
# AND THE
# NOBLE ORIGINS OF ART

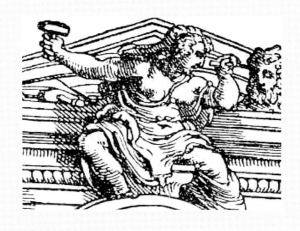

FRA GIOVANNI DA FIESOLE
PITTORE.

# Sia di mano di santo o d'un angelo: Vasari's Life of Fra Angelico

DIANE COLE AHL

Some say that Fra Giovanni would never have taken his brushes in his hand without first offering a prayer. He never painted a Crucifix without tears streaming down his cheeks; wherefore in the countenances and attitudes of his figures one can recognize the goodness, nobility, and sincerity of his mind towards the Christian religion.

—Giorgio Vasari, *Vita di Frate Giovanni da Fiesole* (1568)[1]

In the last quarter of the nineteenth century, Lorenzo Gelati portrayed the painter known as Fra Angelico as Vasari had so unforgettably immortalized him (fig. 1).[2] With palette in hand and head lowered in prayer, the most pious of Renaissance artists kneels before his fresco of the crucified Christ. Beholding the image is a fellow Dominican, perhaps Antonine, the eminent theologian and Archbishop of Florence who was canonized in 1523. The fresco of the crucified Jesus and saints on the wall before them was located in the monastery of San Domenico, Fiesole. There Fra Angelico took his holy vows around 1420, renouncing the comforts of secular life, as Vasari wrote, "to save his soul." Gelati's painting, however, is not an illustration of Vasari's text, but a melancholy reflection upon it, as signaled by its many anachronisms. Bales of straw, planks of wood, and empty wine kegs fill the now-vacant room where monks had once gathered, and the fresco itself is enclosed in shutters with broken boards. Half-hidden in the gloom as he sits with paintbrush in hand, Lorenzo Gelati portrayed himself gazing upon these phantoms.

By the time Gelati created this painting, hundreds of monasteries, convents, and churches throughout Italy had been suppressed and abandoned. The sacred works that had inspired countless prayers had been sawn from walls or seized from

FIG. 1 Lorenzo Gelati, *Refectory of the Monastery of San Domenico*, late nineteenth century, Galleria d'arte moderna di Palazzo Pitti, Florence.

119

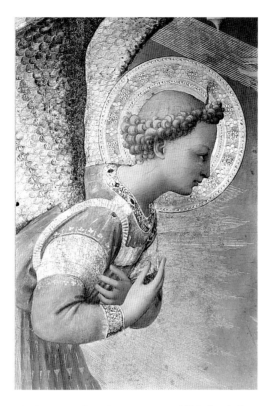

FIG. 2 Fra Angelico, *Annunciation*, ca. 1428, detail of Archangel Gabriel. Museo del Prado, Madrid.

altars and dismembered. They were then sold, egregious and irretrievable losses to Italy's spiritual and artistic patrimony. By 1879, the fresco depicted in Gelati's painting had been detached from the refectory of San Domenico and purchased by the Louvre.[3] Ironically, only one year before, Gaetano Milanesi, a brilliant archivist, critic, and historian, published his exhaustive commentary to the 1568 edition of Vasari's *Lives*, a paean to Italy's artistic genius during the Renaissance. The *Lives* established the conception of Angelico that prevails to this day.

Milanesi distinguished the Life of Angelico as "certainly the most beautiful" of all the *Vite*.[4] Exalting Angelico's holiness in exquisite prose, the *vita* initially seems more hagiography than history, a story suffused with the tropes and language of sacred writing. It praises the "rare and perfect talent" of "this truly angelic friar" who had renounced the pleasures of secular life to devote himself to "the service of God." To Vasari, Angelico's paintings seemed imbued with a truly celestial beauty, reflecting the purity of the friar's soul. So delicate, lovely, and devout are the Virgin and Archangel of the *Annunciation* (fig. 2), then in San Domenico di Fiesole, that they "seem to have been made in Paradise rather than this world"; so exquisite, varied, and sweet are the faces of the saints and angels in the church's *Coronation of the Virgin* that "they must appear in heaven just as Fra Angelico has painted them," as if created "by the hand of a saint or an angel like themselves."

Although Vasari's portrayal of the angelic painter had enchanted generations of critics, Milanesi was not entirely beguiled by its evocative prose and pious tales. He judged the *vita* as uncharacteristic of Vasari's writing, observing that many ascribed it to Vasari's assistant, Don Silvano Razzi, the learned Camaldolese monk, collector, and author of *Delle vite de' santi e beati toscani* (1601).[5] Milanesi rightly dismissed this claim as untenable and proposed another explanation. The devout stories recounted in Angelico's *vita*, he believed, served as pietistic subterfuge. They were intended to distract the reader from a tale that in his opinion was "povero di fatti," disorganized chronologically, and weakened by omissions. To an archivist of Milanesi's diligence—and by the positivist standards of his day—the lapses he perceived must have seemed intolerable. Although I would contend that the chronology of the *vita* is far more accurate than has been appreciated, I believe that the lacunae are less relevant than Milanesi thought.

As Paul Barolsky has taught us, the *Vite* are epic in scope, imaginative literature as well as

history.[6] They are parables about the nature of creation, creativity, and creators, recounting the stories of heroes and personalities of all types, from eccentrics to geniuses. This grand, dramatic saga about the evolution of Italian art from infancy to maturity comprises tales allusive as well as elusive in their meaning. Their myriad richness is revealed through reflection, imagination, and cognizance of the literary, belletristic, and historical traditions from which they emerged. Such intensely personal inventions expressed Vasari's ambitions as an intellectual, a courtier, and a man of faith while they articulated cultural, professional, and ethical ideals for artists. This is especially true with regard to the Life of Angelico, which I believe is one of Vasari's most intellectually ambitious, intricate, and inventive creations.

The *vita* is, first and foremost, a work of literature. From beginning to end, it reveals extraordinary attentiveness to organization and narrative symmetry. Vasari inaugurated it with a lengthy sentence that framed the narrative and simultaneously presented all of its major themes. Vasari introduced the master "Fra Giovanni Angelico da Fiesole," once known in secular life (*al secolo*) as the layman "Guido"; praised his equal excellence as a painter, illuminator, and friar (*religioso*); and concluded that because of Angelico's merit in these endeavors, the "most honorable record (*onoratissima memoria*) should be made of him." In the passage that follows, Vasari established the thematic and moral premises of the *vita*, which are reprised throughout his account and defended in a long excursus toward the conclusion. Although the artist "could have lived in the world with the greatest comfort," he instead chose to become a Dominican friar "to save his soul." The opposition between the secular world and the cloister, the impious man "who takes the vows with some other end in view" and the devout Angelico, becomes the theme of the narrative and propels it forward.[7]

In introducing the works of the prolific friar, Vasari plotted a precisely deliberated itinerary. In order to emphasize the association between Angelico's monastic vocation and his art, the leitmotif of the *vita*, Vasari focused on the friar's works for Dominican congregations. Strategically, he begins his catalogue with "some choral books" in San Marco and San Domenico di Fiesole, a theme he reprised, symmetrically, at the conclusion of the *vita*. Vasari thus signaled at once the artist's origins as a manuscript illuminator, his identity as a Dominican friar, and his association with San Marco, a major locus of Medici patronage. In keeping with this theme, he described in detail the friar's early works for the major Dominican church in Florence, Santa Maria Novella, from the now-lost frescoes in the Chapel of the Coronation to the still-extant reliquaries "which [were] placed on the altar in the most solemn ceremonies." The commissions for San Marco and San Domenico, the congregations with which Angelico was associated most closely, inspired Vasari to extraordinary eloquence.

Vasari devoted the first and most extended discussion in the *vita* to the paintings in San Marco. He did so not only to highlight their beauty, but to invoke the memory and generosity of Cosimo de' Medici, first ruler of Florence, munificent patron of the arts, and namesake of Duke Cosimo I, Vasari's own benefactor.[8] Vasari had dedicated both editions of the *Vite* to Duke Cosimo. As proclaimed in the dedication to the edition of 1550, Cosimo was "following in . . . the footsteps of [his] most Illustrious ancestors" in promoting the arts in Tuscany; as declared in the dedication of 1568, Duke Cosimo lived "in imitation of [his] ancestors [as] sole father, sole lord, and sole protector of these our arts."[9] Thus, Vasari meaningfully began his explication by

relating that Angelico was "greatly beloved for his merits by Cosimo de' Medici." Cosimo was lauded for his generosity in "completing the construction of the Church and Convent of San Marco" and causing "[Angelico] to paint the whole Passion of Jesus Christ on a wall in the chapter house." Vasari extolled the beauty of the *Crucifixion with Saints* in the chapter house at length. His description evokes the grief of the "mourning and weeping" figures, and identifies each saint, martyr, pope, and *beato*. These were depicted by Angelico to delineate the Order's spiritual genealogy and to honor the patron saints associated with the Medici. Vasari admired the high altarpiece as well, remarking that the Madonna "rouses all who see her to devotion" as do the saints. He remarked specifically on the predella, with its "little figures" and stories from the lives of Saints Cosmas and Damian, the patron saints of the Medici family. Although the beauty of these works is indisputable, the attention Vasari devoted to them also served to aggrandize the Medici.

Following his encomium to Cosimo and the decoration of San Marco, Vasari turned to the paintings in San Domenico di Fiesole.[10] It is no coincidence that the most lyrical descriptions in the *vita* are of these works: there Angelico took his holy vows and lived in service to God and his art. Celestial imagery suffuses Vasari's descriptions, evocative not only of the works themselves but of the beatitude of monastic life. The figures in the predella and ciborium of the high altarpiece "are so beautiful, that they appear truly to belong to Paradise"; so too with the sublime Virgin and Archangel Gabriel in the *Annunciation*. Finally, "superior to all the other works that Fra Giovanni made" is the *Coronation of the Virgin* (fig. 3), with Mary portrayed "in the midst of a choir of angels and among an infinite multitude of saints" so numerous, varied, and exquisite that "one is persuaded that those blessed spirits cannot look otherwise in Heaven [.]" Such beauty "appears to be by the hand of a saint or an angel like themselves." This was the reason,

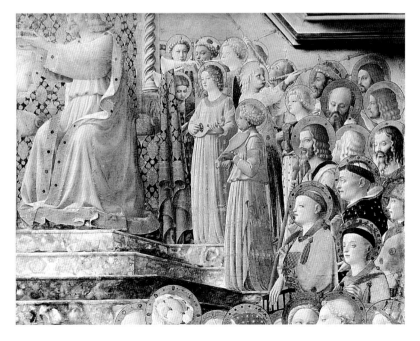

FIG. 3 Fra Angelico, *Coronation of the Virgin*, detail of Saints and Angels. Musée du Louvre, Paris.

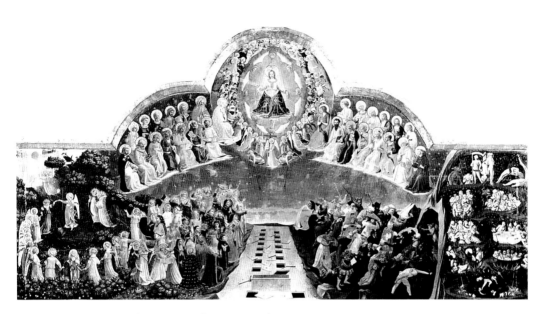

Fig. 4 Fra Angelico, *Last Judgment*. Museo di San Marco. Florence.

Vasari poetically explained, why "this excellent monk was ever called Fra Giovanni Angelico."

After dedicating so much of the *vita* to the paintings Angelico executed for his own Order, Vasari presented an abbreviated catalogue of many of his other works. He began, surely deliberately, with the silver chest in Santissima Annunziata, commissioned by Piero de' Medici, Cosimo de' Medici's son. He then described paintings owned by his contemporaries to compliment their discretion as collectors. Among them was a "very beautiful" Madonna owned by his devoted friend, Don Vincenzo Borghini, a founder of the Accademia del Disegno, who greatly assisted Vasari's revision of the *Vite* in 1568.[11] Among other paintings, Vasari named the magnificent Santa Trinita *Descent from the Cross*, described "among the best works he ever made." Extending his view beyond the confines of Tuscany, he also included Angelico's paintings in Cortona and "certain prophets" in the vaults of the Chapel of the Madonna in the Orvieto Cathedral, astutely remarking that they were finished by Luca Signorelli. The most attentively described of the works is the *Last Judgment* (fig. 4) painted for Santa Maria degli Angeli. Vasari's prose evokes the sensation of experiencing the joys and torments it so vividly portrays: The "blessed [are] very beautiful and full of jubilation and celestial gladness," while the damned, feeling "the pains of Hell [are shown] in various most woeful attitudes, and bearing the stamp of their sins and unworthiness on their faces."[12] As Vasari recounted, by then, the friar was so "illustrious throughout all Italy" that he was called to Rome by Pope Nicholas V.

With the account of Angelico's arrival in the Holy City, Vasari changed the tone and direction of the narrative. Although he extolled the beauty of the Roman works, of which only the Chapel of Nicholas V survives,[13] Vasari soon turned to the more crucial purpose of immortalizing the artist's piety. Vasari recounted how the Pope was so impressed with the friar as "a person of most holy life" that he wished to make him archbishop of Florence. Angelico demurred, because he humbly believed himself unworthy of such an honor. In his stead, the friar nomi-

nated Antonine, among the greatest of the Order's theologians, who, in Vasari's words, was "canonized in our own day."[14] Its apparently pietistic tone notwithstanding, this incident is not apocryphal: it actually was recorded in the proceedings for Antonine's canonization (1516, 1519–1520),[15] and reflects diligent research on Vasari's part. This testimony to Angelico's piety serves as a crucial segue to the next part of the *vita*. Here, in a lengthy and important passage, Vasari defined the ideal religious painter and specified the decorum appropriate to sacred art.

Invoking for posterity the example of "this truly angelic father [who] spent every minute of his life in the service of God," Vasari stated that "a talent so extraordinary and so supreme . . . should not descend on any save a man of most holy life." Only "holy men" should create holy art; when those of "little faith" produce such works, "they often arouse in men's minds evil appetites and licentious desires." As Alexander Nagel has observed,[16] Vasari wrote this section in response to contemporary controversy on the role of religious art. While theologians debated the vexed relationship between artistic license, excellence, and faith, the *vita* of 1550 paradigmatically elevated Angelico as the perfect religious painter, one whose work was never salacious or "rude and inept" (*goffo e inetto*), attributes Vasari ascribed to medieval art. Angelico never transgressed the decorum of place, as did the impious men who created deplorably lascivious works.

Vasari was less sanguine in the second edition of the *Vite* (1568). In 1563, the Council of Trent had issued its proclamations on sacred art and decorum at its final session; in 1565, following impassioned debate, the nudes in Michelangelo's *Last Judgment* were condemned, censored, and veiled. Acknowledging the potential of art to provoke "evil appetites," Vasari rebuked artists who inappropriately portrayed "nearly nude" figures in churches. Attentive to sacred decorum, he cautioned them to "respect persons, times, and places." For Vasari, Angelico unambiguously represented the ideal painter of sacred art.

Following this discourse, Vasari returned to his portrayal of Angelico's piety. Although his account may seem unbelievable, the anecdotes in all likelihood are true. They reflect Dominican ideals of behavior and spirituality as recorded in the Order's Constitutions, the *Summa Theologica* of St. Thomas Aquinas, and the writings of St. Antonine. The tale with which Vasari began the *vita*—that Angelico refused to eat meat without permission from his prior, even when invited to do so by Pope Nicholas V himself—is almost certainly reliable: the Dominican Constitutions forbade the consumption of meat, allowing it only "outside the cloister...to avoid being a nuisance to people" or in case of illness, and fasting was required on the numerous feast days celebrated by the Order.[17] Other statements by Vasari—that Angelico shunned worldly affairs, rejected wealth and celebrity, and embraced poverty and chastity—similarly conform to Dominican ideals.

Vasari's assertion "that Fra Giovanni would never have taken his brushes in his hand without first offering a prayer" fully accords with the Dominican emphasis on empathetic engagement with Jesus's suffering.[18] Indeed, in his *Opera a ben vivere*, St. Antonine, prior of San Domenico di Fiesole during the years of Angelico's novitiate and formation, exhorted the faithful to "kneel before a Crucifix and with the eyes of the mind" to meditate upon Christ's Passion.[19] In this context, Vasari's claim that Angelico "never painted a crucifix without tears" is entirely credible. The statement that the friar never retouched or changed his paintings is certainly true,

as their underdrawings unerringly reveal. After marshalling this evidence of the friar's piety, Vasari ardently proclaimed that "in the countenances and attitudes of his figures one can recognize the goodness, nobility, and sincerity of his mind towards the Christian religion."

With this final encomium to Angelico's character, Vasari recorded that the master died in 1455. As was customary with the *Vite*, Vasari concluded by listing the artist's "disciples." He counted among them Benozzo Gozzoli, whose achievements were immortalized later in the same publication; Zanobi Strozzi; Domenico di Michelino; and, erroneously, Gentile da Fabriano, who predeceased Angelico by almost three decades. Vasari then recorded one of the beautiful epitaphs "carved in the marble" of the master's tombstone in Santa Maria sopra Minerva, significantly located "near the lateral door beside the sacristy."[20] Ascribed by tradition to Pope Nicholas V, who died within a month of Angelico, the epitaph exhorts the beholder:

> Do not praise me because I was another Apelles
> But because to you, O Christ, I gave my livelihood.
> Of my works, some remain on earth, others are in heaven.
> Florence of Etruria is the city that gave birth to me, Giovanni.

As Vasari began the *vita* by praising Angelico's great gifts as a manuscript illuminator, so too did he conclude it. His description of two "very large books illuminated divinely well by the hand of Fra Giovanni" in the Duomo echoes the reference to the beautiful choral books "illuminated by the hand of Fra Giovanni" in San Marco and San Domenico di Fiesole that inaugurated the narrative.[21] In addition to lending symmetry to the narrative, the repetition emphasizes Angelico's prowess as an illuminator, a reminder of this art's importance in the Renaissance.[22] As Vasari recounted in the *vita* of Lorenzo Monaco, reliquaries enshrined the right hands of two friars who were renowned illuminators and scribes in the scriptorium of Santa Maria degli Angeli.[23] An attentive reading of the *Vite* reveals references to manuscripts by major Renaissance masters, from Giotto and Taddeo Gaddi to Botticelli and Ghirlandaio, serving as a corrective to criticism that consistently has privileged monumental painting over illumination.

In fact, recent scholarship on Angelico has reasserted the primacy of manuscript illumination not only in his formation, but throughout his career. In the past fifteen years alone, no less than three complete manuscripts have been discovered and attributed to the friar, expanding our knowledge of this critical aspect of his activity. They include Corale 558 (Museo di San Marco, Florence: fig. 5),[24] with thirty beautifully illustrated folios and figures by the master, long recognized among Angelico's earliest works. In addition, his oeuvre as an illuminator now encompasses several manuscripts:[25] Roman missal (Ms Gerli 54, Biblioteca Braidense, Milan), with illuminations for feast days throughout the liturgical year; a choirbook (Corale 43, Biblioteca Laurenziana, Florence) with eight miniatures, six of the Passion of Christ; and two psalters (Saltero 530 and Saltero 531, Museo di San Marco, Florence), with miniatures by him and his shop. Two exquisitely illuminated leaves in Florence and Turin also are by his hand.[26] No doubt there are others, overlooked, uncatalogued, or misattributed, as were the San Marco psalters, to Zanobi Strozzi. Liturgical manuscripts all, they attest the centrality of Angelico's activity as an illuminator to his religious vocation, the theme that in actuality pervaded his life and with which the *vita* was introduced.

FIG. 5 *Madonna of Mercy Protecting Dominican Friars,* Missale 558, fol. c. 156 verso.

It was in deliberate counterpoint, I believe, to these pious books that Vasari appended a coda to the edition of 1568 that was absent from the text of 1550, but crucial to our understanding of the *vita*.[27] Immediately after praising Angelico's holy books in the Cathedral, Vasari described an illuminated book that he attributed to Attavante Fiorentino, "a celebrated and famous" contemporary of the friar, "whom [he knew by] no other name." Attavante Attavanti (1452– 1520/25) illustrated numerous missals and bibles as well as non-liturgical books. He counted among his patrons some of the great rulers of the day: Federigo II da Montefeltro, Duke of Urbino; Manuel I, King of Portugal; and Matthias Corvinus, King of Hungary.[28] Scholars correctly have concluded, however, that the manuscript is not by Attavante, but rather is by Pesellino (1422–1457).[29]

The book described by Vasari is the *Silius Italicus,* an epic Latin poem from the first century that recounts the history of the Punic Wars. Although the folios of this dismembered manuscript are dispersed between the Hermitage and the Biblioteca Marciana, Vasari's precise description and codicological evidence leave no doubt that they originally were all part of the same book. The folios depict youthful pagan deities, most dramatically, Mars in a brilliant red cuirass and winged helmet, sinuously posed aloft a chariot drawn by scarlet horses. Seductive in their flowing gowns, beautiful female personifications of Carthage and Rome hover above the horizon, gracefully poised on one foot. There also are numerous portraits of once-great heroes, including Scipio Africanus, wearing a gilded, saffron cuirass and crested helmet, brandishing a sword, and gazing, in Vasari's words, "with indescribable fierceness" at Hannibal on the facing page.

Vasari's colorful and detailed description of each folio reveals unabashed admiration of their beauty gained through first-hand observation. Indeed, he remarked that "there are no better examples of illumination to be seen," and justly praised their grace and delicate color. At the same time, the juxtaposition between the *Silius Italicus,* a pagan history of conquest by fallen heroes and once-great civilizations, and Angelico's holy books could not have been more striking. Surely it was no coincidence that this account, immediately following the description of Angelico's "divinely illuminated" books in the Duomo, was appended to the life of the friar. I believe that Vasari used the *Silius Italicus* as a foil to contrast the mortality of these doomed,

pagan heroes to the eternal life of the saints, the fall of terrestrial kingdoms to the City of God. There could not have been a more fitting conclusion to the *vita*.

Although Angelico's *vita* has been dismissed as pietistic fiction, it in fact exhibits conscientious research. The catalogue of works alone reveals Vasari's intense aesthetic and spiritual engagement with the friar's art as well as a sense of connoisseurship that is truly remarkable. The oeuvre of Angelico is stylistically quite diverse, and includes manuscripts, frescoes, and panel paintings. From the earliest paintings, so deeply imbued with Lorenzo Monaco's spirit; to the *San Pietro Martire Triptych*, a manifesto of Masaccio's influence; and much later, with the magisterial Chapel of Nicholas V, his art evolved dramatically, responding to, and then creating, the most expressive devotional language of his day. The accuracy of Vasari's attributions bespeaks his extraordinarily acute eye. Of all the surviving works described in the *vita*, only two seem to have been misattributed: an altarpiece for the Acciauoli Chapel of the Certosa in Florence now identified with Starnina, and the *Annunciation* in Santa Maria sopra Minerva, ascribed to Antoniazzo Romano. Vasari's knowledge of the works in Cortona, Orvieto, and Rome is also striking, given their distance from Florence. He even remarked on the destruction of the Vatican Chapel of the Sacrament by Pope Paul III, praising the portraits rescued by Paolo Giovio, the humanist historian and theoretician, and placed in his famous museum. Perhaps most outstanding is the intensity of Vasari's response to their beauty, epitomized by his exalted praise of the *Coronation of the Virgin*.

Equally impressive is the fidelity of Vasari's account to historic sources. All evidence indicates that the friar in fact was as humble and pious as he was portrayed in the *vita*. Testimonies to his devout character entered the literature almost immediately upon his death in 1455. The nearly contemporary epitaph on the wall of his tomb in Santa Maria sopra Minerva apostrophized him as "tanto doctore carentes" (so immortal a doctor [scholar]) and "Servulus Dei" (Servant of God).[30] These are supreme accolades when contextualized within the Dominican literary and hagiographic tradition. The very fact that he was buried prominently in the Minerva, the motherhouse of the Dominican Observance in Rome, and that his tomb was located to the right of the Chapel of St. Thomas Aquinas, the Order's greatest theologian and doctor of sacred eloquence, attest how highly his piety and wisdom were esteemed by members of his own Order.

The designation "Angelico" by which he came to be known was posthumous.[31] It was accorded to him only a decade and a half after his death by a member of his own Order, the learned Fra Domenico da Corella. In the "Theotocon," written in 1469, Fra Domenico praised him as "Angelicus pictor quam fixerat ante iohannes" (the painter Angelico, formerly known as Giovanni), an artist "inferior to neither Giotto nor Cimabue." Within the context of Dominican spirituality, this designation was resonant with allusions, for "angelicus" hitherto had been applied exclusively to St. Thomas Aquinas. Other authors, from the humanists Antonio Manetti and Cristoforo Landino to Giovanni Santi, adopted the epithet, adding allusions to his "ardent goodness," supreme gifts as a painter, and his extraordinary piety. Given the sources, Vasari's remark that the friar came to be known as "Angelico" because the holy figures in the *Coronation of the Virgin* "appear to be by the hand of a saint or an angel like themselves" seems an imaginative invention, as Paul Barolsky has reminded us, that rendered appropriate homage to the painter's piety and art.[32]

Indeed, as delineated by Vasari, Angelico's virtue transcended that of any other artist whose life was recounted in the *Vite*. This is true even of monastic artists, in whose *vite* there are few allusions to piety.[33] Vasari wrote admiringly of Don Lorenzo Monaco, Angelico's probable teacher and a Camaldolese friar, but only of his mastery as a painter, manuscript illuminator, and director of the scriptorium in Santa Maria degli Angeli. As an evident foil to the *vita* of the chaste Angelico, Vasari portrayed the reprehensibly tumultuous life of his contemporary, the Carmelite Fra Filippo Lippi. The *vita* reproached Filippo for his many deceits, worldliness, and a libidinous fervor that verged on the bestial ("[un] furore amoroso, anzi bestiale"). Vasari lauded the Veronese friar and architect Fra Giocondo, the "rarest and most universal of men," but only for his buildings, while the long *vita* of the sculptor Giovanni Angelo Montorsoli chronicled his agitated movement between one religious order and another as he sought to quell his restless spirit. The Life of Fra Bartolommeo as well seems constructed in antithesis to that of his devout predecessor. Like Angelico, Fra Bartolommeo was a Dominican; unlike the pious friar, Fra Bartolommeo painted nudes. As Vasari disapprovingly remarked, his "*S. Sebastiano ignudo con colorito molto alla carne simile*" provoked lust rather than devotion in women, violating the decorum epitomized by Angelico. Angelico, and Angelico alone, exemplified for Vasari the perfect Christian artist.

Long after Vasari's death, his portrayal of Angelico lived on, proving inexhaustibly rich for succeeding generations. Different ages selectively remembered and refashioned the *vita* in response to the needs of their own time. Critics and artists of the Romantic era who sought God in a faithless world embraced Vasari's portrayal of the friar. They found in Angelico a piety unmatched by any other artist. For the Nazarenes,[34] Pre-Raphaelites, and the Confrérie of painters established by the Dominican Henri Lacordaire, his workshops at Fiesole and San Marco represented the monastic ideal of brotherhood that they hoped to revive.[35] For such pious critics as Alexis-François Rio and the Dominican Vincenzo Marchese,[36] Angelico's spiritual ardor was deemed almost more important than his art.

Veneration of the devout friar reached its zenith in the late nineteenth century. The first paraliturgical celebration of the feast of "Beato" Angelico was recorded at San Domenico di Fiesole in 1886, on March 18, the presumed anniversary of his death.[37] The liturgy for the feast invoked him as "amabile Santo, giustamente chiamato Angelico."[38] It praised the "truly divine hand" of this "dear saint," echoing Vasari's meditation on the *Coronation of the Virgin*, painted by "the hand of a saint or an angel." It included tales told by Vasari about the friar: that he never took up his brushes without first offering a prayer; that he wept each time he painted the crucified Christ; that the only dignity he sought was to escape Hell and seek Paradise. Addressing the friars of San Domenico as "beloved brethren" (*amati confratelli*) the liturgy incorporated Vasari's words on Angelico's piety, exhorting them to live piously, to "repeat that God alone is the true object of your heart." Culminating centuries of devotion, the cult of Angelico was given authoritative sanction by the Roman Catholic Church when Pope John Paul II beatified him on October 3, 1982.

As resonant as the *vita* may be to our appreciation of Angelico, it is also crucial to understanding Vasari. To pursue Barolsky's observations in "Parallel Lives," a chapter from *Why Mona Lisa Smiles*,[39] the *Vite* served as a mirror in which Vasari's own life and aspirations were

reflected, in which he refashioned his own image, idealized and perfected. Writing the Life of Angelico at the height of the Catholic Reform, Vasari found in the friar the epitome of the Christian artist: a painter of peerless gifts and matchless piety; an artist beloved by Cosimo de' Medici, founder of the Medici dynasty; a man who devoted his life to the service of the Lord. By immortalizing a man of such piety, Vasari himself sought to serve God and to procure his own salvation.

NOTES

1. All English translations are from Giorgio Vasari, *Lives of the Most Eminent Painters, Sculptors, and Architects*, trans. Gaston Du C. de Vere, 3 vols. (New York: Harry N. Abrams, Inc., 1979), 1: 478–89. For the text of 1550, I have relied on Giorgio Vasari, *Le vite de' più eccellenti architetti, pittori, et scultori italiani da Cimabue insino a' tempi nostri*, eds. Luciano Bellosi and Aldo Rossi, 2 vols. (Turin: Giulio Einaudi, 1991), 1: 344–50; for that of 1568, see *Le vite de' più eccellenti pittori, scultori, ed architettori scritte da Giorgio Vasari*, ed. Gaetano Milanesi, 11 vols. (Florence: G. C. Sansoni Editore, 1906), 2: 505–34.

2. *Il refettorio del convento di San Domenico*, n.d., Galleria d'arte moderna di Palazzo Pitti, Florence, no. 619, oil on canvas, 55 by 69 cm. The Florentine, Lorenzo Gelati (1824–1893) was primarily a landscape painter on whom little has been written. See the unsigned entry in *Allgemeines Lexikon der Bildenden Künstler*, ed. Ulrich Thieme, 37 vols., (Leipzig: Verlag Seeman), 13: 358. To my knowledge, there is no published discussion of this painting; the interpretation presented here is my own.

3. Originally located in the refectory of the monastery, it was sold by the antiquarian Bardini to the Louvre in 1879.

4. This reference and others to Milanesi's commentary are from Vasari-Milanesi 2: 527.

5. Abate Don Silvano Razzi Camaldolense, *Delle vite de santi e beati toscani* (Florence: Nella Stamperia di Cosimo Giunti, 1601).

6. Paul Barolsky, *Walter Pater's Renaissance* (University Park: The Pennsylvania University Press, 1987), esp. 113–26; idem, *Michelangelo's Nose* (University Park: The Pennsylvania State University Press, 1990) ; idem, *Why Mona Lisa Smiles and Other Tales by Vasari* (University Park: The Pennsylvania State University Press 1991); idem, *Giotto's Father and the Family of Vasari's "Lives"* (University Park: The Pennsylvania State University Press, 1992); idem, *The Faun in the Garden. Michelangelo and the Poetic Origins of Italian Renaissance Art* (University Park: The Pennsylvania State University Press, 1993); and throughout his writings and lectures.

7. Patricia Rubin, *Giorgio Vasari Art and History* (New Haven and London: Yale University Press, 1995), 148–86, identifies classical and early Renaissance precedents for the *Vite*. As with all the *Vite*, the introductory passages to Angelico's Life reflect the influence of epideictic literature; see esp. 155–65.

8. The patronage of Cosmo de' Medici has been the subject of virtually countless studies. See the recent book by Dale Kent, *Cosimo de' Medici and the Florentine Renaissance. The Patron's Oeuvre* (New Haven and London: Yale University Press, 2000).

9. Both from Vasari-de Vere (1550) 3–5; (1568) 6–7.

10. In 1501, the high altarpiece (*in situ*) was modernized by Lorenzo di Credi as a single-panel *sacra conversazione* with a continuous architectural and landscape background; Vasari described it as "retouched by other masters and injured, perchance because it appeared to be spoiling." For a reconstruction, see Umberto Baldini, "Contributi all'Angelico: il trittico di San Domenico di Fiesole e qualche altra aggiunta," in *Scritti di storia dell'arte in onore di Ugo Procacci*, ed. Maria Ciardi Duprè dal Poggetto et al., 2 vols. (Milan: Electa, 1977), 1: 236–46. The beautiful predella of the risen Christ among more than 200 saints, *beati*, angels, and Old Testament worthies, is in the National Gallery, London. The ciborium is in the Hermitage; one of its flanking wings is in the Louvre and the other was sold at Christie's, London, on 11 July 2001. On the ciborium, see Fiorenza Scalia, "Contributo all'Angelico. Nuovi documenti per il Ciborio di San Domenico a Fiesole," *Critica d'Arte* 55 (1990): 34–40.

11. See Robert Williams, "Vincenzo Borghini and Vasari's 'Lives'," Ph.D. diss., Princeton University, 1988.

12. See Anna Santagostino Barboni, "Il Giudizio Universale del Beato Angelico per la chiesa del monastero camaldolese di S. Maria degli Angeli a Firenze," *Memorie domenicane* 9 (1989): 255–78, who proposes the intervention of Ambrogio Traversari—Camaldolese theologian, humanist and iconographer—in its interpretation, and the consequent rapport between him and Angelico.

13. Angelico painted four fresco cycles for the Vatican Palace and St. Peter's; see Creighton Gilbert, "Fra Angelico's Fresco Cycles in Rome: Their Number and Dates," *Zeitschrift für Kunstgeschichte* 38 (1975): 245–65.

14. Antonine was canonized in 1523, when Vasari (born 1511) was twelve years old.

15. Stefano Orlandi, O. P., *Beato Angelico* (Florence: Leo S. Olschki, 1964), tav. XLVI, reproduces f. 88r from the Bull of Saint Antonine's canonization, preserved in Florence, Biblioteca Laurenziana, S. Marco cod. 883. See also Orlandi, 88–89, and 191–92, doc. XVIII, n. 15.

16. Alexander Nagel, *Michelangelo and the Reform of Art* (Cambridge: Cambridge University Press, 2000), 191–92.

17. See William Hood, *Fra Angelico at San Marco* (New Haven and London: Yale University Press, 1993), 291–92, chapters four through seven, which include rules that regulate behavior regarding food.

18. See the analysis of *De modo orandi*, an illustrated Dominican prayer manual from the thirteenth century, by Hood, 199–207.

19. Saint Antonine, *Opera a ben vivere di Sant'Antonino scritta a Dianora Tornabuoni ne' Soderini* (Florence: Libreria Editrice Fiorentina, 1923), parte III, 149. On the visuality of Antonine's writings as related to Angelico, see the suggestive discussion by Eugenio Marino, O. P., "Beato Angelico. Umanesmo e Teologia," in *Beato Angelico. Miscellanea di Studi*, ed. Postulazione Generale dei Domenicani (Rome: Pontificia Coramissione centrale per l'arte sacra in Italia, 1984), 465–533, esp. 493–96.

20. See Lodovico Ferretti, O. P., "Intorno alla tomba del B. Angelico alla Minerva," in *Atti del Congresso nazionale di studi romani*, ed. Congresso nazionale di studi romani, 2 vols. (Rome: Istituto di studi, 1929), 1: 560–64; and "Iscriptiones sepulchri fratris lohannis Faesulani, in ecclesia Sanctae Mariae supra Minervam, Romae, an. 1455," in *Concessionis missae et officii in honorem servi Dei loannis de Faesulis O.P. qui vulgo dicitur "Beatus Angelicus" († 1455)*, ed. Catholic Church, Congregatio Sacrorum Rituum (Rome: Typis polyglottis vaticanis, 1960), Doc. II, 15–18.

21. Vasari-de Vere, 483, also mentions "some books, which are most beautiful," among the works he executed for Pope Nicholas V.

22. See Laurence B. Kanter, "The Illuminators of Early Renaissance Florence," in *Painting and Illumination in Early Renaissance Florence 1330–1450*, exh. cat., eds. Laurence B. Kanter et al. (New York: The Metropolitan Museum of Art, 1994), 3–31, who correctly observes that "conventional histories of the arts in early Renaissance Florence have been only marginally concerned with manuscript painting."

23. Cited by Kanter, 3; from Vasari-Milanesi 2: 23.

24. The most intuitive and comprehensive discussion is Luciano Berti, "Miniature dell'Angelico (e altro)," *Arte acropoli* 2 (1960): 277–308; 3 (1963): 1–38. See most recently *Miniatura del '400 a San Marco dalle suggestioni avignonesi all'ambiente dell'Angelico*, exh. cat., eds. Magnolia Scudieri et al. (Florence: Giunti, 2003).

25. The manuscripts include: MS Gerli 54: First associated with Angelico by Miklòs Boskovits, "Appunti sull'Angelico," *Paragone* 27 (1976): 35–36, 48 n. 10; and discussed by Carl Brandon Strehlke, "Sanctorale and Common from a Gradual," in Kantor et al., No. 48, 332–39; and Milvia Bollati, "Una nota per Beato Angelico miniatore e un Messale ritrovato," in *Settanta studiosi italiani. Scritti per l'Istituto Germanico di Storia dell'Arte di Firenze*, ed. Cristina Acidini Luchinat et al. (Florence: Casa Editrice Le Lettere: 1997), 80–86. Corale 43: Published by Miklòs Boskovits, "Attorno al tondo Cook: Precisazioni sul Beato Angelico su Filippo Lippi e altri," *Mitteilungen des Kunsthistorischen Institutes in Florenz* 39 (1995): 37–46, as Angelico, the illuminations formerly had been given to Zanobi Strozzi. Salterio 530 and Salterio 531: Ascribed to Angelico by Luciano Bellosi in *Pittura di luce. Giovanni di Francesco e l'arte fiorentina di metà Quattrocento*, ed. Luciano Bellosi (Milan: Electra, 1990), 98–101.

26. "Crucifixion," Santa Trinita, Florence, published by Luciano Berti, "Un foglio miniato dell' Angelico," *Bollettino d'Arte* 47 (1962): 207–15, and more recently considered by Luisa Tognoli Bardini, "Crocifissione," in *Arte in Lombardia tra Gotico e Rinascimento* (Milan: Fabbri, 1988), No. 58, 214–15; and Luciano Bellosi, "San Benedetto fra i Santi Mauro e Placido," Private Collection, Turin, published in *Da Biduino ad Algardi— Pittura e scultura a confronto* (Turin: Giulio Einaudi, 1990), No. 4, 39–40. A humanist Bible in Hebrew in the Biblioteca Laurenziana, Florence, Plut. 1.31, also has been ascribed to Angelico and Francesco Rosselli by Luisa Mortara Ottolenghi, "Scribes, Patrons and Artists of Italian Illuminated Manuscripts in Hebrew," *Jewish Art* 19–20 (1993–1994): 95–97, but does not reveal Angelico's hand.

27. Vasari-Milanesi 2: 523–26.

28. His career is summarized concisely by Patrizia Ferretti, "Attavanti, Attavante," in *Encyclopedia of Italian Renaissance and Mannerist Art*, ed. Jane Turner, 2 vols. (London: Macmillan Reference Limited, 2000), 1: 89–90.

29. Hermitage, Leningrad, cat. 1791; Venice, Biblioteca Nazionale, Marciana, MS. Lat. XII 68. See the catalogue entry by Margherita Ferro, No. 20, in Bellosi, 128–33, and Melania Ceccanti, "Le miniature del Silio Italico e la formazione di Pesellino," *Miniatura* 5-6 (1993–1996): 83–88. One of the folios, 50r, in the Hermitage depicts Pope Nicholas V, suggesting that the book may have been commissioned by the pontiff for his great library.

30. See n. 20.

31. The pre-Vasarian texts cited here are gathered in *Concessionis missae et officii*, 18–37.

32. Barolsky, 1991, 43.

33. All references are from Vasari-Milanesi: Lorenzo Monaco, 2: 17–26 ; Fra Filippo Lippi, 2: 611–30 (quotation from 616); Fra Giocondo, 5: 261–73; Montorsoli, 6: 629–60; and Fra Bartolommeo, 4: 175–216.

34. See Mitchell B. Frank, "The Nazarene *Gemeinschaft*: Overbeck and Cornelius," in *Artistic Brotherhood in the Nineteenth Century*, eds. Laura Morowitz and William Vaughan (Aldershot: Ashgate Publishing Limited, 2000), 48–66.

35. On his reception by the Romantics, see Nancy Davenport, "The revival of Fra Angelico and Matthias Grünewald in nineteenth-century French religious art," *Nineteenth-Century French Studies* 27 (1998–1999): 157–99.

36. Alexis-François Rio, *De l'art chrétien*, 3 vols. (Paris: L. Hatchette, 1861), 2: 8ff.; 333–79; and Vincenzo Marchese, O.P., *S. Marco, convento dei Padri Predicatori in Firenze, illustrato e inciso principalmente nei dipinti del B. Giovanni Angelico con la vita dello stesso pittore; e un sunto storico del convento medesimo* (Florence: Presso la società artistica, 1853).

37. *Concessionis missae*, 61–62.

38. Idem, 65–69.

39. Barolsky, 1991, 104–06.

VITA DI BRAMANTE ARCHIT.

# Vasari's Bramante and the Renaissance of Architecture in Rome

Jack Freiberg

Vasari's biography of Bramante is the first devoted to an architect in the Third Part of the *Lives*, closely following the artist-magus Leonardo who opens the Modern Age, and three painters who were inspired by his art. This privileged position alerts us to the elevated role Vasari conceived for Bramante in the grand design of his book, one that is reinforced by the opening sally. Even before naming his subject, Vasari recalled the great achievements of Brunelleschi, claiming that Bramante had followed his tracks, in this way securing the path for those who came after. To an astute reader of Vasari (and of Paul Barolsky), the association with Brunelleschi suggests not only Bramante's honorary membership in that most elite of artistic families, the Florentine, but a far deeper affiliation reaching back to the wellspring of the Italian architectural tradition.[1]

In the Life of Brunelleschi, Vasari proposed an ideal genealogy entirely of his own devising, tracing Brunelleschi's lineage to the Lapi family, and thus to Arnolfo di Cambio, first architect of Florence's cathedral. Vasari further claimed that Arnolfo's father, the legendary patriarch of the family Jacopo Tedesco (also known as Lapo), was responsible for, among other significant works, the church of San Francesco in Assisi, the Palazzo del Podestà in Florence, and the tomb of the Holy Roman Emperor Frederick II in Monreale. The affiliation advanced by Vasari identified Bramante as initiator of the Third Age in architecture, in line with Arnolfo and Brunelleschi who had introduced the First and Second Ages, and in fulfillment of the promise manifested by the progenitor of the family at the dawn of the Italian tradition. Having established this august artistic lineage, Vasari turned to Bramante's inspired patron, Pope Julius II, who he says had the greatest desire to leave memories of himself (*pontefice animoso, e di lasciar memorie desiderosissimo*). In Vasari's view the heroic achievements of the Third Age depended on the felicitous conjunction of the heir to the Florentine architectural tradition and the greatest Renaissance Maecenas. The introduction concludes with the remarkable declaration that Bramante's works superseded even the achievements of the Greeks and Romans since the architect added to the inventiveness of the one and the imitation of the other more beauty and difficulty. For this reason the eternal debt carried by those who study the exertions of the ancients, evocatively rendered as *i sudori antichi*, is also owed to the labors (*fatiche*) of Bramante.

With his main themes thus established, Vasari began a more linear narrative conveying

133

certain biographical details that have fundamentally shaped our understanding of Bramante's life and career. In many instances this information can be corroborated, but in some cases Vasari remains our principal source. He records how Bramante was born in the state of Urbino of "a poor person, but with respectable qualities," and notes that his education included reading, writing, and especially mathematics (*si esercitò grandemente nello abbaco*). Bramante's Giottesque father, having observed his son's love of drawing and conscious of the need to earn a livelihood, apprenticed the boy to the local painter and member of the Dominican order, Bartolomeo Corradini, known as Fra Carnevale. Although well intentioned, Vasari implies that the apprenticeship thwarted the youth's passionate interest in architecture. As soon as he was able, Bramante traveled through Lombardy before arriving in Milan where he studied the cathedral and met its architect. Vasari elided the twenty years Bramante lived in one of the great cities of Renaissance Italy without mentioning the considerable works he executed as architect and engineer of Ludovico Sforza, better to hasten his way to Rome and destiny.

The arrival in Rome, said to have occurred shortly before the Holy Year 1500, provides Vasari with an opportunity to assert a theme that resonates throughout the biography, Bramante's relationship to antiquity. Desiring to devote himself entirely to the study of Roman architecture, Bramante lived frugally on his savings, and setting out alone, wrapped in thought (*solitario e cogitativo*), he measured all the ancient structures in the city and in the surrounding area, including those in Tivoli, Hadrian's villa, and Campania, going as far as Naples. Vasari promoted the central role of solitude in the process of creation in his Life of Michelangelo, using a similar phrase to describe it (*solo e cogitativo*). Elsewhere in the *Lives* Vasari also proclaimed the power of the Eternal City to transform artists, supported in Bramante's case by the nature of the Roman works, and perhaps reinforced by a notice circulating at mid-century purporting to record the architect's personal testimony to this effect.[2]

When viewed against the broader scheme of the biography, however, the emphasis on exploration of the ancient architectural corpus reinforced associations with Brunelleschi that Vasari had couched in the opening sentence of Bramante's Life specifically in terms of antique revival. Vasari was offering a reprise of Brunelleschi's own study trip to Rome in the company of Donatello where he is said to have labored continually, leaving no place left unvisited and nothing left unmeasured, giving himself over body and soul to his studies.[3] Distinguishing this involvement from the detached, cerebral approach of archaeologists working in our own day, is Vasari's comment that when Brunelleschi saw "the grandeur of the buildings and the perfection of the temples, [he] would stand as in a daze, appearing out of his mind" (*stava astratto, che pareva fuor di se*). For Bramante, as for his fifteenth-century predecessor, the study of Roman architecture combined reason and inspiration, both essential components for artistic activity at the highest level that defined the Third Age.

A telling visual parallel to this idea, and one Vasari might have had in mind, is provided by the pamphlet known as the *Antiquarie prospettiche romane* and published in Rome before 1500 with a dedication to Leonardo da Vinci (fig. 1).[4] Its pseudonymous author, referred to as Mr. Perspective, a painter from Milan (*Prospettico melanese depictore*), has sometimes been identified as Bramante, although the true creator seems to have been Bartolomeo Suardi, known as Bramantino due to his close association with the master. The text affords a glimpse of the anti-

quarian culture, and specifically its Lombard variant, existing in Rome at the time Vasari claims Bramante arrived. It has been observed that the description of Rome's splendors employs a rough version of Dante's *terza rima*, suggesting it was written tongue-in-cheek; a similar wry tone characterizes the frontispiece where against a backdrop of ancient structures a kneeling figure, seen in heroic nudity, peers somewhat abstractly toward an armillary sphere while measuring geometric diagrams with a compass.[5] The ambitious nature of the actions depicted, along with the upward turn of the head, suggest that the examination of ancient architecture, like the discipline of geometry, was but a means to fathom higher truths.

Vasari's image of Bramante intensely studying the ancient corpus after arriving in Rome has deeply affected modern evaluations of the Roman works and has contributed to the relative dating assigned to those works. In truth, when

FIG. 1 *Antiquarie prospettiche romane*, frontispiece. Rome, Biblioteca Casanatense.

Bramante actually arrived in Rome his activities during those first years remain shrouded in mystery due to the paucity of hard evidence, and this may have been true in Vasari's day as well. Nevertheless, during this initial phase of the architect's Roman career, between 1500 and the elevation of Julius II to the pontificate in 1503, Vasari records activity in painting, hydraulic engineering, and collaborative efforts in both secular and religious architecture.[6] All of these involved the highest levels of Curial patronage, and notable contact with Spanish patrons. Vasari even claims that on two of those projects Bramante functioned as architect of Pope Alexander VI. Much to the consternation of modern historians, the one work that fits neatly into this series and with the idea of antique revival, the Tempietto at San Pietro in Montorio (traditionally dated 1502), appears in a subsequent section of the biography. Rather than reflecting the late date for this seminal work, as is sometimes claimed, its placement within the biography can be explained by the subjects there under discussion, works left unfinished by Bramante but which were vastly influential as a result of the architect's drawings. The projected circular cloister of San Pietro in Montorio for which Vasari cites the original drawing explains the inclusion of the Tempietto at that point.

The compressed treatment of Bramante's early Roman years was surely due to Vasari's sense of urgency in moving the narrative toward the main theme announced in the

VITA DI BRAMANTE ARCHIT.

introduction, the architectural inventions for Julius II. Vasari was struck by the ambitious nature of these projects and by Bramante's formidable talent, which, he says, referring to the Cortile del Belvedere, tempers inventiveness with judgment (*grandissimo giudizio et ingegno capriccioso*). The architect's contributions to new St. Peter's are discussed in several parts of the *Lives*, but Vasari reserved for the biography proper the most unstinting praise, claiming that the grandeur of so stupendous and magnificent a structure was such that even if it had been begun according to a lesser plan, all architects who came after Bramante, even Michelangelo, would have been able only to diminish it, since he had conceived of something greater. The careful phrasing makes clear that the conceptual foundations, rather than the sheer bulk of the structure, was Vasari's point.

Regarding the structural flaws in Bramante's works, about which there was much comment in the sixteenth century, Vasari noted their existence, but was reluctant to engage in overt criticism, and even defended the architect for the collapse in 1531 of a portion of the corridor of the Belvedere courtyard.[7] Instead, he blamed avaricious assistants and the Pope's own impatience, employing the memorable formulation that Julius desired his buildings not to be built but born (*aveva voglia che tali fabriche non si murassero, ma nascessero*). Contemporaries were not always so accommodating. One even went so far as to explain the flaws by accusing Bramante of siphoning funds provided by the Pope to support his lavish lifestyle.[8] Even more moderate commentators were displeased by the demolition of the venerable Constantinian basilica of St. Peter for which Bramante earned the tag "destroyer," *Bramantem seu potius Ruinantem*, in the words of the papal master of ceremonies, Paris de Grassis, echoed by Vasari, but in a minor key. In contrast to this restraint one can cite the satiric vignette published in 1517 by Andrea Guarna in which the architect appears before the irritated St. Peter at the Gates of Paradise and proudly claims credit for demolishing the basilica, going so far as to propose that Paradise itself be rebuilt, and threatening that if his plan not be accepted he would offer to rebuild Hell.[9]

The equivocal assessment emerging from these and other sources of the period suggests that in his own day Bramante presented considerable problems of interpretation. Vasari's task of crafting the first codified presentation of the architect's life and achievements demanded a clear vision. This vision is adumbrated in the wood-cut portrait introducing the biography, part of a veritable gallery of *uomini famosi* in the arts that distinguishes the 1568 edition of the *Lives* (fig. 2).[10] The image absorbs characteristics drawn from the only certain record of Bramante's

Fig. 3 Recently attributed to Bramante, portrait medal, obverse. London, British Museum.

Fig. 4 Recently attributed to Bramante, portrait medal, reverse. London, British Museum.

features appearing on the stunning bronze portrait medal which Vasari knew and praised as *molto bella* (figs. 3, 4). Although commonly assigned to the Lombard goldsmith Caradosso Foppa, its recent attribution to Bramante himself rings true; Vasari seems to have thought so as well.[11] Vasari absorbed to his own rendering of Bramante's face the prominent nose and tapering chin seen on the medal, but in place of the classical profile and heroic nudity, he substituted a far more sober conception. The downward turn of the head and the balding pate recall the geometer holding the compass and bending deep in the right foreground of Raphael's *School of Athens*, twice identified by Vasari as a portrait of the architect.[12]

In the woodcut, Vasari deliberately altered these sources. In place of the nudity of the medal and the classical haberdashery of the fresco, Bramante is garbed in a monastic habit, complete with a cowl. This aspect of the image is explained by the fact, duly recorded by the author, that as a sign of esteem Julius appointed the architect to the office of the *Piombo*, keeper of the papal seal.[13] The holder of this prestigious position received the generous annual salary of 800 ducats and was charged with authenticating, or with supervising those who would do so, papal documents known as bulls, after the *bulla* or lead seal applied to them. From the fourteenth century onwards, and especially in the decades of concern here, many of the *bullatores litterarum apostolicarum* were lay members of the Cistercian order who took partial vows and were not subject to the same regulations as the full choir monks. Bramante was the first of several Renaissance artists who were rewarded for papal service in this way, the most famous being Sebastiano Luciani, who was granted the office by Pope Clement VII in 1531 and who became known as Sebastiano del Piombo. Despite its financial and professional benefits, Vasari viewed the office as fraught with potential hazards. In the Life of Sebastiano, he claimed that because of the luxurious lifestyle made possible by the lucrative position, once the painter had been vested in the *abito del frate* he ceased to produce art. Benvenuto Cellini records a similar bias in recounting a conversation with Clement VII that preceded Sebastiano's nomination when Cellini requested the title be granted to him. The Pope is reluctant to concede, fearing once in possession of the stipend "you would spend your time in scratching yourself (*grattare il corpo*), and that fine art you have in your hands would be lost." Cellini ends a typically long-winded response by citing Bramante as an alternative model: "Follow the example of Pope Julius of illustrious memory, who conferred an office of the same kind upon Bramante, that most excellent architect." Bramante, it would seem, had not succumbed to the easy life. Indeed, Vasari

FIG. 5 Vasari, *Portrait of Sebastiano del Piombo.*        FIG. 6 Vasari, *Portrait of Fra Angelico.*

claimed that once being named to the post, Bramante invented "an apparatus for stamping the bulls outfitted with a fine winch" (*uno edificio da improntar le bolle con una vite molto bella*). This invention has been identified as the modern screw press, which subsequently Baldassare Peruzzi and Cellini adapted for the minting of coins.[14] Through the subtle orchestration of his woodcut portraits of Bramante and Sebastiano, Vasari conveyed aspects of character conforming to his view of the artists' differing response to their elevation. Both figures wear the Cistercian habit, but Sebastiano appears as a foppish gentleman, in part due to the jaunty way he sports the *biretta*, a sign of clerical distinction extraneous to the monastic spirit (fig. 5). His eyes are raised in greeting, indicating eagerness to engage in the kind of sociable conversation that Vasari notes was his most significant talent after abandoning his profession. In contrast, Bramante is cast as deeply reflective, with head bare and face averted. The simple habit is now brought forward to become a major focus of the image. Vasari's purpose is understood when we recognize that the portrait was conceived as a pendant to the depiction of that most distinguished exemplum of the Christian artist, the Dominican painter Fra Angelico, the only other image in the series defined in this way (fig. 6). When these two portraits are read in tandem, Bramante's balding pate comes into focus as a tonsure and the inclination of his head as a sign of humility and spiritual engagement. The high curial office and its monastic corollary must have been decisive factors in Vasari's promotion of Bramante as a quasi-sacred individual. This conception was surely influenced as well by the unusual qualities everywhere present in the biographical information Vasari drew from, beginning with the architect's name. Bramante was called Donnino by his parents, as well as by Leonardo da Vinci with whom he shared a warm friendship in Milan, but he preferred to be known as Donato, and early in life adopted the nickname of his maternal grandfather, Bramante, as had his father.[15] Notwithstanding (or because of) its family origins,

the name would have evoked those qualities of mind and spirit which were uniquely his. It has been noted that a Duke Bramante appears in *La Tavola Ritonda*, an Italian rendering of the Arthurian cycle, but more meaningful is the derivation of the name from the Italian verb *bramare*, meaning to yearn for ardently.[16] This etymology was employed by the learned members of Bramante's Milanese circle to draw unkind jibes, perhaps with the intention of reversing the architect's own identification of that yearning with philosophical understanding.[17]

In this context one can draw into discussion two qualities consistently associated with Bramante in the biographical sources, his lack of letters and poverty. Bramante himself promoted both conditions as principal supports of his artistic identity in the poems he wrote. Vasari noted that Bramante "delighted in poetry, and loved to improvise upon the lyre, or to hear others doing this: and he composed some sonnets, if not as polished as we now demand them, at least weighty and without faults."[18] Bramante's musical ability is otherwise unrecorded, but his skill at extemporizing poetic ditties is fully corroborated.[19] Over twenty of these poems have come down to us, all dating from the Milanese period when Bramante was on intimate terms with a group of humanists, and especially the nobleman Gaspare Visconti, personal counselor to the Duke, friend and patron of the architect.[20] Several are addressed to Visconti and these, as well as the responses they elicited, were circulated among the group. Visconti addressed Bramante in one of his poems *as huomo singolare*, stating "it would be easier to count the number of blessed souls in the heavens than to recount the knowledge you possess." Vasari's characterization of Bramante's verses as unpolished is apt. They are rough specimens, actually burlesques, with subjects ranging from Bramante's affairs of the heart to his material needs. The first in the series concerns a lengthy trip to Liguria and Piedmont, from which Bramante returns *arostito* and claims that *in borsa un sol quatrin non sona*. Another poem concerns his socks, old and riddled with holes, and he appeals to Visconti for money to purchase a new pair.

These poems attest to Bramante's interest in projecting himself not as a lofty intellectual, but as utterly human and graced with a considerable measure of self-deprecating humor. Contemporaries were quick to seize upon individual aspects of the message Bramante intended. Cesare Cesariano, who claimed to have studied with Bramante in Milan, recorded that even if the architect was illiterate, he wrote poems in the vernacular (*facundo ne li rimati versi de poeti vulgari, licet et fusse illiterato*), noting as well Bramante's perpetually impoverished condition (*patiente filio de paupertate*).[21] A mid-century Sabba da Castiglione, who was unusually well-informed about the artists of his day and who may have known Bramante in Rome, promoted the topos of the unlettered and poor architect. Sabba described "a man of great inspiration, a cosmographer, vernacular poet," and accomplished in both painting and especially architecture, even while noting that some called him *maestro Guastante*, others *maestro Ruinante*. He further reports how following the appointment to the office of the *Piombo*, Bramante replied to a friend who asked how things were going, "very well, now that my ignorance is paying the bills" (*benissimo, poi che la mia ignoranza mi fa le spese*).[22] The rejoinder derived its punch from the traditional requirement that Cistercian lay brothers be illiterate, a deficiency transformed into a virtue when they held the office of the *Piombo*, since it precluded tampering with the documents they were required to authenticate.[23] It requires emphasis that whatever the level of Bramante's education or financial status may have been in reality, illiteracy and poverty need to be

understood in relative terms, on the one hand suggesting the lack of a humanist education, which required knowledge of Latin, and on the other, the necessity of working for a living.[24] Vasari took a balanced view of these aspects of Bramante's life. He picks up on the happy-go-lucky persona, declaring that Bramante was *molto allegra e piacevole*, and cites the youth's early education in reading, writing and arithmetic, referring as well to the poems he authored.[25] Concerning financial matters, Vasari remarks that he was born of a *povera persona*, and when first in Rome lived frugally on savings to devote himself fully to the study of ancient architecture. The additional statement that Bramante lived at the level to which his merits had raised him, but this was nothing compared to what he would have spent had he been able, suggests Vasari's awareness of Bramante's complicated attitude toward wealth.[26]

Cesariano had introduced the idea of Bramante as both poor and a free spender, remarking that the architect had disdained his impoverishment by what he identifies somewhat obliquely as his *prudentissima liberalita*. The distinctive nature of Bramante's financial profile was reinforced by the additional claim that it was "almost against the will of the same Bramante, under threat of sacred obedience" that Julius II made the architect rich by benefices and offices of the highest annual stipend which far exceeded his own needs and those of his servants.[27] In his biography of Michelangelo, Ascanio Condivi pronounced concerning the same aspect of Bramante's character, but without the mitigating cloak of paradox: "everyone knew that Bramante was given to every sort of pleasure and a great spender." He continued in a defamatory vein, asserting how the rich remuneration Bramante received from the Pope was insufficient to support his lifestyle and that he skimped on the materials employed in his buildings, in this way explaining their structural flaws.[28] The paradoxical ideas emerging from these sources of Bramante's learned ignorance and what might be called his penurious profligacy are best viewed as attempts to convey the underpinnings of the identity Bramante himself promoted, involving his command of higher sources of knowledge and detachment from mundane concerns.[29] Nowhere is Bramante's philosophical persona more evident in Vasari's Life than in the famous tale concerning the Vatican hieroglyphs. In the 1568 edition of the *Lives*, Vasari reports that Bramante wished to demonstrate his ingenuity by developing for the facade of the Belvedere a pictographic inscription in the guise of ancient hieroglyphs to represent the name of the Pope along with his own.[30] He describes a rebus of the sort that, along with related visual and literary enigmas, enjoyed considerable popularity during the Renaissance; Leonardo himself explored the form.[31] The Pope's name was expressed by an image of Julius Caesar and a bridge with two arches, followed by the obelisk in the Circus Maximus, to produce "Julius II Pontifex Maximus." Unfortunately, the idea for Bramante's own name goes unrecorded. Julius rejected the proposal, which he called a *scioccheria*, in favor of the handsome classical lettering we see each time we enter the Cortile on the way to the Vatican library (fig. 7). An echo of the rebus—or, perhaps Vasari's inspiration for the tale—is preserved in the inscription as executed where the words *Pont(ifex) Max(imus)*, rather than the name of the Pope as might be expected, appear on the frieze of the projecting, rusticated portal. The arch of the portal thus functions as the visual counterpart to the text, which honors the Pope as "Supreme Bridge Builder," a title originally employed by the ancient emperor in his role as high priest of the state religion.

As suggested long ago by Ernst Gombrich, who took Vasari at his word, one source for the

tale might have been the classical romance, the *Hypnerotomachia Poliphili* (Venice, 1499), where the name and titulature of Julius Caesar appeared in a rebus-like image.[32] Vasari supplied his own footnote to the idea by reporting that Julius had identified Bramante's model for the proposed inscription in a relief in Viterbo created by an architect called Francesco. It consisted of an image of St. Francis, along with an arch (*arco*), a roof (*tetto*), and a tower (*torre*), to form the signature, *Maestro Francesco architetto*. Some years ago a relief responding to this description was discovered where Vasari said it was, and even though it may postdate Bramante's lifetime, its existence reveals something of the method he followed in developing his theme.[33] As Gombrich also noted, in one place only do

FIG. 7  Bramante, entrance to the Belvedere courtyard.

all the components of Vasari's story come together, and that is with the Vatican obelisk. Since Pope Nicholas V had introduced the idea in the mid-fifteenth century, the dream of moving the obelisk from the south flank of the basilica, the position it had occupied since antiquity, to the piazza fronting the church where it could proclaim the triumph of Christianity, was periodically revived, but achieved only in 1586 during the reign of Pope Sixtus V. Egidio da Viterbo, a member of Julius II's inner circle, records how during the planning of new St. Peter's, Bramante suggested that the church be rebuilt with its facade rotated ninety degrees to the south in order to align the entrance with the obelisk, which could remain in its original position.[34] The Pope rejected the proposal, vehemently disapproving of moving the tomb of Peter that the plan would have entailed. Egidio's account indicates that the obelisk was of some concern at that time, and Vasari may have developed his story of the hieroglyphic inscription by transposing information concerning it to the Cortile.

With the obelisk, the underlying link between Julius and the hieroglyphs becomes clear since the gilded bronze globe that surmounted the shaft was traditionally thought to contain the ashes of the Pope's ancient namesake and alter ego, Julius Caesar. What is more, Bramante's rebus would have found a receptive surface on that noble shaft since the Vatican obelisk is distinguished from so many of its brethren by the lack of hieroglyphs.[35] Mindful that the history of Egypt was intricately linked to the fortunes of God's Chosen People and to the millennial progress of the Christian Church, Vasari's purpose in developing the story of the hieroglyphs, which may indeed be true, went beyond simple praise for Bramante's ingenuity. In effect, Vasari credited Bramante with employing the sacred language of Egyptian revelation to commemorate the great achievements of patron and architect who together revitalized the center of Petrine

FIG. 8 Vasari, Santa Maria dell'Umilità, Pistoia, dome.

power at the Vatican. It cannot be coincidental that Vasari follows the story of the Julian hieroglyphs with Bramante's elevation as keeper of the papal seal.

We are now in a position to appreciate more fully why Vasari identified Bramante as the founding architect of the Third Age. Bramante's activities in life, as in art, were based on antique precedent only in part; the other component was spiritual and together the two permitted him to usher in a new age of Christian architecture. Bramante's achievement in revitalizing sacred architecture, and in this way promoting papal authority, would have been especially potent during the years Vasari was occupied first with writing and then reworking the *Lives*, the same years that Church reform was being pursued at the Council of Trent and construction of St. Peter's was moving forward under the energetic leadership of Michelangelo. It would be incorrect, however, to view Vasari's vision of Bramante purely in terms of ideas surfacing long after the architect's own lifetime. In fundamental ways, the themes promoted in the Life are adumbrated by Bramante's own portrait medal (figs. 3, 4). The obverse presents the architect in a striking antique mode (in profile, nude, the arm truncated below the shoulder to suggest a sculptural fragment) with his name and city of origin featured in classical letters, BRAMANTES ASDRVVALDINUS. The letters do not face inward, as is common on Renaissance medals, but outward in the manner of some ancient coins, those of Julius Caesar among them.[36] The image on the reverse complements the obverse, referring to Bramante's role as Christian architect. The female figure sports a high, peaked crown and is garbed in fluttering drapery, suggesting spiritual animation. She sits upon the curule chair of the Roman magistrate, one foot raised on a large plumb bob and firmly wields the tools of the profession of architecture, the measuring rod planted firmly in the earth and the compass, toward which she gazes, held aloft. New St. Peter's appears in diminished scale as if located in the distant background, drawn into primary position through the streaming drapery of the sibylline figure. The embracing legend—*Fidelitas Labor*—now seen right side up, assumes the role of a motto, conveying the mix of spiritual and earthly principles expressed by the personification and epitomizing Bramante's majestic achievement.[37] The dual personas of classical hero and Christian sage purposefully knit together on the obverse and reverse of the medal are precisely those resonating throughout Vasari's Life of Bramante. In composing his biography, Vasari carefully worked through the literary and visual evidence and then, as he did when creating one of his iconographically charged paintings, plaited the individual strands to produce a compelling

image. We can observe his method at close range by comparing the conclusions appearing in the two editions of the Life. In 1550, Vasari reports that when Bramante died at age seventy in 1514, he received a state funeral attended by the papal court and all the sculptors, architects, and painters. It is further claimed that Bramante was buried in St. Peter's, and his tomb was adorned with an epitaph suggesting that he had outshone even Dinocrates, that most ambitious of architects whom Alexander the Great had chosen to build his eponymous city, the greatest in the ancient world. The funeral rites, the place of burial, and even the antique reference recall Brunelleschi who Vasari records was buried with the most honorable obsequies and distinctions in his own masterpiece, the cathedral of Florence. In the amplified, and further orchestrated, second edition of the Life, Vasari preserved Bramante's burial in St. Peter's, but in place of the apocryphal epitaph he added a detailed account of the history of the church of the Madonna dell'Umiltà in Pistoia.[38] In his view, the church was begun by Ventura Vitoni, a carpenter of *bonissimo ingegno* who had worked with Bramante. Vitoni died before completing the dome, and since no one knew how to resolve certain structural problems owed to the architect's inexperience in working on so grand a scale, construction was suspended. In 1561, Vasari was called upon by Duke Cosimo I de' Medici to assess the situation and to develop a solution, which he did forthwith. At the time he was engaged on the second edition of the *Lives*, the dome of the church was being raised (fig. 8). What at first appears as a self-serving interpolation to the text assumes greater significance when we recall that in its ogival profile and double-shell construction Vasari's Pistoia dome was based on Florence's cathedral. The parallel between the two projects includes the dedication of the churches to the Virgin and extends to the twin stages by which their grand design was realized. Brunelleschi had realized the promise of Arnolfo's project for the cathedral by completing the dome which was its most challenging feature. Vasari achieved something similar by resuscitating a structure long abandoned, and by rectifying the flaws that had prevented construction of its dome.

This new ending to the Life parallels that of 1550 in its allusion to Brunelleschi, now depending on the reader's knowledge of art historical material including visual and technical elements. Only if these are understood do we realize how Vasari has deftly inscribed himself in the same family of architects he had associated with Bramante, one leading back to Brunelleschi, to Arnolfo and beyond. It was only through Vitoni, however, that he was able to assert a direct, tangible link between himself and Bramante, and thus, to those intellectual and spiritual qualities defining the Modern Age.

NOTES

* A lively dialogue with the participants of "Reading Vasari" was essential in developing my contribution for publication. My foremost debt is to Debra Pincus for assistance in sharpening the argument. For their generous help, I also thank Franco Di Fazio, David Friedman, Jean Hudson, Ralph Lieberman, Eleonora Luciano, Michael Mezzatesta, Luke Syson, Marie Tanner, and Shelley Zuraw.

1. Paul Barolsky, Giotto's Father and the Family of Vasari's Lives (University Park, PA, 1992), 11–13. Vasari"s biography of Bramante has been discussed by Stefano Borsi, "La vita di Bramante di Giorgio Vasari," in idem, Bramante e Urbino, il problema della formazione (Rome, 1997), 130–56. See also Franz Graf Wolff Metternich, "Bramante, Skizze eines Lebensbildes," Römische Quartalschrift 63 (1968): 1–28, revised version in idem, Bramante und St. Peter (Munich, 1975), 179–221; Dizionario biografico degli italiani (Rome, 1960-), 13:712–25 (entry by Arnaldo Bruschi); and Arnaldo Bruschi, "Identità di Bramante '. . . al mondo huom singulare . . .,'" in Donato Bramante, ricerche, proposte, riletture, ed. Francesco Paolo di Teodoro (Urbino, 2001), 7–18.

2. Concerning the significance of Rome for Vasari, see Borsi, "Vita di Bramante," 136–37. Bramante's testimony is conveyed in a letter Guglielmo della Porta wrote to Bartolomeo Ammanati ca. 1560; see Carlo Pedretti, Leonardo architetto (Milan, 1978), 116; and Pietro C. Marani, "Tivoli, Hadrian and Antinoös: New Evidence of Leonardo's Relation to the Antique," Achademia Leonardi Vinci 8 (1995): 209–10.

3. Brunelleschi's study of ancient architecture in Rome was introduced in a biography written ca. 1480; Antonio di Tuccio Manetti, The Life of Brunelleschi, ed. Howard Saalman, trans. Catherine Enggass (University Park, PA and London, 1970), 50–55.

4. Concerning the Antiquarie and its attribution, see Franco Borsi, Bramante (Milan, 1989), 260–63, cat. no. 22 (entry by Stefano Borsi); and Giovanni Agosti, "Sul gusto per l'antico a Milano, tra regime Sforzesco e dominazione francese," Prospettiva 49 (1987): 33–46. An attribution of the text to Bramantino has been persuasively argued by Charles Robertson, "Bramantino: Prospectivo Melanese Depictore," in Giovanni Antonio Amadeo: Scultura e architettura del suo tempo, eds. J. Shell and L. Castelfranchi (Milan, 1993), 377–91; and Enrico Guidoni, "L'autore e la data delle Antiquarie prospettiche romane: Bartolomeo Suardi detto il Bramantino," L'Urbe, 3d ser., 59 (1999): 7–19.

5. Ingrid D. Rowland, The Culture of the High Renaissance: Ancients and Moderns in Sixteenth-Century Rome (Cambridge, 1998), 105–08, where the text is also attributed to Bramante.

6. Only one of the early Roman projects Vasari mentioned (the cloister of Santa Maria della Pace) is supported by documents of 1500, proving that at least by then Bramante was in Rome.

7. Borsi, "Vita di Bramante," 140, notes the measured way Vasari handled the issue in his biography of Bramante, even when he increased his criticisms of the architect in the 1568 edition of the Life of Michelangelo. Further to Vasari"s treatment of the relationship between Bramante and Michelangelo, see Charles Robertson, "Bramante, Michelangelo and the Sixtine Ceiling," Journal of the Warburg and Courtauld Institutes 49 (1986): 91–105.

8. See James S. Ackerman, "Notes on Bramante's Bad Reputation," in Studi bramanteschi (Rome, 1974), 339–49; and Borsi, Bramante, 25–32. The claim of misappropriated funds was made by Ascanio Condivi, for which see below.

9. See Federico Patetta, "La figura del Bramante e alcuni riflessi di vita romana dei suoi tempi nel Simia' d'Andrea Guarna," in Atti della Reale Accademia d'Italia, memorie della classee di scienze morali e storiche, Ser. 7, 4, fasc. 7 (1943): 195–96. The passage has been discussed by Carlo Vecce, ed., Donato Bramante, sonetti e altri scritti (Rome, 1995), 23.

10. The wood-cuts have been collected and their visual sources discussed by Wolfram Prinz, "Vasaris Sammlung von Künstlerbildnissen, mit einem kritischen Verzeichnis der 144 Vitenbildnisse in der zweiten Ausgabe der Lebensbeschreibungen von 1568," Mitteilungen des Kunsthistorischen Institutes in Florenz, Supp. to vol. 12 (Florence, 1966). Wolff Metternich, Bramante, 185, offered a sensitive discussion of Vasari's portrait of Bramante and its visual models.

11. The attribution of the medal to Bramante was proposed by Luke Syson in The Currency of Fame: Portrait Medals of the Renaissance, ed. Stephen K. Scher (New York, 1994), 112–15, in part based on a new reading of Vasari"s text. See also Joanna Woods-Marsden, Renaissance Self-Portraiture: The Visual Construction of Identity and the Social Status of the Artist (New Haven and London, 1998), 99–102; The Renaissance from Brunelleschi to Michelangelo: The Representation of Architecture, eds. H. Millon and V. Magnago Lampugnani (Milan, 1994), 602–03, no. 285 (entry by Christoph L. Frommel); Wolff Metternich, Bramante, 189; and G. F. Hill, A Corpus of the Italian Medals of the Renaissance before Cellini, 2 vols. (London, 1930), no. 657.

12. Vasari identified Raphael's geometer as a portrait of Bramante in both the Life of Bramante and that of Raphael. Vasari may have been inspired to draw this

connection by similarities between Raphael's image and the figure of Mr. Perspective cited earlier, first proposed by Doris D. Fienga, "Bramante autore delle 'Antiquarie prospettiche romane,' poemetto dedicato a Leonardo da Vinci," in *Studi bramanteschi* (Rome, 1974), 417–26; and also by Rowland, *Culture*, 105–08. Other presumed portraits of Bramante are discussed by Wolff Metternich, *Bramante*, 185–87, 195–97; Robertson, "Bramante, Michelangelo," 105; and Charles Roberton, "Bramante and Gian Giacomo Trivulzio," in *Bramante milanese e l'architettura del Rinascimento lombardo*, eds. Christoph L. Frommel, Luisa Giordano, Richard Schofield (Venice, 2002), 78–81.

13. Wolff Metternich, *Bramante*, 185, 195, first noted that Vasari's portrait of Bramante as a monk was related to his nomination to the office of *bullator papale* and membership in the Cistercian order, and he provided reference to the relevant documentation. Bramante is also named in construction documents for Saint Peter's as "frate Bramante"; Bruschi, in *Dizionario biografico degli italiani*, 13:721.

14. Nicholas Adams, "New Information about the Screw Press as a Device for Minting Coins: Bramante, Cellini and Baldassare Peruzzi," *Museum Notes* (The American Numismatic Society) 23 (1978): 201–06.

15. The nickname was also adopted by Bramante's younger brother, Antonio, and his descendants; Fert Sangiorgi, *Bramante 'hastrubaldino': Documenti per una biografia bramantesca* (Urbino, 1970), vi–viii, 37–47.

16. The Arthurian association of the name was suggested by Sangiorgi, *Bramante*, 45–46, n. 73.

17. For the poems written in Milan ridiculing Bramante with reference to his name, see Vecce, ed., *Bramante*, 18–19.

18. The poems were part of a larger literary output, now lost; see Bruschi, "Identità di Bramante," 11. The only surviving example of Bramante's technical writing is the *Opinio* of 1488 concerning the *tiburio* of Milan Duomo, published in Vecce, ed., *Bramante*, 11–12, 58–63.

19. The improvisational nature of some of Bramante's poems is discussed by Vecce, ed., *Bramante*, 20–21; and Richard V. Schofield, "Gaspare Visconti, mecenate del Bramante," in *Arte, committenza ed economia a Roma e nelle corti del Rinascimento (1420–1530)*, eds. Arnold Esch and Christoph Luitpold Frommel (Turin, 1995), 311. Rowland, *Culture*, 96–97, has proposed a link to the tradition of *strombotti*.

20. See the edition of the poems by Vecce, ed., *Bramante*. The content and context of the poems have been discussed by Carlo Bertelli, "Architecto doctissimo," in *Bramante e la sua cerchia a Milano e in Lombardia 1480–1500*, ed. Luciano Patetta (Milan,

2001), 67–75; and Luciano Patetta, "Bramante autore di sonnette burleschi," in *idem*, 77–81. Bramante"s relationship to Visconti is the subject of a masterful study by Schofield, "Gaspare Visconti," 297–324.

21. The sources referring to Bramante's illiteracy were first collected and discussed by Heinrich von Geymüller, *Les projets primitifs pour la basilique de Saint-Pierre de Rome. . .*, 2 vols. (Vienna–Paris, 1875–80), 1: 21–22; see also Sangiorgi, *Bramante*, 3–5; and Wolff Metternich, *Bramante*, 194–95.

22. Sabba da Castiglione, *Ricordi overo ammasestramenti nei quali con prudenti & christiani discorsi si ragiona di tutte le materie honorate, che si ricercano ad un vero gentilhuomo* (Venice, 1569) [first ed., 1549], 139r (Ricordo CX, "Cerca il creare de i figliuoli"). Sabba was born in Milan in 1480 and lived in Rome from 1507 until around 1514. For details of his life and the publication history of the *Ricordi*, see *Dizionario biografico degli italiani* (Rome, 1960–), 22:100–06 (entry by F. Petrucci); and see also Wolff Metternich, *Bramante*, 183, 209.

23. On this issue, see Wolff Metternich, *Bramante*, 197; and Paul Maria Baumgarten, *Aus Kanzlei und Kammer, Erörterungen zur kurialen Hof- und Verwaltungsgeschichte im XIII. XIV. und XV. Jahrhundert* (Freiburg in Breisgau, 1907), 8.

24. For the meaning of not knowing "letters," see Wolff Metternich, *Bramante*, 211; and Rowland, *Culture*, 158.

25. Bramante"s jocularity was addressed by Andrea Guarna; see Patetta, "La figura di Bramante," 190. Other sources possibly known to Vasari record that Bramante commanded a profound knowledge of Dante; see Wolff Metternich, *Bramante*, 212–14; Sangiorgi, *Bramante*, 5; and Robertson, "Bramante, Michelangelo," 100.

26. "Sempre splendidissimamente si onorò e visse, ed al grado dove i meriti della sua vita l'avevano posto, era niente quel che aveva a petto a quello che egli avrebbe speso." Vasari–Milanesi, 4: 164.

27. "Questo sufferse longissimamente la paupertate spreciandola anchora piu con la sua prudentissima liberalita: Tandem Iulio summo Pontifice per singulare amore gli portaua: quasi contra la uoglia di epso Bramante soto pena di sancta ubedientia: lo fece richo & gli dono beneficii & officii de maxime pensione annuaria piu che non bisognaua asai a la sua decente uita & uestimenti: per epso & suoi serui." Cesare Cesariano, ed. and trans., *Di Lucio Vitruvio Pollione De architectura libri dece. . .* (Como, 1521), fol. LXX verso. This text was repeated with modifications by Giovanni Battista Caporali, ed. and trans., *Architettura con il suo comento et figure, Vetruvio in volgar lingua . . .* (Perugia, 1536), fol. CII recto. Both passages are quoted in Förster, *Bramante*, 288, 290.

28. Condivi is explaining how Bramante turned Julius II's mind from the grand scheme for the pope's tomb: "Stimolava Bramante, oltre all'invidia, il timore che aveva del giudicio di Michelangnolo, il quale molti suoi errori scopriva; perciochè, essendo Bramante, come ognun sa, dato ad ogni sorte di piacere e largo spenditore, né bastandogli la provision datagli dal papa, quantunque ricca fusse, cercava d'avanzare nelle sue opere facendo le muraglie di cattiva materia e alla grandezza e vastità loro poco ferme e sicure." Ascanio Condivi, *Vita di Michelangnolo Buonarroti*, ed. Giovanni Nencioni (Florence, 1998), 24. See the comments in Ackerman, "Bramante"s Bad Reputation," 344.

29. In 1517 Andrea Guarna identified Bramante as a follower of Epicurus, thus imparting to his behavior a philosophical character that deserves serious attention; see Vecce, ed., *Bramante*, 23; and Bruschi, "Identità di Bramante," 17. For Bramante's apparently complicated relationship to money, see Schofield, "Gaspare Visconti," 297–324.

30. "Entrò Bramante in capriccio di fare in Belvedere in un fregio nella facciata di fuori alcune lettere a guisa di ieroglifi antichi, per dimostrare maggiormente l'ingegno ch'aveva, e per mettere il nome di quel pontefice e 'l suo [nome] . . . ,"; Vasari–Milanesi, 4: 158. For a discussion of this episode, see Rowland, *Culture*, 174–75.

31. See Carlo Vecce, "La parola e l'icona: Dai rebus di Leonardo ai 'fermagli' di Fabricio Luna," *Achademia Leonardi Vinci* 8 (1995): 173–83; idem, "Leonardo e il gioco," in *Passare il tempo, la letteratura del gioco e dell'intrattenimento dal XII al XVI secolo*, 2 vols. (Rome, 1993), 2:269–312; esp. 280–86; and see also the note by Carlo Pedretti, "Tomi," in *ibid.*, 2:313–16; and Augusto Marinoni, *Leonardo da Vinci, Rebus* (Milan, 1983). Bramante"s own literary enigma has been treated by

Dawson Kiang, "The 'Enigma of the Dice: A Bramante Sonnet Published by Lomazzo," *Achademia Leonardi Vinci* 4 (1991): 196–99.

32. Ernst Gombrich, "Hypnerotomachiana," in *Symbolic Images, Studies in the Art of the Renaissance* (London, 1972), 102–08. See also Stefano Borsi, *Polifilo architetto, cultura architettonica e teoria artistica nell' Hypnerotomachia Poliphili di Francesco Colonna (1499)* (Rome, 1995), 224–28. Bruschi, "Identità di Bramante," 11, suggested that the publication of the *Hieroglyphica* of Horapollo in 1505 was influential as well.

33. Enzo Bentivoglio, "Bramante e il geroglifico di Viterbo," *Mitteilungen des Kunsthistorischen Institutes in Florenz* 16 (1972): 167–74.

34. For the Latin text and an English translation of Egidio's text, see Rowland, *Culture*, 172–73.

35. Concerning this obelisk, see most recently Brian Curan and Anthony Grafton, "A Fifteenth-Century Site Report on the Vatican Obelisk," *Journal of the Warburg and Courtauld Institutes* 58 (1995): 234–48.

36. Syson in *Currency of Fame*, 115, was the first to link this feature to ancient models, citing coins of Tiberius, but it occurs on Republican coins and those of Augustus as well.

37. For the concept of *labor*, see Kristina Herrmann-Fiore, "Il tema 'Labor' nella creazione artistica del Rinascimento," in *Der Künstler über sich in seinem Werk*, ed. Matthias Winner (Weinheim, 1992), 245–92.

38. The church was begun in 1495, based on a design by Giuliano da Sangallo; construction was supervised by Vitoni until his death in 1522; Leon Satkowski, *Giorgio Vasari, Architect and Courtier* (Princeton, 1993), 61–66.

# A Scene from the Life of Peruzzi

RALPH LIEBERMAN

Last winter, a student I know was trying to work his way through the versions of Vasari's Life of Michelangelo and growing frustrated. The description of the Bruges *Madonna* was the last straw. "Vasari was a dork," he declared, and the *Vite* "useless." I responded by telling him that rude remarks would not do in civilized discourse, but worse, were off the mark, and I urged him to be more attentive to the spirit of the text than its letter. Never one to miss the opportunity to employ a cliché, I added that he was throwing the baby out with the bath water, concentrating only on the errors and not the vast body of fact and anecdote Vasari had, if not under his rigid command, at least under some sort of control.

Then I went on to mount a favorite hobby horse of mine and suggested that although there are certainly puzzling errors in the *Lives*, they often relate to something factual, and if studied in a thoughtful manner rather than being dismissed as mere foolishness, Vasari's mistakes can sometimes lead to worthwhile insights. At the very least, they reveal that while he may have been wrong, he was thinking, and we can see how he was trying to understand things.

The young man challenged me, wanting to know what we can learn from the muddle over the Bruges *Madonna* and what it shows about Vasari's thought. Condivi, you will recall, said the piece was bronze,[1] and Vasari, who hadn't seen it either, compounded the error by saying it was a roundel.[2]

"Well," I replied, "Vasari knew that all the other sculpted and painted Virgin and Child compositions of the period when the Bruges *Madonna* was made were tondi. And there would have been nothing in itself unlikely about a bronze roundel, for Vasari knew that Michelangelo had planned round bronze plaques as inserts for the San Lorenzo façade, and had painted fictive ones on the Sistine ceiling. So when he learned from Condivi that Michelangelo had made a bronze Virgin and Child, Vasari concluded that it ought to be a roundel, and said so. He was wrong, but he was by no means thoughtless, and in fact, given what we know of the period, he turns out to have been in some ways more reasonable than Condivi; if Michelangelo had made a bronze *Virgin and Child* in those years it probably would have been a tondo."

I'm sorry to report that the kid was unconvinced, insisting that as the Bruges *Madonna* is marble not bronze, Condivi was only wrong once, while Vasari, who puts down Condivi as an ignoramus was, when saying it is a roundel, mistaken twice, and by any way of reckoning, that is more.

I remain persuaded, however, that one should now and then look up from the bottom-line

147

tally of correct answers; to skip over the errors in Vasari, rather than ponder them, is to close oneself off from interesting things and the opportunity to understand him better.

It is worth bearing in mind that the 1568 edition of the *Lives* was the biggest book of its kind ever written. Even excluding those sections written by others it is still almost as long as the Bible, remarkable for a full-time painter/architect to have written in the evenings and on weekends. Vasari wrote quickly: the first edition, at 290,000 words, appears to have been produced in a year, working at a speed between ten and twenty times faster than Bellori or Cellini.[3] Although when reading both editions of the book, we can sometimes get the impression that Vasari wrote rather than looked, obviously he did look at lots of things, often quite intelligently, and usually wrote of them eloquently. He did some reading too, but his major source of information must have been by talking to people, gathering anecdotes and gossip. He talked to collectors and visited them to see what they had, and as he himself collected drawings there must have been some common ground. If an artist had recently died, he must have talked to their families, to people who worked in their shops, and probably to their patrons as well.

We have no surviving interview notes to guide us in our search for what Vasari may have been told, but in one case I think we can reconstruct what he heard, and when, and work out how and why he misunderstood it, leading him to one of his famous, and characteristic, mistakes.

In September of 1513, a few months after his election to the throne of Peter as Leo X, Giovanni de' Medici asked the city government to confer full Roman citizenship on his two closest relatives: his younger brother Giuliano and his nephew Lorenzo—the son of his deceased older brother Piero. In life, and then in death, these two short-lived princes, neither of whom survived Leo X, were well looked after by the first Medici popes; after Leo had them made citizens of Rome, Clement VII had their tombs carved in a new chapel in the family church back home.

The ceremonies and celebrations to mark their citizenship took place over two days in a large, lavish temporary building erected for the occasion on the Capitoline: a combination theater and banqueting hall. Snippets of information about the theater are spread among several different places. The visual evidence is scanty, and consists mostly of a plan, carefully labeled but not entirely accurate, in the Codex Coner.[4] We are much more fortunate with literary testimony.

The chief sources for our knowledge of the event and the building that housed it are two detailed reports written by people who were there,[5] and on the basis of them it is possible to reconstruct the major elements of the theater. In the second edition of *Le Vite* Vasari describes the event and the theater in the Life of Peruzzi.[6] He seems to have known neither of the texts that deal with it, so his account was probably based on hearsay. He tells us that Baldassare painted a panel with a scene of Tarpeia betraying the Romans, which was regarded as the best of all the pictures made for the theater. Tarpeia, the avaricious daughter of the keeper of the Roman citadel, had agreed to open the gates to the Sabine army if each soldier who entered would give her what he wore on his left arm, by which she meant their gold bracelets. When the Sabines entered they honored their pledge, at least the letter of it, by throwing at the traitress the other things they wore on their left arms—their shields—and she was crushed to death by the accumulated weight.[7] The scene was chosen because the event took place quite close to the site of the theater, and Tarpeia gave her name to the rock on the Capitoline from which Roman traitors were hurled as execution for their crimes.

Vasari tells us that Peruzzi's picture of Tarpeia was 7 *canne* high, which would be huge; a *canna*, literally a cane—the word was used in Renaissance Italian as "rod" used to be used in English—was roughly equal to 3.8 Florentine *braccia*, and so about 2 ¼ meters, a little more than 7 feet 3 inches, so Vasari puts the picture at 50 feet. Working out the dimensions of the theater from the descriptions suggests that the painted panels were placed in an arch in fact not more than about 3 *canne*, 22 feet, high and the panels may not have filled the entire arch. Nonetheless they were probably better than 16 feet high; still tall, if not the size Vasari reports.

Vasari does not mention anybody else who contributed scenes for the theater decoration, but from a third contemporary source, a long Latin poem about the event by one Aurelio Sereno, we hear of another artist who was involved. It seems that a Giovanni Battista Parmense worked for three months on a painting that was ruined, Sereno says, "in only an hour" by the great number of spectators who, unable to get into the theater, climbed on the exterior and "cut holes, almost windows" in the painting in order to gain a view of the performance inside.[8]

Peruzzi is not named by Vasari as the architect of the theater, and he was not; we know from Altieri's account of the festivities and the theater that it was designed by a chap the author calls Pietro Posselli, otherwise entirely unknown.[9] It has been suggested that Posselli, an unusual name, is a slip of the pen for Rosselli,[10] but that doesn't help much. We know nothing about the designer, but it is interesting that the descriptions of the exterior suggest something very close to the loggia that Falconetto built for Alvise Cornaro in the garden of his house in Padua in 1524.[11] Falconetto may well have been in Rome at the time of the conferral of citizenship on the papal kin, and would seem to have made or seen drawings that he put to good use over a decade later.[12]

After mentioning the great success of Peruzzi's *Tarpeia Killed by the Sabines*, Vasari goes on to say "Ma quello che fece stupire ognuno" ("But what really knocked everybody's socks off") was the stage set or scenery for a play, so beautiful that it is impossible to imagine anything more so, and so much variety and style was to be seen in the loggias, windows and doors of the architecture "that it is not possible to describe even a thousandth part of it."[13]

Very exciting it sounds, but alas the Capitoline theater never contained such a thing. The contemporary accounts of the theater are unambiguous in their description of the stage as the type made in imitation of the *scenae frons* of ancient Roman theaters that were, and still are, to be seen in various parts of the empire.

So it is clear that Vasari gave to history a breathless account of a fabulous perspective stage that sounds convincing but turns out to be a generic fantasy. That is not surprising if we bear in mind that Peruzzi was known by Vasari to have been an expert at illusionistic perspective painting; the artist's *trompe l'oeuil* frescoes in the Farnesina are accurately described in the *vita*, and Vasari goes so far as to tell us that when he took Titian to see them, the great Venetian could not believe they were fictive.[14] Furthermore, in the first edition Vasari describes with great enthusiasm a perspective stage Peruzzi made in the time of Pope Leo for a performance of Cardinal Bibbiena's *Calandria* on the Campidoglio,[15] but does not connect it with the theater for the Medici princes. Nor does he mention the painting of Giulia Tarpeia in the first edition.

I am not always sure how to account for the differences between the two editions of the *Lives*; in some cases Vasari probably included in the 1568 edition information he had obtained

by 1550 but had no room for, but in others he must have added new material that had come to his attention in the meantime. He would have continued to talk to people, but he must also have been inundated with suggestions and corrections; all of us know there is nothing like a publication to bring out of the woodwork all sorts of people who tell you where you went wrong and what you ought to have said, and Vasari was probably no exception.

Whether that earlier description of a stage set for Leo X was accurate in its details is impossible to say, but it seems that between the two editions he was told something new. Nonetheless, when he discusses the perspective stage of the Capitoline theater in the second edition, it is certain that he is talking about what had never existed.

While some folks take a dismissive attitude toward Vasari, there are many scholars who prefer to tie themselves in knots trying to preserve his accounts. In the case before us, this effort has been made in several different ways. One was by the suggestion that while the theater itself was built with a *scenae frons* stage, Vasari could be describing a removable set, either simply painted or perhaps constructed in foreshortened architecture, that would have been set up for one of the plays.[16] Several factors mitigate against this notion. In the first place, with a perfectly good, classically accurate and appropriate stage already built in the theater, it would have been extremely odd had another one been put up in front of it. But more telling is the fact that nowhere in any of the descriptions of the theater, or of the banquet and performances in it, which are complete down to lists of courses served, is there mention of such a stage.

It might be that Vasari was referring to a curtain, painted by Peruzzi with a perspective scene and hung in front of the arcades on the end of the theater opposite the entrance, but there is no mention of anything like this either, and when he describes the interior Palliolo, the most complete of the authors, goes directly from a discussion of the two columns that flanked the entrance to a description of the "fronte della scena," giving the distinct impression that the first thing one saw on passing though the entrance arch was the glittering five-bay stage.[17] So a curtain painted with a great perspective scene too seems highly improbable.

And finally, the argument has been made that, rather than being mistaken about a perspective stage in the Capitoline theater, Vasari was actually describing two different theaters. In this view, he is seen as having intended no connection between the Capitoline theater for which Peruzzi painted the picture of Tarpeia and what is described in the sentence which begins "Ma quello che fece stupire ognuno ...." This claim has been made tacitly, by breaking the passage up and, while not quoting the first part, using the second part as a description of a performance of *Calandria* put on for Leo X some years after the 1513 event.[18] This interpretation takes advantage of the fact that the account in Vasari's second sentence is not site-specific, and it is based on the assumption that we need only find a documented production and apply the description to it to give the passage historical accuracy. In this reading the description of the perspective stage that is said not to have been in the Capitoline theater is seen as an expansion of the description in the first edition of the theater Peruzzi did on the Capitoline later on in the reign of Pope Leo. But the problem with this reading is that the sentences in Vasari are sequential, and from the point of view of their literary style they belong together. He first describes something of Peruzzi's that he considers very good—the painting of Tarpeia—and then climaxes his account with something that he considers stupendous: the stage set. It seems certain that this

connection was intentional, and that he thought both works he was describing went together.

At this point we could stop, as have many students of Renaissance theater, and write off Vasari's mention of the stage as another example of his letting his imaginative enthusiasm run away with him. In doing this, we see him as a kind of Pavlovian dog, so conditioned to respond that while considering Peruzzi he heard "theater" and salivated, writing a description of a marvelous perspective stage. Because he respected Peruzzi's talents as an illusionistic designer, and expected to see them applied in every theater with which Peruzzi was ever connected, whether as architect or not, Vasari mistakenly put a perspective stage on the Capitoline. This is not unreasonable, but I think there is a better way to understand his error than just as the result of inappropriate, albeit sincere and respectful, reflex.

We know from the descriptions of the theater that there were pictures on the interior as well as the outside, and among them was one that showed a large theater crowded with spectators, and with actors and mime artists on the stage who seemed to be delighting with their gestures and words the people who watched them. It was suggested many years ago, by Hubert Janitschek, that Vasari's description in the "Ma quello che fece stupire ognuno" passage was of this picture.[19] But the case is more intriguing and instructive than that, and here it is important to consider the nature of the theater and the location of the pictures.

One aspect of the Capitoline theater that impressed people at the time was that the large building was put up quickly. Yet we have already seen that according to one account Giovanni Battista Parmense spent three months working on his panel. Even making allowance for rhetorical overstatement of the time it took him to do the work in the lament over the damage to it, we are on safe ground concluding that the painting was made before the theater went up. There would not have been time to decorate from scratch the lavish building, over a hundred feet long, in the few days it took to erect it. That means it must have been prefabricated, and designed so that its constituent parts, of light construction, allowed for quick assembly. The chief risk was rain, and while late summer weather in Rome is likely to be temperate, taking even a few weeks to put up a theater that was only roofed with colored cloth, and installing all the pictures in it, would have been asking for trouble.

A pre-fab building of the sort the descriptions suggest would have required a skeleton of piers, arches, and entablatures, with panels filling the spaces between them to serve as walls. That the narrative paintings that filled the arches and closed the building were light in construction is clear from the fact that spectators easily cut large holes in at least one of them to peek inside.

In organizing the event, the people responsible would have hired an architect to make a design, working out the dimensions of the arcades. Then they lined up people to produce the pictures. Time must have been too short for all the historical narratives of the decoration to be assigned to a single artist, so the work was parceled out. The painters, Peruzzi among them, would have been given precise instructions about the subject, size and shape of their panels—perhaps they were even provided with blank panels or canvas already cut to the proper size— and then left to produce them by a given date. As the theater was decorated with pictures both inside and out, the most efficient way for it to be prefabricated would be by having a painter assigned a section of wall and painting both sides of it.

The major descriptions of the theater both list all the paintings both on exterior and interior, and it is not difficult to work out where they were. Palliolo always begins describing things from the right side, and the death of Tarpeia is the second façade picture he mentions.[20] Altieri always begins from the left, and the Tarpeia panel is the third he describes, which would put it in the bay to the right of the door, which had no picture in it to describe.[21]

Palliolo, the author who best describes the interior of the theater, does not say—as he tells us what is on the inner façade—that he is beginning on the right, as he did when dealing with the outside, but because he starts his descriptions of the exterior and the stage from the right, however, it seems fair to assume that when dealing with the inner façade he does so as well. In this part of his account we learn that the picture with the view of the theater performance was in the fourth section,[22] which would place it in the same bay as the picture of Tarpeia on the outer façade.

That Peruzzi drew the assignment to paint the panel that had a theater scene on the interior side might have been just coincidence, having no bearings on his skill at designing stage sets. It does, however, look as though Vasari heard that for the Capitoline theater Peruzzi painted the death of Tarpeia and a stage performance of a comedy, but understood what he had been told to mean that Peruzzi had painted a picture and designed the stage for a comedy.

Janitschek would have us believe that Vasari and the chronicler of the Capitoline theater are describing the same painting, but in the Vasari passage there is a distinct feeling of a large perspective illusion, and the whole account would seem misapplied if it is of just a picture of a crowded theater with performers delighting an audience. It is difficult to imagine that Vasari would have described the variety of loggias, bizarre windows, and doors—significant architectural features—in the enthusiastic manner he does, if he thought they were mere details of a picture of a performance. As he believed there had been a perspective stage he set out to describe it, and did so in a highly plausible way. He had certainly seen enough such stages in his day, and he also knew Peruzzi's drawings for stage sets, and for narrative paintings organized like theater productions, with a deep piazza behind the characters; in fact, Vasari owned such a drawing by Peruzzi.[23] In his mistaken impression that Peruzzi had designed a stage set rather than painting a picture of one, he resorted to stock exclamations and auto-pilot enthusiasm to describe it. Vasari is guilty of misinterpretation, not complete invention, but there is more here than pleading his mistake down to a lesser charge. Making an effort to understand it offers some insight into how an important bit of architectural ephemera was put together, what Vasari is likely to have heard, and how he misheard it. By no means should this be dismissed as an entirely useless error.

## NOTES

1. Ascanio Condivi, *The Life of Michelangelo*, translated by Alice Sedgwick Wohl, edited by Helmut Wohl, 2nd edition, 1999, 28.

2. Giorgio Vasari, *La vita di Michelangelo nelle redazioni del 1550 e del 1568*, ed. Paola Barocchi, 5 vols (Milan-Naples, 1962) I, 23.

2. Statistics courtesy of Charles Hope, to whom I am much obliged for them.

4. See Thomas Ashby, Jr., "Sixteenth-century drawings of Roman buildings attributed to Andreas Coner," *Papers of the British School at Rome*, II, 1904, 23 and pl. 23c.

5. The two texts, by Paolo Palliolo ("de Paulo Palliolo Fanese narratione delli spettacoli celebrati in Campidoglio da Romani nel ricevere lo Magnifico Juliano et Laurentio di Medici per suoi patritii") and Marcantonio Altieri ("Avviso di Marcantonio Altieri dato all'Illustre Signor Renzo di Cere intorno alla Civiltà, donata in persona del Magnifico Giuliano et alla case de Medici"), as well as a poem ("Teatrum Capitolinum Magnifico Iuliano institutem per Aurelio Serenum Monopolitanum") that also describes the theater, were collected by Fabrizio Cruciani, *Il Teatro del Campidoglio e le feste Romane del 1513, con la ricostruzione architettonica del teatro di Arnaldo Bruschi* (Milan, 1968).

6. *Le vite de' più eccelenti pittori, scultori, ed architetti scritte da Giorgio Vasari pittore aretino*, con nuove annotazioni e commenti di Gaetano Milanesi (Florence, 1906) IV, 595.

7. The story is told by Livy, *The History of Rome*, Book 7, section. 11: "Spurius Tarpeius was in command of the Roman citadel. Whilst his daughter had gone outside the fortifications to fetch water for some religious ceremonies, Tatius bribed her to admit his troops within the citadel. Once admitted, they crushed her to death beneath their shields, either that the citadel might appear to have been taken by assault, or that her example might be left as a warning that no faith should be kept with traitors. A further story runs that the Sabines were in the habit of wearing heavy gold armlets on their left arms and richly jewelled rings, and that the girl made them promise to give her 'what they had on their left arms,' accordingly they piled their shields upon her instead of golden gifts. Some say that in bargaining for what they had in their left hands, she expressly asked for their shields, and being suspected of wishing to betray them, fell a victim to her own bargain.": vol. I, Electronic Text Center, University of Virginia Library; http://etext.lib.virginia.edu/toc/mod-eng/public/Liv1His.html.

8. See Cruciani, *op. cit.*, 110 for Sereno's Latin text: 122 for an Italian translation.

9. In an edition of the Altieri account (M. Ant. Altieri, "Giuliano de' Medici eletto Cittadino Romano ovvero Il Natale di Roma," Rome, 1881, Loresto Pasqualucci wrote that after much research he could find no reference anywhere else to a Posselli (68–69, n. 22).

10. The suggestion that Posselli is more likely Rosselli was first made by O. Guerrini in an edition of the Palliolo account (Paolo Palliolo, "Le feste pel conferimento del patriziato Romano a Giuliano e Lorenzo de' Medici," Bologna, 1885, 146–47, n. 3). It was taken over by Cruciani, *op. cit.*, lvii and lxxxiii, n. 2.

11. See Giuseppe Fiocco, *Alvise Cornaro, il suo tempo e le sue opera* (Vicenza, 1965) pls. 28 & 29.

12. Ralph E. Lieberman, Studies in Early Sixteenth-century Italian Stage Design, unpublished M.A. thesis, Institute of Fine Arts, New York University, 1964, 14.

13. Vasari-Milanesi, *op. cit.*, IV, 595–96.

14. Vasari-Milanesi, *op. cit.*, IV, 593–94.

15. The reference to this production was preserved in the second edition, Vasari-Milanesi, *op. cit.*, IV, 600, but there it was not connected to a performance on the Campidoglio.

16. This is the view taken by Ashby in the corrections and additions to his original publication of the Codex Coner ("Addenda and Corrigenda to 'Sixteenth-century drawings of Roman buildings attributed to Andreas Coner, Papers of the British School at Rome, II,'") *Papers of the British School at Rome*, VI, 1913, 184–210.

17. One gets exactly the same impression from the Altieri account.

18. Licisco Magagnato, *Teatri Italiani del Cinquecento* (Venice, 1954) 36.

19. Hubert Janitschek, "Das Capitolinische Theater vom Jahre 1513," *Repertorium für Kunstwissenschaft*, V, 1882, 259–70, esp. 269.

20. Cruciani, *op. cit.*, 26.

21. Cruciani, *op. cit.*, 7.

22. Cruciani, *op. cit.*, 32.

23. An *Allegory of Mercury* now in the Cabinet des Dessins at the Louvre. See Licia Ragghianti Collobi, *Il Libro de' Disigni del Vasari*, 2 vols.(Florence, 1974) I, cat. no. 344; II, pl. 181.

# "If he, with his genius, had lived in Rome" Vasari and the Transformative Myth of Rome

MAUREEN PELTA

In an interview with novelist Penelope Fitzgerald conducted shortly before her death, *New Yorker* staff writer Joan Acocella asked: "Why do we bother to interview artists? Why expect them, in two hours, to tell us their story, or—what we're really looking for—a story that will dovetail with their work, explain it? The better the artist, the harder it is to produce such an accounting, for the life has been more fully transformed. Why violate their privacy, brush aside their years of work—the labor of creating stories that are not their story?"[1] Nonetheless, Acocella tries, gamely attempting to pinpoint those events or moments in the life of the artist that might serve to illuminate and broaden our understanding of that "art" thing, an experience we already perceive as beautiful or valuable, which gives us pleasure and which, in the end, stands alone. The temptation to uncover (or construct?) a definitive instant where life experience launches creative enterprise may daunt the most meticulous historian. In the sphere of history writing, the voices of the dead cannot emend as Fitzgerald did, "No, I wouldn't dare do that…No, I wouldn't." What is more, we sometimes feel compelled to ignore the voice, even in the face of flat denial.[2]

Biography remains history's mother lode. It is a vast genre at least as old as ancient Greece, encompassing sincere attempts to explain the *Bioi*, or "ways of life," and opportunities to indulge in the human propensity for gossip or invent outrageous stories when facts are scarce, as well as everything in between.[3] Biographical writing frequently serves an alternative quest, answering questions as time-bound and specific to the biographer as the information encapsulated in the examined life. Endeavoring to untangle these threads, we evaluate the enterprise of the biographer by not only weighing and weighting known facts but also identifying *topoi* and questioning their purpose and value.

Like Acocella, art historians use biography in numerous ways, ultimately attempting to explain or "read" works of art, often shuttling between the warp of biography and the weft of an art object to reconstruct a fabric of history. Yet it seems to me that the more extraordinary the work of art and the more it speaks to us across time, the more this task approximates that of Homer's Penelope, weaving in the sure knowledge of some later unraveling. James McNeill

155

Whistler once remarked in connection with what is arguably his most famous painting, *Arrangement in Gray and Black No. 1: The Artist's Mother* of 1872: "To me it is interesting as a picture of my mother; but can and ought the public to care about the identity of the portrait? It must stand and fall on its own merits as an arrangement."[4] As Whistler understood, what is tricky about the enterprise is that, while the life may inform the work, the work has a life of its own. Similarly, a series of illuminating texts by Paul Barolsky reminds us to respect a visual artist's complementary activity as a writer in its own right, astutely instructing that we neglect the literary component of Vasari's *Lives* at the peril of limiting our insight and, not incidentally, our pleasures.[5]

Barolsky's cautionary directive to examine Vasari's agency as author is significant if we desire to understand Renaissance art on its own terms within its original context. Correggio's work, for example, has come to occupy an interesting position in our construction of European art history. Much that signals "Correggio" to us was produced in Parma during the third decade of the sixteenth century and not widely disseminated beyond the geographical confines of the artist's native Emilia during his lifetime. The hindsight of Baroque art history has cast Correggio as an indispensable trailblazer. Correggio's subtle manipulations of the tonalities of light and color have been viewed as fundamental to the Carracci reform of painting. His ability to represent the miraculous as a tangible reality made the expression of similar impulses in seventeenth-century Italian art more comprehensible.[6]

Renaissance art history has offered a slightly different teleology, framing Correggio's work as a *coda*, a path off the main routes of Florence, Venice, and Rome. Moreover, Correggio's achievement, the formal complexity of his painting in the 1520s, has been increasingly ascribed to the influence of Michelangelo and Raphael. Correggio's pervasive illusionism and bold foreshortenings with their intricate physical and spatial relationships, the psychological directness of his figures, powerful in physique and dynamic in pose yet eloquent in gesture and expression, have been judged unimaginable—indeed, not possible—without Correggio's awareness of Roman painting. Accordingly, Correggio's work has prompted us to refashion his biography in support of our judgment that a trip to Rome was essential to his artistic development. It is now a commonplace of art historical literature to read that Correggio traveled to Rome.[7] Substantiation, however, has proven stubbornly elusive; in addition to Vasari's premier biography, no other early account or, for that matter, no recovered archival data supports this assessment.

Evidence for Correggio's biography is scant. Information about his artistic training, workshop experience, early career, and earliest autograph paintings, has been gleaned mainly from contracts and other legal documents. We know that the artist Antonio Allegri died on March 5, 1534 in the town by whose name he is better known and was buried there. Upon his death, he left a remarkable legacy in the form of paintings. Correggio's birth date has been variously calculated between 1489 and 1494; the latest scholarship, favoring the earlier date, now postulates that Correggio received his initial artistic training from an uncle, Lorenzo Allegri (d. 1527), believed to have been a local painter.[8] What little is known about his biography is so much debated that we still remain at a loss to explain Correggio's creative combustion in Parma of the 1520s.

The idea that Correggio traveled to Rome, where his exposure to contemporary trends in Roman painting both significantly changed and enhanced his artistic development, derives from the opening passage of Vasari's biography of the artist. To be more precise, the idea that Correggio traveled to Rome before establishing himself as a painter in Parma originated in opposition to Vasari's account. Although Vasari's view prevailed unchallenged for nearly a century and a half after the initial publication of the *Lives* in 1550, his remarks about Correggio and Rome have since drawn harsh censure. What distinguishes these critics and their criticism has been a quality of literal-mindedness, which faults Vasari's methods and attitudes generically at the very same time that his biography of Correggio is viewed in ever increasingly isolation from the rest of Vasari's text.[9]

Correggio's biography occurs in the Third Part of the *Lives*, grouped with artists of the so-called modern manner and in the company of Leonardo, whom Vasari placed as the initiator of that manner.[10] The linguistic construction of Vasari's remarks as well as the subsequent history of this passage makes them worth quoting in full:

> Antonio was the first who began to work in the modern manner in Lombardy; wherefore it is thought that if he with his genius, had gone forth from Lombardy and lived in Rome, he would have wrought miracles, and would have brought the sweat to the brow of many who were held to be great men in his time. For, his works being such as they are without his having seen any of the ancient or the best of the modern, it necessarily follows that, if he had seen them he would have vastly improved his own, and, advancing from good to better, would have reached the highest rank. It may, at least, be held for certain that no one ever handled colors better than he, and that no craftsman ever painted with greater delicacy or with more relief, such was the softness of his flesh-painting, and such the grace with which he finished his works.[11]

Despite their ostensible praise, Vasari's words are linguistically loaded. His conditional voice, "se l'ingegno di Antonio fosse uscito di Lombardia e stato a Roma, averebbe fatto miracoli," implies an alternative history, one which invites us to conclude that Correggio was not, in fact, among the artists of the highest rank. Correggio had *ingegno*, talent bordering on genius and, to quote the immortal words voiced by Marlon Brando, "could have been a contender," but ultimately remained an inspired provincial, not unlike Pordenone.[12] The only other sixteenth-century source to touch upon this question, Ortensio Landi's *Sette Libri di Cataloghi a' varie cose appartenenti*, published in Venice 1552/53, confirmed Vasari's appraisal, stating that Correggio "died young without ever seeing Rome."[13] The burgeoning art historical literature of the seventeenth century, which recognized that Correggio's artistic achievement placed him within the pantheon of the great "moderns," seemed content to echo Vasari's opinion, lamenting, as Guercino among others was reportedly overheard to have said, "If only Correggio had gone to Rome!"[14]

Without Rome, Vasari tells us, Correggio lacked the benefit of "having seen any of the ancient or the best of the modern," which would have improved his work immeasurably. Vasari's proposition, that an experience of Rome was necessary to transform men of innate

talent to artists of the first rank, was not unique to his biography of Correggio but rather a persistent theme throughout the Third Part of the *Lives*. What did it mean within the framework of the *Lives* to have gone to Rome? The recurrence and positioning of similar statements, sometimes surprising in their contexts, indicate that it was not merely a trip to Rome but specific qualities of that experience that Vasari deemed crucial for an individual's artistic growth, personal development, and the advancement of an artist's career. A more explicit and provocative picture of what Vasari thought Rome provided artists, and consequently might have offered Correggio, emerges from aggregate references to the Eternal City situated throughout the *Lives*. Neither a brief sightseeing trip to Rome, nor an apprenticeship in a Roman workshop or studio whatever its caliber, nor, for that matter, a significant Roman commission for a worthy patron, was enough.

In the biography of Benvenuto Tisi, called il Garofalo, which opens the segment on painters of Lombardy with "the men of Ferrara," Vasari tells us that Garofalo traveled twice to Rome, spending first fifteen months and later, two years there.[15] Nevertheless, Vasari writes, "If Benvenuto had pursued his studies in Rome, without a doubt he would have done things worthy of his beautiful genius," a sentence in which Vasari's linguistic structuring of "if," "would," "Rome," and "genius," parallels the same alternative history projected for Correggio.[16]

Although the most vociferous proponents of Correggio's journey to Rome have sometimes attempted to interpret Vasari's comment as a veiled critique of Correggio's flawed *disegno*, this was apparently not the case with Garofalo.[17] We learn instead that the similarly Rome-deficient Garofalo was born "so inclined to painting," that, although he was sent to school for reading, "he would do nothing but draw" and despite determined efforts by his father, "would never do anything day and night but draw."[18] In the end, Garofalo's father acquiesced, placing him with a local painter and thereby initiating the steps in the artist's training that would eventually lead him from Cremona to Rome: "where having placed himself with Giovanni Baldini, a Florentine painter of passing good skill, who possessed many very beautiful drawings by various excellent masters, he was constantly practicing his hand on those drawings whenever he had time, and particularly at night."[19] Garofalo remained in Rome over a period of fifteen months, after which time his father's illness necessitated the artist's return to Ferrara.

When summoned to Rome by a patron several years later, Garofalo set forth eagerly. Despite a relatively short absence, fruitfully occupied with numerous commissions in his native Ferarra as well as considerable success in Mantua resulting from Gonzaga patronage:

> he was struck with amazement, and almost with despair, by seeing the grace and vivacity that the pictures of Raffaello revealed, and the depth in the design of Michelangelo. Wherefore he cursed the manners of Lombardy, and that which he had learned with so much study and effort at Mantua, and right willingly would have purged himself of all that knowledge; but he resolved, since there was no help for it, that he would unlearn it all, and change from a master into a disciple. And so he began to draw from such works that were the best and the most difficult, and to study with all possible diligence those greatly celebrated manners, and gave his attention to scarcely any other thing for a period of two whole years; by reason of

which he so changed his method, transforming his bad manner into a good one, that notice was taken of him by the craftsmen. And, what is more, he so went to work with humility and every kind of loving service, that he became the friend of Raffaello da Urbino, who taught him many things, and always assisted and favored him.[20]

Constrained by unidentified circumstance to quit Rome a second time after these two years, Garofalo returned again to Ferrara, and appeared once more to have been inundated by commissions, including the significant patronage of his duke, Alfonso d'Este. Yet Vasari recorded that, "remembering at times how he had turned his back on Rome, he felt the bitterest regret."[21]

Vasari linked the biography of Garofalo with that of Girolamo da Carpi, which immediately follows, in several intriguing ways. Their stories are closely positioned and intertwined, the result of the two artists' working relationship, first as master and pupil, then as artistic collaborators, as well as a consequence of their geographical proximity and status as artists of Ferrara. More provocatively, Vasari inserted himself into both accounts as if to underscore the veracity of his own narrative, claiming personal friendship with Girolamo and implying that his information about Garofalo was drawn from first-hand experience: "in his friendships he was loving beyond measure...and most affectionate toward all men of art in general; and to this I can bear witness, for on two occasions when I was at Ferrara in his time I received from him innumerable favors and courtesies."[22]

It is within a similar context of friendship that we learn that Girolamo da Carpi was another Rome-bereft artist, who not only voiced his regret directly to the author but, more remarkably, while *in* Rome: "[A]ll these particulars I heard from Girolamo da Carpi, who was much my friend, at Rome in the year 1550; and he lamented very often to me that he had consumed his youth and his best years in Ferarra and Bologna, and not in Rome where, without a doubt, he would have made much greater proficience."[23]

Girolamo da Carpi's personal circumstances, at the precise moment when Vasari placed this lament in his mouth, might argue instead that the artist had, in fact, achieved the pinnacle of his career. Brought to Rome by Cardinal d'Este to renovate the cardinal's newly purchased property at Monte Cavallo:

> Girolamo came into very great credit in Rome, and in the year 1550 he was introduced by the above-named Cardinal, his lord, who loved him dearly, into the service of Pope Julius III, who made him architect over the works of the Belvedere, giving him rooms in that place and a very good salary.[24]

The Pope proved an unreasonably difficult patron, and Girolamo's abilities provoked the envy, and therefore ill-will, of unfraternal colleagues.[25] As a result, Girolamo "chose, as the better course, to return to the service of the Cardinal at Monte Cavallo; for which action Girolamo was much commended," and in due course returned with the cardinal to Ferrara, "to enjoy the peace of his home leaving the hopes and rewards of fortune in the possession of his adversaries, who received from that Pope the same as he had done, neither more nor less."[26]

It has been observed that Vasari's estimation of artists born and successfully employed in

northern Italy suffered from his partiality toward central Italian art and Tuscan artists in particular, a bias well known even to his contemporaries.[27] Given Vasari's own biography as we now know it,[28] distinct from but in addition to the narrative account that he, himself, constructed and wrote, it is both difficult and perhaps unnecessary for us to imagine that it might be otherwise. Nonetheless, even Florentines did not escape the Vasarian imperative of Rome. In the exemplary life of Leonardo da Vinci's nephew, the star-crossed Pierino da Vinci, the theme of Rome revealed the admirable mettle of the young sculptor's character. Having achieved such success working with Tribolo that his "parentage and his birth were likewise revealed," Pierino heard:

> various persons speaking of things connected with the arts to be seen in Rome, and extolling them a great desire had been kindled in him to see them, hoping to be able to derive profit by beholding not only the works of the ancients, but also those of Michelangelo, and even the master himself, who was then alive and residing in Rome. He went therefore, in company with friends; but after seeing Rome and all he wished, he returned to Florence, having reflected judiciously that the things of Rome were as yet too profound for him, and should be studied and imitated not so early in his career, but after a greater acquaintance with art.[29]

Old enough to know that he was yet too young for Rome, Pierino, therefore, returned to Florence and to work again with Tribolo, and Vasari's approbation is clear. Through Tribolo, Pierino was introduced to Luca Martini, the patron cast by Vasari as the catalyst of Pierino's astrological destiny. As an agent for Duke Cosimo, Martini provided not only the means for the sculptor to proclaim his "proficience" in Florence, but also the opportunity for Pierino to return to Rome for a year of work and study: "[H]e remained a year, studying all the time, and executed some works worthy of remembrance."[30] Ultimately, however, neither blood nor talent, good judgment nor good training, neither worthy experience of Rome nor proper patronage was proof against the dictates of fate. Luca Martini, who had advanced Pierino's desire to return to Rome as well as his career, was also the unwitting instrument of Pierino's prefigured and premature death. In poignant literary *contrapposto* to his own vivid account of Leonardo's death as a venerated, elderly man surrounded by friends and servants in foreign France and embraced at the very moment of his passing by the French monarch, Vasari described Pierino's tragic end: Leonardo's nephew died young and virtually alone but for the presence of a solitary assistant, on the outskirts of Pisa.[31]

Vasari reconfigured the biography of Andrea del Sarto, certainly a successful artist and Vasari's master for a time in Florence, to present another opportunity for reflection on the merits of Rome. As in the biographies of Correggio and Garofalo, Vasari interjected a similarly cadenced alternative history in his account of Andrea. A passage added to Andrea's biography in the second edition of the *Lives* repeated twice in the same paragraph:

> Nor is there any doubt that if Andrea had stayed in Rome when he went there to see the works of Raffaello and Michelangelo, and the statues and the ruins of that city, he would have enriched his manner greatly in the composition and force of his

Fig 1 Federico Zuccaro, *Taddeo at the Entrance to Rome Greeted by Servitude, Hardship, and Toil, and by Fortitude and Patience*, ca. 1590, detail.

Fig. 2 Federico Zuccaro, *Taddeo Returns to Rome Escorted by Drawing and Spirit Towards the Three Graces*, ca. 1590, detail.

scenes, and would one day have given more delicacy and greater force to his figures; which has never been thoroughly achieved save by one who has been some time in Rome, to study those works in detail and become familiar with them. Having then from nature a sweet and gracious manner of drawing and great facility and vivacity of coloring, both in fresco work and in oils, it is believed without a doubt that if he had stayed in Rome, he would have surpassed all the craftsmen of his time.[32]

Explicit in his account of Andrea, and indeed typical of all these narratives, is the idea that although many artists traveled to Rome and had undeniably been and stayed in Rome, their experience of Rome was still insufficient for their art to achieve greatness. Vasari's biographies of Correggio and Pordenone contained the same rubric couched in similar language and are exceptional only in their lack of an actual Roman journey.

Even consummately successful Roman artists could be regarded within this paradigm. Vasari chronicled the many hardships of Taddeo Zuccaro's early career, detailing the artist's numerous arrivals, departures, and returns to the Eternal City. He concluded, however, that the prodigious Taddeo only truly "arrived" in Rome after 1560, upon receiving the commission from Cardinal Alessandro Farnese for the decoration of Caprarola. Despite earlier successes, this commission benchmarked Taddeo's status as an artist of Rome: "Whereupon Taddeo, having so honorable an appointment and the support of so great a lord, determined that he would give himself some peace of mind, and would no longer accept any mean work in Rome, as he had done up to that time."[33]

Many of the events described by Vasari were later recounted by Taddeo's brother, Federico Zuccaro, in a remarkable series of drawings probably dating from the 1590s, now part of the Getty Museum Collection.[34] Federico's drawings illustrate Taddeo's literal and allegorical journey toward artistic fame in Rome; they also stand as response and corrective to Vasari's earlier account of Taddeo's career. Taddeo appears initially as a young boy, shepherded by guardian angels as he takes leave of his family (the infant Federico peeks out at us from behind his mother's skirts) in Taddeo *Leaving Home, Escorted by Two Guardian Angels*. The next drawing, entitled *Minerva Shows Taddeo the Prospect of Rome*, portrays a chubby adolescent, seen from behind and clearly labeled "TADDEO ZVCCHARO," on the border of his tunic, in the magisterial presence of Minerva. This drawing conveys a lyrical sense of wonder as Minerva herself points the boy toward a distant vista of Rome, replete with tantalizing bits of ancient ruins.

Taddeo's actual arrival in Rome is less auspicious (fig. 1). The fourth drawing in the series depicts the young artist-to-be immediately outside the city walls; St. Peter's rises above, its cupola still under construction and fully occupying the top third of the sheet. Taddeo is greeted by a tall woman, whose worn face and dress with its rolled-up sleeves reiterate her identity as Toil, inscribed as "FATICA" on her hem. She is accompanied by personifications of servitude and hardship, represented by a disheveled woman seen beyond two beasts of burden, a donkey and an ox, as well as an old man; they crowd in the shadow around her and are labeled "SERVITU" and "DISAGIO," on the wall behind them. Foreshadowing the difficulties he will encounter once he crosses the threshold into Rome, Taddeo clutches a yoke. The lines of *terza rima* originally accompanying the drawing leave no doubt as to the drawing's message:

Fɪɢ. 3  Federico Zuccaro, *Taddeo Decorating the Façade of Palazzo Mattei*, ca. 1590.

*Disagio, e servitù in sù la Porta*
*Incontro se li fan, et ei non teme*
*Fatica alcuna, ch'a Virtude la porta.*[35]

Most of Federico's drawings narrate Taddeo's quest for artistic excellence as something akin to the labors of Hercules; Taddeo is seen suffering various privations and indignities yet he remains admirably persistent in his pursuit of the rudiments of art. He gradually ages and slims to youthful maturity before our eyes in the final sequence of drawings. Federico represents Taddeo entering Rome for a second time, having recovered from the illness that forced his return to the parental home in Urbino (fig. 2). Taddeo, designated unmistakably again by name in the border of his cloak and now a strapping young man, stands once more outside Rome. This time, however, he is accompanied by a personification of "Disegno" as well as a muscular male, labeled "Spirito" and sporting wings on his head, who clasps Taddeo's right hand and points through the threshold into Rome where the Three Graces await.[36]

The narrative series is brought to a close with the scene of *Taddeo Decorating the Façade of Palazzo Mattei* (fig. 3). Taddeo is represented in the midst of his labor, a small figure perched on scaffolding in the middle ground, just to the left of the composition's center. Absorbed in his painting, Taddeo is observed by the Graces as well as "artistic Rome." Congregating in the foreground and identified by name are Salviati, Danielle da Volterra, and most prominent, Michelangelo seated nobly on horseback and Vasari. Federico's visual biography thus culminates in apotheosis; winged Victories literally trumpet Taddeo's artistic worthiness and Taddeo's audacious spirit—inscribed above him, *"grazie spirito fierezza,"*—has earned him his rightful

place among his fellow artists in Rome. This sheet, the largest and most elaborate of the series, challenges the authority of Vasari's biography by asserting that the façade decorations for the Palazzo Mattei in 1548 mark the defining moment of Taddeo's artistic "arrival" in Rome, more than a decade before the Caprarola commission vaunted by Vasari. At the same time, Federico's numerous drawings of Taddeo's persistence, the self-knowledge that he must "make it" in Rome, validate Vasari's view of Rome's importance.

More than an aggregate of bricks and marble, more than a repository for modern works of the highest *maniera* as well as the finest ruins and collections of antiquity, Vasari's Rome was a pilgrimage destination, charged with possibilities for improvement, advancement, and metamorphosis. In biographies that constitute the Third Part of the *Lives*, Rome was a mythically transformative place, a living primer for artistic development and education, both blueprint and pedigree for social advancement. Most significant, Vasari also determined that Rome was something which could be seen, a quality to be assessed in a work of art, itself.

Throughout the *Lives*, Vasari placed a number of artists before Rome like Hercules at the crossroads, situating their achievement on the crucible of Rome as a metaphorical journey between craftsmen's proficiency and the highest rank of artistic excellence. Returning to our famous prototype, Correggio, the artist with whom we began, should we still ask if Correggio visited Rome? Although modern art historical literature posits that Correggio traveled to Rome, archival evidence may never emerge to offer any certainty. In terms of "raw" biographical data, it is even possible that Vasari was told, first-hand from people in a position to know, that Correggio never visited Rome.[37] This, however, is scarcely the point, because Correggio never reached Vasari's Rome. Vasari's alternative histories signal a constructed ideation of Rome.[38] To arrive at Vasari's Rome was not merely to reach a geographical destination but to achieve an aesthetic designation, a plane of artistic accomplishment consonant with the *bella maniera* of Vasari's own generation.

NOTES

1. "Assassination on A Small Scale," *The New Yorker*, 7 February 2000, 82.

2. Among myriad examples in the visual arts, see Pierre Cabanne's extended interview with Marcel Duchamp, *Dialogues with Marcel Duchamp: The Documents of 20th Century Art*, trans. Ron Padgett (NY: Viking Press, 1971). In response to recurrent questions about the symbolic content of his work, Duchamp repeatedly answered, "None at all," 31, "It has no meaning," 41, "I never even thought of that," 61.

3. "Biography, Greek, and Roman," *The Oxford Classical Dictionary*, 2nd edition (Oxford: Clarendon Press, 1970), 167–68.

4. Stanley Weintraub, *Whistler: A Biography* (NY: Weybright and Talley, 1974), 148, among others.

5. Most notably, Paul Barolsky, *Why Mona Lisa Smiles and Other Tales by Vasari* (University Park, PA: The Pennsylvania State University Press, 1991), and *Giotto's Father and the Family of Vasari's Lives* (University Park, PA: The Pennsylvania State University Press, 1992); my debt to this work and its author is incalculable.

6. See, for example, *The Age of Correggio and the Carracci: Emilian Painting of the 16th and 17th Centuries*. Pinocoteca nazionale di Bologna (Washington, D.C.: National Gallery of Art, 1986).

7. Most recently, Carmen C. Bambach, "Correggio as a Draughtsman," in Carmen C. Bambach, Hugh Chapman, Martin Clayton, and George R. Goldner, *Correggio and Parmigianino: Master Draughtsmen of the Renaissance* (London: British Museum Press, 2000), 13; Eugenio Riccomini, "The Frescoes of Correggio and Parmigianino: From Beauty to Elegance," in *The Age of Correggio and the Carracci: Emilian Painting of the 16th*

and 17th Centuries (1986), 5ff; and Cecil Gould, "The Question of the Rome Journey," in *The Paintings of Correggio* (Ithaca, NY: Cornell University Press, 1976), 40–50, among others.

8. See David Ekserdjian, *Correggio* (New Haven and London: Yale University Press, 1997), 1–2, and Pelta, "Antonio Allegri da Correggio," *Encyclopedia of the Renaissance* (New York: Charles Scribner's Sons in association with the Renaissance Society of America, 1999), vol. 2, 87–88; and Giovanni Romano, "Correggio in Mantua and San Benedetto Po," in *Dosso's Fate*: *Painting and Court Culture in Renaissance Italy*, ed. Luisa Ciammitti, Steven F. Ostrow, and Salvatore Settis (Los Angeles: The Getty Research Institute for the History of Art and the Humanitites, 1998), 15–40.

9. When, why and how Vasari's words became the subject of debate is briefly discussed in my dissertation, *Form and Convent: Correggio and the Decoration of the Camera di San Paolo*, Ph.D. Diss., Bryn Mawr College, 1989, 7–24, as well as my review of Bambach, et al., *Correggio and Parmigianino: Master Draughtsmen of the Renaissance*, *CAA Reviews*, March 2002, and is the subject of a forthcoming article of mine.

10. "il quale dando principio a quella terza maniera che noi vogliamo chiamare la moderna," *Proemio* to the Third Part, Giorgio Vasari, *Le vite de' più eccellenti pittori scultori e architettori nella redazioni del 1550 e 1558*, ed. R. Bettarini and P. Barocchi (Florence: Sansoni, 1966–1987), 8.

11. Giorgio Vasari, *Lives of the Most Eminent Painters, Sculptors, and Architects*, trans. Gaston Du C. de Vere (NY: Harry N. Abrams, Inc., 1979), 2, 802; here as elsewhere I have opted for the de Vere English translation. It is significant to note that this passage remained the same in both the 1550 and 1568 editions of the *Lives*: "Et egli fu il primo che in Lombardia cominciasse cose della maniera moderna: per che si giudica che, se l'ingegno di Antonio fosse uscito di Lombardia e stato a Roma, averebbe fatto miracoli e dato delle fatiche a molti che nel suo tempo furono tenuti grandi; con ciò sia che, essendo tali le cose sue senza aver egli visto de le cose antiche o de le buone moderne, necessariamente ne seguita che, se le avesse vedute, arebbe infinitamente migliorato l'opere sue, e crescendo di bene in meglio sarebbe venuto al sommo de' gradi. Tengasi pur per certo che nessuno meglio di lui toccò colori, né con maggior vaghezza o con più rilievo alcun artefice dipinse meglio di lui, tanta era la morbidezza delle carni ch'egli faceva, e la grazia con che e' finiva i suoi lavori," Giorgio Vasari, *Le vite-Edizioni Giuntina e Torrentiniana*, www.cribecu.sns.it, 50.

12. Charles Cohen, *The Art of Giovanni Antonio da*

*Pordenone: Between Dialect and Language* (Cambridge: The University Press, 1996), 4–5, and 32 n. 4, and Vasari's introduction to the life of Pordenone and other painters of the Friuli: "It would seem...that Nature, the kindly mother of the universe, sometimes presents the rarest things to certain places that never had any knowledge of such gifts, and that at times she creates in some country men so much inclined to design and to painting that, without masters but only by imitating living and natural objects, they become most excellent. And it also happens very often that when one man has begun, many set themselves to work in competition with him, and labor to such a purpose, without seeing Rome, Florence or any other place full of notable pictures, but merely through rivalry one with another, that marvelous works are seen to issue from their hands," de Vere, 2, 1063. Marlon Brando's memorable tag line occurs in the film "On the Waterfront," 1954.

13. "... mori giovane senza aver potuto veder Roma," Libro VI, 498; this passage may have been first noted by Padre Ireneo Affò in the eighteenth century, *Ragionamento del Padre Ireneo Affò sopra una Stanza Dipinta dal Celeberrimo Antonio Allegri da Correggio nel Monistero di San Paolo in Parma* (Parma, 1794), 43; and is cited by Gould, *The Paintings of Correggio*, 40.

14. Mentioned briefly, albeit often, throughout seventeenth-century literature, it is clear that Correggio was judged to hold place with Raphael and Titian; see Denis Mahon, *Studies in Seicento Art and Theory* (London: The Warburg Institute, 1947) 28, 41–42, and Robert Enggass and Jonathan Brown, *Italy and Spain 1600-1750: Sources and Documents* (New Jersey: Prentice-Hall, 1970), 33 n.32, 120; as well as Gould, "Correggio in the Seventeenth Century and Later," *The Paintings of Correggio*, 150–61, for a brief but fairly accurate summary. For Correggio's fame in the sixteenth century, see Diane DeGrazia's introductory essay to *Correggio and His Legacy* (Washington, D.C.: National Gallery of Art, 1984), 31–35.

15. De Vere, 3, 1626.

16. De Vere, 3, 1628 and Vasari, *Giuntina*, www.cribecu.sns.it, 5, 412: "se avesse seguitato la practica di Roma, senz'alcun dubbio avrebbe fatto cose degne del bell'ingegno suo."

17. Gould, *The Paintings of Correggio*, 41: "The passage in question is an illustration of a doctrine which Vasari expounds at intervals throughout his history . . . There is an antagonism between draughtsmanship and painting . . . Correggio was to him an insecure draughtsman...A visit to Rome, Vasari thought, would have corrected this shortcoming."

18. Vasari, *Giuntina*, www.cribecu.sns.it, 5, 409–10: ". . . nacque, dico, di maniera inclinato alla pittura . . .

non faceva altro che disegnare . . . non faceva altro giorno e notte che disegnare;" Garofalo's biography was new to Vasari's second edition.

19. Garofalo's father was clearly of the type recognized by Paul Barolsky, *Giotto's Father and the Family of Vasari's Lives* (University Park, PA: The Pennsylvania State University Press, 1992), 6, 44, as one of those fathers Vasari praised for recognizing the importance of their sons' natural inclination to art; de Vere, 3, 1627 and Vasari, *Giuntina*, www.cribecu.sns.it, 5, 410: ". . . dove postosi con Giovanni Baldini pittor fiorentino assai practico, et il quale aveva molti bellissimi disegni di diversi maestri eccelenti, sopra quelli, quando tempo gl'avanzava e massimamente la notte, si andava continuamente esercitando."

20. De Vere, 3, 1628, and Vasari, *Giuntina*, www.cribecu.sns.it, 5, 411–12: ". . . restò quasi disperato nonché stupito nel vedere la grazia e la vivezza che avevano le pitture di Raffaello e la profondità del disegno di Michelagnolo; onde malediva le maniere di Lombardia e quella che avea con tanto studio e stento imparato in Mantoa, e volentieri, se avesse potuto, se ne sarebbe smorbato. Ma poiché altro non si poteva, si risolvé a volere disimparare e, dopo la perdita di tanti anni, di maestro divenire discepolo. Per che cominciato a disegnare di quelle cose che erano migliori e più difficili, et a studiare con ogni possibile diligenza quelle maniere tanto lodate, non attese quasi ad altro per ispazio di due anni continui: per lo che mutò in tanto la pratica e maniera cattiva in buona, che n'era tenuto dagl'artefici conto; e che fu più, tanto adoperò col sottomettersi e con ogni qualità d'amorevole ufficio, che divenne amico di Raffaello da Urbino, il quale, come gentilissimo e non in grato, insegnò molte cose, aiutò e favorì sempre Benvenuto."

21. De Vere, 3, 1628, and Vasari, *Giuntina*, www.cribecu.sns.it, 5, 411: "Nel fare delle quali opere ricordandosi alcuna volta d'avere lasciato Roma, ne sentiva dolore estremo."

22. De Vere, 3, 1631–32, and Vasari, *Giuntina*, www.cribecu.sns.it, V, 413-14: ". . . e fu nell'amicizie ufficiosissimo e amorevole oltre misura . . . et in generale affezionatissimo a tutti gl'uomini dell'arte; et io ne posso far fede, il quale, due volte ch'o fui al suo tempo a Ferrara, ricevei da lui infinite amorevolezze e cortesie."

23. De Vere, 3, 1633, and Vasari, *Giuntina*, www.cribecu.sns.it, 5, 415–416: "E tutti questi particolari seppi io dallo stesso Girolamo, che più volte d'aver consumato la sua giovanezza et i migliori anni in fu molto amio amico, l'anno 1550 in Roma, et il quale meco si dolse Ferrara e Bologna e non in Roma o altro luogo, dove avereppe fatto senza dubbio molto maggiore acquisto."

24. De Vere, 3, 1637, and Vasari, *Giuntina*,

www.cribecu.sns.it, 5, 418: "Per le quali opere essendo in Roma venuto Girolamo in bonissimo credito, fu dal detto cardinale suo signore, che molto l''amava, messo l'anno 1550 al servizio di papa Giulio III, il quale lo fece architetto sopra le cose di Belvedere, dandogli stanze in quel luogo e buona provisione." Not much is known about the precise nature of Girolamo's work for the Pope, although his sketchbooks have remained an extraordinary legacy of his Roman experience; see Norman W. Canedy, *The Roman Sketchbook of Girolamo da Carpi*, Studies of the Warburg Institute, ed. E.H.Gombrich, vol. 35 (London and Leiden: the Warburg Institute, Univ. of London and E. J. Brill, 1976).

25. Difficult papal patrons and jealous colleagues number among Vasari's favorite themes. His particular pleasure in criticizing Julius III via Girolamo's biography may have arisen from his own difficulties with the Pope concerning compensation for an altarpiece.

26. De Vere, 3, 1637, and Vasari, *Giuntina*, www.cribecu.sns.it, 5, 419: "e così per lo meglio se ne tornò a Montecavallo al servizio del cardinale. Della qual cosa fu Girolamo da molti lodato, essendo vita troppo disperata aver tutto il giorno e per ogni minima cosa a star a contendere con questo e quello: e, come diceva egli, è talvolta meglio godere la quiete dell'animo con l'acqua e col pane, che stentare nelle grandezze e negli onori. Fatto dunque che ebbe Girolamo al carinale suo signore un molto bel quadro, che a me, il quale il vidi, piacque sommamente; essendo già stracco, se ne tornò con esso lui a Ferrara a godersi la quiete di casa sua con la moglie e con i figliuoli, lasciando le speranze e le cose della Fortuna nella mani de'suoi avversarj, che da quel Papa cavarano il medesimo che egli e non altro."

27. Patricia Lee Rubin, *Giorgio Vasari: Art and History* (New Haven and London: Yale University Press, 1995), noted Federico Zuccaro's marginalia to Vasari's biography of his brother: "And if those drawings had been by the hand of some Florentine, he would have praised them to the stars," 214.

28. Rubin, *Vasari*; Maia W. Gahtan and Phillip J. Jacks, *Vasari's Florence: Artists and Literati at the Medicean Court*, exhibition catalogue to accompany International Symposium organized by Beinecke Rare Book and Mss Library, Yale University Art Gallery, Apr 14-May 15, 1994; and T.S.R. Boase, *Giorgio Vasari: The Man and the Book*, Mellon Lectures in the Fine Arts, 1971; Bollingen series, vol. 35, 20 (Princeton, NJ: Princeton University Press, 1979), among others.

29. De Vere, 2, 1429, 1430–1431, and Vasari, *Giuntina*, www.cribecu.sns.it, 5, 231: "di qui si scoperse insieme il parentado e'l sangue" and "più volte e da

diverse persone aveva udito ragionare delle cose di Roma appartenenti all'arte e celebrarle, come sempre da ognuno si fa; onde in lui s'era un grande desiderio acceso di vederle, sperando d'averne a cavare profitto, non solamente vedendo l'opere degli antichi, ma quelle di Michelagnolo, e lui stesso allora vivo e dimorante in Roma. Andò addunque in compagnia d'alcuni amici suoi, e veduta Roma e tutto quello che egli desiderava, se ne tornò a Firenze, considerato giudiziosamente che le cose di Roma erano ancora per lui troppo profonde, e volevano esser vedute et immitate non così ne' principi, ma dopo maggior notizia dell'arte."

30. De Vere, 1431, and Vasari, *Giuntina*, www.cribecu.sns.it, 5, 233: "dove studiando tuttavia dimorò un anno, e fece alcune opere degne di memoria."

31. De Vere, 2, Leonardo, 793 and Pierino, 1435: for Pierino as something more than a literary invention, see James Fenton, *Leonardo's Nephew: Essays on Art and Artists* (Chicago: University of Chicago Press, 1998) 68–87.

32. De Vere, 2, 1040, and Vasari, *Giuntina*, www.cribecu.sns.it, 4, 394: "Né è dubbio che se Andrea si fusse fermo a Roma, quando egli vi andò per vedere l'opere di Raffaello e di Michelagnolo, e parimente le statue e le rovine di quella città, che egli averebbe molto arric[c]hita la maniera ne' componimenti delle storie et averebbe dato un giorno più finezza e maggior forza alle sue figure: il che non è venuto fatto interamente se non a chi è stato qualche tempo in Roma a praticarle e considerarle minutamente. Avendo egli dunque dalla natura una dolce e graziosa maniera nel disegno et un colorito facile e vivace molto, così nel lavorare in fresco come a olio, si crede senza dubbio, se si fusse fermo in Roma, che egli averebbe avanzati tutti gl"artefici del tempo suo."

33. De Vere, 3, 1798, and Vasari, *Giuntina*, www.cribecu.sns.it, 5, 561: "Per lo che Taddeo avendo così onorato trattenimento e l"appoggio di tanto signore, si risolvé a posare l'animo et a non volere più pigliare per Roma, come insino allora aveva fatto, ogni basso lavoro . . ."; see Marcia B. Hall, *After Raphael Painting in Central Italy in the Sixteenth Century* (Cambridge: Cambridge University Press, 1999), 201–06, for recent discussion of Taddeo's work.

34. J.A. Gere, *The Life of Taddeo Zuccaro by Federico Zuccaro from the collection of the British Rail Pension Fund*, Sotheby's auction cat., 11 January 1990. As Gere notes in his introduction, the complete series has been reconstructed as comprised of twenty-four compositions; of the twenty still extant, sixteen are narrative scenes. Their subject and variety of framing shapes, in addition to the fact that there was no reference to the series before 1760, have suggested that the drawings may have been intended as designs for a larger decoration, perhaps for Taddeo's own house, which was under construction in Rome during the 1590s. I thank Barbara Wisch for bringing this work to my attention, as well as her keen and patient editorial contributions.

35. Gere, 24, and translated by this author: "Hardship and servitude before the portal/Face him, and he does not fear /Any toil, as Virtue has conveyed him."

36. The accompanying stanza reads: *Disegno Gratia, e Spirito su la porta / Il giovane Taddeo trove tornando; / O felice colui ch'ha si gran scorta.*" Gere, 48.

37. Historically, Vasari was in an excellent position to know. He not only traveled at least twice to Parma, once in 1541 and again in 1566, when Vasari saw Girolamo Mazzola-Bedoli's unfinished Nativity frescoes from scaffolding in the Church of the Steccata, but also certainly knew some of Correggio's colleagues and patrons firsthand: see Pelta, *Form and Convent*, 186–87, n. 41, and Rubin, *Vasari*, 11, 16.

38. Vasari's Rome appears to be another example of what David Cast has termed the privileged instance or a Baconian prerogative; David Cast, "Reading Vasari Again: History, Philosophy," *Word & Image* 9 (January–March 1993): 34.

M. PROPERZIA DE ROSSI SCVL.
BOLOGNESE.

# VASARI'S WOMEN:
# VIRTUE AND VICE

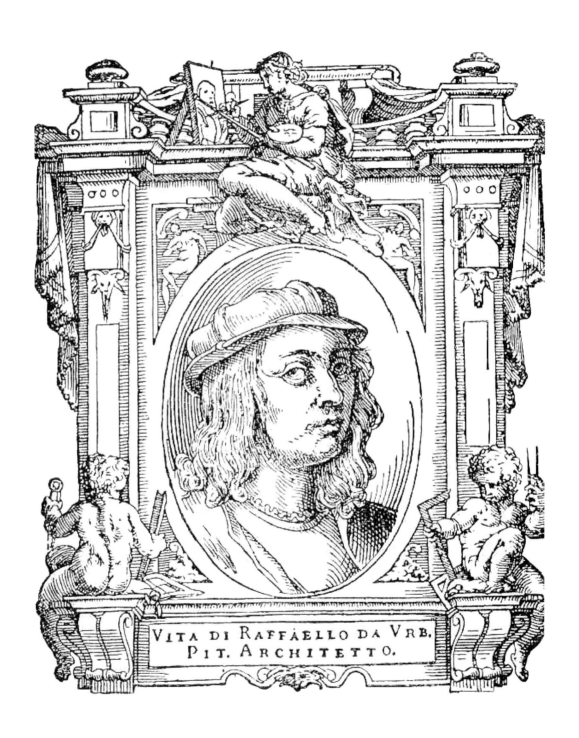

VITA DI RAFFAELLO DA VRB,
PIT. ARCHITETTO.

# Vasari's Mothers

## JERYLDENE M. WOOD

Fathers and sons, grandfathers, uncles and brothers form the actual and fictional lineages of artists in Giorgio Vasari's monumental opus. Mothers and daughters, grandmothers, aunts and sisters are lesser players in his almost exclusively masculine world. This stands to reason, for as Paul Barolsky has shown, Vasari's artistic genealogies stem from ancient and biblical precedents, mimic aristocratic family trees, and reflect the patriarchal society of the times.[1] Still, the dozen or so artists' mothers mentioned by Vasari perform essential cameo roles: noble mothers authenticate family lineages; while good mothers facilitate their progenies' pursuit of art and divine their children's greatness. As we shall see, "Vasari's Mothers," like *Giotto's Father*, elucidate the "deep theme of family relations" in the *Lives of the Artists*.[2]

### All in the Family

Filippo Brunelleschi's mother was "a most excellent young woman from the noble family of Spini," who literally enriched the marriage by bringing "as part payment of her dowry a house wherein [Ser Brunellesco] and his sons dwelt to the day of their death."[3] Vasari's identification of Brunelleschi with a prosperous, upper-class Florentine *casa*—at once house and clan—and his allusion to the Florentine's architectural achievements exemplify his use of maternal lineage to enhance the social standing of artists in the minds of his largely patrician readership. For Vasari's ideal artist, like Castiglione's ideal courtier, should be well born or should possess singular talent, and in the best of all worlds—both. Thus, Michelangelo was the son of Lodovico di Lionardo Buonarroti Simoni and of "very noble" birth in the 1550 edition, but in the 1568 version he also "was born of an excellent and noble mother."[4] Not many artists had Michelangelo's pedigree, and so Vasari glossed over most artists' middle to lower class birth by accentuating their nobility, innate virtue, and God-given talent, as in his anecdotes about the infancies of Michelangelo and Raphael. Michelangelo's suckling by a country wet-nurse was appropriate for the son of an "excellent and noble mother" and a father whose family "was always noble and honorable"; whereas, Raphael's nursing at the breast of his own mother hinted at a humbler artisan lineage.[5] Vasari consequently elevated Raphael's nursing into a component of his saintly character—theologians and humanists had long praised the benefits of maternal nurturing. And he aligned it with the artist's exceptional talent, thereby raising middling origins to a more "gentile" class.

Vasari not only stated that Sofonisba Anguissola's parents "belong[ed] to the most noble families in Cremona," but he also named her mother, Bianca Ponzoni, whose lineage surpassed the painter's father's.[6] When he visited the Anguissola home, Sofonisba was already a court painter in Madrid, yet Vasari met her gifted sisters Minerva, Lucia, Anna, and Europa (the youngest sister in Sofonisba's *The Chess Game* in the Museum Narodowe, Poznan, Poland). Europa, he informs us, "executed many portraits of gentlemen at Cremona, which are altogether beautiful and natural, and one of her mother Signora Bianca, she sent to Spain, which vastly pleased Sofonisba and everyone of that Court who saw it."[7] In addition to manifesting Europa's skill, Vasari's remarks about the favorable reception of the picture call attention to Bianca Ponzoni's social rank, which like her daughter's deemed her worthy of portraiture, and imply that Sofonisba's particular pleasure resulted from the subject matter since the representation of any sitter would have demonstrated her sister's talent. Vasari's suggestion of a bond between Sofonisba and her mother confirms what Alessandra Strozzi's letters to her married daughters also evince—that upper-class Italian women sustained filial relationships even after leaving their natal houses.[8]

Artistic talent descends through the generations in Vasari's *Lives*. Like papal nephews, the sons of artists' sisters continued artistic bloodlines. Trained and sometimes the heirs to their uncles' workshops, these nephews perpetuated the artistic *casa*. Giuliano and Antonio da Sangallo's nephew Antonio the younger was the son of their sister Smeralda, and their nephews Aristotile and Giovanni Francesco were the progeny of their sister Maddalena. Indeed, while Vasari's own claim to kinship with Luca Signorelli stemmed from the paternal family tree, the connecting limb was his great aunt, Signorelli's mother.[9]

### "What's in a Name?"

Specifying mothers' names signals their importance to their children's lives. Vasari pretends that Piero della Francesca bore his mother's name because his father had died while she was pregnant with the painter "and because it was she who had brought him up and assisted him to attain the rank that his good-fortune held out to him."[10] He goes on to relate that Piero studied mathematics until he was fifteen years old, when "it was settled that he was to be a painter."[11] After finishing frescoes in the papal palace at Rome, Piero returned to work in his native Sansepolcro "where his mother had just died."[12] Despite its inaccuracies—Piero's mother was named Romana and his father was very much alive at the time of his son's birth—Vasari's biography evokes Piero's devotion to family and *patria* alike.[13] Jacopo Sansovino's mother, who *was* named Francesca, foresees her son's artistic destiny, and like the mother of St. Francis of Assisi, she works behind the scenes to advance his hopes. Vasari relates that Jacopo's father, the "excellent" Antonio Tatti, forced his son to study letters and "the scabrous rudiments of grammar" and then to learn the trade of a merchant, which he liked "even less," in spite of the boy's clear preference for *disegno*.[14] Fortunately, Vasari observes, "His mother, whom he resembled strongly, perceiving this and fostering his genius, gave him assistance, causing him to be taught design in secret, because she loved the thought that her son should be a sculptor, perchance in emulation of the then rising glory of Michelangelo Buonarroti."[15] Although his father changed his mind

and permitted him to study *disegno*, Jacopo changed *his* name to that of his beloved master Andrea Sansovino.

Following the death of her husband, Timoteo Viti's mother Calliope, herself the daughter of a painter, inspires and assists her son's desire to become an artist. Vasari reports that Timoteo benefitted "with good and happy augury, from the circumstance that Calliope is one of the nine muses, and the conformity that exists between poetry and painting."[16] Perhaps Viti's completion of the *Nine Muses* in the ducal palace at Urbino, begun by Raphael's father Giovanni Santi, motivated Vasari, for he adds, "after he had been brought discreetly through his boyhood by his wise mother and initiated by her into the studies of the simpler arts and likewise drawing, the young man came into his first knowledge of the world at the very time when the divine Raffaello Sanzio was flourishing. . ."[17] At his inventive best in this Life, Vasari contrives biographical details prompted by Viti's birth in the same city as Raphael, the stylistic affinities he observed in the two artists' paintings, and their known professional connection—that Viti worked on Raphael's *Sibyls* in S. Maria della Pace. In actuality, Timoteo Viti was at least thirteen years older than Raphael and presumably had already embarked on his career while Raphael was still a child. Be that as it may, Vasari fabricates a cautionary tale in which Viti does the unthinkable: he rejects a position in Raphael's studio at Rome to return to Urbino "at the urging of his family and the prayers of his mother, now an old woman."[18] That Timoteo Viti, the good son of a worthy mother, relinquished opportunities in the great city of Rome to return to his family at Urbino suggests the detrimental effect of domestic commitments, even filial attachments, to an artist's success. Barolsky reminds us, moreover, that Calliope's influence and her son's refusal to remain in Raphael's artistic "family," a dynasty including Giulio Romano, Gian Francesco Penni, and Perino del Vaga, provides a foil to the story of Raphael and his mother. Recognizing the great talent of her son, Raphael's mother agrees with her husband's plan to send their youngster to study with the famous Perugino, albeit not without "many tears."[19] These intertwined stories of Viti and Raphael, Barolsky proposed, illustrate the divided loyalties between "actual" and "artistic" families: Raphael's "prudent mother" permits her son to enter Perugino's *bottega*, whereas Timoteo's mother entreats her son to come home.[20]

### Truth in Fiction

Vasari's imaginary account of Raphael's childhood masks a less pleasant reality. His mother Magia di Giovanni Battista Ciarla died in 1491; within two years Giovanni Santi had married Bernardina di Pietro Parte, who gave birth to a daughter shortly after Santi's death in August of 1494; and for the next decade Raphael and his stepmother disputed the settlement of Santi's estate.[21] However fanciful, the tearful farewell of Raphael and his mother continues to resonate with readers, just as the legend that the young artist painted the charming Madonna and Child on the wall of his home delights visitors to his house at Urbino. For throughout the *Lives*, Vasari draws on the reader's knowledge of the artists' works to make his stories credible—to create fictions that convey essential "truths." Giovanni Santi's insistence that his wife nurse their son versus Michelangelo's dispatch to a wet-nurse, who happened to be a stonecutter's wife, Barolsky argued, establishes an antithesis: "whereas Michelangelo's feeding at the breast

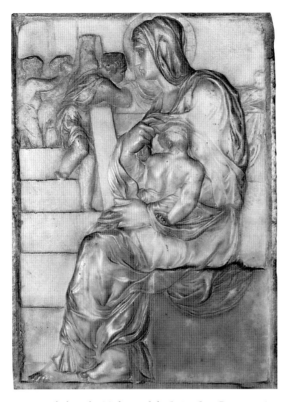

FIG. 1 Michelangelo, *Madonna of the Stairs*, Casa Buonarroti, Florence.

resulted in the marmoreal hardness of his works, Raphael's infancy at his mother's breast led to the softness and tender grace of his art" (figs. 1 and 2).[22] Vasari, who shared his readers' attitudes and experiences, instinctively matched underlying themes to their expectations. In these nursing stories, for instance, the widespread belief that the appearance and temperament of the mother was imprinted on the infant corroborated his association of personalities and artistic styles. Raphael's gracious mother and harmonious household logically explained her son's generous character, reflected the grace or *gentilezza* of his style, and highlighted the subject matter for which he was famed. Quattrocento treatises on marriage and family life by Alberti and Palmieri counseled that mothers should teach their children virtue and fathers should educate them in reason. As Barolsky points out, the "virtue" of Perino del Vaga's metaphorical mother—the art that "guided and governed him and whom he honored without ceasing"—allowed that painter to achieve greatness.[23]

There are no bad mothers of artists comparable to Andrea del Sarto's troublesome wife in the *Lives*. One looks in vain for Lucrezia Buti, the nun whose affair with Fra Lippi produced Filippino and his sister Alessandra and whose refusal to abandon her mate so anguished her own father. Not only does Vasari exorcize the mother from the *vita*, but he also transforms scandal into parable by having the son's "blameless life" redeem the father's. Like a priest who exhorts his congregation to atone for Adam and Eve's original sin, Vasari declares that Filippino "blotted out the stain . . . left to him by his father. . .not only by the excellence of his art . . . but also by the modesty and regularity of his life, and, above all, by his courtesy and amiability."[24] Though he "follow[ed] in the footsteps of his dead father in the art of painting," the "regularity" of Filippino's habits compensates for his father's lack of discipline.[25] And, the reliable son finishes incomplete projects: "In his earliest youth he completed the Chapel of the Brancacci," where, the reader is expected to remember, his father had once watched Masaccio paint.[26]

### Great Expectations

Vasari casts both Lippi as orphans whose guardians failed to fulfill their duties. Fra Lippi's mother died shortly after his birth and his father Tommaso passed away two years later. Tommaso's sister, who cared for the orphan, until "she could no longer manage," placed him with the monks at Santa Maria del Carmine.[27] Abandonment proved fortuitous—even destined—because observing Masaccio (another Tommaso) at work sparked the boy's desire to become an artist. Fra Lippi left the guardianship of his son to his trusted assistant Fra Diamante, who stole the boy's inheritance, and, disregarding his promise to his dying friend, sent him to Botticelli, who "brought up" the "still very young" Filippino.[28] Vasari's accounts of the Lippi stretch the facts, for Lucrezia was certainly alive during Filippino's childhood and Fra Filippo's step-mother Antonia was still living ten years after he had professed monastic vows. As in the

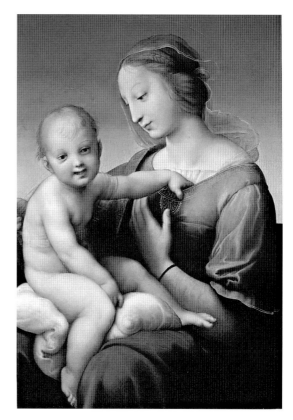

Fig. 2 Raphael, *The Niccolini-Cowper Madonna*, 1508.

story of Raphael's mother, the narrative operates on more than one level, linking family history and stylistic resemblance, while also illustrating that children belonged to fathers, not to mothers, in Renaissance Italy. Fathers were ultimately responsible for their children's well-being: they hired wet nurses, ensured a proper education; orchestrated their sons' professional training through higher education or an apprenticeship, and arranged and financed marriages.[29]

Even caring relatives could not offset the deprivation of a father's assistance. Vasari counterposes the successive deaths in the family of Jacopo da Pontormo with the young painter's passing from shop to shop in search of a master. After his father, mother and grandfather died, Jacopo was raised by his maternal grandmother Monna Brigida. She "taught him reading, writing, and the first rudiments of Latin grammar," and when he was thirteen, took him to Florence, where she "placed him with the Pupilli, to the end that his small property might be safeguarded and preserved by that board."[30] The grandmother soon passed away and Jacopo brought his only sister to Florence, where she also died "before ever she was married."[31] Unlike Timoteo Viti and Perino del Vaga, who become members of workshop "families," Jacopo studied in quick succession with Leonardo da Vinci, Mariotto Albertinelli, and Piero di Cosimo. "Left without a master" when Mariotto departed Florence, he joined Andrea del Sarto's *bottega* until that master's jealousy compelled him to leave. Is it any wonder that Vasari describes Jacopo as "young, solitary and melancholy"?[32]

### Vasari's Mother

The widowed mothers in Vasari's biographies manage to retain custody of their offspring, and they put the welfare of their children first: they do not risk losing them by remarrying, and they furnish astute guidance. Nonetheless, as the sons matured, they had to assume responsibility for the family, sometimes for many years and at great cost to their careers. Baldassare Peruzzi suffered because "he had to accept many commissions to sustain his mother and siblings."[33] Giovanni Antonio Lappoli had been left at the death of his father, the painter Matteo Lappoli, "with a good income under the guardianship of his mother, and lived thus up to the age of twelve."[34] Yet, he was only able to study painting in Florence because his mother had died and his sister had married.

When his father passed away in the plague of 1527, the sixteen-year-old Vasari, like Peruzzi, had to support a substantial family, including three sisters, two brothers, and his mother, Maddalena de' Tacci, who outlived her husband by thirty years.[35] Although his remarks about Peruzzi and Lappoli intimate that Monna Maddalena's welfare could be a burden, Vasari's consistent references to supportive mothers in the *Lives*, like the autobiographical elements Barolsky detected in "the stories of tensions between fathers and sons," may also reflect his personal experience.[36] Indeed, Vasari apparently enjoyed a close relationship with his mother. When he contacted a serious illness in Rome during the 1530s, he was carried to Arezzo, where Monna Maddalena nursed him back to health. His mother lived in the house Vasari purchased at Arezzo in 1541, she accompanied him to Rome in 1545–1546, and she continued to reside in his homes at both Arezzo and Florence after he married in 1550.[37]

But what part does Vasari's mother specifically play in the *Lives*? In the *vita* of his great-grandfather Lazzaro he describes "the new burial place for all the descendants of the house of Vasari," which he designed for the Pieve at Arezzo.[38] Into "the new tomb in the middle of the choir he laid the bones of his ancestors, both male and female. In like manner, the body of his mother, after having remained for some years in S. Croce, has been deposited by him in the said tomb, according to her own desire, together with Antonio, her husband and his father." He continues: "In the predella there are portraits from nature, made by the said Giorgio, of Lazzaro, of the elder Giorgio, his grandfather, of his father Antonio, and of his mother Monna Maddalena de' Tacci."[39] Vasari thus cares for his mother in death as he had throughout her long life, and, more importantly, he commemorates her in his art, for hers is the only portrait of a female ancestor on the altarpiece.

Like the fictional genealogy of his illustrious forefathers in this same *vita*, Vasari's imitation of aristocratic funerary chapels in his ancestral shrine alludes to a higher social position than his family actually held. In fact, by substituting a "Description of the Works of Giorgio Vasari" for a proper autobiography in the *Lives*, he implicitly acknowledges that his reputation, like Raphael's, derived from accomplishment rather than high birth. And since his mother did not connect him to a consequential lineage, Vasari produced an anecdote in the Life of Michele San Michele in which his ennobling of Maddalena's gracious character calls to mind Raphael's mother. He remembers that once while in Venice he "made Michele a large drawing ... and at the time Michele did not do anything but thank Giorgio for it when he took leave of him. But not

many days after, returning to Arezzo, Giorgio found that San Michele had sent long before to his mother ... a quantity of presents beautiful and honorable enough to be the gifts of a very rich nobleman, with a letter in which he did her great honor for love of her son."[40] In essence, Vasari draws upon his mastery of the visual and literary arts to eulogize his mother. His father may have set him on the path of virtue and particularly design "with all manner of lovingness," but Vasari's mother seems to have won her son's enduring affection.[41]

NOTES

1. Paul Barolsky, *Giotto's Father and the Family in Vasari's Lives* (University Park, PA: The Pennsylvania State University Press, 1992). In particular see the Preface, xvi–xix.

2. Ibid, xviii.

3. Giorgio Vasari, *The Lives of the Painters, Sculptors and Architects*, 2 vols., translated by Gaston du C. de Vere (New York: Alfred A. Knopf, 1996), 1: 325 [hereafter Vasari-de Vere]. Vasari, whose information derives from Antonio Manetti's *Life of Filippo Brunelleschi*, adds that the house was across from San Michele Berteldi (now San Gaetano) near the piazza degli Agli. For the earlier biography, see Antonio Manetti, *The Life of Brunelleschi*, Introduction, Notes and Critical Text Edition by Howard Saalman, translated by Catherine Enggass (University Park, PA: Pennsylvania State University Press, 1992), 36–38. For Brunelleschi's mother Giuliana di Giovanni Spini, also see Giorgio Vasari, *Le vite de' più eccellenti pittori, scultori ed architettori*, 9 vols., ed. Gaetano Milanesi (Florence, 1878–1885; reprint ed. Florence: G. C. Sansoni Editore, 1981), 3: 134 [hereafter Vasari-Milanesi]. When he similarly remarks that the brothers Agostino and Agnolo da Siena "were born from a father and mother of Siena, and their forefathers were architects"(Vasari-de Vere, 118), Vasari creates an artistic ancestry descending from the maternal as well as the paternal branches that calls attention to the *patria* of these obscure thirteenth-century sculptor-architects.

4. "Nacque dunque in Fiorenza l'anno MCCCCLXXIIII un figliuolo a Ludovico Simon Buonaroti' . . . E nacque nobilissimo, perciochè i Simoni sono sempre stati nobili et onorevolo cittadini." (Giorgio Vasari, *Le Vite de' più eccellenti architetti, pittori, et scultori italiani, da Cimabue, insino a' tempi nostri*, 2 vols. [Florence, 1550; reprint ed. Turin: Einaudi Tascabili, 1991]: 2: 881). Vasari may have learned about Michelangelo's connections to the Rucellai and Medici families from Condivi's biography (See Paul Barolsky and William E. Wallace, "The Myth of Michelangelo and Il Magnifico," *Source* 11 [Spring, 1993]: 17-18). Also see Paul Barolsky, *The Faun in the Garden: Michelangelo and the Poetic Origins of Italian Renaissance Art* (University Park, PA: The Pennsylvania

State University Press, 1994), 1–12, for Michelangelo's ancestry dating back to the Canossa.

5. For Raphael's infancy, see Vasari-de Vere, 1, 711. For the nursing of children, see Christiane Klapisch-Zuber, *Women, Family, and Ritual in Renaissance Italy*, translated by Lydia G. Cochrane (Chicago: University of Chicago Press, 1985), chap. 7, and Margaret L. King, *Women of the Renaissance* (Chicago: University of Chicago Press, 1991), 12–14.

6. Vasari-de Vere, 2: 466.

7. Ibid., 468. One also wonders if Sofonisba's display of the portrait was an attempt to gain work for her sister at the Spanish court. For an illustration of *The Chess Game*, see Ilya Sandra Perlingieri, *Sofonisba Anguissola: The First Great Woman Painter of the Renaissance* (New York: Rizzoli, 1992), plate 49.

8. Sofonisba married twice: to Fabrizio de Moncada in 1571 and to Orazio Lomellino in 1580. For the circumstances of married women, see Klapisch-Zuber, chap. 6, and for her letters, see Alessandra de' Macinghi Strozzi, *Lettere de una gentildonna fiorentina del secolo XV*, ed. Cesare Guasti (Florence: G. C. Sansoni, 1877).

9. I would like to thank Shelley Zuraw for bringing the importance of nephews to my attention. For the San Gallo, Vasari-Milanesi, 6: 429–30, 433; for the Vasari family tree and the kinship of Signorelli, T. S. R. Boase, *Giorgio Vasari: The Man and the Book*, (A. W. Mellon Lectures in the Fine Arts, 1971, The National Gallery of Art, Washington, D.C.) Bolligen Series 35 (Princeton: Princeton University Press, 1979), 6.

10. Vasari-de Vere, 1: 397.

11. Ibid., 398.

12. Ibid., 399.

13. Piero's father was alive when he was born; in fact, his parents had additional children. For the family and Piero's mother's name see Ronald Lightbown, *Piero della Francesca* (New York: Abbeville Press, 1992), 11–12.

14. Vasari-de Vere, 2: 829.

15. Ibid.

16. Vasari-de Vere, 1: 778. Calliope was the daughter of Antonio Alberto da Ferrara.

17. Ibid.

18. Ibid., 780. Timoteo was born in 1469 and Raphael

in 1483. Malvasia stated that Viti studied with Francia in Bologna after initial training with a goldsmith. He had returned to Urbino by 1495, where he painted an altarpiece for the cathedral in 1504. For this and additional information on the artist, see *Pittura in Umbria tra il 1480 e il 1540* (Milan: Electa, 1983), 207.

19. Vasari-de Vere, 1: 711. The problem of Raphael's training—he was 11 years old when Giovanni Santi died in August 1494—remains conjectural. For a review of this issue, see Roger Jones and Nicholas Penny, *Raphael* (New Haven and London: Yale University Press, 1983), 4–5.

20. Barolsky, *Giotto's Father*, 74–77.

21. For the documentation, see V. Golzio, *Raffaello nei documenti, nelle testimonianze dei contemporanei e nell letteratura del suo secolo* (Vatican City, 1936), 3–6.

22. Barolsky, *Giotto's Father*, 74–75.

23. Vasari-de Vere, 2: 152–54. Vasari introduces Perino's "true mother" as if to counter the detrimental effects of the infant's nursing after the death of his actual mother (initially with goat's milk and then with the plague-infected milk of his step-mother). Moralists from San Bernardino onward objected to animal milk for infants. For church and humanist attitudes about nursing, see King, 12–13.

24. Vasari-de Vere, 1: 570.

25. Ibid., 564–65.

26. Ibid., 565.

27. Ibid., 435. For documentation on Fra Lippi's life, see Jeffrey Ruda, *Fra Filippo Lippi* (New York and London, 1993), 40, 540.

28. Ibid., 442–43.

29. For parental responsibilities, see King, 19–59. The death of a mother does not weigh as heavily as a father's in the *Lives*; nor, as with Fra Lippi, does the existence of a stepmother, although the fathers of many young artists, including Raphael, Michelangelo, and Leonardo, remarried (the latter's four times).

30. Vasari-de Vere, 2: 339–40. According to Vasari, Jacopo's father Bartolommeo Carrucci, "said to have been a disciple of Domenico Ghirlandaio," died in 1499, his mother Alessandra, "a virtuous girl of good condition," in 1504, and the maternal grandfather in 1506.

31. Ibid., 340.

32. Ibid.

33. Vasari-de Vere, 1: 809.

34. Vasari-de Vere, 2: 203–04.

35. Vasari-de Vere, 2: 809. He cites persistent plague and the political turmoil succeeding the Sack of Rome as his reasons for remaining at Arezzo, where he completed a number of paintings for local churches, but providing for his family must also have hindered his return to Florence. The necessity of a steady income, as well as his enormous energy and ambition, no doubt drove Vasari to travel relentlessly after commissions in Rome and Florence until well into middle age. He left the family finances in the hands of his paternal uncle Don Bartolommeo during his absences from Arezzo. For Vasari's activities and his portrait of his mother, see Boase, 3–42, and fig. 2, and Patricia Lee Rubin, *Giorgio Vasari: Art and History* (New Haven and London: Yale University Press, 1995), 9–19. For Vasari's construction of his own life and identity see Rubin, 21-59, and Barolsky, *Giotto's Father*, 114–29.

36. Barolsky, *Giotto's Father*, 114.

37. See Rubin, 380 and as in note 35, and Boase, as in note 35.

38. Vasari-de Vere, 1: 423-24. For an illustration of the Vasari Family Shrine in Arezzo, see Boase, 174, fig. 112.

39. Ibid.

40. Vasari-de Vere, 2: 412.

41. Ibid., 1020.

# *Vasari's Women*

KATHERINE MCIVER

Venus or Virgin? What were the roles that women played in Vasari's *Lives*?[1] Whatever the answer may be, one thing is certain: Vasari constructed their lives for a particular purpose; and it was a construction based most often on contrasting pairs. His juxtaposition of the loose-living sculptor, Properzia de' Rossi, with the pious nun-painter, Plautilla Nelli, is a particularly tantalizing example—the two women were total opposites. Yet, Vasari found common ground in their clientele: the noblewomen of Bologna, who sought out Properzia de' Rossi's delicately carved peach pits and the noblemen of Florence in whose homes so many of Plautilla Nelli's paintings hung. The nobility of their clientele tied the two women together.

As we will see, Vasari's account of Properzia's life, in which Plautilla is placed, is both positive and negative, as a virtue often becomes a vice. Furthermore, in his second edition of the *Lives*, Vasari included over a dozen women who were artists.[2] Drawn from multiple commentaries on women,[3] Vasari's discourse, at the most basic level, gives us insight into his attitude toward women in general. Vasari, like men throughout history, struggled with the idea that women were actually the true creators because they bore children.[4] The woman as a creator of art, moreover, was a puzzle for Vasari that he seemed unable to resolve; she was an anomaly and should not have existed at all. Other women, such as wives of artists, were equally confusing for Vasari, who questioned whether marriage was beneficial or not. In the case of Andrea del Sarto, for example, he felt that Lucrezia was a hindrance to Andrea's career.[5] Yet he criticized Girolamo da Carpi for his amorous pleasures and lute playing—both pursuits were detrimental to the artist's career.[6] Vasari did admire one artist's wife, Ammanati's Laura Battiferri, to whom he addressed two sonnets and about whom Bronzino said "iron within and outside ice."[7] Was it because of her strong will and the fact that she actively supported her husband's career?

More importantly, Vasari's most acclaimed women artists were either virgins or nuns, and his vision of who should receive artistic training is quite clear. At the highest level, Vasari placed the noblewoman, whose education included at least some instruction in drawing and, perhaps, painting as well. Next came the nun, who often learned to draw and even paint while behind convent walls. For Vasari, these women practiced art, more specifically drawing, as a means of intellectual improvement, not as professionals. Yet we know of many nuns who earned money for their convents through their artistic production, and of at least one noblewoman who became a court painter. At the lowest level, Vasari placed the daughters of artists who took up their fathers' craft. He was reluctant to say much about these women, preferring the nobility of

a woman's birth or her confinement safely behind convent walls. As this study hopes to suggest, Vasari's placement of women artists within his text and his treatment of their lives served a particular purpose, and had little to do with recording their biographies. By way of conclusion, I will consider the life of the professional Bolognese painter, Lavinia Fontana and Vasari's omission.

In thinking of Vasari's treatment of women's lives, we cannot help wondering why Properzia de' Rossi was accorded the singular distinction of being the only woman artist with a life of her own. Sofonisba Anguissola, on the other hand, like many of the male artists in Vasari's text, was placed within another's life. First mention of her is made at the end of Properzia's; and again, at the end of Giulio Campi's, whose Life is at the end of Garofalo's.[8] Vasari praised Anguissola's talent in portraiture noting, in particular, her *Chess Players* (ca. 1555, Muzeum Narodowe, Pozanan, Poland), and de' Rossi, whose *Joseph and Potipher's Wife* (ca. 1526, Museo di San Petronio, Bologna), he praised as being "a lovely picture, sculpted with womanly grace and more than admirable."[9] At the same time, he stressed their feminine characteristics and nobility. More importantly, both women were skilled in those things all noblewomen were expected to attain some accomplishment: deportment, grace, musical talent, and artistic training.

We begin with a look at Vasari's Life of Properzia de'Rossi. Situated between the Life of the Florentine painter, Andrea del Sarto, and that of the Ferrarese sculptor, Alfonso Lombardi, Properzia's Life opens with a recounting of famous women of the past.[10] Like Boccaccio, Vasari used women from the past in order to validate the existence of women artists in his own time—women who were exceptional, foreswearing their womanly duties to pursue a masculine profession. Vasari continued his Life of Properzia with a list of contemporary women of letters and then wrote, "Nor have they been too proud to set themselves with their little hands, so tender and white, as if to wrest from us the palm of supremacy, to manual labors, braving the roughness of marble and the unkindly chisels, in order to attain to their desire and thereby win fame; as did, in our own day, Properzia de' Rossi of Bologna."[11] Vasari went on to say that Properzia was accomplished in household management, beautiful of body, a better singer than any woman in her city, and finally, a skilled carver. Here, and with Sofonisba Anguissola as well, Vasari stressed the woman's character over artistic ability and talent; whereas with the male artist, it was just the opposite: creative genius was stressed over character.

Properzia de' Rossi's carved peach pits were particularly appealing to Vasari—small and delicate like the hands that carved them.[12] Unfortunately, her success in this endeavor encouraged her to try her hand at carving marble. With the help of her husband, she attained the commission for the now-famous relief for S. Petronio in Bologna. But, first, she had to prove herself capable of the task. Properzia responded by carving a fine bust of Count Guido de' Peppoli—another success. Overcome with passion for a young man, de' Rossi chose the story of Potipher's wife for her relief. Thus, Vasari framed her career as a sculptor by two men, the husband who obtained the commission for her and her supposed lover who inspired the subject of the relief. As an expression of her desire, this effort exhausted her creative abilities; and turning away from carving, she took up copperplate engraving. Her downfall: unrequited love—passion for a man, but not for her art! Finally, Pope Clement VII sought her out only to find that she had died—a tragic life indeed!

Sofonisba Anguissola is the antithesis of Properzia de' Rossi. Of noble birth and a court painter to the Queen of Spain, Sofonisba, who earned a good salary, chose drawing and painting, not the manual, dirty task of carving. Like Properzia, she had musical skills; yet, she maintained a life appropriate for a noblewoman and did not encroach on a man's world as Properzia did. She was Vasari's ideal (and a virgin without passion for anything except her art). Furthermore, Sofonisba Anguissola's role in the *Lives* is greater than this. As a noblewoman, trained in both music and painting, Sofonisba is included in Vasari's book, twice, in order to celebrate the noble status of the courtly, musically talented painter.[13] More importantly, her placement at the end of Properzia's Life speaks to the debate concerning the superiority of painting over sculpture; and as Castiglione suggested, and Vasari seems to have concurred, painting was nobler, a worthy and beneficial art.[14] This comparison brings to mind Vasari's underlying theme in the *Lives* of contrasting pairs. Here, Properzia de' Rossi is deviant, straying away from those things considered appropriate for a woman, whereas Sofonisba Anguissola is superlative, not only because she stuck to the noble art of painting, but because she worked within the boundaries appropriate for her gender.

Properzia de Rossi and Sofonisba Anguissola frame the lives of two other women: one the nun-painter, Plautilla Nelli, and the other, a noblewoman, Lucrezia Quistelli della Mirandola.[15] Vasari introduced their lives by emphasizing the significance of drawing. "In our book are some very good drawings by the hand of this Properzia, done with the pen and copied from the works of Raphael of Urbino; and her portrait was given to me by certain painters who were very much her friends. But, although Properzia drew well, there have not been wanting women not only equal to her in drawing, but also to do as good a work in painting as she did in sculpture.[16] As his first example, Vasari wrote of Plautilla Nelli, nun and sometimes abbess at the Florentine convent of Sta. Caterina of Siena.[17] Significantly, she was a Florentine who was still alive when he wrote his book. Vasari noted that she owned drawings by Fra Bartolomeo and that she trained with his pupil, Fra Paolino.[18] So why did he place her life here, rather than with her master as was his custom? Vasari wrote that Plautilla began, "little by little, to draw and to imitate in colors, pictures and paintings by excellent masters." She executed some works with diligence and caused the craftsmen to marvel. For the most part, Vasari merely listed Plautilla's large-scale religious paintings without comment. For the refectory of her convent in Florence, for example, Vasari wrote only that she painted a large *Last Supper* (1550s). However, he did praise the fact that she was skilled in manuscript illumination, just as he praised Properzia de' Rossi for her tiny peach pit carvings. Such small, delicate works of art were far more appropriate for women's creative invention. More significantly, as Vasari wrote toward the end of his page on Plautilla: "The best works from her hand are those that she copied from others, wherein she shows that she would have done marvelous things if she had enjoyed, as men do, advantages for studying, devoting herself to drawing and copying living and natural objects."[19] In the final sentence, referring to a portrait of Costanza de' Doni, he stated, "painting her so well, that it is impossible to expect more from a woman who has had no great practice in her art."[20] Like Properzia, whose sculpted bust was a great success, Plautilla's best independent work was a portrait. Women should copy after works by men, possibly sculpt objects like peach pits or paint illuminated manuscripts or portraits, but should never attempt masculine endeavors as Properzia did—it would only lead to failure.

181

The Life of another Florentine, the noblewoman Lucrezia Quistelli, follows that of Plautilla Nelli. It just so happens that her teacher was Alessandro Allori, pupil of Bronzino, and a member of Vasari's *Accademia del Disegno*—so why is she placed here and not with Allori? Lucrezia, appropriately, occupied herself with drawing. Little more is said of her. Finally, Vasari concluded Properzia de' Rossi's Life with that of the north Italian noblewoman and painter, Sofonisba Anguissola, who "labored at the difficulties of design with greater study and better grace than any other woman of our time, and she has not only succeeded in drawing, coloring and copying from nature, and in making excellent copies of other masters, but has also executed by herself alone some very choice and beautiful paintings."[21] Compared to his treatment of de' Rossi, Nelli and Quistelli, Anguissola is almost equal to the male artist!

What were Vasari's motives in placing these three women with Properzia de' Rossi? Catherine King has suggested that because they were still living, and Properzia de' Rossi was dead, their inclusion within her Life protected them from publicity.[22] Yet, Sofonisba Anguissola was exposed, as it were, to public scrutiny when Vasari discussed her career in more detail in Campi's Life. At the most basic level, the inclusion of other artists within another's life conformed to the overall format of Vasari's book. More importantly, each life, no matter how brief, served a purpose. Unlike Properzia de' Rossi, these women did not deviate from tradition, rather they stuck to painting and drawing—both endeavors considered appropriate for the noblewoman or nun. Indeed, Vasari stressed that Plautilla Nelli's paintings were to be found in the homes of the nobility of Florence. He enhanced this connection to Florentine nobility when he noted that she had made a copy of Bronzino's *Nativity* that he had painted for Filippo Salviati and when he mentioned her portrait of the Florentine noblewoman, Costanza de' Doni, who was the model of beauty and virtue. This repeated connection to Florentine nobility along with his brief mention of the noblewoman-painter, Lucrezia Quistelli, supported Vasari's claim for the nobility of painting and of the artist which culminated, in de' Rossi's Life, with Vasari's ideal woman artist, Sofonisba Anguissola.

While lack of training did not allow these three women to progress significantly beyond copying the works of male masters, that marvel, Sofonisba Angiussola, did. When Vasari returned to her Life, while writing that of Giulio Campi, he stressed, once again, that she, as well as her sisters, were "most gifted maidens," born of noble parents; and that they were all skilled in drawing. Again, he mentioned that Anguissola was the court painter to the Queen of Spain and that she earned a good salary. She had musical skill and had a particular knack for portraiture, which he praised highly.[23] Anguissola had attained what most male artists, including Vasari, strove for: fame, nobility, and money. Her life, therefore, contrasted sharply with that of de' Rossi. Moreover, as a court painter in Spain, Anguissola was far away and could not compete with the professional male artist in Italy. She was a paragon on a pedestal—an ideal model for both the male and female artist to follow. Of course, if she had competed for commissions for major altarpieces, as Lavinia Fontana did, the story might have been different. How would Vasari have felt about her then?

When Vasari did discuss a woman who was a daughter of an artist, the comments were brief. Barbara Longhi and her father Luca Longhi of Ravenna are mentioned at the end of Primaticcio's Life, which is followed by that of Titian, in which Irene de Spilimbergo is

mentioned.[24] It is no accident that these two women's lives follow one another, nor that the emphasis for both is on drawing, grace, and their lovely maidenly qualities. Here, too, as he did with Plautilla Nelli and Lucrezia Quistelli, Vasari paired two exemplary women: one still a young girl, who happened to be the daughter of a painter, and the other a noblewoman, who was also a painter. Of Barbara Longhi, Vasari wrote, "Nor must I omit to say that a daughter of his, still a little girl, called Barbara, draws very well, and has begun to do some work in color with no little grace and excellence of manner."[25] Unfortunately, Vasari had died (1574) before Longhi's career had gotten underway; she was best known for her small-scale devotional paintings of the Madonna and Child—a subject that Vasari would certainly have deemed appropriate for a woman artist. Irene de Spilimbergo, born of a noble family, was, according to Vasari, "a very lovely maiden, skilled in letters and music and a student of design who, dying about seven years ago, was celebrated by the pens of almost all the writers of Italy."[26] And why not? She had followed the right course, and therefore, was almost equivalent to Sofonisba Anguissola. Even Uccello's daughter "had a knowledge of drawing."[27]

Another marvel, Diana Mantovana Scultore, whose father was the sculptor and engraver Giovanni Battista Mantovano, was mentioned in the Life of Garofalo:". . . what is even more astonishing, a daughter, who also engraves so well that it is a thing to marvel at; and I who saw her, a very gentle and gracious girl, and her works, which are most beautiful, was struck with amazement."[28] No mention of drawing here; perhaps engraving was close enough. All these maidens were marvels, exceptional. None of them, apparently, painted in fresco, unless it was unseen behind convent walls. Was it because such an endeavor would expose them to public scrutiny (they would be on display; their every move visible for all to see) or was it because fresco was a difficult medium beyond the capacity of a mere woman?

Curiously, Vasari failed to mention Lavinia Fontana, the daughter of the late mannerist painter, Prospero Fontana. Vasari was well acquainted with Prospero Fontana; they first met in 1550 in Rome and remained friends. Fontana worked with Vasari in the Sala dei Cinquecento from 1567–71; and when Vasari wanted news of artists in and around Bologna for his second edition of the *Lives*, he turned to Prospero Fontana. What makes his omission even more curious is this: Lavinia Fontana and Barbara Longhi were both born in 1552 and would have been about fourteen years old when Vasari visited the region in April and May of 1566.[29] Perhaps, even more significant is the fact that Vasari discussed Prospero Fontana's career on four different occasions in the *Lives*.[30] Two of these occur in the Life of Primaticcio, the very one in which Vasari made brief mention of Barbara Longhi and her father.[31] So why did not Vasari at least mention Lavinia Fontana as he did Barbara Longhi? Surely, Fontana would have been training his daughter and would have been proud to show her work to Vasari, as Luca Longhi must have done with his daughter Barbara. The cultivated atmosphere of Prospero Fontana's studio, moreover, would certainly have appealed to Vasari. But, perhaps, Lavinia Fontana was too precocious for Vasari, as her *Head of a Boy* (fig. 1) might indicate. In this drawing of tempera and wash, Fontana's spontaneous and fluid brushwork enlivens the turning of the boy's head, his sparkling eyes, his tousled curls, and his smiling acknowledgement of the viewer. It is as if he is about to speak to us! Here, Vasari's *disegno* and *invenzione* come together in one astounding image—by a woman artist![32]

FIG. 1  Lavinia Fontana, *Head of a Boy*, 1606, Rome, Galleria Borghese.

There is little doubt that Vasari would have known of Fontana and his omission may simply reflect his compliance to Prospero's request not to include his daughter in his book. Was this an effort, on Prospero's part, to protect her from publicity?[33] Could Prospero Fontana have been thinking of that other Bolognese artist—the infamous Properzia de' Rossi?[34] One wonders, too, if Vasari had lived to write a third edition, would he have addressed the issue of the professional woman artist. In some ways, Lavinia Fontana's life and career fits Vasari's ideal for the male artist, who was to seek social identity and professional advancement. For Vasari, this was a conscious construction, on the part of the artist, to conform to the ideals of behavior associated with the learned and the courtly, the well educated and the well behaved.[35] Certainly, Lavinia Fontana was all of these things. In 1577, Fontana married a minor nobleman from Imola, Gian Paolo Zappi, who also happened to be a painter. Fontana was well educated, having received a degree from the University of Bologna in 1580; she could sing and play the harpsichord, and she mingled with the courtly crowd of Bologna and later, that of Rome. She did not give up her lucrative career for her marriage; rather it was a selling point in the negotiations with the nearly impoverished Zappi family.[36] Nor did her production decline; instead, her husband, acting as her agent, promoted her career. Between 1578 and 1595, she bore eleven children, three of whom she taught to paint. Because her father was old and nearly blind, Fontana took over his studio, remaining there until his death, whereupon she moved to Rome and continued her career with great success. She supported the entire family, husband included, as a first-born son might have done.[37]

In considering how Vasari might have written about Lavinia Fontana, it is enlightening to consider Giovanni Baglione's treatment of the Bolognese painter.[38] In praising her portraiture, Baglione, like Vasari, followed traditional rhetoric when he stated: "Quite good and skillful master who was an excellent portraitist . . . and being a woman, in this kind of painting she did well."[39] Like Vasari, Baglione saw limitations in women's abilities to paint. Works were diligent and skillful; and due to a lack of proper training available only to the male artist, women could not paint the anatomy of their figures effectively.[40] Women like Plautilla Nelli and Lavinia Fontana were at their best when, as Vasari wrote, they stuck to painting "the faces and features of women."[41]

Of Fontana's *Vision of St. Hyacinth* (Rome, Sta. Sabina, Ascoli Chapel, 1599–1600), Baglione conceded with qualified praise that the altarpiece showed "diligence, good colors, and was almost her best work."[42] Commissioned by Cardinal Ascoli, (the former Dominican friar, Gerolamo Berniero of Correggio), the altarpiece was sent to Rome from Bologna and it brought Fontana into the limelight in the Papal city. Cardinal Ascoli's secretary, Rosato Rosati, writing to Fontana from Rome in 1600, remarked that the altarpiece "astounds all of Rome."[43]

After Fontana received the commission for an altarpiece for one of the major Roman basilicas, St. Paul's Outside the Walls, Baglione became more critical. Writing about her *Stoning*

Fig. 2 Felice Antonio Casoni, Reverse, *Medal of Lavinia Fontana*, 1611, Imola, Pinacoteca Civica.

*of St. Stephen* of 1603 (destroyed by fire, 1823), Baglione wrote, "Better painters than Fontana were passed over and the result was not a success."[44] He asserted, moreover, that Fontana turned away from public commissions to focus on portraiture and private works.[45] Thus, he implied that the work had been a failure, not only in his eyes, but in those of all of Rome as well! Echoes of Vasari ring throughout Baglione's criticism. For both biographers, the female artist was a puzzle, not easily understood. Although "creators of living men," women were not supposed to have creative talent; yet many of them did.

And what would Vasari have said of Felice Antonio Casoni's 1611 medal (Imola, Biblioteca Comunale) of Lavinia Fontana? The front is typical; it shows a profile bust portrait of the artist with the inscription: "Lavinia Fontana Zappi Pictrix. Ant. Casoni 1611." The reverse (fig. 2) is altogether different, and because it depicts a woman inspired by genius, it is revolutionary for its time. Lavinia Fontana, as the allegory of painting, sits at her easel, seized by divine inspiration, her luxuriant Medusa-like hair flying about her.[46] She has discarded her mahlstick (a prop to steady the painter's hand) and paints freely. The inscription on the medal reads: "Through you, joyous state, I am sustained" (*Per te stat gioioso mi mantene*). Looking more closely at the medal, we see that her eyebrows are prominent and strongly arched. A cloth band covers her mouth and is fastened behind her ear. Around her neck, a large teardrop shaped object hangs on a chain. On the ground at her feet lie other brushes, and behind her lies her palette. Beneath her, in the border with the inscription, lie calipers and a square. It is of interest to note that the most unusual features—the band over her mouth, her wild hair and the necklace—coincide with Cesare Ripa's description of the Allegory of Painting:

185

Painting: a beautiful woman with hair which is thick, dark and disheveled, curling in different ways; and with arched eyebrows, which indicate imaginative thoughts. Her mouth is covered with a band tied behind her ears; around her neck she wears a golden chain from which hangs a mask, inscribed on the front, "imitation". She holds a brush in one hand and, in the other, a panel. She wears a dress of iridescent fabric, which covers her feet. And at her feet let there be put some instruments of painting to show that painting is a noble exercise and cannot be done without much application of the intellect.[47]

The inclusion of the mahlstick and the portrayal of the figure as actively painting are variants from Ripa's text that enhance the idea of artistic genius. The combination of the unused mahlstick and the artist's flying hair, read in the context of the inscription, suggests creative fury. Moreover, Ripa's exalted concept of painting as an intellectual pursuit, and of the artist who works from imagination to create an imitation of reality, is embodied not only in this image, but also in Fontana's magnificent *Head of a Boy* (see fig. 1) discussed above.

Has Lavinia Fontana, then, surpassed the elder Anguissola as Vasari so often portrayed in his Lives of male artists? She was not noble, but married nobility. As Vasari recommended, Fontana sought social identity and professional advancement. She constructed her life to conform to the ideals of a learned, courteous, yet highly successful painter, who was willing to risk the criticism of her contemporaries in order to succeed as a professional painter.

NOTES

1. For this paper I have used the English translation: Giorgio Vasari, *Lives of the Painters, Sculptors and Architects* (New York and Toronto: Alfred A. Knopf, Everyman's Library, 1996) 2 volumes, trans. by Gaston du C. de Vere with introductory notes by David Ekserdjian.

2. Vasari lists the following women as artists. Italians include: Sofonisba Anguissola and her sisters, Anna, Europa, Lucia, and Minerva; Properzia de' Rossi, Barbara Longhi, Diana Mantovana Scultore; Plautilla Nelli, Lucrezia Quistelli de Mirandola, Irene di Spilimbergo, and Uccello's daughter. North Europeans include: Levina Bening, Catherina Hemessen, Susanna Horebout, Anna Seghers, and Clara Skeyers. All of the northern women are listed together at the end of Vasari's survey of northern artists. See also Fredrika Herman Jacobs, *Defining the Renaissance Virtuosa: Women Artists and the Language of Art History and Criticism* (Cambridge and New York: Cambridge University Press, 1997).

3. See for example: Pliny, the Elder, *Natural History* (London: Penguin Classics, 1991), Book 35: Painting, Sculpture and Architecture; Giovanni Boccaccio, *De Claris Mulieribus* of 1370 and Baldassare Castiglione, *Book of the Courtier* (London: Penguin Classics, 1967).

4. Vasari remained childless, which he seemed to regret. He wrote to a newly married friend wishing him children, "whereas he, Giorgio, could only cover walls, panels, canvas and paper with figures." T. R. S. Boase, *Giorgio Vasari, the Man and the Book* (Princeton: Princeton University Press, 1979), 301.

5. Vasari, vol. 1, 831. Interestingly, Properzia de' Rossi's Life follows Sarto's. Vasari himself resisted marriage until late in life. Cosina was simply someone who ran the household and "was a comfort" to him.

6. Vasari, vol. 2, 453.

7. Boase, 188. She was, of course, a poet.

8. Vasari, vol. 1, 860; vol. 2, 466–68. She is mentioned a third time with a sentence about a painting in Taddeo Zuccaro's life (vol. 2, 641).

9. Vasari, vol. 1, 857.

10. Lombardi's Life begins a series of several artists' lives and is, therefore, not strictly speaking, a single life (vol. 1, 861). It is well known that Vasari drew upon both Pliny, the Elder and Boccaccio for this list. See preceding note 3 for citations.

11. Vasari, vol. 1, 857. This is almost parallel to

Boccaccio: "I thought these achievements worthy of some praise, for art is much alien to the mind of women, and these things cannot be accomplished without a great deal of talent, which in women is usually very scarce." *De Claris Mulieribus*, 1370. At the very least, the sentiments of the two are the same.

12. One peach stone was carved with the Passion of Christ; it existed until 1864, after which it disappeared. Eleven peach stones survive. They are carved with, on one side, the figures of saints, and on the other, those of the apostles, their names and references to their particular virtue. They are now embedded in a filigree crucifix, an elaborate setting with a two-headed eagle and an imperial crown (Museo Civico Medievale, Bologna).

13. See my article, "Maniera, Music and Vasari," *Sixteenth Century Journal* 28/1(Spring, 1997): 52.

14. Castiglione, 100–101; he also suggested that a woman be of good family, naturally graceful and well-mannered (211)—the very words Vasari used to describe women artists, who chose to draw and paint.

15. Another interesting parallel in de' Rossi's Life—both de'Rossi and Anguissola are north Italian, and they frame the lives of two Florentines, certainly not accidental on Vasari's part. One wonders if the women in de' Rossi's Life reflect those in Vasari's—his lover, wife, mother, and so on. Is he giving us a composite picture of his ideal woman?

16. Vasari, vol. 1, 858. The use of pen and ink rather than pencil is significant. It shows skill; Michelangelo chose it because it was more difficult.

17. For the most recent research on Plautilla Nelli, see: Jonathan Nelson, ed., *Suor Plautilla Nelli (1523–1588), the First Woman Painter of Florence*. Proceedings from the symposium, Florence and Fiesole, 27 May 1998 (Fiesole: Edizione Cadmo, 2000).

18. Vasari, vol. 1, 679, 858.

19. Vasari, vol. 1, 859.

20. Ibid.

21. Vasari, vol. 1, 860.

22. "Looking a Sight: 16th Century Portraits of Women Artists," *Zeitschrift fur Kunstgeschichte* 58/3 (1995): 400–401.

23. Vasari, vol. 2, 466–68.

24. Vasari, vol. 2, 779, 796.

25. Vasari, vol. 2, 779.

26. Vasari, vol. 2, 796. Her portrait (Washington, National Gallery of Art, ca. 1560) was painted by Giovanni Paolo Pace and retouched by Titian. It was commissioned by her grandfather, who was also her guardian.

27. Vasari, vol. 2, 289.

28. Vasari, vol. 2, 463.

29. Patricia Rubin, *Giorgio Vasari: Art and History* (New Haven and London: Yale University Press, 1995): 18, 122, 124, 179.

30. Vasari, vol. 2, 604, Taddeo Zuccaro's Life, 772, 774–75, Primaticcio's Life and 884, he is listed with the academicians.

31. Vasari, vol. 2, 779.

32. Vasari defined *invenzione* as the artful presentation of a narrative and the control of the number and appropriate actions of depicted figures; *disegno* is the capacity to conceive and actualize *invenzione*.

33. I wish to thank Eric Apfelstadt for this suggestion.

34. In the end, Prospero Fontana did arrange a marriage for his daughter, thus keeping her in his workshop well after her talents were well known. At the time of Vasari's visit, Prospero may already have been going blind and knew that he would need his daughter to run the business and, therefore, he attempted to safeguard her.

35. Rubin, 22.

36. Orazio Sammachini, Fontana's friend and colleague, wrote to her future father-in-law concerning Fontana's career, "If she lives a few years she will be able to draw great profit from her painting, as well as being God-fearing and of purest life and handsome manners." This letter is published in Maria Theresa Cantaro, *Lavinia Fontana Bolognese, "pittura singolare"* (Milan: Jandi Sapi Editore, 1989), 319.

37. See the numerous articles by Caroline Murphy on Lavinia Fontana, as well as the 1998 exhibition catalogue with several essays that discuss her career.

38. Giovanni Baglione, *Le Vite di pittori, scultori ed architetti dal Pontificato di Gregorio XIII del 1572. In fino a tempi di Papa Urbano VIII nel 1642* (Rome: Calco-offset, 1935), introduction by Valerio Mariani, 143–44. See also, Raffaello Borghini, *Il Riposo* (Florence: Tip. G. Marescotti, 1584), 568, and Carlo Cesare Malvasia, *Felsina Pittrice. Vite de' pittori Bolognesi* (Bologna: Arnaldo Forni Editore, 1841), 172–80.

39. Baglione, 143.

40. Baglione, 143–44; Vasari, vol. 1, 858–59.

41. Vasari, vol. 1, 858–59.

42. Baglione, 143.

43. The letter is published in Cantaro, 311–12.

44. Baglione, 143–44.

45. Baglione, 144.

46. The medal exists in three examples in the Biblioteca Comunale, Imola, the British Museum, London, and in the National Gallery, Washington. When this paper was presented at the conference, "Reading Vasari" held in Athens, Georgia, 16–17 November, 2001, many people had suggestions related to the figure on the reverse of the medal. Rebecca Edwards thought that the band across her mouth related to an aulos player who used

the band to hold the dual instrument (there are no musical instruments depicted on the medal), while Norman Land saw the band as symbolizing "silent poetry." Laurie Schneider saw the wild hair as connected to Medusa. This author is pursuing these suggestions. Fontana's medal brings to mind Artemesia Gentileschi's *Self-Portrait* (1630, London, Kensington Palace, Collection of Her Majesty the Queen)—one generation of women building on that of the past.
47. Cesare Ripa, *Iconologia*, 1603, 404–05. "Pittura: Donna, bella, con cappelli neri, e grossi, sparsi e reforti in diverse maniere, con le ciglia inarcate, che mostrino pensieri fantastichi, si cuopra la bocca, con una fascia ligata dietro a gli orecchi, con una catena d'oro al collo, dalla quale penda una maschera, e habbia scritto nella fronte 'imitatio'. Terra in una mano il pennello, e nell' altra la tavola; con la veste di drappo cangiante, la quale le cuopra li piedi, e a pie di essa di potranno fare alcuni istromenti della pittura, per mostrare che la pittura, e esercitio nobile, no si potendo fare sense molta applicatione dell' intelletto. . . ."

# VASARI AND THE
# POETIC IMAGINATION

PIERO DI COSIMO PITTOR
FIORENTINO

# Piero di Cosimo: The Egg-Eating Elegist

### Anne B. Barriault

"Knowing how to read Vasari," writes Paul Barolsky, "we come to see just how much history is poetically embedded in his tall tales."[1]

Among Vasari's tall tales, the Life of Piero di Cosimo may be one of the most poetic. Vasari creates a portrait of an eccentric artist as wild as untamed Nature and as capricious as his paintings.[2] While Erwin Panofsky reinforced this perception when he characterized Piero as an "atavistic phenomenon,"[3] recently discovered documentation has helped to balance our understanding of the artist. We now have evidence about Piero's family name, Ubaldini; his real estate holdings that comprised three houses; his identity as a miniaturist; and his patronage of the Servites, which included provisions for his own funeral and posthumous masses. Records indicate that an assistant lived with the aged Piero in his house, that Piero died of the plague, and that his death occurred in the morning.[4]

These details about Piero's life illuminate traces of truth in Vasari's history, even as they cast Vasari's poetic devices into higher relief. Vasari makes mention of miniatures by Piero: a book of pen-and-ink drawings of "beautiful and bizarre" animals given to Duke Cosimo de'Medici by Vasari's friend, Cosimo Bartoli, as well as the depiction of a verisimilar "book bound in vellum" read by St. Anthony in Piero's *Visitation*. About Piero's religious commitment, Vasari comments, "Not that he was not a good man or did not have faith, in fact he was most zealous." Newfound facts about Piero's daily life, from owning a house to departing this world, more clearly define Vasari's adumbrations. Beneath Vasari's embellishments of the circumstances surrounding Piero's demise, we can detect actual trace elements of historical biography. Vasari elaborates about Piero's increasingly anti-social and reclusive tendencies—shutting himself indoors and forbidding his rooms to be swept or his assistants to stay with him. Tormented by age, illness, and the evils of modern medicine, Piero reached "such a state that one morning . . . he was found lying dead at the foot of a staircase."

Vasari tints and shades Piero's life, so that the more colorful passages create our image of the artist. "He lived unsocially as an animal," Vasari says, "for, having fallen in love with painting, he cared nothing for his creature comforts and reduced himself to eating only boiled eggs, which...he used to cook whenever he was boiling glue . . . fifty at a time, keeping them in a basket and eating them one by one." Vasari's is a portrait of an obsessed painter. Sustenance was of secondary importance to art. Boiling glue for panel paintings occasioned the boiling of eggs for nourishment.

Although he emerges as "a spirit set apart and very different from other painters," Vasari's Piero is in very good company. Caring nothing for his creature comforts, Piero joins Vasari's true artists—Masaccio, Donatello, Brunelleschi, Michelangelo. Vasari describes the "absent-minded and erratic" Masaccio, who "refused to give any time to worldly cares and possessions, even to the way he dressed." With similar disregard, the young Michelangelo would sleep in his clothes when he was tired from work and, being so intent on work, Vasari tells us, he would subsist only on a little bread and wine.[5]

Like Michelangelo, Piero drew spiritual sustenance from art and physical subsistence from simple foods with spiritual connotations: eggs, bread, wine. Of Piero's artistic intensity, Vasari says the artist would fly into a rage when his hand would not obey his artistic will. Even more intriguing, Vasari's describes Piero as being so "fond of solitude that he was never happy except when, wrapped in his thoughts, he could pursue his ideas and fancies." Portrayed by Vasari as a solitary artist, Piero understands the "subtle secrets hidden deep in nature," a quality that reminds us of Boccaccio's description of Giotto, from whom "Nature hid no secrets." Boccaccio argued in the *Art of Poetry* that "poets seek to dwell in sylvan spots . . . not from want of sophistication, but to serve God with a freer mind"; such solitary, bucolic sensibilities connect Renaissance painters and poets to arcadian shepherds of a golden age.[6]

As is painting, so is poetry, and so, in this bucolic spirit, Paul Barolsky has called Piero di Cosimo a "pastoralist." In the *The Faun in the Garden*, Barolsky suggests that Vasari's Piero emerges from Nature to advance art and culture, in the company of Giotto the shepherd and Michelangelo the cultivator of stone. He argues further that Vasari centered his biography on Piero's mythological paintings and, through diction that mirrors its subject, the biography itself becomes bucolic poetry as well, grounded in the pastoral tradition.[7]

It could be said, moreover, that Vasari not only describes Piero's painted mythologies in pastoral language, but more precisely, he draws on a particular type of pastoral suited to the artist—the pastoral elegy—to shape Piero's life. The very structure of the Life of Piero parallels that of pastoral elegies so popular among the Neo-Latin poets of Vasari's day, including his elders (and Piero's contemporaries), Baldassare Castiglione and Jacopo Sannazaro. Their writing and Piero's painting share an elegiac diction, and Piero paints images evoked by the poets' words. His *Bacchanals, Satyr Mourning a Nymph*, and *Battle of the Lapiths and Centaurs* echo Sannazaro's woodland songs, faithful groves and caves, garlands and green ivy, full-fed flocks and sacred springs. The pastoral language of Sannazaro, whom Vasari characterized as a "gentiluomo napoletano e poeta veramente singolare e rarissimo," also fills Vasari's Life of Piero. He describes Piero's myrtle, dove, faun, wood-nymph, strange trees, and grottoes to laud the artist's diligence and invention—from landscapes to portraits, altarpieces to mythologies—while he fashions an elegy for an elegiac painter.[8]

### Vasari's Lament

Rooted in the lineage of Boccaccio and Giotto, Michelangelo and Sannazaro, Piero's pastoral genealogy inspires Vasari's biography, and his Life of Piero blossoms from the branches of a green artistic-family tree. Vasari begins the Life by placing Piero's art in the context of other

praiseworthy pastoral artists, following the Lives of Giorgione and Correggio in Part III. [9] Vasari compares Piero to these fellow pastoral painters, as he characterizes Piero's graceful style and soft coloring in diction (*morbidezza* and *grazia)* that he applies to their works as well.

Next, Vasari grafts Piero onto the branch of "good" artists who have "true" fathers. Vasari asserts that Piero was blessed by having not one, but two true fathers—"someone who teaches us excellence and gives us a good way of life." Piero's biological father, Lorenzo, recognized his son's talents, while Piero's artistic mentor, Cosimo Rosselli, "loved him as a son," and acknowledged that his student "had a more beautiful style and better judgment than he did himself."

Vasari then orchestrates Cosimo Rosselli's death as a catalyst for the elegiac tenor of Piero di Cosimo's life. The "strangeness of Piero's mind...showed still more after the death of Cosimo," Vasari writes. The author laments that Piero, being prone to melancholy, grieved so after the death of his true artistic father that "he stayed all the time shut up indoors and never let himself be seen at work." Neither letting his rooms be swept, nor his garden pruned, nor his trees and vines trimmed, Piero was "content to see everything run wild, like his own nature, asserting that nature's own things should be left to her to look after." The "odd and whimsical" Piero, mythical and untamed, first emerges here to become the atavistic caricature that we often perpetuate today. The roots of Vasari's characterization of the lamenting and lamentable Piero run deeper, however.

Vasari's Life of Piero is a song of loss, laced with pastoral references, lamentations, and meditations on life and death—the essential definition of the pastoral elegy. The ancient pastoral elegy may be characterized as a performance of pastoral sequences or moods recounted by a shepherd-narrator. The shepherd invokes muses to grace a lamentation for the deceased, and the deceased is mourned by Nature, which is personified by fellow herdsmen, nymphs, and satyrs.[10] Renaissance elegists from Petrarch to Sannazaro adopted the conventions of the genre, as a central narrator mourns the loss of a friend, a lover, a mentor, a city, or a civilization and then progresses through stages of grief and awareness: the lament of nature, the eulogy for the deceased, the apotheosis.[11] Vasari, too, follows these conventions, and his Life of Piero unfolds paragraph by paragraph as elegiac prose.

### Vasari's Elegiac Age

The ancient Greek word *elegeion*, or lament, originated as a flute song expressing grief over love, or war, or death. From its early identification by meter and during its fluctuating history, the elegy of ancient Greece evolves from eighth-century military songs of mourning for warriors to third-century poems of love and loss, refined by Theocritus in his *Bucolics*. The elegy as penned by ancient Roman and Renaissance poets grows into a vehicle for the expression of a wide range of topics, themes, and feelings, cultivated as a pastoral by Virgil in his *Eclogues*, and then transformed by Ovid into a love poem in elegiac couplets.[12] Ovid personifies Elegy herself in the *Amores*, where she appears in a pastoral setting—an ancient wood of sacred springs, grottoes, and songbirds. Ovid's Elegy is lovely but limping, a reference to the poet's elegiac couplets of alternating hexameter and pentameter lines. Ovid says that when Cupid lopped off one of Elegy's feet, he also struck the poet with his arrow and love became his theme. The tale helps to

explain one facet of the prismatic elegy, as love poem or *epithalamium*, as well as dirge or *epicedium*.[13]

Vasari's age is regarded as a time of transition for the elegy. Despite oscillations in elegiac subject, theme, and meter, however, its pastoral nature remained constant. Petrarch, Boccaccio, and Neo-Latin poets practiced the pastoral elegy as both a song of love and a song of lament, before the elegy coalesced during the seventeenth century into the melancholic poem of mourning as we think of it today.[14] John Milton represents both the end of a period in which the pastoral elegy flourished and the beginning of modern elegy—a poem that mourns the death of a beloved individual—as we know it in the poetry of Rilke, or Auden, or Zbigniew Herbert.[15] Today, poet Edward Hirsh defines the modern elegy as a poem "ritualizing grief into language and thereby making it more bearable."[16]

When Vasari wrote his Life of Piero, the Italian pastoral elegy had reached its height of popularity. Practiced by a circle of humanist poets in the early sixteenth century, the Italian elegy thrived during second half of the century and then declined during the seventeenth century, as its influence spread to other European cultures in France, Germany, and England.[17] During Vasari's elegiac age, the popularity of the elegy had been celebrated in the 1546 publication of the *Auctores Bucolici*, a collection of elegies by thirty-eight Neo-Latin pastoral poets, including Petrarch, Boccaccio, and Vasari's contemporaries. Virgil's *Eclogues* were widely known, and Aldus of Venice had published Theocritus's *Idylls* in 1495, which were translated into Latin hexameters by Elius Eobanus of Hesse in 1531.[18] Modern elegists emulated the ancients, and Theocritus, Ovid, and Virgil inspired early elegies by Petrarch and Boccaccio and later poems by Castiglione and Sannazaro. Just as Ovid and a circle of Augustan Roman poets including Catullus, Propertius, and Tibullus perfected the elegy as love poem, so a coterie of Renaissance poets comprising Giovanni Pontano, Castiglione, and Sannazaro, among others, refined their elegies on love, friendship, death, and a lost golden age in response to one another.[19]

### Elegies from Propertius to Piero

In Rome, Raphael immortalized these ancient and modern elegists in the *Parnassus* for Julius II's *Stanze*. Among the modern poets in this painting, Sannazaro and Castiglione are believed to stand in the company of Petrarch, Boccaccio, Ovid, Propertius, and Virgil.[20] Just as the pastoral elegy became the genre of exchange within these circles of poets, so an elegiac tenor resonates within paintings of a kindred spirit by Raphael's contemporaries.

The pastoral poets and painters of sixteenth-century Italy lamented lost worlds away from urban centers where art, music, poetry and painting originated. Set in Urbino, near Propertius's native Umbria, Castlligone's *Book of the Courtier* has been called an elegy for a lost world of courtly innocence.[21] In Naples, the home of the poets' Academy, Sannazaro wrote *Arcadia*, his melancholic shepherd's songs, and later invented the fisherman's eclogue, in homage to Virgil. As Sannazaro's settings for his piscatory eclogues shift from meadows to seashores, fishermen take the place of shepherds, and nymphs become nereids, while the poet laments love spurred or lovers lost to death. Raphael's *Galatea* stands within this tradition, as does Piero di Cosimo's frieze of *Tritons and Nereids*.[22]

Fɪɢ. 1  Piero di Cosimo, *Satyr Mourning a Nymph*, ca. 1500-10.

The shepherds and fisherman, nymphs and nereids, satyrs and tritons, green fields and sandy shores that inform the yearning poets' songs are given visual life in paintings by Piero di Cosimo, Signorelli, Botticelli, Giorgione, Titian, and Correggio. Many a painted idyll may be regarded as a visual elegy, and a catalogue of painted lamentations from the late quattrocento and cinquecento would include Piero's *Satyr Mourning a Nymph* and *Battle of the Lapiths and Centaurs*; Signorelli's *School of Pan*; Botticelli's *Primavera*; Sebastiano del Piombo's *Venus and Adonis*; Jacopo del Sellaio's *Orpheus*, and even the *Story of Jupitor and Io* by Bartolommeo di Giovanni and its more famous legacy by Correggio. Small, tender stories of fidelity and devotion painted by the Griselda Master—Eunostus of Tanagra, Artemisia, and Tiberius Gracchus—as well as the grand histories of Virginia and Lucretia also have elegiac overtones, as grieving fathers, remorseful lovers, chaste widows, and desolate widowers mourn the death of their beloveds.[23]

It has been observed that just as myths of mourning intertwine to enrich pastoral poems of loss and lamentation—for example, Cephalus and Procris, Apollo and Daphne, Pan and Syrinx, Jupitor and Io in Ovid's *Metamorphoses*—so they intermingle in the Renaissance paintings that are the poems' counterparts.[24] Piero's image of a satyr mourning an unknown nymph, perhaps Procris, partakes of Ovidian conventions and Petrarchan conceits (fig. 1). In cool Arcadia, Ovid writes of Syrinx, "a woodland nymph," so like the goddess Diana, "fled through pathless places until she came to Ladon's river, flowing peaceful along sandy banks, whose water halted her flight."[25] Along the sandy banks in Piero's painting, a satyr tenderly contemplates a nymph's death, his bewilderment and sorrow mirrored in the lost look of his companion dog. Just as the nymph is reminiscent of Ovid's Syrinx or Procris, so Piero's sad satyr embodies the sensibilities of Petrarch's elegist in the *Bucolicum Carmen*: "I alone remain with my grief on the sorrowful shore."[26]

Piero summons these elegiac emotions again in the *Battle of the Lapiths and Centaurs*, a painting that may rival Signorelli's *School of Pan* as a lamentation for a faded pastoral age (fig. 2). Signorelli's image, a painted flute song, has been characterized by Paul Barolsky as "one of the greatest pastorals of the Renaissance...a painter's nostalgic vision of a lost pastoral world."[27] While Signorelli's picture is graceful and contemplative, Piero's is active and disruptive. Clubs

Fig. 2 Piero di Cosimo, *Battle of the Lapiths and Centaurs*, ca. 1505.

are raised, wine is spilled, bones are broken. It is easy to imagine the unruly hand of Vasari's wild and raging artist here. Yet, just as elegiac conventions inform Vasari's Life of Piero, so Piero's painting arrests the elegy in all of its powerful, and poignant, complexities.

Piero's image is a painted song of loss and love at once, where themes of war and death are inseparable from those of tenderness and devotion. A battle rages at the wedding of Pirithous and Hippodame, and yet, the violence serves as mere background to war's consequence. In the foreground, centaurs of profound humanity mourn their final moments together, as Hylonome cradles the wounded Cyllarus, her promised lover. Inspired by Ovid's tale in the *Metamorphoses*, Piero interlaces nuptial and funeral elements as the poet does, and doing so, the artist reveals the deeper nature of the elegy as a song of mourning.[28] Piero's painted elegy for Cyllarus and Hylonome conjures up ancient laments for lifeless warriors and conflates them, gently, with Renaissance laments for lost love.

### Vasari's Triumphs of Love and Death

Piero's elegy reveals an essential nature of Renaissance art by intertwining nuptial and funereal themes. Weddings and funerals were occasions for art. Pastoral paintings and masques celebrated nuptials; just as frescoes, tomb sculpture, processions, and elegies memorialized the dead. In his Life of Piero, Vasari observes that the elegiac artist created both triumphs of love in the form of nuptial mythologies and triumphs of death in the form of funeral chariots.

Marveling over the great fanfare surrounding Piero's spectacle of the *Triumph of Death*, Vasari tells us that Piero designed a *carro della morte* drawn by oxen (*bufali*), painted with human bones and white crosses, and surmounted by a figure of Death with scythe in hand. Piero's imagery and Vasari's attentive descriptions derive from Petrarch's *Triumphs*, illuminated in late fifteenth century manuscripts (fig. 3). Torchbearers, mourners, and impersonators of the dead accompanied Piero's cart, and Vasari then says that they chanted "music full of melancholy," a psalm of "grief, woe, and penitence":

> We are dead, as now you see
> And we'll see you dead too
> Once alive like you were we
> Just like us will you be

196

*Morti siam, come vedete*
*Cosi morti vedren voi*
*Fummo gia come voi siete*
*Vo'sarete come noi*

This Italian *memento mori* may be traced at least to the mid trecento, and we recognize it as a variation of the inscription beneath Masaccio's *Trinity*, the fresco that Vasari hid behind his own altarpiece for the Capponi family in Santa Maria Novella in 1570.[30]

Vasari's meditation on death in the middle of Piero's Life is an elegiac device. In her study of the elegy, *Placing Sorrow*, Ellen Lambert observes that the Renaissance elegy is a private, personal lament, more self-conscious and less public than its performed ancient antecedents. She describes the Renaissance elegy as "most often, an occasional piece, bound not to the pastoral series but to the subject that it calls forth…it might take place among the funeral obsequies, perhaps even be pinned to the hearse itself… and becomes a gift to the deceased rather than the listening herdsmen…."[31]

Vasari's personal tribute to Piero as the inventor of carnival masquerades and chariots of death is indeed a gift to the artist that could well have been pinned, metaphorically, to Piero's hearse itself. It is also a turning point in Vasari's narrative. As it turns, Vasari's Life of Piero progresses through elegiac conventions summarized by Peter Sacks in his book *The English Elegy*: 1) a pastoral context; 2) a vegetation deity; 3) a language of repetition and refrain; 4) passages of questioning and anger; 5) processions of mourners; 6) movement from grief to consolation; 7) images of resurrection; 8) a resolution that assures the elegist's survival.[32]

As we have seen, Vasari's Life of Piero introduces the painter in a pastoral setting, in the context of Giorgione and Correggio. In the second paragraph, Vasari invokes Nature, who grants Piero a lofty spirit fond of solitude and a beautiful style to be seen in his landscapes. Throughout Piero's Life, the author punctuates his narrative with refrains of the beautiful, the bizarre, the strange, and the fanciful, repeated to illuminate both the states of Piero's mind and his art. The elegist's moment of questioning and anger becomes Vasari's admonition to young artists. Remembering Piero's fatal flaw in failing to care for himself, Vasari creates a parable about the squandering of artistic promise and cautions his readers to heed Piero's example. Vasari peppers his chronicle of Piero's artistic achievements with comments about the artist's undermining eccentricities: "through his brutish ways, he was rather held to be a madman, even though at the end he did harm to no one except himself."

Vasari then creates a procession of mourners to guide the reader to the end of Piero's life, declaring that Piero had earned a distinguished reputation for creating the *carro della morte* and public ceremonial decorations. Piero, eulogizes Vasari, is "the reason why…increasingly witty and ingenious inventions came to be devised so that truly the city of Florence has never had an equal for . . . putting on such festivals."

Following his account of Piero's dirge-like spectacle, Vasari returns to narrating Piero's life, as though to finish on a note of elegiac consolation and promise. He quotes Piero's colleagues and students, Andrea di Cosimo and Andrea del Sarto, and resumes his lively history of Piero's art, describing paintings for the Servite friars, the Pugliese, the Strozzi, the Vespucci. As

O ciechi iltanto affaticarche gioua·
　Turn tornate allagram madre antica·
　El nome uoltro a pena fititruoua.

N on afpectate/che lamotte fcocchi
Chome fa lapiu patte:che per certo
Infinita e lafchiera degli fciocchi·

FIG. 3 Attributed to Francesco Rosselli (after Cosimo Rosselli?), *The Triumph of Death*, ca. 1480.

an elegist, Vasari assures the reader that life continues: Piero's legacy survives in his portraits of fathers and grandfathers, such as *Francesco Giamberti*; in his depictions of famous women, such as *Cleopatra*; in works by his disciple, Andrea del Sarto; and of course, in Vasari's history.

### Vasari as Elegist

Would Vasari consciously have adapted elegiac conventions to commemorate Piero's life? The elegies of Vasari's day were dedicated to professional colleagues, family members, and patrons. By the late sixteenth century, the genre was so popular that it was mocked, for example by Marco Publio Fontana in *Caprea*, his elegy for a friend's pet goat.[33] It has been observed that we often understand the conventions of a genre through its parody, and Patricia Rubin has demonstrated that Vasari drew from many genres—history, poetry, the *novella*, hearsay—in his writing about painting.[34] Vasari's *Lives* follow the conventions of Renaissance biography, as Rubin observes. Life by life, the sequences consist of narratives of deeds, descriptions of character, death, burial, epitaphs, and references to students—all devices employed by biographers to commemorate their subjects. Rubin also notes that Vasari not only incorporated rituals of mourning into many *Lives* and but also invented epitaphs to honor the artists of his biographies.

Biography celebrates life; elegy mourns its passing. If the elegy includes pastoral imagery, nature grieving, songs of lamentation, and the living remembering, then Vasari's biography of Piero contains the trappings of elegy, just as Piero's art does. Vasari's Masaccesque *memento mori* within Piero's life serves both as an inventive epitaph, and as a nostalgic nod to the originator of modern painting and the beginnings of a modern golden age, a renewed arcadia. Masaccio, another "extraordinarily neglectful artist" in Vasari's words, "perceived that the best painters follow nature," and pursued his art to become a founding father of Italian painting, the history of which Vasari chronicles.[35] Had Piero, from whom Nature hid no secrets, "paid more heed to himself," Vasari elegizes, he could have followed this path and "won recognition for the great talent he possessed." Vasari offers tall tales about Piero—a poetic history, as Paul Barolsky believes, about a poetic painter and an elegiac artist. If Vasari is perceived as historian, biographer, journalist, gossip, and novelist, could he not be regarded as an elegist as well?

NOTES

1. Paul Barolsky, *Why the Mona Lisa Smiles and Other Tales by Vasari* (University Park: The Pennsylvania State University Press, 1991), 4.

2. Giorgio Vasari, "Life of Piero di Cosimo," *Lives of the Artists*, trans. George Bull, vol. 2. (Middlesex: Penguin Books, 1987), 105–15. All quotations from Vasari's "Life of Piero di Cosimo" in this essay have been taken from this source. See also, Giorgio Vasari, "Piero di Cosimo," *Le Vite de' più eccellenti pittori, scultori ed architettori scritte*, ed. Gaetano Milanesi, vol. 4, pt. 3 (1906; reprint, Firenze: G. C. Sansoni, editore, 1981), 131–44.

3. Erwin Panofsky, "Early History of Man," *Studies in Iconology* (New York: Harper & Row, 1972), 67.

4. See Louis Alexander Waldman, "Fact, Fiction, Hearsay: Notes on Vasari's Life of Piero di Cosimo," *Art Bulletin* 82 (March 2000: 171–79). Waldman notes that a painter, Nicola Giovanni di Rosa Caprini, is recorded in Piero's house, and speculates from the records about the hour of Piero's death. See also Dennis Geronimus. "The Birth Date, Early Life, and Career of Piero di Cosimo." *Art Bulletin* 82 (March 2000: 164–70), and Sharon Fermor, *Piero di Cosimo: Fiction, invention, and fantasia* (London: Reaktion Books Ltd, 1993), 13–28.

5. Giorgio Vasari, "Life of Masaccio." 125, and "Life of Michelangelo Buonarroti," 423-24, in *Lives of the Artists*, trans. George Bull (Harmondsworth: Penguin Books [1965], 1976).

6. For Boccaccio's statements in *Amorosa Visione* and *Genealogy of the Gods: XIV*, see *Boccaccio on Poetry*, ed. Charles G. Osgood (Indianapolis: The Bobbs-Merrill Company, Inc., 1956), 56, 155, nn. 9 and 10.

7. Paul Barolsky, *The Faun in the Garden* (University Park: The Pennsylvania State University Press, 1994), 87, 94.

8. Baldassare Castiglione (1478–1529) and Jacopo Sannasaro (ca. 1456–1530) were Piero's contemporaries (1461/62–1522, see preceding n. 4). Sannazaro's first elegy, to Lucio Crasso (ca.1430–90), his teacher, is dated to the 1470s; see elegy 1.1 in *The Major Poems of Jacopo Sannazaro*, trans. Ralph Nash (Detroit: Wayne State University Press, 1996), 99. W. Leonard Grant dates the golden age of Italian Neo-Latin poetry from the 1450s through the 1500s, and notes that "between 1300 and 1700, over two hundred Neo-Latinists wrote anywhere from one to twenty eclogues a piece," see W. Leonard Grant, *Neo-Latin Literature and the Pastoral* (Chapel Hill: University of North Carolina Press, 1965) 62. Vasari characterizes Sannazaro while describing his tomb in the "Life of Fra Giovann'Agnolo Montorsoli," Vasari-Milanesi, vol. 6, 637.

9. Giorgio Vasari, "Giorgione," "Correggio," "Piero di Cosimo," in Vasari-Milanesi, vol. 4, pt. 3, 91–100, 109–22, 131.

10. See Ellen Zetzel Lambert, *Placing Sorrow: A Study of the Pastoral Elegy Convention from Theocritus to Milton* (Chapel Hill: The University of North Carolina Press, 1976), especially on Theocritus and what is considered the first pastoral elegy, the lament for Daphnis in the first *Idyll*, and on "Petrarch, Boccaccio, Castiglione, Sannazaro," xii, 51-88. I want to thank Roy Eriksen for this reference. See also Peter M. Sacks, *The English Elegy* (Baltimore and London: The Johns Hopkins University Press, 1985), 4.

11. For progressions through the elegy from grief to consolation, see Lambert, *Placing Sorrow*, 84, and Sacks, *The English Elegy*, 4. For Neo-Latin elegists, including Sannazaro and his circle, and variations on elegiac subjects, for example, Sannazaro's elegies to Rome, Venice, and Naples, see William Kennedy, *Jacopo Sannazaro and the Uses of the Pastoral* (Hanover and London: University Press of New England, 1983), 73, 78. See Grant, *Neo-Latin Literature and the Pastoral*, 306 ff.

12. For a brief history of the origins of the elegy as a fluted military song of mourning and its evolution as a lyric poem of lamentation or love in hexameter and pentameter lines (as opposed to the epic pentameter), see the *Oxford Classical Dictionary*, ed. N.G.L. Hammond and H. H. Scullard (Oxford: Clarendon Press; London: Oxford University Press, 1970), 378–79; Sacks, *The English Elegy*; and Edward Hirsh, *How to Read a Poem* (New York: Harcourt Brace and Company, 1999), 85, 277–78. Albin Leskey reports that Euripides uses the word *elegos*, meaning a song of lamentation; Critias uses *elegion* in the fifth century in reference to meter; and later Horace calls the elegy a "lamentation" and alludes to its unknown inventor in the *Ars Poetica*; see

Albin Leskey, *A History of Greek Literature*, trans. James Willis and Cornelis de Heer (New York: Thomas Y. Crowell Company; Great Britain: Methuen & Co. Ltd., 1966), 117, 118–28.

13. Ovid *Amores*, Bk. 1.1; Bk. 3.1, in Ovid, *The Erotic Poems*, trans. Peter Green (London: Penguin Books Ltd, 1982), 78, 86, 137. "So let my verse rise on six stresses, drop to five on the downbeat" writes Ovid of the elegiac meter that Petrarch and others later adopted. Grant classifies the commemorative pastoral eclogue into three types: the *genethliacon* (birthday); the *epithalamium* (wedding); and the *epicedium* (dirge or elegy), see Grant, *Neo-Latin Literature and the Pastoral*, 290 ff.

14. See Lambert, *Placing Sorrow*, xix, 81-83, and Hirsh, *How to Read a Poem*, 277, also William Packard, *The Poet's Dictionary* (New York: Harper & Row Publishers, 1989), 49.

15. Lambert observes that Milton's "Epitaphim Damonis" of 1639, which draws on Castiglione's elegy "Alcon" as its primary source, "comes, like 'Lycidas,' among the vernacular laments, at the end of a tradition," in *Placing Sorrow*, 82. The modern elegy is given voice in, for example, Percy Bysshe Shelley's "Adonais"; Rainer Maria Rilke's "First Elegy" from the *Duino Elegies*; W.H. Auden's "In Memory of W.B. Yeats"; and Zbigniew Herbert's "What Our Dead Do" and "Elegy for the Departure of Pen Ink and Lamp."

16. Hirsh, *How to Read a Poem*, 84, 278.

17. See Lambert, *Placing Sorrow*, 81–82.

18. See Lambert, *Placing Sorrow*, 81–82, 214, n. 28; 215, n. 35.

19. Kennedy discusses the appeal among Renaissance poets of the ancient Roman concepts of *sodales* (colleagues), the *sodalicium* (members of a group), and *convictus* (a friendly circle) shared by Catullus, Tibullus, Propertius, and Ovid who wrote their poems within 50 years of one another, in *Jacopo Sannazaro and the Uses of the Pastoral*, 73. Grant details cinquecento circles of poetic exchange, for example: Giovanni Pontano of Cerreto (1424–1503) served as the head of the Academy of Naples and mentored his more famous protégé, Jacopo Sannazaro, who in turn led the Neapolitan Academy between 1525 and 1530. Giovanni Pontano wrote the pastoral elegy "Meliseus" to mourn his wife Adriana Sassone; the monk Basilio Zanchi of Bergamo (1501–58) then wrote the elegies "Meliseus" to mourn Giovanni Pontano and "Damon" to mourn Castiglione; his Fifth Eclogue mourns Venetian poet Andrea Navagero (1483-1529). Both Castiglione and Pontano are said to have inspired the shepherds in Navagero's own elegy "Damon" for Julius II, a panegyric for Easter 1512 that mourns a papal defeat and then celebrates the turn of events in the pope's favor. Grant also notes

other elegies within the papal circle, including several anonymous pastoral dirges for Pietro Bembo from 1548. See Grant, *Neo-Latin Literature and the Pastoral*, 306-14, 332-33, and also Lambert, *Placing Sorrow*, 213-14, n. 27; 215, n. 34.

20. Identification of the modern poets in Raphael's *Parnassus* is debated. Sannazaro and Castiglione are believed to stand among the ancient and modern poets on the far right. The figures have been variously identified in descending order to Horace, who is seated in the foreground opposite Sappho: Tebaldeo or Castiglione, Boccaccio, Tibullus, Aristo or Tebaldeo, Sannazaro or Propertius, Ovid or Sannazaro. In descending order on the left are Virgil, Homer, Dante, and Petrarch. See *The Complete Paintings of Raphael*, intro. Richard Cocke, notes and catalogue by Pierluigi de Vecchi (New York: Harry N. Abrams, 1969), cat. no. 85.

21. See Lambert, *Placing Sorrow*, 74–75, 213, n. 26.

22. Sannazaro's *Arcadia* dates to the 1480s and was first published in 1504, though selections were copied in Naples in 1489. See Carol Kidwell, *Sannazaro and Arcadia* (London: Gerald Duckworth & Co. Ltd., 1993), 9–34; 207, n. 2. Among Sannazaro's *Piscatory Eclogues*—his "pastoral" elegies to the Neopolitan coast published in 1526—are the first through fourth eclogues, titled "Phyllis," "Galatea," "Mopsus," and "Proteus." See Grant, *Neo-Latin Literature and the Pastoral*, 205–13; Lambert, *Placing Sorrow*, 75-80. Poliziano is often cited as the source for Raphael's *Galatea* in the Farnesina, in Rome, ca. 1511, see *The Complete Paintings of Raphael*, 105; and Ovid for Piero's Tuscan frieze, which dates ca. 1510 and has been associated with his *Battle of Lapiths and Centaurs*, see Fermor, *Piero di Cosimo*, 59–60.

23. See Paul Barolsky and Anne Barriault, "Botticelli's Primavera and the Origins of the Elegiac in Italian Renaissance Painting," *Gazette des Beaux Arts* (Septembre 1996): 63–70; and Anne B. Barriault, *Spalliera Paintings of Renaissance Tuscany* (University Park: The Pennsylvania State University Press, 1994), 145-52, 154-55. See also Barolsky on the intertwining of ancient myths in elegiac painting, especially Ovid and Botticelli, in *The Faun in the Garden*, 23. See Ovid, *Metamorphoses*, trans. Rolfe Humphries (Bloomington and London: Indiana University Press, 1955), Bk. 1 and Bk.7, for example. Ovid unfolds the story of Pan, Syrinx, and the birth of the Pan pipes from lost love within the story of Io, the nymph who was loved by Jupitor, cruelly transformed into a cow to hide her from a jealous Juno, and desperately sought by her grieving father, Inachus, the river god. The story of Pan and Syrinx becomes Mercury's flute song by which he lulls Io's captor, Argos, to sleep and rescues the nymph, as

Bartolommeo di Giovanni charmingly displays in his two panel paintings.

24. Barolsky, *Faun in the Garden*, 23.

25. Ovid, *Metamorphoses*, Bk. 1, 701–12.

26. *Solus ego afflicto merens in litore mansi*; see Lambert on Petrarch's eclogues in *Placing Sorrow*, 58–61.

27. Barolsky, *The Faun in the Garden*, 94–95.

28. Ovid, *Metamorphoses*, Bk. 12, 210–432. From lines 416–20: "...They loved each other/Together they ranged the mountain-sides, together/Rested in caves; together they had come/This time, to the palace of the Lapithae/Together joined the battle...."

29. Anne B. Barriault, *Spalliera Paintings of Renaissance Tuscany*, 95–109.

30. For illustrations of Petrarch's *Triumphs*, see Annarosa Garzelli, *Miniatura Fiorentina del Rinascimento 1440-1525* (Firenze: Giunta regionale Toscana & La Nuova Italia Editrice, 1985) vol. 1, 120 ff, and vol. 2 (ills). The verse and translation is taken from George Bull, see preceding n. 2. Vasari says the entire company sang the psalm of David, the *Miserere*. On related inscriptions in Pisa's Camposanto and the Italian *memento mori*, see L. Guerry, *Le Thème du Triomphe de la Mort dans la peinture italiene* (Paris, 1950). The inscription in Masaccio's fresco reads: *io fu gia quel che voi siete e quel chio son voi anco sarete* (I was once that which you are and that which I am you also will be), see Frederick Hartt, *History of Italian Renaissance Art*, 2nd ed. (Englewood Cliffs: Prentice Hall, Inc., 1979), 205. On Masaccio's fresco and Vasari, see Eve Borsook, *The Mural Painters of Tuscany* (Oxford: Clarendon Press, 1980), 58–63, and Ursula Schlegel, "Observations on Masaccio's Trinity Fresco in Santa Maria Novella," *Art Bulletin 45* (March 1963): 19–33. For Vasari's interest in triumphal chariots by Piero and their roots in Petrarch, a fellow Aretine, see Barolsky, *Mona Lisa*, 82–83.

31. See Lambert, *Placing Sorrow*, 83.

32. For the conventions of the elegy, see Sacks, *The English Elegy*, 4; and Hirsh, *How to Read a Poem*, 278.

33. See Lambert, *Placing Sorrow*, 85; and Grant, *Neo-Latin Literature and the Pastoral*, 317.

34. Patricia Lee Rubin, *Giorgio Vasari: Art and History* (New Haven: Yale University Press, 1995), 160, 169–71, 185–86, 403–12. Among Vasari's sources that Rubin cites: Dante, Petrarch, and Boccaccio; Plutarch, Pliny, and Cicero; artists' notes, including Ghirlandaio, Raphael, and Ghiberti's *Commentaries*; historians Leonardo Bruni and Paolo Giovio, and conversations.

35. Vasari, "Life of Masaccio," *Lives of the Artists*, 124–25.

# Michelangelo's Snowman
# and the Art of Snow in Vasari's Lives

I do believe, divinest Angelo,
that winter-hour, in Via Larga, when
They bade thee build a statue up in snow
And straight that marvel of thine art again
Dissolved beneath the sun's Italian glow,
Thine eyes, dilated with the plastic passion,
Thawing too, in drops of wounded manhood, since,
To mock alike thine art and indignation,
Laughed at the palace-window the new prince . . .[1]

Thus Elizabeth Barrett Browning imagined Michelangelo's statue of snow as it "trembled and withdrew" from the mockery of Piero de'Medici. Its eyes "'flattened," its brow "palseyed," and its right hand, once proudly raised, "dropt," now "a mere snowball".[2] Reduced to a puddle in the Via Larga, Browning's snowman foretells a waning golden age. Just as it mourns the passage of Lorenzo Il Magnifico and the accession of the cruel Piero, it weeps for the uncertain fate of a country on the eve of the 1848 revolt; and perhaps for Browning herself, who quietly observes Florence from the confines of her room at Casa Guidi.

The following considers the creation and the legacy of the most famous snowman ever built: Michelangelo's snow-sculpture; among his "lost" masterpieces, which he fashioned one snowy winter day at the behest of Piero de' Medici. We first hear of Michelangelo's *opera giovanile* in Ascanio Condivi's 1553 biography of the great artist. In an episode purportedly dictated by Michelangelo himself, the "living oracle of his [Condivi's] speech," Condivi recounts the events that led to the creation of the sculpture. When his beloved patron Lorenzo de'Medici died, the grief-stricken Michelangelo departed the Medici court and returned to his father's house.[3] At first unable to set his mind to making art, Michelangelo at last emerged from his despair, purchased a block of weathered marble, and fashioned from it a Hercules four braccia high.[4] At this point Lorenzo's successor, Piero de'Medici, enters Condivi's narrative. Michelangelo had hardly finished the Hercules, says Condivi, when Piero called the artist back to Florence. Piero, "being young" and lacking the grace of his father, had the young master build in his courtyard *not* a marble statue, but a statue of snow (*una statua di neve*). Michelangelo's snow-sculpture earned him a position in the Medici household, where the artist was given a room and a place at the duke's table, as in the time of Lorenzo. Michelangelo's father saw that his son resided among

illustrious men and dressed him in finer clothing, as befit his status at the Medici court. Condivi adds that Michelangelo fast became one of Piero's prized possessions—along with a Spanish groom, who had won the duke's favor not only because of his beauty, but also for his astonishing ability to run faster than the duke's own charger.

Condivi's account resounds with chords of dismay for Piero's irreverant treatment of the divine Michelangelo. For Condivi, as for Browning, the tale of Michelangelo's snowman evokes the fate of Florence under Lorenzo de' Medici's tyrranical son. Alas, Piero was no Hercules. Piero's commission of a snow-sculpture from the most famous of artists was but a whim; a childish request from a duke who had inherited neither the wisdom nor the "grace" of his father. Piero's courtyard, now a barren space save for Michelangelo's melting statue, hardly compared to Lorenzo's mythical sculpture garden of San Marco, that *locus amoenus* that had cultivated the imaginations of so many Florentine artists and poets, including the young Michelangelo. To add insult to injury, Piero had inherited nothing of his father's appreciation for great artists, for he hardly distinguished between Michelangelo and the beautiful, swift Spanish groom. Both men held equal footing in Piero's collection of "rare persons."

The tale of Piero's impious commission makes up the first episode in Condivi's brief history of the downfall of the Medici. It is the vision of Cardiere, a minstral at Piero's court and friend to Michelangelo, which heralds Piero's expulsion. In the next event of Condivi's narrative, Cardiere recounts that Lorenzo had appeared to him in a dream, and "commanded him to tell Piero that he would shortly be driven from his house, never to return again." Cardiere rushes to warn Piero of the impending doom, but the "insolent" and "intemperate" Piero, as Condivi puts it, dismisses Cardiere's vision with "a thousand jeers." Michelangelo wisely takes heed and flees to Bologna. Shortly thereafter, Piero and his court were driven from Florence, and for the time being, Medici power had dissolved. With the exile of Piero, Condivi completes his episode of Michelangelo's melting statue. Even though Michelangelo would return some years later to carve his marble David, a monument to the renewed Florentine Republic, the Laurentian age had ended. Lorenzo's idyllic garden, now but a memory, would bear no more fruit.

Fifteen years after Condivi published Michelangelo's "autobiography," the snow-sculpture materialized once more in the second edition of Vasari's *Lives* (1568).[5] In Vasari's account, Lorenzo dies and the grieving Michelangelo returns to his father's house. There, he sets to work on the marble Hercules.[6] Despite Lorenzo's death, Vasari recounts that all the while, Michelangelo maintained "intimate" relations with Piero. From Vasari we learn that Piero often asked the artist's advice on antique cameos, gems, and other objects that he wished to collect. Then, on a snowy winter day, Piero had Michelangelo build a statue of snow. The beautiful sculpture so pleased the duke that he "did many favors on account of his [Michelangelo's] talents." In turn, the artist's father recognized his son's heightened status at the Medici court by providing him with finer clothing than before.

Although the main events of Vasari's story of the snow-sculpture recall Condivi's tale, his account of Michelangelo's relationship with Piero tells a much different story. Though Vasari later attributes the expulsion of the Medici and Michelangelo's decision to depart for Bologna to Piero's "insolence and bad government," he does not link the snow-sculpture with Piero's youthful indifference, as in Condivi's tale. Nor do the duke's favorite Spanish groom or the

visionary Cardiere appear in the later tale. For Vasari, Piero's limitations as a ruler were disconnected from his patronage, for not only did the duke commission the snow-sculpture, but he judiciously called upon Michelangelo for advice on antiquities. Just as Lorenzo had amassed a garden full of antiquities and had surrounded himself with famous artists, so Piero carried on his father's tradition of collecting and, like Lorenzo, maintained ties with the divine artist. Whereas Condivi used Michelangelo's snow-sculpture to illustrate the moral and aesthetic vaccum at the heart of Piero's rule, which led inexorably to Piero's expulsion, in Vasari's *Lives*, the activity of building snowmen is essential to the education of young sculptors.

Snow was not unusual to Florentine winters of the late fifteenth century, nor was it uncommon for young boys—or artists—to try their hand at snow sculpture. If we are to believe the Florentine diarist Landucci, the fateful storm that provided the raw material for Michelangelo's creation occurred in 1494, during "the severest snowstorm in Florence that the oldest people could remember":

> And amongst other extraordinary things, it was accompanied by such violent wind that for the whole day it was impossible to open the shops, or the doors and windows. It lasted from the Ave Maria one morning till the Ave Maria the next morning, twenty-four hours, without ceasing for a minute, and without the wind abating, so that there was not the slightest crack or a hole, however small, that did not let a heap of snow into the house. In fact, there was not a house so hermetically sealed as not to become so full of snow that it took several days to clear it out. All along the street were heaps of snow, so that in many places neither men nor beasts could pass. There was such a quantity that it took a long time to melt away, as sometimes when boys made a snow-lion. In fact, these mountains lasted a week. It is difficult to believe without having seen it.[7]

Like each of the four winter storms that Landucci recorded between 1494–1515, the snowfall of 1494 not only inspired wonder, but also frustration, a sentiment familiar to anyone who has cursed the task of shoveling snow.[8] While the citizens of Florentince were busy cleaning up the mess, Landucci tells us that Florentine boys took to the streets and fashioned snow-lions.

The snow-lions that Landucci described in his account of the January 1494 snowfall made additional appearances during the winter storms of 1494, 1500, and 1510, and even as early as 1409, according to an entry in Bartolommeo del Corazzo's diary. The lions, which were to be found "on every corner and on the loggias" throughout Florence, perhaps echoed the Florentine *marzocchi*, their permanent, stony counterparts.[9] Artists also took part in the snow-sculpting. In his entry of 1409, Corazzo records a six-foot Hercules in the piazza of San Michele Berteldi, and Landucci mentions a proliferation of anthropomorphic and architectonic sculptures in his account of the 1510 snowfall. In addition to the snow-lions, Landucci saw "many nude figures made also by good masters at the Canto de' Pazzi; and in Borgo San Lorenzo a city with fortresses was made, and many galleys . . ."[10] For Florentine youths and artists alike, the snow presented an opportunity for recreation. For artists, moreover, the snow provided a means to try their hand at sculpture of monumental proportions.

The practice of snow-sculpture entails both an additive and a subtractive process. Snow,

much like clay, is a malleable substance that lends itself well to modeling, while its adhesive nature is ideal for adding appendages to a work in progress. To define negative contours, the snow-sculptor must remove excess snow or, in its frozen state, the sculptor would require a hammer and chisel to shape an image. Unlike clay, generally used for small models, snow comes free of charge, with no additional labor, and in ample supply—until it melts, of course. As such, snow presents an ideal medium for creating figures of monumental scale. The end product, a *bozzo* of snow, would have resembled a glistening colossus of the whitest marble. Thus Leonardo da Vinci alluded to snow as a metaphor for marble in his description of the marble sculptor who, at the end of the day, is "covered in minute chips of marble, which make him look as if he is covered in snowflakes."[11]

It is within the tradition of snow-sculpture in Renaissance Florence that we can appreciate Vasari's detailed account of young Baccio Bandinelli and his early experimentation with the medium. When a great quantity of snow fell one winter, Girolamo del Buda, "a common-place painter" and acquaintance of Baccio, challenged the young artist to make out of snow a Marforio, a reclining river god. Vasari tells us that young Baccio set to work right away on his colossus of snow, "as if it were marble":

> . . . enthusiastically throwing off his cloak . . . he set his hands to the snow, and, assisted by other boys, taking away the snow where there was too much, and adding some in other places, he made a rough figure (*bozzo*) of Marforio lying down, eight braccia in length.[12]

After Baccio had finished his task, Girolamo del Buda and others marveled that such a "young and small" boy could make a snow-sculpture so vast in scale. With his colossal snow-Marforio, Baccio had proved his aptitude for monumental sculpture. Seeing his son's inclination for sculpture, Baccio's father transferred the boy from his own workshop, which specialized in draftsmanship and goldsmithery, to the workshop of the sculptor Giovan Francesco Rustici.

The Marforio colossus not only marks young Baccio's first effort in monumental sculpture, but, similar to the tale of Michelangelo's experimentation with snow, it also foreshadows Baccio's career as a sculptor of marble. In a Vasarian contest between a painter and sculptor, Baccio accepts the challenge of building a colossus of snow, and in so doing, astonishes his challenger, the painter Girolamo del Buda. By having his protagonist build a snow-Marforio, a classical river god, Vasari alludes to Baccio's life-long endeavor to replicate antique statuary.[13]

Condivi's story of the mocking Piero and his commission had given birth not to one, but to two snow-sculptures in Vasari's *Lives*. We might view Baccio's snow-Marforio, which also made its debut in Vasari's second edition of the *Lives*, as a distant cousin of Michelangelo's snow-sculpture. Vasari's tale of the two snowmen alludes to the rivalry between Michelangelo and Baccio Bandinelli; specifically, Baccio's life-long pursuit to surpass the divine Michelangelo. Although Michelangelo would emerge as Vasari's hero, both snow-sculptures play similar roles in Vasari's accounts of the early career of each artist.

While Baccio produced his snow-Marforio in response to a challenge from his friend, Giralomo del Buda, it was none other than Piero de'Medici who prompted Michelangelo's creation. Michelangelo's frozen offering may have provided a test-piece for a patron reticent to

entrust a large block of marble to an inexperienced sculptor. Marble carving required skill, as we learn from the famous case of Simone da Fiesole, whose incompetence rendered useless a block of marble that only the genius Michelangelo could resurrect as David. Or so Vasari tells us. For Michelangelo, Piero's commission presented the artist an opportunity to show off his expertise, his artistry, and his ability to handle monumental sculpture. From Vasari's brief account, we imagine Michelangelo's snow-sculpture alongside the permanent marbles in the Medici courtyard, where they were open not only to Piero's scrutiny, but to all who entered the courtyard on that snowy winter day. Although the snow-statue was by no means Michelangelo's first sculpture, as was the case with Baccio's Marforio, Michelangelo's snow-sculpture plays a significant role in Vasari's version of the episode. By subtracting Condivi's account of the graceless Piero, Vasari had recast Michelangelo's creation. For in Vasari's tale, Michelangelo's statue of snow—however fleeting—marks the young artist's first large-scale sculptural commission.

Although the circumstances behind the creation of Baccio's and Michelangelo's sculptures differ in each of Vasari's biographies, nature plays a prominent role in both tales. In rendering a Leonardesque *paragone* between snow and marble in each tale, Vasari reminds us of the close links between nature and artifice, a major theme in the *Lives*. In making their snowmen, Vasari's heroes shape art from nature and breathe life into a creation that would ultimately return to its former state, as in the case of Baccio's river god, which melted and transformed into what it had once been: water. In his tale of two protean statues, Vasari not only contributes to a long history of ephemera, but more significantly, he comments on the ephemeral nature of art.

What, then, of the appearance of Michelangelo's snow-sculpture? Although both Condivi and Vasari remained silent on the form of Michelangelo's creation, both saw fit to include the sculpture of snow in their biographies. In so doing, each had a hand in shaping Michelangelo's snowman. Just as Baccio "took away snow when there was too much" and added it in other places to form his Marforio, so Vasari refashioned Michelangelo's snow-sculpture by removing Condivi's commentary on Piero and adding another snowman—the Marforio—to his Life of Baccio Bandinelli. Though it existed only briefly, Michelangelo's lost statue led a remarkably fruitful afterlife through Condivi, Vasari, Browning, and many others who resurrected it. As with all poetry, the shape of Michelangelo's masterpiece changes with each retelling, and with his tale of the snowman, Vasari reminds us that the power of art lies in how we remember.

NOTES

1. Elizabeth Barrett Browning, *Casa Guidi Windows*. Ed. Julia Markus. (New York: Browning Institute, 1977): ll. 98–106. It is well known that the Brownings were familiar with Vasari's writings, and that they owned *Le vite de' più eccellenti pittori, scultor ed architetti*, published in 14 volumes by the Florentine publisher, Le Monnier (1846–1855). For Robert Browning's Vasarian writing, see "Pictor Ignotus" (*Dramatic Lyrics and Romances*, 1845), "Fra Lippo Lippi" and "Andrea del Sarto (*Men and Women*, 1855)," and for further bibliography, see *Andrea del Sarto, Pictor Ignotus, Fra Lippo Lippi*, ed. Francesco Rognoni (Venice: Marsilio, 1998): 46–52.

2. Browning, ll. 115–18.

3. Ascanio Condivi, *Vita di Michelangelo Buonarroti*. Ed. Emma Spina Barelli. (Milano: Rizzoli, 1964): 29. For the English translation, I have used *The Life of Michelangelo*. Trans. Alice Sedgwick Wohl, Ed. Hellmut Wohl. (Baton Rough: Louisiana State UP, 1976): 4.

4. Condivi reports that the Hercules—now among the lost sculptures of Michelangelo—was sent to France.

5. Giorgio Vasari, *La Vita di Michelangelo nelle Redazioni del 1550 e del 1568*. Ed. Paola Barocchi. (Milan: Riccardo Ricciardi, 1962): I, 12–13.

6. Vasari adds that the Hercules was sent to Francis I "when Florence was under seige" after Piero's expulsion in 1494.

7. Luca Landucci, *Diario Fiorentino dal 1450–1516*. Ed. I. del Badia. (Firenze, 1883): 66–67. All English translations are those of Alice de Rosen Jervis. See L. Landucci, *A Florentine Diary from 1450-1516*. Trans. A. de Rosen Jervis, (New York: E.P. Dutton and Company, 1927).

E a dì 20 di gennaio 1493 el dì di San Sebastiano, nevicò in Firenze la maggiore neve che si ricordi mai, secondo che dissono e più antichi. E infra l'altre cose mirande, ch'ella venne con certo vento con una bufera, in tal modo, che per tutto 'l dì non si poté mai punto aprire usci, nè bottega, nè finestre di casa. E durò dalla mattina, a l'Avemaria, insino a l'altra mattina a l'Avemaria, che furono 24 ore, che mai cessò punto, sempre colla bufera; per modo tale che non era fesso ne'bucolino sì piccolino, che non avessi el monte della neve in casa; ne'si suggellata casa che non fussi sì piena di neve, che si penò più dì a votarle. Vedevi per tutte le vie gittato dalle finestre e monti della neve, che bastorono molti dì, che non poteva passare nè bestie nè persone, in molti luoghi. Ed erono tanta la gran quantità per le strade, che bastò molti dì che non si poteva consumare, come fa qualche volta quando si raguna per fare un lione. Così durono que'monti, perchè più d'otto giorni durò per la città. Chi lo vide lo crede.

8. Landucci reports snowstorms on 20 January, 1494; 21–24 November, 1500; 13 January, 1510; and 15 March, 1515.

9. Alison Brown has added that the construction of the snow-lions are indicative of Florentine civic pride. See A. Brown, "City and Citizen, Changing Perceptions in the 15th and 16th centuries," ed. Anthony Molho. *City-States and Classical Antiquity in Medieval Italy*. (Ann Arbor, 1991): 95n. For Corazzo, see *Diario Fiorentino: 1405–1439*. Ed. Roberta Gentile. (Roma: De Rubeis, 1991): n.46, p. 25. (*Fecionsi per Firenze grande quantità di lioni e begli: quasi in sun ogni canto ne era uno: e alle logge, grandi e begli; e fèssi in sulla piazza di San Michele Berteldi uno Ercole lungo II braccia, e stette bene.*) Similarly, Landucci mentions that after the 1510 snowfall, he found snow-lions throughout the city and a "very large and fine one next to the campanile of Santa Maria del Fiore, and one in front of Santa Trinità." (*infra gli altri se ne fece uno dal campanile di Santa Maria del Fiore, grandissimo e molto bello, e a S.Trinità...*). See Landucci, 306. In the case of a snowstorm in 1355, the snow-lions were reportedly destroyed, an action that prompted the Florentine government's investigation. See Evelyn Welch, *Art and Society in Italy, 1350–1500* (Oxford: Oxford UP, 1997): 217.

10. Landucci, 306, (*. . . molte altre figure fu fatto al Canto de'Pazzi, igniudi, da buon maestri; e in Borgo S. Lorenzo si fece citta con fortezze e molte galee: e questo fu per tutto Firenze*).

11. Leonardo was comparing the artistry of the painter with the manual labor of the sculptor. See Leonardo da Vinci, *Trattato della Pittura*. (Milan: TEA, 1995): n. 32, p. 33.

Tra la pittura e la scultura non trovo altra differenza, senonchè lo scultore conduce le sue opere con maggior fatica di corpo che il pittore, ed il pittore conduce le opere sue con maggior fatica di mente. Provasi così esser vero, conciossiachè lo scultore nel fare la sua opera fa per forza di braccia e di percussione a consumare il marmo, od altra pietra soverchia, ch'eccede la figura che dentro a quella si rinchiude, con esercizio meccanicissimo, accompagnato spesse volte da gran sudore composto di polvere e convertito in fango, con la faccio impastata, e tutto infarinato di polvere di marmo che pare un fornaio, e coperto di minute scaglie, che pare gli sia fioccato addosso. . .

For the English translation, see *Trattato della Pittura*. Ed. and tr. Martin Kemp and Margaret Walker. (Yale UP, 1989): 38–39.

12. Giorgio Vasari, "Vita di Baccio Bandinelli," in *Le Vite*, Vol. V, Ed. Rosanna Bettarini and Paola Barocchi. (Firenze: Studio per Edizinoi Scelte, 1967): 240. For the

English translation, see Giorgio Vasari, "The Life of Baccio Bandinelli," in *Lives of the Artists*. Trans. Gaston du C. de Vere. (NY: Everyman's Library, 1996): 265–66. 13. On Baccio's snow-Marforio in relation to Baccio's career and his classicizing sculpture, see Leonard Barkan, *Unearthing the Past: Archaeology and Aesthetics in the Making of Renaissance Culture* (New Haven: Yale University Press, 1999).

TIZIANO DA CADOR
PITTORE.

# Titian, Michelangelo, and Vasari

NORMAN E. LAND

In October of 1494, mourning the death of his friend, the Florentine poet, Angelo Poliziano, and apprehensive of the political climate in Florence at the time, Michelangelo, who was nineteen years old, visited Venice. During his brief stay there, as he looked for suitable employment, he sought out examples of sculpture and painting by central Italian artists who in the preceding decades had left works in the city or in nearby Padua. Among those masters were Paolo Uccello, Fra Filippo Lippi, Donatello, Andrea del Castagno, and Andrea del Verrocchio. No doubt in the course of his visit he also saw works by gifted Venetian artists, past and present, and met some of his local counterparts, such as the Lombardi—Pietro and his sons, Tullio and Antonio—and the Bellini brothers, Giovanni and Gentile. Possibly, too, he encountered the German painter, Albrecht Dürer, who also visited Venice for the first time in the autumn of the same year.[1]

FIG. 1  Martino Rota, Engraving after Titian. *Martyrdom of St. Peter.*

Michelangelo visited Venice again in September of 1529, when, having been warned that his life was in danger, he and his assistant, Antonio Mini, left Florence with the intention of going to France, but fearing the dangers of the open road, they traveled only as far as Venice. Several times during Michelangelo's stay of just over a month in *La Serenissima*, he visited Jacopo Sansovino, a Florentine sculptor recently settled in the city, and Titian, who was then painting his (now-destroyed) *Martyrdom of St. Peter* (fig. 1) for the Scuola di San Pietro Martire,

211

which had ordered the painting for its altar in the nave of the Dominican church of Santi Giovanni e Paolo. During one of those visits, Titian told Michelangelo the story of his fierce competition with other artists for the commission, namely his rivals, Palma Vecchio and Giovanni Pordenone. As Titian recounted his tale of strife and triumph, Michelangelo noticed that in his stupendous painting his Venetian friend had imitated nature with exceptional bravura and unequaled skill.

Standing in front of Titian's painting, Michelangelo witnessed the assassination of Peter of Verona, better known as St. Peter Martyr, who was the son of Catharist heretics. Peter, as Michelangelo knew, was converted to Christianity by an uncle and was later admitted by St. Dominic himself to his new religious order in Bologna. As a Dominican preacher Peter exhibited an exceptionally strong religious fervor as he traveled throughout northern Italy, including Venice. In 1234 he was appointed inquisitor in Milan and in 1251 inquisitor of northern Italy. He was murdered in 1252 by his enemies, the Cathars, just as he himself had prophesied. According to eye-witness accounts, as he died Peter extended his arms heavenward, saying "Into your hands, Lord, I commend my spirit."

The attack on St. Peter occurred after a visit to Milan, where he had convincingly preached against the wickedness of the heretics. Now in Titian's painting, as the saint returns to his monastery in Como, he is assailed by a thug whom his enemies have sent to kill him. "Why," Michelangelo silently wondered as he gazed at Titian's painting, "does such faith, conviction and integrity bring about such an ugly hatred?"—a question he later answered in one of his poems (no. 48):

> Just as a flame grows stronger the more it is blown
> by the wind, so every virtue exulted by heaven
> shines more brightly the more it is attacked.

In Titian's painting Michelangelo saw a dense wood of old oak trees, the leaves of which protect good and evil alike from the sun. He saw that the black trunks of the ancient trees and their dark and sad branches are in sympathy with the already wounded saint. Here at the edge of a forest the brutal assassin has overwhelmed St. Peter, and grasping his victim's cape, the barbarous heretic is about to strike him again, even though the saint has fallen helplessly to the ground and is dying. With the forefinger of his left hand, St. Peter touches a pool of his own blood, as if, Michelangelo thought, he is about to affirm his faith by writing in the soil, "I believe in God-the-Father Almighty, maker of Heaven and Earth."

For St. Peter, every escape is blocked; there is no hope of flight, nor of divine intervention, although the sky has opened and a heavenly light floods the scene. Titian, Michelangelo observed, chose to represent the very moment when the cruel murderer releases a second blow to the head of the helpless martyr, who, nevertheless, has strength enough in his left arm to raise himself, showing in the extension of his right hand and in the opening of his rigid fingers that he has been fiercely struck by an unexpected terror. In the pallor filling St. Peter's face, in the exhaustion of his eyes, and in his half-opened mouth, Michelangelo saw the saint's horror and repugnance at his imminent death.

Michelangelo stood marveling at every detail of the painting's invention, admiring the

judicious arrangement of everything represented in it, and was almost overwhelmed by Titian's matchless coloring, which delights the eye of every viewer with its clever deception. He was stupefied by the face of St. Peter, in which he discerned the paleness of death, and he was deeply impressed by the boldness of the assassin and by the way in which the other friar, who was the saint's companion, expresses fright as he runs for his life. Indeed, the friar precipitously flees the scene with so vigorous a movement and such a natural robustness of person that Michelangelo thought he could hear his heavy breathing and his loud cry. The forms and colors of the friar's flesh are those suitable to a man who shamelessly tries to save his own life as he abandons his stricken friend. Observing St. Peter's companion more closely, Michelangelo noticed that he, too, has been struck on the head and that his face has the whiteness of cowardice and fear, as he tries to escape the brutal assassin. We cannot imagine that Michelangelo condemned the fleeing figure too quickly, for, as the great sculptor had shown in the cartoon for his *Battle of Cascina*, the fear of death will sometimes cause those in danger suddenly to abandon their companions.

The assassin's physique, which Titian depicted as somewhat larger than is true to life, his strongly pronounced muscles, his scorched and brown skin, the cruel air of his face, and the vigor of his limbs—all vividly echo the savagery of his spirit and increased Michelangelo's commiseration with the frail and wasted saint. In this moment the power and beauty of Titian's painting left Michelangelo almost speechless. He could not find the words to express the beauty of Titian's figures, nor his judicious use of colors, which is especially praiseworthy because the artist's palette was severely restricted by the black and white garments of the Dominican order worn by St. Peter and his companion. The great Florentine artist managed to voice praise only for Titian's moderation in the limited number of actors he introduced in the scene, a virtue quite foreign to many other painters.

So lively is Titian's St. Peter, whose face is filled with terror, that he seems to loudly call out in fear, but, Michelangelo thought, because such pain and torments as the saint suffers can be unbearable, Heaven has sent him the comfort of two infant angels, who bring the palm-of-triumph, nude angels that are so beautiful they seem to have been born in Paradise. Michelangelo noticed again, this time with just a touch of envy, that the branches of the trees behind the prostrate saint reach upward as if lamenting his impending death. In an instant he realized that Titian deeply loved trees, not the pruned and dense ones, the bay and cypress, that he was used to seeing in Florence and Rome, but those "in which the softness of spreading leaves contrasts with the hardness of trunk and branch." He noticed, too, that the somber colors of the sky echo the sad plight of the saint, while in contrast to the dramatic event, the distant landscape has the feel of natural simplicity and serenity. Michelangelo noticed in the foreground the stream of clear water running swiftly over mossy rocks, reminding him that Titian's amazingly lifelike creation flowed from the tip of his paint-filled brush, that obedient instrument of his matchless skill and fertile imagination.

For Michelangelo the skill exhibited by Titian in his *Martyrdom of St. Peter* seemed beyond description. He was especially impressed by the infant angels descending on a heavenly light toward the saint. They seemed marvelously executed not only in the coloring of their flesh but also in their design. By the time of Michelangelo's visit, Titian had already achieved an

understanding of the art of antiquity, largely through the imitation of ancient works, and in a few strokes of his brush he was able to paint the angels in such a manner that they are comparable in the harmony of their proportions to works by ancient Greek sculptors. Indeed, his figures cannot have been composed with greater beauty and symmetry. All this Michelangelo saw and could not stop admiring.

Only his innate sense of dignity prevented Michelangelo from kneeling in admiration before Titian's stupendous creation. He marveled at so grand and graceful a style, at the simple, vigorous, robust coloring, the broad, yet precise execution, the unrivaled delicacy of touch, the proud mastery appropriate to "the god of painting," as in his mind he had begun to call Titian. This, he said to himself, is the only artist whom the modern world can oppose to those of antiquity for calm strength, tranquil splendor, and eternal serenity.

Titian was probably nearing completion of his painting when Michelangelo saw it. Yet, the new Apelles, wishing to show his admiration for the modern Praxiteles, humbly asked Michelangelo to correct any inaccuracies he might find in the picture. Michelangelo, though astonished by Titian's request, immediately recognized the honor bestowed upon him, and taking up one of his friend's brushes, quickly made a few revisions to the anatomy of the figures. He then respectfully returned the brush to Titian's hand.

After Michelangelo had departed Venice, and Titian's painting had been placed above the high altar in the church of Santi Giovanni e Paolo, it was a wonderful sight to see, for from the moment viewers entered the church, they thought there was an actual event transpiring before them. To them there seemed to be natural mountains beyond the trees, in the far distance. They believed that the white and vermilion streaks of the sky at dawn had just a moment ago disappeared, that the morning sun had begun its slow ascent, filling the fresh, blue sky with golden rays. For those who knew Titian well, the landscape recalled the views of the pristine mountains around Cadore on the morning of a clear day.

Viewing Titian's profoundly beautiful and deeply moving painting, many recalled, too, the example of the ancient Greek painter Zeuxis who wrote beneath his famous picture of an athlete: "It may sooner be envied than imitated."

Perhaps on his return to Rome, Michelangelo recommended Titian's altarpiece to the fiery Florentine goldsmith–turned–sculptor, Benvenuto Cellini. In any case, Cellini saw the painting during a visit to Venice in 1535 with a fellow sculptor and traveling companion, Niccolò de' Pericoli, called Il Tribolo. When Cellini and Tribolo, accompanied by their friend, the poet and playwright, Pietro Aretino, who lived in Venice, first saw Titian's painting, they responded to it in much the same way that Michelangelo had. Indeed, so powerful was the effect of the painting on the two sculptors that Aretino heard them gasp in astonishment at the liveliness of the scene. Their delight in the painting was so great that they declared it the most beautiful in all of Italy and repeatedly praised the miraculous brush of the divine Titian.

About ten years after the visit of Cellini and Tribolo to Venice, in the autumn of 1545, Titian set out for Rome, stopping along the way in Ferrara, Pesaro, and Urbino, where he was treated royally. He had not previously visited Rome, although he seems to have been invited there on at least two previous occasions. Early in the century, when his reputation had grown beyond Venice, the Venetian poet and secretary to Pope Leo X, Pietro Bembo, invited the artist

to work for the papacy. In addition to the paintings of Raphael and Michelangelo, Bembo told Titian, Pope Leo wished to have something divine from his hand. Unfortunately for Bembo and the Pope, the Venetian humanist and historiographer, Andrea Navagero, who is said to have understood the artist's paintings as if they were poems, managed to talk Titian out of leaving Venice. Perhaps Navagero recalled the example of the Venetian painter Sebastiano Luciani, who in 1510 had abandoned his native city for a career in Rome and a new name, Fra Sebastiano del Piombo. In that case Navagero would have been keenly aware that if Titian visited Rome, Venice might well lose its greatest artist.

Later, in 1543, Cardinal Alessandro Farnese invited Titian to Ferrara to meet Pope Paul III, who was visiting that city. While there, he painted a portrait of the Pope (fig. 2). One day, having varnished

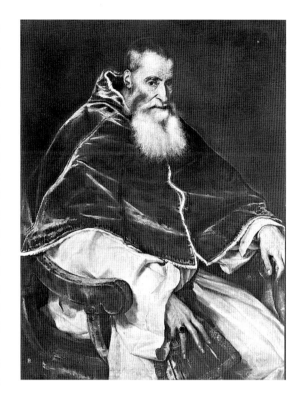

FIG. 2 Titian, *Portrait of Pope Paul III,* 1543.

the painting, Titian set it out of doors on a terrace to dry. As people walked passed the portrait, some, mistaking it for the Pope himself, took off their hats and others bowed. The Pope was so pleased with Titian's skill that he asked him to come to Rome. Titian declined the invitation, saying that he was obligated to Duke Francesco Maria della Rovere of Urbino, for whom he was then working, and hoped to serve His Holiness at some other time.

Soon, Titian was again invited to Rome and again by Cardinal Alessandro Farnese. This time he accepted the invitation, and when he arrived in the Eternal city, he was met by Pietro Bembo. A few days later, Cardinal Farnese reintroduced Titian to Giorgio Vasari, who had just returned from a trip to Naples. Vasari, a native of Arezzo, who spent much of his career in Florence, was charged with keeping Titian company and showing him the sights of the city. A few years earlier, in 1541–1542, at the invitation of Pietro Aretino, Vasari had visited Venice to make some ceiling paintings for the church of Santo Spirito in Isola. Although he never finished those works—the commission went to Titian—he made paintings for the ceiling of the Palazzo Corner–Spinelli and a *Holy Family with St. Francis* for Francesco Leoni, a wealthy Venetian banker. He also designed theatrical sets for the production of Aretino's play about a beautiful courtesan, *La Talanta.* At that time, Vasari also made the acquaintance of Titian and marveled at the *Martyrdom of St. Peter,* which he gives high praise in his *Lives of the Artists* (Florence, 1568), calling it the best conceived and executed of all the artist's paintings.

Within a few days of Titian's arrival in Rome, after he had rested, rooms were prepared for

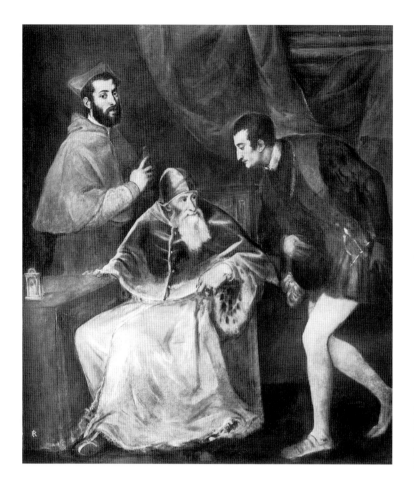

FIG. 3 Titian, *Portarit of Pope Paul III with his grandsons, Cardinal Alessandro Farnese and Duke Ottavio Farnese,* 1545–1546.

him in the Belvedere Palace, so that he might set his hand to a group portrait of Pope Paul III and his grandsons, Cardinal Alessandro Farnese and Duke Ottavio Farnese (fig. 3). Although Titian seems not to have completely finished the painting, it is well executed and greatly satisfied his patrons.

Titian was also persuaded to paint, for presentation to the Pope, another picture showing Christ from the waist up. In that painting (fig. 4), Christ seemed to suffer the torments brought upon Him by the wretchedness of mankind, while His face, though filled with painful emotions, radiated the light of divine forgiveness. So convincing and authentic was Titian's figure that it brought tears to the eyes of those who saw it and filled their hearts with sympathy for His suffering and humility. In the opinion of Roman artists, however, the painting, though it turned out well enough, did not compare favorably to the works of Michelangelo, Raphael, Polidoro da Caravaggio, and other painters who worked in Rome. In addition, according to those connoisseurs, Titian's picture did not appear to be of the same high quality as many others by his hand, especially his portraits.

In spite of the negative criticism of his half-length *Christ*, Titian painted a number of pictures in Rome, including a figure of St. Mary Magdalen (now lost, compare fig. 5). He represented her at the beginning of her penitence, when she had retreated to the wilderness to

216

FIG. 4 Titian, *Ecce Homo.*

meditate on Heaven. In the painting, she has taken off the seductive clothing belonging to her former life of sin and wears humble garments, and although her partial nudity has a sensuous appeal, her faith is uppermost. Remarkably, because of the spiritual nature of the painting, a reflection of Titian's character, the figure of the Magdalen does not cause the viewer to have lustful thoughts.

One day Vasari took Titian to see the palace of Agostino Chigi, now known as the Villa Farnesina, in which the Sienese artist, Baldassare Peruzzi, had painted a loggia with some frescoes in grisaille. The frescoes, which included depictions of playful infants, were lighted from the bottom and were so skillfully painted that many viewers were duped into believing that they were relief sculptures. Even Titian, who had deceived so many others with his art, thought they were carved in stone. He could not believe that the figures were painted until he had changed his position and saw them from another point of view. Then he was amazed by Peruzzi's ability to create such lifelike illusions.

Titian had not been in Rome long before a rumor arose in the papal court, and then spread throughout the city, to the effect that he had been asked to paint with his own hand some scenes in the Hall of Kings in the papal palace. Already Perino del Vaga had been commissioned to paint the scenes, and the stucco decoration was in progress. Because of the rumor, Titian's arrival caused Perino such vexation that he complained about the Venetian to many of his friends. He did not believe for a moment, he told them, that Titian was better than he at painting historical scenes in fresco. Rather, he was disturbed because he had planned to occupy himself with the work in the papal palace peacefully and honorably until his death. He also told his friends that if he was to paint the frescoes, he wished to do so without competition, for, even as matters stood, his work was sure to be

FIG. 5 Titian. *St. Mary Magdalen.* 1567.

217

compared to Michelangelo's ceiling and to his *Last Judgment* in the Sistine Chapel nearby. In any case, while Titian remained in Rome, Perino always avoided him and remained in bad temper until his Venetian rival (as he thought) had departed.

During his stay in Rome, Titian received a letter from his friend, Aretino, who had remained in Venice. In the letter Aretino says that he longed to know Titian's evaluation of the works by ancient artists that he was seeing in Rome. Specifically, he asks, to what extent, in Titian's opinion, do the ancient works surpass those of Michelangelo? He wanted to know, too, Titian's opinion of Michelangelo's paintings in relation to those of Raphael. Is Michelangelo, as a painter, close to Raphael, or does he surpass him? Aretino says that he looks forward to discussing Bramante's church of St. Peter with Titian and asks him to seek out the works of Sebastiano del Piombo, Perino del Vaga, and an engraver named Bucino. He advises Titian to compare the sculptural works of their mutual friend, Jacopo Sansovino, still living in Venice, to those of his rivals in Rome, and warns the painter that he should not become lost in the contemplation of Michelangelo's *Last Judgment* on the altar wall of the Sistine Chapel.

After Titian had returned to Venice, he spoke with Aretino about Rome and about the art he had seen, and among the occasions that he recounted to his friend was his visit to Raphael's Stanze in the Vatican apartments. When, in 1527, Rome was sacked by Imperial troops under the leadership of the Duke of Bourbon, some of the ferociously barbaric German soldiers, who had seized the papal palace, made a fire in one of the rooms painted by Raphael. Either the smoke from the soldiers' fires or their dirty, careless and disrespectful hands damaged some of the heads of Raphael's divinely beautiful figures. After the troops had departed and Pope Clement had returned to the palace, he could not tolerate that such fine heads should remain damaged and commissioned Fra Sebastiano del Piombo to restore them.

Many years later, when Titian was in Rome, he and Fra Sebastiano one day visited the Stanze to see Raphael's paintings. There, Titian carefully studied Raphael's work, which he had never before seen. When he reached the portion of the fresco in which Fra Sebastiano had repainted the damaged heads, Titian was surprised, for he noticed a sharp contrast between the quality of Raphael's work and that of the restored portions of the fresco. Not knowing that Fra Sebastiano had been responsible for the restoration of the work, Titian asked him if he knew the arrogant ignoramus who had daubed and blotched Raphael's faces. We can only imagine what the *frate*, who must have turned red with embarrassment, might have said in response.

Long before Titian arrived in Rome, Fra Sebastiano had spoken disparagingly of his compatriot's designs for a woodcut called the *Triumph of Faith*, published in 1508. That print, as was generally held, demonstrated the boldness and beauty of Titian's manner, as well as the facility of his hand. Fra Sebastiano, however, explained to Vasari that Titian should have visited Rome before designing his print. If only he first had seen the works of Michelangelo and Raphael, if only he had carefully studied examples of ancient sculpture, if only he had learn to draw and design properly, he would have made absolutely stupendous things. Considering his mastery of coloring, Fra Sebastiano continued, Titian deserved to be exalted as the most accomplished imitator of Nature. If only he had acquired a foundation in the grand method of *disegno*, he might have equaled Raphael and Michelangelo.

Several times during Titian's stay in Rome, Michelangelo, who had recently begun his fres-

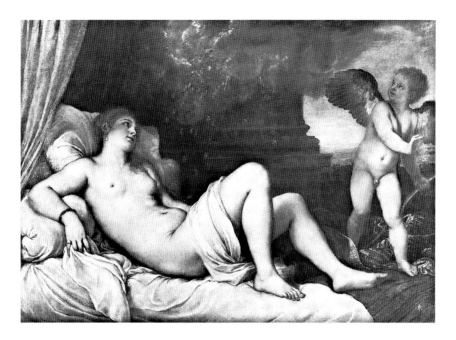

Fɪɢ. 6 Titian. *Danaë and Cupid,* 1544–1546.

coes in the Pauline Chapel, and Vasari called upon the Venetian painter as he was working in the Belvedere. There, for Cardinal Alessandro Farnese, he was painting a picture of Danaë (fig. 6), in which, imprisoned by her father, she is visited by Jupiter disguised as a shower of gold falling into her lap. When Michelangelo and Vasari viewed Titian's *Danäe,* they responded with appropriate courtesy in the painter's presence. Standing with Titian and Vasari, Michelangelo more than once praised the painting as a singular work, affirming that it was impossible to use colors better.

Nevertheless, according to Vasari, on one occasion, after he and Michelangelo had left Titian's workplace, they began to discuss the Venetian's method of painting. Michelangelo, Vasari says, praised Titian for his splendid spirit, lively coloring, and pleasing style, but he also said that it was a pity that in Venice artists did not learn to draw well when they were young. He wished, he said, that Venetian painters would pursue a better method in their studies. No one could achieve more or do better work than Titian. If only he was assisted as much by art and design, as he is by his innate talent for representing, he would be an even greater painter. Michelangelo's opinions echo those of Vasari who believed that for an artist to achieve excellence, he must draw a great deal and study examples of ancient sculpture so that he can improve the things that he imitates from life, giving them that grace and perfection wherein art goes beyond Nature, which generally produces people and things that are neither perfect, nor beautiful.

While in Rome Titian also painted a pendant to the *Danaë,* a *Venus and Adonis* (fig. 7) in which the figures were slightly smaller than life-size. In that picture, the artist depicted the luscious beauty and sweet charm of the goddess of Love, a beauty and a charm that tames the

219

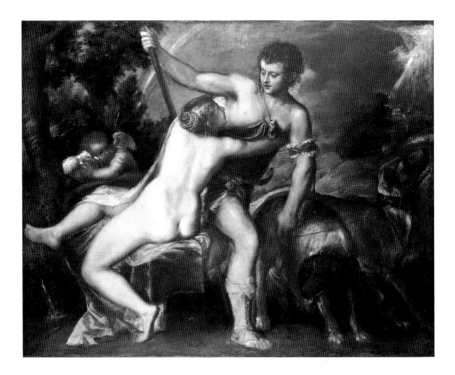

FIG. 7 Titian, *Venus and Adonis*, ca. 1560. Widener Collection, 1942.9.84.

wildest of tigers and softens the hardest of stones. He showed Venus embracing Adonis with her soft arms, as if she wished to keep him from leaving her. But he, resisting her caresses, steps forward as if to depart. The painting appeared so lifelike to those who saw it that they often would cry out apprehensively, "Oh, handsome Adonis, where are you going? Do you not know that a wild boar awaits you and will kill you? Stay and enjoy the soft caresses of this beautiful goddess."

Although Vasari passionately held that Titian's sense of design was weak, sound-minded connoisseurs always considered the Venetian painter to be incomparable in representing the female body, which does not require the correct depiction of anatomy or the precise representation of powerful muscles but only a certain softness and gentle proportion. Seemingly Vasari was always quick to condemn paintings displaying the sensuous beauty of nude women.

In spite of the adverse criticism of his paintings, Titian was well rewarded for his work in Rome, receiving gifts from the Pope and a substantial benefice, the bishopric of Ceneda, for his son Pomponio. Titian, however, felt that the bishopric was not a suitable appointment for his son, who was of a feckless nature, and declined it. The Pope asked Titian to remain at his court and offered him the office of the Piombo, the same office that had been filled by Fra Sebastiano. Titian declined the Pope's offer because, as he let it be known, he did not want to face any longer the petty jealousies, hatreds, pretenses, and persecutions of the papal court. Rather, he preferred the relative freedom of *La Serenissima*, where he could enjoy the company of his friends especially Aretino, Sansovino, and Francesco Zuccato, a mosaicist and the son of his first mentor in Venice.

At last the day arrived when Titian departed Rome and began his journey back to Venice. On the return trip he briefly stopped in Florence where he saw the rare works of that city and was no less amazed by them than he had been by the wonders of Rome. He visited Duke Cosimo de' Medici, who was staying at his villa at Poggio a Caiano, and offered to paint his portrait. The Duke did not accept the offer, perhaps because he was afraid that he might offend the many noble Tuscan artists who worked in his realm. Although he did not paint a likeness of the Duke, Titian would later send portraits of the Holy Roman Emperor Charles V and his son, King Philip II of Spain to Cosimo, who kept them in his wardrobe.

In truth Vasari did not like Venice. He believed that she had given herself up to sensuous pleasures and the delights of the flesh. Still, he returned there in 1566 to gather material for the second edition of his *Lives* and to visit Titian. He found the aging artist in his studio, brushes in hand, as he worked on several paintings, which, Vasari says, Titian seems not to have regarded very highly, although they had some good things in them. Titian, Vasari explains, believed they lacked the perfection of his earlier works. In fact, as Vasari noticed, Titian's style had changed dramatically from his early manner, which had been one of finesse and an infinite care for details. Those early paintings could be seen from up close as well as from a distance, but the viewer had to see his last pictures from afar because they were executed with a loose, broad, and rapid stroke of the brush. These latter works seemed as though they had been executed without much effort, but in truth Titian had labored long over them. His great skill allowed him to conceal his effort.

While visiting Venice, Vasari informed Titian of the newly established Academy of Design, or *Accademia del disegno* in Florence and of the catalfaque that the academy's members had designed in honor of the recently deceased Michelangelo. In response, Titian and six other artists then living in Venice—Andrea Palladio, Giuseppe Salviati, Danese Cataneo, Battista Veronese, and Jacopo Tintoretto—asked that their names be inscribed as members of the new organization. In due course Titian and the others were accepted as "foreign academics," *accademici forestieri*. We cannot know for certain why Titian wanted to be a member of the Florentine academy. Perhaps he wished only to show his admiration for Michelangelo. Possibly, too, he believed that membership in the academy would advance his social and intellectual status. Whatever the case may have been, he and the other Venetian artists never paid their dues.

NOTES
1. This essay is a narrative of the visits that Michelangelo made to Venice and Titian made to Rome, written in the style of Vasari. The narrative is based upon documents, letters, and biographical writings of the sixteenth and seventeenth centuries. This is the first time that these events have been recounted in detail and in relation to one another.

So much of what we know about the fact and fiction of Italian art history begins with Vasari. By presenting new information about Michelangelo and Titian in the tradition of the *Lives*, this essay illuminates Vasari's approach and serves as a fitting tribute to the father of Italian art history.

FRA FILIPPO LIPPI
PITTORE FIOR.

# Imagining the Renaissance: Browning Reads Vasari

Roy Eriksen

In a recent article in defense of Vasari's historical imagination, one of our time's greatest connoisseurs of this artist-historian's foundational text, argues that:

> If we acknowledge, however, that Vasari's poetic sensibility is not inimical to an understanding of history, that it is in fact essential to such historical understanding, we find an unexpected, indeed exemplary, depth in Vasari's historical imagination, nowhere more so than in the still surprisingly little examined fable of Leonardo's shield.[1]

The short tale in the Life of Leonardo—less than 500 words and only twelve sentences long—has been frowned upon or neglected by most critics and received little serious comment, but it is nevertheless a *locus amoenus* for investigating Vasari's reach of imagination and synthesizing intelligence. In fact, it is a fable, Paul Barolsky demonstrates to us, "about the refinement of art [that] points toward a striking conjunction in the history of art in Italy c. 1500—the twin birth of the pastoral and the ideal of the *bella maniera*."[2] In this sense, fiction provides both a diagnosis and an analysis of utmost value.

What Barolsky says about Vasari holds true for Robert Browning as well, the Victorian poet in self-imposed exile in Italy, who was an avid reader of Vasari's *Lives* and other leading cinquecento writers, Tasso in particular. Browning, too, creates small fictions, which are of an almost exemplary nature, possessing a significance of almost universal proportions.[3] The dramatic monologues are in actual fact truncated dialogues in which a "real" historical person or a purely fictionalized persona speaks. The celebrated mixed form has been said to be "par excellence the literary genre of historicism,"[4] but the monologues that focus on Renaissance art and artists also have a wider significance because they exemplify and diagnose the state of art at a particular moment in history. Browning chose individual artists' lives from Vasari's account of the rise of art for the raw material upon which to build his fictions of the Renaissance. And his selections and elaborations are in themselves feats of rhetorical *inventio*.

In so doing Browning shows that he had grasped the essence of Vasari's historical imagination and the crucial function in the *Lives* of the brief sketch that encapsulates the culture, mentality, and art of the Renaisssance. After being severely criticized by John Ruskin and others for being morbidly self-centered, Browning turned from his early attempts at writing epic

poetry and drama on historical topics to compose poems on artists or invented characters. He seems to have been especially intrigued by the reactions of individuals who are torn between the old and the new, and whose lives can be said to be emblematic of "what was a transitional moment."[5] We see this clearly in poems like "My Last Duchess" (1842), "Pictor Ignotus" (1845), "The Bishop Orders his Tomb at Saint Praxed's Church, Rome 15-" (1845), "Andrea del Sarto" (1855), "Fra Lippo Lippi" (1855), and "A Grammarian's Funeral" (1855). For instance, the last mentioned of these Italian monologues has been provided with a subtitle "Shortly after the Revival of Learning in Europe" as a guideline to the readers. Browning chose the poetic form of the dramatic monologue, which is a poem that is a truncated verse dialogue in the sense that we hear only the voice of one of the interlocutors, whereas the other's voice is implied, his lines being understood only indirectly. Inspired by the soliloquy in drama and dramatic dialogue, the sub-genre affords the poet the same anonymity and a chance to be impersonal, if not disinterested, in the affairs represented, that is given to the dramatist.

Like Walter Pater, who admired Browning's ability to allow us to peep into "the human mind...and see it at work weaving strange fancies,"[6] Browning perceived the intrinsic power and mythopoetic significance of Vasari's histrionic excursions. In actual fact, the poet reveals an unexpected thoughtfulness in his response to major shifts in artistic sensibility—surprisingly so, perhaps, in view of his own taste and preferences in art.

If we turn to a concrete example, the dramatic monologue "Fra Lippo Lippi," a poem that anatomizes the mentality of a jocund friar-artist with a boundless taste for carnal pleasure, we perceive how Browning selects and reassembles materials from Vasari's Life of Fra Filippo Lippi. Here the painter is described as a man who greatly enjoyed merriment and always appreciated good company: "Fu Fra Filippo molto amico delle persone allegre, e sempre lietamente visse."[7] From such brief glimpses the poet creates a well-rounded character that is caught up in the bustle of life. Details concerning the artist's birth and childhood crop up sporadically in the monologue, but no attempt is made at establishing a chronology or a narrative line relating to the ordered events of Lippi's life. Instead Browning seizes on the anecdotal and makes it into the foundation and point of departure for his own portrait of the artist.

Vasari tells us how Lippi—sick with love—escapes from Palazzo Medici after having been locked up for two days while working on some frescoes:

> It is said that he was so amorous, that, if he saw any women who pleased him, and if they were to be won, he would give all his possessions to win them; and if he could in no way do this, he would paint their portraits and cool the flame of his love by reasoning with himself. So much was he a slave to this appetite, that when he was in this humour he gave little or no attention to the works he had undertaken; wherefore on one occasion Cosimo de' Medici, having commissioned him to paint a picture, shut him up in his own house, in order that he could not go out and waste his time; but after staying there for two whole days, being driven forth by his amorous—nay, beastly passion, one night he cut some ropes out of his bed-sheets with a pair of scissors and let himself down from a window, and then abandoned himself for many days to his pleasures. Thereupon, since he could not be found, Cosimo sent out to

look for him, and finally brought him back to his labor; and thenceforward Cosimo gave him liberty to go out when he pleased, repenting greatly that he had previously shut him up, when he thought of his madness and of the danger that he might run.[8]

The account of the spectacular escape provides the main conceit behind Browning's version in which we learn that Lippi has been locked up for "three weeks."[9] We spot him in the street after he has been stopped by the night watch in a street off San Lorenzo, presumably in the Via delle belle donne. The artist explains the circumstances for his nightly excursion as follows:

> I am poor brother Lippo, by your leave!
> You need not clap your torches to my face.
> Zooks, what's to blame? You think you see a monk!
> What, 'tis past midnight, and you go the rounds,
> And here you catch me at an alley's end
> Where sportive ladies leave their doors ajar?. . .
> Here's spring come, and the nights one makes up bands
> To roam the town and sing out carnival,
> And I've been three weeks shut within my mew,
> A-painting for the great man. Saints and saints
> And saints again. I could not paint all night—(1–6; 45–49)

When the restless Fra Lippo had leaned out of the window to take a spell of fresh air he detected a band of sportive ladies below:

> Round they went.
> Scarce had they turned the corner when a titter
> Like the skipping of rabbits by moonlight,—three slim shapes,
> And a face looked up. . .zooks, sir, flesh and blood,
> That's all I am made of! Into shreds it went,
> Curtains and counterpane and coverlet,
> All the bed furniture—a dozen knots,
> There was a ladder! Down I let myself,
> Hands and feet, scrambling somehow, and so dropped,
> And after them. . . (57–66)

Vasari's brief anecdote has here seemingly been turned into an account of wantonness, but Browning's truncated dialogue between watchmen and runaway painter is no less than an artistic manifesto with roots in Vasari's account as a whole. The biographer stresses Fra Filippo's ability to represent human beings and material objects as if they were alive and present, and his novelty in initiating the modern *maniera*. His works in the present-day Cathedral of Prato, then the Piève di Castello, are for example characterized by figures with *artificio e naturale similitudine contrafatte* ("made with artfulness and natural likeness"), drawing praise from all quarters for *lo buon disegno, colorito, componimento* ("the exquisite design, colouring, and composition". In the former [Piève], he also introduced figures larger than life, thus establishing the technique of

rendering greatness, which was to become typical of cinquecento art. The same qualities also appear in his portraits which are drawn *di naturale molto vivamente* ("highly vividly from nature"). Fra Filippo's concern with nature in Vasari's book reemerges in Browning when the painter-persona preaches the gospel of competing with nature:

Nature is complete:
Suppose you reproduce her–(which you can't)
'There's no advantage! You must beat her, then.'
For don't you mark? We're made so that we love

First when we see them painted, things we have passed
Perhaps a hundred times nor cared to see;
And so they are better, painted–better to us,

Which is the same thing. Art was given for that;
God uses us to help each other so.
Lending our minds out. (297-306)

Fra Lippo is a Renaissance overreacher both with regard to his personal conduct and the role he attributes to his art. But whereas his transgressive life, including eloping with the nun Lucrezia Buti and having two children by her,[10] is something for which he needs and obtains pardon, his art requires no pardon. To Browning, Fra Lippo becomes a new Apelles, when he invents how the painter's lifelike fresco of the devils tormenting Saint Laurence is "scratched and prodded" (329) by the enraged Prato congregation. The Prior contentedly reports "we get on fast to see the bricks beneath" (332). As in the case with the birds tricked by Apelles's painting, the pious people mistake the painterly illusion for a truthful scene, thus testifying to the persuasive power of Fra Lippo's art to incite people to virtuous action.

Browning's emphases in "Fra Lippo Lippi" show him to have used the preamble to the Life of Fra Filippo Lippi in the 1550 edition of the Vite, which stresses the capacity of art to redeem an unruly life, an argument that was muted in the post-tridentine edition of 1568. When Pope Eugene IV absolved both Fra Filippo and Lucrezia from their monastic vows, the painter had fully shown that he could not and would not reform and repair to the Carmine. After 1564 he was therefore unsuitable to serve as an example for the artist's possibility to annul personal vice by virtuoso painting.

The use to which Browning puts the brief anecdote from the Life of Fra Filippo Lippi in the *Vite* is analogous to his approach when composing the poem entitled "Andrea del Sarto, Called the Faultless Painter," but here he draws on both the Torrentina and the Giuntina editions of *Le Vite*. Obviously, the poet did not find the moralizing account of the operations of Fortune in the lives of men in the 1550 edition to be a sufficient starting point for writing about the fate of del Sarto. For the tone of his poem he therefore also drew on the succinct characterization in the 1568 edition of the *Vite* of the artist's timidity and dejected mood (*una certa timidità d'animo, ed una certa natura dimessa e semplice*).[11] Had it not been for this disposition, del Sarto would have become "truly divine," Vasari explains. But in Browning's del Sarto monologue, too, it is a

novelistic anecdote that constitutes the basis on which the poet erects his long dramatic mono-logue set in 1525: a tale about the artist's beautiful, but inconstant and nagging wife. In what is one of the longest Lives, only four pages shorter than that of Michelangelo, the brief tale about the victimized Andrea occupies six full sentences, of which I quote the crucial opening, one which is worthy of Boccaccio:

> During that time there lived in Via San Gallo a very beautiful, young woman married to a cap-maker, who was no less haughty and vain, though being the daughter of a poor and depraved father, than she was extremely pleased by being courted and desired by other men, among whom she succeeded to ensnare our unfortunate Andrea, who was so tormented by his excessive love for her that he had abandoned his studies in art and for a great part also ceased to assist his father and mother. [12]

In the following sentences we hear how Andrea marries Lucrezia di Baccio del Fede—even the name smacks of the novella— immediately upon the sudden death of her husband, obeying his own appetites rather than to the counsel of his well-intending friends. Vasari remarks curtly: *Con la tinta di quella macchia avessi oscurato per un tempo la gloria e l'onore di così chiara virtù* ("Thus the glory and honour of his spotless virtue became tainted by a dark blot"; Vasari-Bellosi 705).

Particularly detrimental to the artist's virtue and reputation is Lucrezia's emotional black-mail via letters that caused the artist to leave the court of Francois I at Fountainbleu to stay with his young wife, who had remained in Firenze (*rimasa in Fiorenza sconsolata*).[13] Andrea's loss of his powerful patron seriously damaged his career and aggravated his financial situation.

Vasari's description of Lucrezia is emblematic. She personifies the calculating and faithless woman of the novella, and the brief description of her flirtatious nature and as a woman who enjoyed to be entertained and courted by other men (*vaga d'essere volentieri intrattenuta e vagheggiata d' altrui*), becomes the main source for the dramatic situation in Browning's poem. The scene is set one evening in Andrea's workshop, and we hear the artist beg Lucrezia not to go out to see her "cousin":

> . . . let me sit
> Here by the window with your hand in mine
> And look a half-hour forth on Fiesole,
> Both of one mind, as married people use,
> Quietly, quietly the evening through. . . (13–17)

The poem ends some 240 lines later when he lets her slip away: "Again the Cousin's whistle! Go, my love" (267). But this poem, too, is more than the record of a man enslaved by his love for a faithless woman. For in it Browning uses the artist's psychology to offer a precise analysis of a particular moment in the history of art and artistic sensibility; that is, the shift from the first flowering of Renaissance art to incipient *bella maniera*.

Andrea, the perfect artist, lacks the courage and the daring to experiment and overreach. He tells Lucrezia that he could correct an arm in Raphael's painting, but realizes that "all the play, the insight and the stretch" (116) are missing in him:

> Out of me, out of me! And wherefore out?
> Had you enjoined them on me, given me soul,
> We might have risen to Raphael, I and you! (117-119)

Andrea seems to be locked within an impasse, seemingly unable to make the necessary leap into *maniera* playfulness and *contrapposti*: "Ah, but a man's reach should exceed his grasp, . . "(97). Ironically, it is only when he describes what Vasari had diagnosed as the cause of his fate, his wife and model, that the very order of his words become *manieroso*:

> So! Keep looking so —
> My serpentining beauty, rounds on rounds!/ . . .
> My face, my moon, my everybody's moon,
> Which everybody looks on and calls his,
> And, I suppose, is lookcd on by in turn,
> While she looks—no none's: very dear, no less. (26; 29–32)

Andrea may capture "the perfect brow,/And perfect eyes, and more than perfect mouth" of his inconstant wife in a perfect picture, but serpent-like she slides away to other suitors. Lucrezia thus symbolizes the state of painting at that time. The perfectly balanced forms of Renaissance perspectival compositions are transmuted into the new ideals of the *bella maniera* and its spiraling and serpentine solutions. Interestingly, Browning lets Andrea's brooding thoughts on his art and that of others such as Raphael, become a general meditation on Florentine art in about 1525. The poet thus anticipates Arnold Hauser and "Angst Mannerism" (in James Mirollo's happy phrase), so that the psychological portrait of Andrea turns into a portrait of a style that has gone stale. And it is Lucrezia in Browning's poem who becomes the embodiment of the cherished quality of *mozione* (movement) in Mannerist art, not Andrea, and hers is a *mozione* that is snake-like and seductive. Still, the inventive and penetrating analysis of del Sarto's mind and career is more or less lifted directly from Vasari's novella-like account of the effect of the haughty and inconstant wife on the potentially "divine" painter.

My third and final example of how the Victorian poet grasped the essentials of Vasari's historical imagination is "My Last Duchess," a poem for which he collects materials for an awesome psychological portrait of an absolutist prince, probably inspired by Alfonso II, the duke who imprisoned Torquato Tasso at Ferrara. Hence the dramatic monologue is given the setting "Ferrara" in the subtitle. The duke, who is in the process of negotiating a new marriage, communicates his crass demands to his interlocutor by means of descriptions of two works of art, a breathtaking fresco of his previous wife and a stunning piece of bronze sculpture. And his depictions of the *objets d'art* serve as an indirect warning delivered to the envoy of the Count, whose daughter is to be married to the duke. Unless the next duchess—he implies—behaves respectfully and submissively in the manner expected of woman marrying a prince with a "nine-hundred-year-old name" (33), she, too, will end up as a fresco image:

> That's my last Duchess painted on the wall,
> Looking as if she were alive. I call

> That piece a wonder, now: Fra Pandolf's hands
> Worked busily a day, and there she stands. (1–4)

Fra Pandolf is a fictitious painter, but both his superior technique and the location of the fresco he completes in one day only suggest inspiration from passages in Vasari's Life of Andrea del Sarto, Browning's "faultless painter." In the concluding paragraph of the Life, Andrea is praised for the lifelike quality of his figures and for his speed and dexterity in completing them:

> He understood very well the management of light and shade and how to make things recede in the darks, and painted his pictures with a sweetness full of vivacity; not to mention that he showed us the method of working in fresco with perfect unity and without doing much retouching on the dry, which makes his every work appear to have been painted in a single day. [14]

When Vasari earlier in the Life gives an example of that "destrissima pratica," he mentions "una Pietà colorita nel noviziato, in fresco in una nicchia, a sommo a una scala, che fu molto bella, . ." (Vasari-Bellosi, 713). It seems highly probable that the mention of that beautiful fresco in a niche at the top of the staircase provided the idea for the hidden image of the Duchess. But when this is said, the source is not important, nor the name of the artist, for Fra Pandolf's image does not convey an idea of still and balanced perfection, but rather one of paradoxical vitality in death that is not found in "Andrea del Sarto." The Duke's jealous thoughts circle around "that spot /Of joy . . . into the Duchess's cheek" (14–15). His remark on the portrait's striking vividness in fact acquires a double meaning ("As if alive;"2 and 47), referring both to the woman and an artistic ideal. It reminds us that the duchess no longer lives while also drawing attention to the ideal of lifelike representation to produce *naturalezza*. The fact that it was finished in but one day alludes to the Mannerist ideal of *sprezzatura* first voiced by Castiglione: to execute things difficult swiftly and with ease. With regard to the Duke's ruthless attitudes and desire to be in complete command, he, too, could be said to embody the same ideal.

It is a paradox that when Vasari's short tale in the Life of Leonardo has been neglected and received little serious attention by the critics, Browning's story about Fra Pandolf's fresco and its subject has been heralded as an unsurpassed comment on the Renaissance. Literary critics have focused on the poet's stunning psychological portrait of the duke, and the birth of the tormented modern individual, whereas less interest has been shown in its implicit comment on the shift from an artistic ideal that favors *naturalezza, disegno,* and imitation of real objects, a line that was initiated by Giotto, to an aesthetic that favors the *bella maniera* and *maraviglia*. The passage from the one ideal to the other is seen in the Duke's comments throughout—"I call/ that piece *a wonder,* now"(2–3)—but particularly in his implicit juxtaposition of the fresco with the bronze sculpture in the final lines of the poem. Addressing the envoy, he remarks:

> Notice, Neptune, though,
> Taming a sea-horse, thought *a rarity,*
> Which Claus of Insbruck cast in bronze for me! (54–56)

Apart from noting the obvious parallel and contrast pointed between the carefree Duchess seated on the white mule (28), and the striving and subdued sea-horse (55), we here appreciate how the aesthetic of wonder, or *maraviglia*, is praised in a piece which displays violent motion and intricate *contrapposti*—in the manner of Bartolommeo Ammanati's *Vittoria* (1540) and Giambologna's *Firenze Defeating Pisa* (1565). On the level of psychology lurks the jealous duke's threat of coercion, even death, to the next duchess in line; indeed the reward of the last duchess who had smiled at such simple wonders of nature as the sunset, or a "bough of cherries" (26; 27). But on the level of cinquecento aesthetic and art history we witness the victory of the aesthetic of wonder and the cultivation of refined form over a simpler aesthetic of *verosimile* and *naturalezza*. Thus in "My Last Duchess" Browning suggestively presents another instance of how fiction provides an analysis and a diagnosis of art at a particular moment in the history of Italian aesthetic sensibility. In offering us this poetic example, Browning shows that he had grasped the genius of Vasari, teaching his audience—and us—how to read Messer Giorgio's fables of art and how to appreciate his powerful historical imagination.

NOTES

1. Paul Barolsky, "Vasari and the Historical Imagination," *Word & Image* 15 (1999): 286–91.
2. Barolsky, 287.
3. He proposes that "it also embodies a universal philosophy of art, one presented in *novella* form!" Barolsky, 287.
4. J. Hillis Miller, *The Disappearance of God: Five Nineteenth-Century Writers*, 108.
5. Robert Bristow, *Robert Browning* (New York, London, Toronto, Sydney, Tokyo, Singapore: Harvester Wheatsheaf, 1991) 87.
6. Walter Pater, *The Renaissance*, ed. Adam Philips [Oxford and New York: Oxford World Classics, 1998] 23.
7. Unless otherwise indicated, all translations are from *Lives of the Painters, Sculptors, and Architects*, translated by Gaston de Vere [Harmondsworh: Penguin, 1996]. For the translation here, see Vol. 1, 437. Unless otherwise stated, all citations are taken from Vasari, *Le vite de' più eccellenti pittori, scultori et architetti italiani, . . . per i tipi di Lorenzo Torrentino, Firenze 1550*. Edited by L. Bellosi and A. Rossi (Turin: Einaudi, 1986).
8. Vasari-de Vere, 1, 437. The translated passage is: Dicesi ch' era tanto venereo, che vedendo donne che gli piacessero, se le poteva, ogni sua facultà donato le arebbe; . . . Onde una volta, fra l' altre, Cosimo de' Medici, facendogli fare un' opera in casa sua [Palazzo Medici], lo rinchiuse, perchè fuori a perder tempo non andasse. Ma egli, statoci già due giorni, spinto da furore amoroso, anzi bestiale, una sera, con un paio di forbici fece alcune liste de' lenzuoli del letto, e da una finestra calatosi, attese per molti giorni a' suoi piaceri. Onde non lo trovando e facendone Cosimo cercare, al fine pur lo ritornò al lavoro; e d' allora in poi gli diede la libertà, che a suo piacere andasse; pentito assai d' averlo per lo passato rinchiuso, pensando alla pazzìa suo ed al pericolo che poteva incorrere. (Vasari-Bellosi, 375).
9. Browning's poems are cited from *Robert Browning. . . Selected Poetry*, ed. Daniel Karlin (Harmondsworth: Penguin Classics, 1989). Vasari's citations, p. 217, Vasari-Bellosi, 378; translations, p. 217, Vasari-de Vere, 625.
10. "[V]ide fra' Filippo un dí una figliuola di Francesco Buti, cittadin fiorentino, la quale o in serbanza o per monaca era quivi. Fra Filippo, dato d' occhio alla Lucrezia: che così era il nome della fanciulla, la quale aveva bellissima grazia ed aria; tanto operò con le monache, che ottenne di farne un ritratto, per metterlo in una figura di nostra donna per l' opra loro." (Vasari-Bellosi, 377).
11. "Andrea del Sarto nel quale uno mostrarono la natura e l' arte tutto quello che può far la pittura mediante il disegno, il colorire, e l'invenzione: intanto che, se fusse stato Andrea d' animo alquanto più fiero ed ardito, sì come era d' ingegno e giudizio profondissimo in questa arte, sarebbe stato, senza dubitazione alcuna, senza pari. Ma *una certa timidità d' animo, ed una certa natura dimessa e semplice*, non lasciò mai vedere in lui un certo vivace ardore, nè quella fierezza che, aggiunta all' altre sue parti, l'arebbe fatto essere nella pittura veramente divino . . ." (*emphases added*); cited from Giorgio Vasari, *Le vite de' più eccellenti pittori, scultori ed architetti nelle redazioni del 1550 e 1568*, testo a cura di Rosanna Bettarini ; commento secolare a cura di Paola Barocchi (Firenze : Studio per edizioni scelte, 1962), 4, 341–42.
12. Author's translation. Vasari's text reads: "Era in quel tempo in via di S. Gallo maritata una bellissima giovane a un berrettaio, la quale teneva seco non meno l' alterezza e la superbia, ancorché fussi nata di povero e vizioso padre, ch' ella fossi piacevolissima e vaga d' essere volentieri intrattenuta e vagheggiata d' altrui: fra i quali de l' amor suo invaghì il povero Andrea, il quale dal tormento del troppo amarla aveva abbandonato gli studii de l'arte et in gran parte gli aiuti del padre e della madre." (Vasari - Bellosi, 704–05).
13. "Mentre ch'egli lavorava . . .venne un giorno una man di lettere infra molte che prima gli eron venute, mandate dalla Lucrezia sua donna, rimasa in Fiorenza sconsolata" (Vasari - Bellosi, 711); ("When he was working [in France] . . . a handful of letters arrived, and among which were many sent by his woman, who had remained unconsolable in Florence"). The statement is anticipated already in the opening paragraph of the Life where we are told about Andrea's return to Florence "dove per satisfare al desiderio de l'appetito di lei et di lui, tornò et visse sempre bassamente: . . ." (Vasari - Bellosi, 697) ("where he because of his desire to satisfy his and her appetites, returned and lived basely": author's translation).
14. Vasari – de Vere, 2, 855. Vasari's text reads: "Per aver inteso benissimo l'ombre et i lumi e lo sfuggire le cose nelli scuri, dipinti con una dolcezza molto viva, oltra lo avere mostro il modo di lavorare in fresco, con quella unione e senza ritoccar troppo a secco che fa parere fatto tutta in un medesimo giorno." (Vasari-Bellosi, 727).

# VASARI'S HUMOR

MICHELAGNOLO BVONAR. PIT.
SCVLTORE ET ARCHITET.

# Michelangelo Ha Ha

## WILLIAM E. WALLACE

Giorgio Vasari relates a delightful tale of a peasant who once requested a picture of St. Francis from the "crude and commonplace painter" Domenico da Terranuova, known as Menighella. On seeing the saint represented in a dull gray habit, the peasant expressed disappointment as he had hoped for something brighter. So, Menighella repainted the holy man with a brocaded pluvial, and the peasant went away "happy as a lark." This was one of many anecdotes that Menighella told his friend Michelangelo Buonarroti who "roared with laughter" at his stories and who much enjoyed the company of this "very agreeable man."[1]

It is a delightful thing to imagine Michelangelo "roaring with laughter." Our image of the artist is too much fashioned of saturnine melancholy and *terribilità*. Although Vasari is partly responsible for creating the portrait of a melancholic Michelangelo, he also presented a different aspect of his hero. We might call this the wit and wisdom of Michelangelo; it has been little remarked upon, except by Paul Barolsky, the doyen of Renaissance humor.

Vasari tells us that Michelangelo not only enjoyed the company of Menighella, but others like him. Jacopo L'Indaco, for example, was a "gay and humorous" artist who much amused Michelangelo with his jokes and mirthful chattering.[2] Michelangelo also took delight in the simplicity of his friend Giuliano Bugiardini, whom he fondly dubbed "beato."[3] And it is obvious that he thoroughly enjoyed bantering with certain friends, such as Bartolomeo Angelini, Luigi del Riccio, Francesco Berni, and especially, Sebastiano del Piombo. More than once Sebastiano wrote, "I know that you will laugh at my chatter."[4] For example, the two friends took delight in the fact that the unholy Venetian was required to take Holy Orders prior to accepting the lucrative office of "Piombatore"—the keeper of the papal seal. Sebastiano quipped, "If you saw me I'm sure you would laugh. I am the handsomest friar in Rome."[5]

Vasari offers the further example of Topolino, of whom Michelangelo was immensely fond. Topolino was a thoroughly mediocre stonecutter who imagined himself a great artist; he was forever sending Michelangelo examples of his work which caused the master to "nearly die of laughter" (*moriva delle risa*).[6] This would be mere cruelty at the expense of another's lack of talent except the artist's correspondence confirms that the two enjoyed a warm and enduring friendship. The same is true of Michelangelo's maladroit pupil, Antonio Mini. Mini had little artistic promise, as Vasari cuttingly remarks and Michelangelo was painfully aware. But their association is misunderstood if we imagine them simply as master and apprentice—their friendship went beyond this. Rather, the evidence suggests that more than talent cemented their

friendship; they drew, scribbled, and laughed together, even indulging in the occasional bawdy and scatological joke that was common currency in the Renaissance.[7]

It may be hard to imagine Michelangelo sitting around cutting up with Mini or Menighella; such friendly merriment is mostly lost to posterity. However, we catch a glimpse of some jocular moments when Michelangelo's friend Pierantonio Cecchini invited the artist to his house to enjoy "a few jokes" together (un pocho di baia). No one, Cecchini assured him conspiratorially, "will be the wiser."[8] How true! And so we persist in thinking Michelangelo a brooding melancholic even though the artist's contemporaries amply attest a merry Michelangelo with a well-marinated, often sarcastic Tuscan wit.

We know, for example, that Michelangelo's letters often made their recipients laugh. One was so amusing that Sebastiano passed it around the Vatican causing such merriment "that everyone in the palace talks of nothing else."[9] Paul Barolsky has discussed another carefully crafted letter of ironic and ridiculing wit in which Michelangelo proposed a colossus for piazza San Lorenzo forty braccia high, with a barber shop under its rump, a cornucopia for a chimney, a dovecote in the hollow head, and bells ringing from the gaping mouth. Michelangelo concluded with some ingenious gibberish that fully reveals a Shakespearian mastery of wordplay: "To do or not to do the things that are to be done, it is better to let them be done by whoever will do them, for I will have so much to do that I don't wish to do more." The verbal tour-de-force is even more delicious, poetic and ridiculous in Italian: "Del fare o del non fare le chose che s'ànno a fare, che voi dite che ànno a soprastare, è meglio lasciarle fare a chi l'à fare, ché io arò tanto da fare ch'i' non mi churo più di fare."[10]

Therefore, should we suspect Vasari of exaggerating Michelangelo's capacity for mirth we need only turn to the artist's correspondence, his drawings, and occasionally his art and poetry. Not surprisingly, Paul Barolsky has been a pioneer in this endeavor.[11] Thus, I can think of no more appropriate and enjoyable subject for the author of Infinite Jest than Michelangelo's wit and humor as portrayed by his admiring friend, Giorgio Vasari. It may require some revision of our received stereotype, but with Vasari as guide—corroborated by Michelangelo and others— we will be pleasantly surprised to discover the irascible, anti-social recluse with a pungent sense of humor and a dry, sometimes acerbic wit.

Michelangelo frequently laughed, and sometimes mocked; he had little patience with pretension and he suffered no fools. Thus, for example, he poked fun at the meddling ways of a high church cleric by dubbing him "Mr. Busybody" (il Tantecose).[12] Similarly, he compared a priest who acted with duplicity to a sewage drain, recommending to "have nothing to do with gutter people who have two mouths" (uomini fognati con due bocche)."[13] More bantering than biting is the story Vasari relates about Michelangelo's friend who came to Rome all decked out as a pilgrim. When he greeted Michelangelo, the artist pretended not to recognize him until the friend was forced to explain who he was. "Oh," Michelangelo exclaimed, "you do look fine! It would be good for your soul if you were as good within as you seem on the outside."[14]

These choice vignettes are part of a long series of anecdotes, quips, and apothegms that Giorgio Vasari relates at the end of his Life of Michelangelo. Vasari introduces his character sketch by noting that Michelangelo made remarks that "were usually profound, but he was also capable of shrewd and witty pleasantries."[15] Vasari claims to have made note of many of these

"but," he writes, "to save time I shall quote just a few of them." There are twenty-three grouped together, and they run from anecdote to aphorism, from judgments on art and artists to observations on life and living. A collection of twelve sayings was included in Vasari's first edition of 1550; by 1568, Vasari had added an additional eleven. They are recorded in no apparent order, and since only a few are related to ancient or contemporary collections of *facezie* and proverbs, they have a genuine ring, even if many were gathered second and third hand. What Michelangelo was said to have said soon became just as important as what he might actually have said.

Vasari generally concluded his individual lives by describing an artist's death, character, epitaphs and students.[16] Thus, directly after relating Michelangelo's death, Vasari launches into a lengthy characterization of his hero. This recitation includes a long list of his friends and notable patrons, an explanation for the artist's love of solitude, and instances of his generosity. Vasari also notes that Michelangelo was wealthy but lived frugally, was a devout Christian, a willing teacher, and enjoyed a profound and retentive memory. Concluding this list of Michelangelo's personal attributes is the collection of his memorable sayings.

This Bartlettian collection of Michelangelo quotations is notable for being unique. There are no such collections in other lives, even of those artists who Vasari knew well such as Perino del Vaga, Giovanni da Montorsoli, Francesco Salviati, Tribolo, Pierino del Vinci, Baccio Bandinelli, or Rosso Fiorentino. Neither do we find a collection of recorded sayings in lives for whom one might expect witty or profound remarks, such as Leonardo, Raphael, Giulio Romano, Sebastiano del Piombo, or Titian.[17] Vasari, of course, frequently relates anecdotes and sprinkles artists' sayings throughout his *Lives*, but there is nothing like the "collected utterances" of Michelangelo. These run some five pages and nearly two-hundred lines in a modern translation.[18]

Michelangelo's drawings were kept "like relics"; similarly Vasari has preserved a precious collection of "Buonarrotisms." These accomplish a variety of related purposes. Most importantly, they testify to the character of his hero, and they give him a voice; he becomes human, an immediate, tangible presence. At the same time, a quick wit was a sign of genius and wisdom, as in Socrates, Cicero, and Montaigne. For a Renaissance audience, Michelangelo's verbal facility demonstrated an essential quality of the Renaissance courtier who cultivated eloquence and an urbane humor, preferring verbal wit to crude practical jokes.[19] It is noteworthy—and speaks to Michelangelo's elevated self-perception—that none of Vasari's anecdotes relates to the extremely popular genre of the *beffa*: pranks, practical jokes, tricks, and deceptions. There is no sex or scatology, and no Calandrinos or Grassos in Vasari's refined portrait.[20] Rather, parallel to Plutarch's lives of famous military and political leaders, Vasari's collection of sayings situates Michelangelo in the company of princes, such as Alexander the Great and Julius Caesar, as well "as modern rulers such as King Alfonso and Cosimo de' Medici, whose wise remarks and witticisms were admired, recorded, and repeated.[21] Thus were the pronouncements of an artist as significant and memorable as those of ancient kings and modern rulers.

Indeed, Michelangelo's opinions set the standards by which art was judged. His assessments, whether wittily or witheringly expressed, could cause a work to be forever celebrated, or eternally damned. His remark on Ghiberti's Baptistery doors became proverbial: "They are so

beautiful that they could stand at the entrance to Paradise.[22] Similarly, when asked his opinion of Donatello's St. Mark, he replied "that he had never seen a figure which had more the air of a good man than this one, and that if St. Mark were such a man, one could believe what he had written."[23] Michelangelo could be generous in his bestowal of praise, even on seemingly minor artists, as when he admired the *Deposition* group in terracotta by Antonio Begarelli in Modena: "If that clay were to become marble, woe to the ancients."[24] Such admiration of a work by a lesser artist well removed from the artistic centers of Florence, Rome, and Venice, lends credibility to the unexpected remark.

But Michelangelo's comments were not always so kind. When he characterized Baccio d'Agnolo's *ballatoio* for the Florentine cathedral as a "cricket cage," his comment squelched any enthusiasm to continue the project.[25] He could be merciless, as when he ridiculed Pietro Perugino in public, calling his art clumsy (*goffo*).[26] He used the same word when he angrily dismissed Francesco Francia as a profound dolt because he admired the bronze of Michelangelo's statue of Julius II more than the artist's skill in fashioning it.[27] And when he heard that the friars were meddling with Sebastiano del Piombo's great painting of the Flagellation in San Pietro in Montorio, Michelangelo expressed genuine dismay. When asked why, he remarked, "seeing that the friars had ruined the world, which was so big, it was not surprising that they should spoil the chapel, which was so small."[28]

Once, when a gentleman who claimed to understand Vitruvius joined the commissioners of St. Peter's, Michelangelo was told: "You now have someone in charge of the building who has great genius," to which the artist replied: "That is true, but he has no judgment."[29] And when shown drawings of a boy whose sponsors apologized "that he had only just started to study the art." Michelangelo laconically noted: "That's evident."[30] He made a similarly curt, but cleverly punning reply to a painter who had produced a mediocre *Pietà*, remarking that indeed it was a pity to see it, "*era proprio una pietà a vederla.*"[31]

His most famous and most damning judgment was expressed against Antonio da Sangallo's model for St. Peter's. When Sangallo's faction attempted to praise the model as "a meadow where there would never be any lack of pasture," Michelangelo responded, "That's only too true," by which he meant that it "provided pasture for dumb oxen and silly sheep that knew nothing about art."[32] We might suspect Vasari of cleverly inventing this piquant exchange if not for an extant letter in which Michelangelo himself offers an even more colorful critique. He wrote:

> For with his outside ambulatory, Sangallo immediately took away all and every light from Bramante's plan . . . And there are so many hiding-places above and below, all dark, that they provide great opportunities for no end of vile misdemeanors: such as the concealment of outlaws, the counterfeiting of money, getting nuns pregnant, and other sordid misbehaviour; and so in the evening after the church closes, you would need twenty-five men to seek out those who are hidden there.[33]

Michelangelo could be especially cutting if an artist's talent was unequal to his boasting. Thus, when Ugo da Carpi claimed in an inscription that an altarpiece was painted without a brush—that is, miraculously like St. Luke, Michelangelo remarked with a laugh, "it would have been

better if he had used a brush, for then he might have done a better job."[34] Another time, an important nobleman got the idea that he would like to be an architect. He had several niches constructed but, even with statues and decorative iron rings, the effect was disappointing. When he asked Michelangelo what could be done to rectify it, the artist replied: "Hang bunches of eels on the ring," which is much more absurd and clever in the alliterative Italian: "*De' mazzi d'anguille appiccate a quello anello.*"[35]

When asked his opinion about an artist who claimed that his copies of famous antique statues "were far better than the originals," Michelangelo offered the following sage advice: "No one who follows others can ever get in front of them, and those who can't do good work on their own account can hardly make good use of what others have done."[36] Another time, when a painter copied so much from other pictures and drawings that there was nothing original in his work, Michelangelo dryly remarked: "He has done well, but at the Day of Judgment when every body takes back its own members, I don't know what the picture will do, because it will have nothing left."[37] As in the case of the sculptor who copied antiques, Michelangelo's observation, Vasari tells us, was a warning to be original.[38]

A similar lesson is learned from the anecdote about the stonecutter who was carving an ornamental terminus figure for the tomb of Julius II. Michelangelo guided him: "Cut away here, make it level there, polish here...." Without realizing what was happening, the astonished man suddenly was staring at a completed figure. Michelangelo inquired, "Well, what do you think?," to which the stonecutter replied, "I think it's fine and I'm grateful to you." "Why's that?" asked Michelangelo. "Because through you I've discovered a talent I never knew I had."[39]

This latter story reveals an indulgent Michelangelo, with the well-bred manners of a gentleman. Baldassare Castiglione recommended that in making his jests the courtier should "take care not to be so sharp and biting that he earns a reputation for malice; he should never attack without cause or with manifest hatred those who are extremely powerful, which would be imprudent, or those who are defenseless, which would be cruel, or those who are really wicked, which would be a waste of time."[40] Thus, when working for a prince "who changed his plans every day and could never make up his mind" Michelangelo remarked: "This lord has a mind like a weather-cock; it turns with every wind that touches it." But Michelangelo prudently expressed his comment in private to a friend where it remained more humorous than offensive.[41]

Michelangelo's remarks occasionally were aphoristic in nature. When asked his opinion of an artist who labored long over his work, Michelangelo replied: "So long as he wants to be rich he'll stay poor."[42] Told that he ought to resent the way Nanni di Baccio Bigio was always trying to compete with him, Michelangelo supposedly replied: "*Chi combatte con da pochi, non vince a nulla,*" which, even in translation, retains its pungency: "Anyone who fights with a good-for-nothing gains nothing."[43] Just as Castiglione recommended, Michelangelo revealed his good breeding and superior moral character by refusing to stoop to Nanni's level.

One of Vasari's collected anecdotes reveals Michelangelo deviating from the bourgeois attitudes of his contemporaries. A friend once observed, "It's a shame you haven't taken a wife and had many sons..." to which Michelangelo retorted: "I've always had only too harassing a wife in this demanding art of mine, and the works I leave behind will be my sons." Michelangelo embellished the witticism by adding: "It would have been a disaster for Lorenzo Ghiberti if he

hadn't made the doors of San Giovanni, seeing that they are still standing whereas his children and grandchildren sold and squandered all he left."[44] Thus did Michelangelo prove his devotion to art and justify his solitary nature.

Another well-known anecdote regarding the Florentine *Pietà* reveals Michelangelo's pre-occupation with death, just at the time Vasari was gathering material for his *Lives*. Vasari had stopped by Michelangelo's house to fetch a design. When his eyes alighted on the unfinished *Pietà*, Michelangelo let the lamp drop, plunging them both into darkness. Michelangelo said: "I am so old that death often tugs my cloak for me to go with him. One day my body will fall just like that lamp, and my light will go out."[45] Vasari's specificity and apparent eye-witness account endow the anecdote with verisimilitude, until, following Paul Barolsky's recommendation, we consider it as imaginative literature: the aging artist breaks a lamp, as he also broke the very sculpture that was intended to mark his grave; the light is extinguished, just as Michelangelo—who, according to Vasari, gave "light and vision" to other artists—would soon be snuffed out. Not surprisingly, the story appears only in Vasari's second edition where, following the artist's death, the writer was at liberty to fashion the story to his own ends.

Probably the most famous of all Michelangelo's sayings—"every painter paints him-self"—is the one that is most obviously rooted in contemporary culture, being a phrase attrib-uted by Angelo Poliziano to Cosimo de' Medici and echoed by Leonardo da Vinci and Savonarola.[46] The pithy phrase is too often extracted from Vasari's robustly bovine tale: "Again, some painter or other had produced a picture in which the best thing was an ox. Michelangelo was asked why the artist painted the ox more convincingly than the rest and he replied: 'Every painter does a good self-portrait'."[47] But if this latter tale, which belongs to a long tradition of such anecdotes, is a whole or partial fabrication, another, appearing in both editions, has an entirely authentic ring.

> Once a friend of his started talking to him about death and remarked that it must sadden him to think of it, seeing that he had devoted all his time to art, without any respite. Michelangelo replied that this was not so, because if life was found to be agreeable then so should death, for it came from the hands of the same master.[48]

In both editions, this is the first anecdote related by Vasari. It sounds like Michelangelo the poet: "Death's the best doctor for time's misery."[49] This is wisdom tinged with morbidity and Christian resignation. Authentically michelangelesque.

And so we have run the gamut, from witty aphorism to moralizing anecdote. How much is authentically Michelangelo, and how much Vasarian invention? No matter what we decide, the stories and sayings will be repeated. Like much else in the Michelangelo mythology, we are reluctant to expunge the anecdotes even if they are tinged with fiction. Some of these so-called "Buonarrotisms" clearly reveal Vasari's enterprise and his literary inheritance, exposing him as a master storyteller and myth-maker. But the picture of a jocular Michelangelo is also substan-tially true: there is much that confirms Vasari's literary portrait. And it *is* a portrait. While some passages are rendered more convincingly than others, even the occasional fabrication lends truth to a good likeness.

The same artist, who is more famously known for his *terribilità*, also had an agile and

sometimes wicked wit, and, like most of his contemporaries, he enjoyed "roaring with laughter." Few have detected him roaring, or chuckling, more clearly than Paul Barolsky. But in order to hear we must avoid taking our subject too seriously. Rather, let us just say we have "enjoyed a few jokes together" and no one "will be the wiser."

NOTES

1. G. Vasari, *Lives of the Artists*, vol. 1, trans. G. Bull (London, 1987), 429–30 (hereafter Vasari-Bull); G. Vasari, *Le Vite de' più eccellenti pittori, scultori e architettori*, ed. R. Bettarini and P. Barocchi, 6 vols. (Florence, 1967–87), 6: 120–21 (hereafter Bettarini-Barocchi).

2. Bettarini-Barocchi 3:629.

3. See the essay by Norman Land, "Michelangelo's Shadow: Giuliano Bugiardini." *Explorations in Renaissance Culture* (2005), forthcoming.

4. "So ve la riderete de le mie chi[a]chiare" and "Credo certissimamente ve la ridete de le mie littere." *Il Carteggio di Michelangelo*, 5 vols., ed. P. Barocchi and R. Ristori (Florence, 1965–83), 3:305 and 3:389 (hereafter *Carteggio*).

5. *Carteggio* 3:342.

6. Vasari-Bull, 429–30; Bettarini-Barocchi 6:121.

7. See W. E. Wallace, "Instruction and Originality in Michelangelo's Drawings." in *The Craft of Art: Originality and Industry in the Italian Renaissance and Baroque Workshop*, ed. A Ladis and C. Wood (Athens, GA and London: University of Georgia Press, 1995), 113–33.

8. *Carteggio*, 4:69.

9. Sebastiano to Michelangelo, 3 July 1520 (*Carteggio* 2:233). Once Clement VII read a letter over five or six times before reading it aloud to his entire household (*Carteggio* 3:220). Another letter greatly delighted the pontiff and prompted his laughter (*Carteggio* 3:215).

10. *Carteggio* 3:190–91. The letter was discussed by Paul Barolsky in *Infinite Jest: Wit and Humor in Italian Renaissance Art* (Columbia and London, 1978), 68–70.

11. For example, P. Barolsky, *Infinite Jest*, esp. Chap. 3; idem, "Michelangelo's Erotic Investment," *Source 11* (1992):32–34; idem, *The Faun in the Garden: Michelangelo and the Poetic Origins of Renaissance Art* (University Park, PA, 1994), Chap. 4; idem, "Michelangelo's Self-Mockery," *Arion* (Spring 2000):167–74. Henry Thode devoted a chapter to Michelangelo's humor in *Michelangelo und das Ende der Renaissance*, vol. 1 (Berlin, 1912), 166–91. See also R. J. Clements, *The Poetry of Michelangelo* (New York, 1966), esp. Chap. 15; D. Romei, "Bernismo' di Michelangelo" in *Berni e berneschi del Cinquecento* (Florence, 1984), 139–82, and A. Corsaro, "Michelangelo, il comico e la malinconia," *Studi e problemi di critica testuale* 49 (1994): 97–119.

12. Vasari-Bull, 395–96; Bettarini-Barocchi 6:85. Vasari got this directly from Michelangelo who used the nickname in a letter to Vasari 13 October 1550 (*Carteggio* 4:355). Once, in order to shut up the gossips who claimed that he had broken one of the marble allegories for the Medici Chapel, Michelangelo admitted that it was true—a caustic riposte that much amused Pope Clement (*Carteggio* 3:215).

13. "...ripose che gli dispiacevano gli uomini fognati, stando nella metafora della architettura, intendendo che con quegli che hanno due bocche mal si può practicare" (Bettarini-Barocchi 6:118).

14. Vasari-Bull, 426; Bettarini-Barocchi 6:117–18.

15. Vasari-Bull, 425; Bettarini-Barocchi 6:116. Ascanio Condivi noted that Michelangelo's manner was "also seasoned with charm and witticisms" (A. Condivi, in *Michelangelo: Life, Letters, and Poetry*, trans. G. Bull [Oxford and New York, 1987], 71 [hereafter Condivi-Bull]).

16. P. Rubin, *Giorgio Vasari: Art and History* (New Haven and London, 1995), 160.

17. At the end of the Life of Botticelli, Vasari relates three long anecdotes that reveal him to be "a very good-humoured man" (Vasari-Bull, 228); nonetheless, the stories are unlike the long list of witticisms and sayings that Vasari records of Michelangelo.

18. Vasari-Bull, 425–30; in the Bettarini-Barocchi edition, the anecdotes run some four pages and 145 lines (6:116–21). Condivi records just three anecdotes, all three directed against the Bolognese, only one of which appears in Vasari's first edition: (Condivi-Bull, 71–72).

19. B. Castiglione, *The Book of the Courtier*, trans. G. Bull (London, rev. ed., 1976), 151–200. For Machiavelli, aphoristic wit was "the highest manifestation of human *ingegno et gravità*" (J. T. Schnapp, "Machiavellian Foundlings: Castruccio Castracani and the Aphorism," *Renaissance Quarterly* 45 [1992]:665). See also P. Burke, *Varieties of Cultural History* (Ithaca NY, 1997), 91, and M. O'Rourke Boyle, "Gracious Laughter: Marsilio Ficino's Anthropology." *Renaissance Quarterly* 52 (1999): 719.

20. See L. Martines, "The Italian Renaissance Tale as History," *Language and Images of Renaissance Italy*, ed.

A. Brown (Oxford, 1995), 313–30.

21. See A. Brown, "Cosimo de' Medici's Wit and Wisdom," in *Cosimo 'il Vecchio' de' Medici, 1389–1464*, ed. F. Ames-Lewis (Oxford, 1992), 95–113.

22. Vasari-Bull, 427. The anecdote is related also in the Life of Lorenzo Ghiberti; see Bettarini-Barocchi 3:100.

23. Vasari-Bull, 425–26; Bettarini-Barocchi 6:116.

24. Bettarini-Barocchi 6: 120.

25. Bettarini-Barocchi 4: 613.

26. Bettarini-Barocchi 3: 608. See A. Ladis, "Perugino and the Wages of Fortune," *Gazette des Beaux-Arts* 131 (1998):221–34, and on the word "goffo," P. Barolsky, *Why Mona Lisa Smiles and Other Tales by Vasari* (University Park, PA, 1991), 13–14.

27. Bettarini-Barocchi 6:32. In Vasari's 1550 edition, Michelangelo's response is more colorful; he tells Francia, "Va' al bordello, tu e'l Cossa [Francesco del Cossa], che siete due solennissimi goffi nell'arte" (Bettarini-Barocchi 6:32). Condivi repeats the story and adds two more Bolognese tales that are not in Vasari's 1550 edition. First, Condivi has Michelangelo making fun of the Bolognese by comparing them to large, dumb oxen, and then he records Michelangelo's quip upon meeting Francia's handsome son: "My boy, your father's live figures are better-looking than those he paints" (Condivi-Bull, 72). This latter anecdote finds contemporary parallels in stories related by Niccolò Angèli dal Bucine (C. Speroni, *Wit and Wisdom of the Italian Renaissance* [Berkeley and Los Angeles, 1964], 160–61, no. 10) and Leonardo (*The Notebooks of Leonardo da Vinci*, ed. E. MacCurdy, 2 vols. [New York, 1938], 2:449). Vasari incorporates both tales into the 1568 edition (Bettarini-Barocchi 6: 31–32; Vasari-Bull, 348).

28. Vasari-Bull, 426; Bettarini-Barocchi 6: 117.

29. Vasari-Bull, 427; Bettarini-Barocchi 6: 119.

30. Vasari-Bull, 426; Bettarini-Barocchi 6: 116–17. This is a perfect example of Castiglione's recommendation that a "pungent remark must be uttered and must hit the target before the speaker seems to have had time to think," a quality, notes Castiglione, that "springs entirely from genius and Nature" (Castiglione, *Courtier*, 152).

31. Vasari-Bull, 426; Bettarini-Barocchi 6: 117.

32. Vasari-Bull, 386; Bettarini-Barocchi 6: 77.

33. Letter of January 1547 from Michelangelo to Bartolomeo Ferratini (*Carteggio* 4:251; translated in Condivi-Bull, 119).

34. "Sarebbe meglio che avesse adoperato il pennello e l'avesse fatta di miglior maniera" (Bettarini-Barocchi 5:15).

35. Bettarini-Barocchi 6:119. Further context for this remark is provided by Michelangelo's advice against carved decoration, such as foliage (or, one supposes,

eels!), "where there were marble figures nothing else was needed" (Vasari-Bull, 392; Bettarini-Barocchi 6:82).

36. Vasari-Bull, 426–27; Bettarini-Barocchi 6:118. The remark is a variant of the proverb: "Chi va dietro agli altri, non passa mai avanti" (G. Giusti and G. Capponi, *Dizionario dei Proverbi Italiani* [Milan, 1956], 248). The metaphor of the foot race is common; see L. Barkan, *Unearthing the Past: Archaeology and Aesthetics in the Making of Renaissance Culture* (New Haven and London, 1999), 288–89.

37. Vasari-Bull, 427–28; Bettarini-Barocchi 6: 119–20. A curious parallel to this anecdote is found in a letter that Michelangelo wrote his friend Luigi del Riccio following the death of Cecchino Bracci, in which the artist plays on the notion that a person's beauty, confected from others, will be returned on the day of Judgment (see *Carteggio* 4: 178).

38. The striving for originality was a *topos* in the Renaissance, expressed by Michelangelo elsewhere—"if you want to do well, always vary." This is a marginal note by Tiberio Calcagni recording Michelangelo's comment; see C. Elam, "Ché ultima mano!": Tiberio Calcagni's Marginal Annotations to Condivi's *Life of Michelangelo*, *Renaissance Quarterly* 51 (1998): 492. A similar sentiment was expressed by Leonardo da Vinci who noted that "no one should ever imitate the style of another because he will be called a nephew and not a child of nature" (*Leonardo on Painting*, ed. M. Kemp [New Haven and London, 1989], 193).

39. Vasari-Bull, 430; Bettarini-Barocchi 6: 121.

40. Castiglione, *Courtier*, 186. Similarly, in his *Galateo*, Giovanni della Casa recommends that one observes the distinctions: "You must know that there is no difference between joking and mocking except in purpose and intention; for joking is done for amusement, and mocking is done to hurt" (G. della Casa, *Galateo*, trans. K. Eisenbichler and K. R. Bartlett [Toronto, 1986], 33).

41. Vasari-Bull, 427; Bettarini-Barocchi 6:119. Discretion, for example, was considered a hallmark of Cosimo de' Medici's wisdom (Brown, "Wit and Wisdom," 99).

42. Vasari-Bull, 426; Bettarini-Barocchi 6: 117.

43. Vasari-Bull, 428; Bettarini-Barocchi 6: 120.

44. Vasari-Bull, 428; Bettarini-Barocchi 6: 120. The correspondence confirms Michelangelo's impatience with the suggestion that he take a wife (see *Carteggio* 3:17, 22).

45. Vasari-Bull, 428–29; Bettarini-Barocchi 6: 120.

46. Vasari-Bull, 427; Bettarini-Barocchi 6: 118. Poliziano puts the phrase in Cosimo de' Medici's mouth; see Angelo Poliziano, *Detti piacevoli*, ed. Tiziano Zanato (Rome, 1983), 67, no. 152. For the remark, see M.

Kemp, "'Ogni dipintore dipinge sè': A Neoplatonic Echo in Leonardo's Art Theory?" in *Cultural Aspects of the Italian Renaissance: Essays in Honour of Paul Oscar Kristeller*, ed. C. Clough (Manchester, 1976), 311–23; C. Eisler, "Every Artist Paints Himself: Art History as Biography and Autobiography," *Social Research* 54 (1987): 73–99; F. Zöllner, "'Ogni pittore dipinge sè.' Leonardo da Vinci and 'Automimesis'," in *Der Künstler über sich in seinem Werke*, ed. M. Winner (Weinheim, 1992), 137–60, and N. E. Land, "Giotto as an Ugly Genius: A Study in Self-Portrayal," *Explorations in Renaissance Culture* 23 (1997): 23–36. Echoes of the phrase are found in Michelangelo's poetry: "As self's what we portray when we paint. . ." and "As, working in hard stone to make the face of someone else, one images his own. . ." (*The Complete Poems of Michelangelo*, trans. J. F. Nims [Chicago and London, 1998], nos. 173 and 242).

47. "Ogni pittore ritrae sè medesimo bene" (Bettarini-Barocchi, 118; Vasari-Bull, 427).

48. Vasari-Bull, 425; Bettarini-Barocchi 6: 116.

49. Nims, *Complete Poems*, no. 269.

# VASARI ON VASARI

# Lumi Fantastichi : The Landscape Ornament of Giorgio Vasari

KAREN GOODCHILD

Vasari describes a *Nativity* (fig. 1) he painted for the Camaldoline order as a night scene illuminated largely by the splendor of the newborn Christ, whose radiance imitates "the color of the sun's rays." In this painting, Vasari says he strove to make the lighting and "all the things in the work from Nature . . .as similar as possible to the reality."[1] To that end, he writes that since the rays from the Christ child could not realistically pass through the ceiling of the manger, he illuminated the landscape with other light sources, including glowing angels singing on high, shepherds holding burning sheaves of straw, the moon and stars, and a brilliant angel announcing Christ's birth to shepherds sleeping in a field.

We must assume that in his description of his own works, as in the works of others, Vasari emphasizes the elements that he thinks are most worthy of praise. In describing how he arrived at the composition for the *Nativity*, Vasari wastes little time discussing

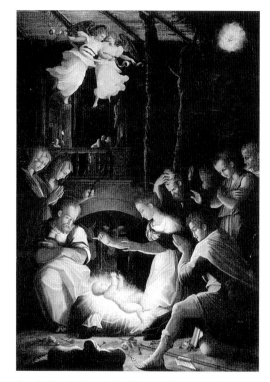

FIG. 1 Giorgio Vasari, *The Nativity*, Monastero di Camaldoli, Chiesa dei SS Donato e Ilariano.

the figures. Indeed, for Vasari, the challenge facing artists of his own generation was not to portray the eternal proportions of the human figure convincingly—previous generations had mastered that. Rather, it was to present the dramatic, sensual, changing ornaments of light and color in ways that would convince with their naturalistic rendering and startle with their artifice. The *Nativity* embodies the two aspects of landscape ornament that Vasari most praised—fidelity to nature and dramatic uses of light. And while Vasari appreciates many kinds of land-

scapes, he takes the most delight in and describes most vividly those showing striking lighting. As we will see, what he calls *lumi fantastichi*, or fantastic light effects, were highly prized by Vasari because he thought they displayed both a painter's manual and mental talents to best advantage.

It is important to note that for Vasari *lumi fantastichi* are part of the landscape, or at least they are inextricably connected with it. For Vasari, the term "landscape" could include what the term means to us—copses of trees or green views melting into aerial perspective or other representations of nature—but its meaning was not limited to these. His understanding of landscape is paradoxically both more extensive and more restrictive than ours. It is more expansive in that it could include buildings and figures, and also, as we will see, many types of light sources. In fact, it could include any aspect of the decorative setting of a work. Yet his description is less expansive in that a landscape was often (although not always) a mere detail in a very busy composition. Supporting this view is the fact that Vasari's descriptions of paintings frequently refer to landscape in the plural, *paesi*, as though the term refers to multiple ornamental vignettes within a single work. Indeed, Vasari will sometimes praise a landscape highly, and when we turn to look at the work itself, our modern eyes will be disappointed to see only a tiny bit of setting tucked away in a corner.

Given that Vasari's conception of landscape is different from our own, it is important to have some understanding of his general attitude towards it. Thus, I will first give a brief overview of Vasari's progression in the *Lives* towards the perfect style of landscape ornament, a style that includes the ability to portray dramatic light effects. Then I will situate "dramatic lights" historically in the context of the mounting sixteenth-century interest in them. Finally, I will analyze passages from the *Lives* where Vasari praises the use of ornamental lighting by other painters and describes the compositions of his own fantastically lit landscape settings. I hope to show that rather than being mere novelties, *lumi fantastichi* were for Vasari one of the premier signs of both a painter's masterful execution and his exalted conception.

### The Role of Landscape in Vasari's Lives of the Artists

As several references in the *Lives* make clear, Vasari recognizes the existence of images we would construe as "pure" landscapes. In Vasari's opinion, however, pure landscapes are not notable examples of painting because, although they often show great displays of painterly skill, they are generally undertaken as small-scale, private works, and thus are not vehicles to promote an artist's fame. In his response to Benedetto Varchi's *Inquiry*, Vasari states that landscape is an essential ornament of "universal" painting.[2] Thus, the true function of landscape for Vasari is to adorn important subjects, whether mythological, religious, or architectural, and, as stated above, often the landscapes Vasari praises occupy only a small portion of the works they grace. The subsidiary role of landscape does not, however, diminish Vasari's admiration for it. In reading the *Lives*, it becomes clear that the ability to depict ornament well is central to Vasari's theory of art, and the details of landscape emerge in the *Lives* as the premier ornaments of painting. For Vasari, landscapes are important partly because they provide passages full of visual delights for viewers. He knows, as well, that the enjoyment viewers feel when looking at land-

scape has multiple aspects: viewers may simply appreciate the brilliant replication of nature's charming colors; they may enjoy the naturalism of a scene; they may marvel at the skill a painter used to recreate the evanescent, atmospheric, and colorful details of settings; or they may wonder at the invention an artist used to come up with embellishments that are at once novel and believably depicted.

Even though Vasari nowhere sets forth a concise theory of landscape painting, the histor- ical move towards the "perfect" style of landscape is one of the many narrative progressions told in *Lives of the Artists*. In Part One of the *Lives*, Vasari uses the word *paese* only once.[3] Still, the few outdoor scenes Vasari recounts in this section begin to reveal some of the aspects of landscape painting that he deems central and will return to repeatedly, including naturalism and unusual light effects.

Landscape gains authority in Part Two of the *Lives*. Second-style painters, according to Vasari, "attempted to give more reality to landscapes, trees, herbs, flowers, skies, clouds, and other objects of nature."[4] While Vasari recognizes this is an advance in the journey towards per- fect landscape, all that these second-style artists achieve, he reports, is an increased mimetic naturalness, *e non più*, "and no more." Increased mimesis is not enough for Vasari—landscape is an ornament to painting, and as such, its elements should be appropriately chosen to add live- liness, grace, and charm to a work. Thus, artists of the Second Manner fall short in showing unadorned, unidealized nature.

The artists of the Third Manner improve on nature. Vasari claimed landscape was essen- tial to universal painting. Given this, it is not surprising that Raphael, the painter who for Vasari achieved a "catholic excellence" in all things, understood the importance of landscape, and that within his life we find a synopsis of what ornamental details might be included in an ideal land- scape setting. Raphael, according to a famous passage in Vasari, knew he would never surpass Michelangelo in figure studies, and so he resolved to develop another, competing manner—a style that pleased patrons as well as painters, one that was as adept at creating landscapes as at portraying the human body. Raphael reasoned that this alternate style should encompass all the pleasurable aspects of painting that Michelangelo neglected, and so he decided to perfect his manner by learning to embellish his works with:

> an endless variety of . . . things, such as . . . draperies, foot-ware, helmets, armour, women's head-dresses, hair, beards, vases, trees, grottoes, rocks, fires, skies turbid or serene, clouds, rain, lightning, clear weather, night, the light of the moon, the splen- dour of the sun, and innumerable other things, which are called for every moment by the requirements of the art of painting.[5]

Here, Vasari is essentially compiling the ornaments of painting, the embellishments of both fig- ures and settings. The things he lists do not require great skill in *disegno* to execute, but instead show off dexterity in manipulating paint to recreate tangibly the surfaces of things as they exist in light. Though some of the items he lists, like beards and headdresses, relate to ornamenting figures, most are to be found in landscape, either as the material details of outdoor scenes such as trees and rocks, or as *lumi fantastichi*, visible sources of light within a painting such as fire, lightning, brilliant sun, and moonlight.

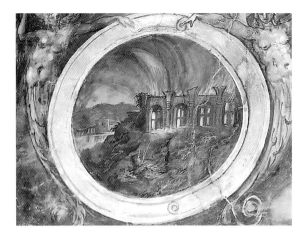

Fɪɢ. 2 Giorgio Vasari, *Burning Landscape*, ceiling roundel from the Palazzo Vecchio, Florence.

Striking light effects are ornaments that Vasari never fails to single out for praise in the paintings of others and strives to include as often as possible in his own paintings. They are a distinct mark of the perfect manner of painting achieved in his own lifetime, and they can enhance a painting in several ways. Because *lumi fantastichi* are often areas of extreme brightness in otherwise dark paintings, they allow for intense contrasts to throw figures into high relief, enhancing the form and movement of bodies, and thus underscoring an artist's facility. Lights are also areas where ornament can enhance meaning, as in Vasari's *Nativity* (fig. 1), where the glowing angel is the manifest light of grace appearing to the shepherds in the distance. In these ways, dramatic lights can showcase an artist's skill and his heightened conceptions.

Painted light and its effects were also one of the chief ways that Renaissance painters could compete with sculptors. Vasari certainly knew that Pliny had praised Apelles by saying he "even painted things that cannot be represented in pictures—thunder, lightning, and thunderbolts."[6] In outdoor scenes, sunlight, moonlight, lightning, or supernatural occurrences could be shown, and the ability to portray such ephemera was seen by some as the ultimate challenge of the painter's skill, for these were phenomena that the sculptor could not reproduce. These details of light and color were transitory, however, and thus the paradox of their depiction was that they exhibited a painter's skill most fully at the same time that they had to cede place of importance to the central subject matter of a work.

### Renaissance Interest in Fantasies of Lighting

While descriptions in the *Lives* certainly show that Vasari enjoyed innovative uses of lighting, he was far from the only artist interested in *lumi fantastichi*. Lighting effects increasingly intrigued Italian painters throughout the sixteenth century. For example, Leonardo suggests a way to paint a night scene:

> introduce a great fire there . . .and . . . represent all the things illuminated by it . . . of a ruddy hue, while those which are further away from the fire should be dyed more deeply with the black color of the night. The figures between you and the fire should appear dark against the brightness of the flame...and those visible beyond the edge of the flames will be all lit up with a ruddy light against a dark background.[7]

Although there is no documented paint-
ing by Leonardo showing such a scene,
many other artists took his advice. Vasari
himself, as a roundel from the Palazzo
Vecchio decoration shows, paid heed to
the way the color of fire will light up a
dark landscape around it "with a ruddy
light (fig. 2)."

Earlier artists had also evinced an
interest in strange lighting. For instance,
Piero di Cosimo, an artist Vasari says was
influenced by Leonardo, painted several
fires. Vasari also tells us that Francia, one
of the early masters of oil painting, deco-
rated a horse's caparison for the Duke of
Urbino with an image of a vast forest
aflame, showing animals of earth and air
rushing to escape the conflagration. This
work, which we might dismiss as minor
due to its function, was apparently quite
important—Vasari notes that whereas
Francia's frescoes and panel paintings
had already caused him "to be held in the
light of a god," the success of the horse's

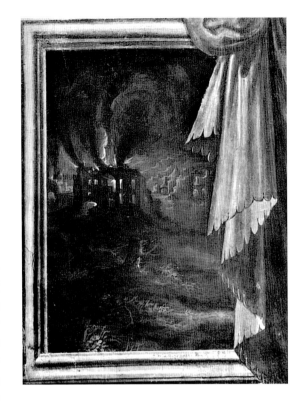

Fig. 3 Giorgio Vasari, *Burning Landscape*, fresco from the
*Chamber of Fortune*, Casa Vasari, Arezzo.

caparison caused this regard to grow "infinitely greater," and placed the Duke forever in
Francia's debt.[8]

As the Duke's interest in and gratitude for Francia's fiery work shows, Italian patrons were
quite taken with imaginative images of light, and one source for these paintings was the North.
Indeed, Italian artists' interest in learning to paint *lumi fantastichi* like fires in the night may
have been spurred by a desire to compete with their Northern brethren, who had been depict-
ing these effects for some time. Vasari notes that certain Northern painters excelled at showing
"landscapes in oils, fantasies (*fantasticherie*), bizarre inventions, dreams, and...imaginings...fires,
nights, splendours...and other things of that kind."[9] Images such as these were being avidly col-
lected by Italian patrons. In 1535, for example, Federigo Gonzaga bought twenty landscapes
from the painter and art dealer Matteo del Nassaro, and these works were said to show "noth-
ing but landscapes on fire which seem to burn one's hands if one goes near to touch them."[10]

Works with dramatic lighting were valued, whether produced abroad or at home, because,
due to a combination of painterly skill and imaginative composition, the unusual lights in them
appeared real, yet extraordinary. Vasari, as noted, calls scenes with unusual light sources "fan-
tasies" and "splendors," terms which underscore the great degree of invention and skill he
believes these works display. His thoughts on this matter are evident in a comment he makes
about the painter Gian Girolamo Bresciano, better known as Savoldo. Vasari says Savoldo

painted pictures of night and fire, and a *Nativity* with a lovely effect of night, as well as

> . . . other similar works of fantasy, in which he was a master. But, since he occupied himself only with things of this kind, and executed no large works, there is nothing more to be said of him save that he was a man of fanciful (*capriccioso*) and inquiring mind (*sofistico*), and that what he did deserves to be much commended.[11]

The vocabulary Vasari uses to describe Savoldo's paintings suggests that such works take much imagination and even erudition to create, and plainly provide great pleasure to viewers who marvel at their exciting effects.

This passage also makes clear, however, that fantastic light effects are best used in the service of important, publicly viewed paintings—because Vasari knows only of small-scale oils from Savoldo, he gives the painter scant mention. There is evidence that artists and their advisors cast about to uncover significant subject matter that would lend itself to extraordinary light displays. For example, at the end of the sixteenth century G. P. Lomazzo compiled a list of stories that could be set in fiery landscapes, suggesting elevated themes like Sodom and Gomorrah and the burning of Troy.[12]

Still, merely painting an important subject was not enough to ensure an artist's fame and to win Vasari's unmitigated approval. Savoldo had painted a *Nativity*, itself surely a hallowed subject, but it was small in scale and not thus a truly "important" work. Perhaps partly because of a desire to display *lumi fantastichi* in public, large-scale works, artists began to incorporate them more frequently as embellishments to architectural settings. Vasari painted fiery images in his own house in Arezzo (fig. 3). The burning landscape illustrated here is paired with another one in the most important room in his home, the *Chamber of Fortune*. The landscapes, presumed to represent the burning of Troy, are painted over the fireplace, which bears inscriptions concerning fire, and they are meant to be understood in relation to the focal point of the room, a statue of Venus, which stands on

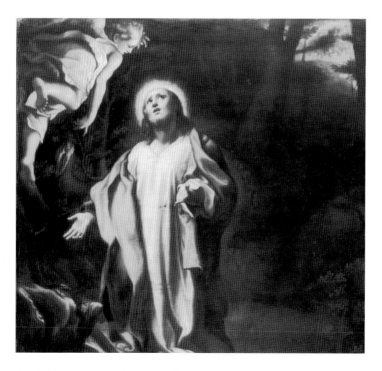

FIG. 4 After Correggio, *The Agony in the Garden*, London, National Gallery.

the mantle in front of the flaming images and functions as an emblem of art. Taken together, these artworks are part of an elaborate program of painting, sculpture, and architecture that expresses a complex allegory about art, and the flaming landscapes display the triumph of art through their artistic virtuosity as well as through their connection to the program's meaning. [13]

Another documented example of a cycle of architectural embellishments with extraordinary lighting comes to us from Vasari's friend and literary advisor Annibale Caro, who suggested the imagery for Taddeo Zucchero to paint in Cardinal Alessandro Farnese's villa. Caro invented an extremely detailed allegory of night, which he said would allow for a painting "out-of-common in invention and workmanship," two

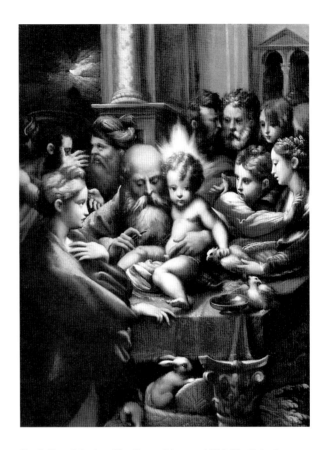

Fig. 5 Parmigianino, *The Circumcision*, ca. 1523. The Detroit Institute of Art.

attributes which were both essential given the patron's illustriousness. Caro writes: "I would have a night painted [in the bedroom]...because...it would be appropriate to sleep, [and] it would be a subject not very customary and very different from the other rooms, and would give you an occasion of executing rare and beautiful works in your art . . . ."[14] This Night was to be variously illuminated, Caro says, by "celestial lights and earthly fires," and he goes on to specify these as lamps, torches, hearths, forges, bonfires, stars, planets, and radiant allegorical figures like dawn and the moon.[15]

### Vasari's Praises for Lumi Fantastichi in the Lives of the Artists

We have seen that Vasari, like many artists of his generation, was eager to place extraordinary sources of light within his landscapes. His personal affection for this type of effect can be surmised from the prominent placement of burning landscapes in the most important and public room in his home (fig. 3). His *magnum opus*, the *Lives of the Artists*, also attests to his love of *lumi fanstastici*. In the Life of Correggio, for instance, Vasari waxes rhapsodic over a painting showing *Christ in the Garden* (fig. 4), saying it is "the rarest and most beautiful work to be seen by his hand." This work is described by Vasari as:

representing an effect of night . . . wherein the Angel, appearing to Christ, illumines him with the splendour of his light, with such truth to nature that nothing better can be imagined or expressed. Below, on a plain at the foot of the mountain, are seen three Apostles sleeping, over whom the mountain on which Christ is praying casts a shadow, giving those figures a force which one is not able to describe. Far in the background, over a distant landscape, there is shown appearing the dawn. [16]

In this painting, the radiance of the angel penetrates the dark night to bathe Christ in the light of grace, a light which has not yet been made manifest to his followers. The promise of grace to come, however, is symbolized in the approaching dawn. In this way, the lights in the scene not only provide a striking and unusual composition of singular beauty, but also embody the central meaning of the Christian religion. As his ekphrasis shows, Vasari admires this inextricable joining of form and content, just as he admires the conception that went into inventing it, saying there is "no work equal to it either in patience or in study."[17]

Correggio's followers also garner praise from Vasari for their inventive landscape lighting. In the first sentence in the biography of Parmigianino, Vasari writes that of all the artists in Lombardy who have been gifted with facility in landscape painting, Parmigianino is the finest.[18] Not surprisingly, Parmigianino is an innovator in lighting his paintings in striking and symbolic ways, as is shown in a *Circumcision* that Vasari says he painted for the Pope (fig. 5). This scene, which is generally depicted by artists inside the temple, is conceived by Parmigianino outside the holy building. Vasari identifies the light as the most beautiful element of the work, demonstrating extraordinary inventiveness because of "three most fanciful lights" *(lumi fantastichi)*: the radiance of Christ, torches, and the dawn's light.[19] Christ's circumcision is the first shedding of his blood and a prefiguration of his redemptive sacrifice. Those closest to the holy event are lit by his supernatural radiance. A distant dawn could not only allude to the symbolic meaning of daybreak casting its enlivening rays across the landscape (a reference to the miracle that comes from Christ's offering), but would also afford the dramatic effect of the infant Christ's luminescence playing on the faces and figures of those on the temple stairs, figures otherwise immersed in the darkness of night. Once more, form and content could come together to create a work that is extraordinarily, even startlingly, artful, but still pregnant with spiritual meaning.

### Vasari's own Lumi Fantastichi

Vasari's descriptions of the paintings of other artists give us an idea of the landscape ornaments he esteems. Vasari's autobiography is even more revealing, for in it he describes the settings of his own paintings in great detail both with regard to their appearance and the planning of their compositions. One such striking passage occurs in Vasari's discussion of an altarpiece he painted, *St. Francis Receiving the Stigmata*. Vasari's explanation of this work shows the thought he put into making his landscapes innovative as well as naturalistic. He says that he represented the event taking place "on the mountain of La Verna, copied from nature."[20] He did not want to deviate from the gray stone of the mountain, nor could he alter the beige habit of the Franciscans. His solution to this enforced monochromatism was to encompass the apparition of

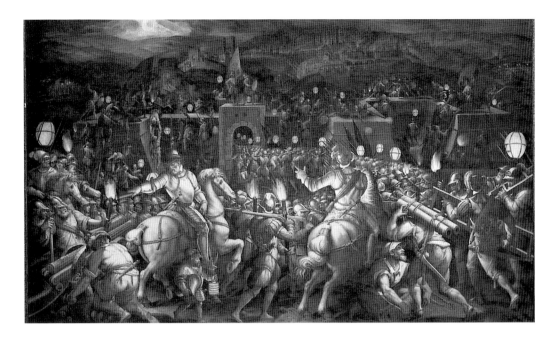

FIG. 6  Giorgio Vasari, *Assault on the Fort of Siena near the Camollia Gate*. Palazzo Vecchio, Florence.

Christ in a glowing sun which lit up St. Francis, while casting the landscape into a multitude of colored shadows. The inventive lighting introduces variety to the coloring, allows the figures to be lit dramatically, and, further, adds to the spiritual meaning of the painting, all the while remaining true to the facts of the story.

As his discussion of the St. Francis altarpiece suggests, Vasari believes that, where appropriate, a landscape painter should be able to show a distinguishable location. This was a task he often undertook himself. Vasari's grand commissions for the Palazzo Vecchio offer numerous examples. In the *Assault on the Fort of Siena near the Camollia Gate* (fig. 5), for instance, we see a verifiable view of that town, which was attacked by the Florentines under cover of darkness. Such an event, of course, provides Vasari with the pretext for numerous inventive lights, including lanterns, torches, moonlight, exploding munitions, and near and distant fires.

Documents show that the novel lighting of the *Assault on Siena* did in fact delight its Medici patrons.[21] In the *Lives*, Vasari often notes when works of his are singled out for praise, as many of his paintings showing *lumi fantastichi* apparently were. We find out, for instance, that the Camaldoline *Nativity* (see fig. 1) was praised in Latin verse. Vasari seems to attribute this praise to the work's novelty of invention, and he says that though he worked with all his power and knowledge, in this painting his hand and brush did not rise to the heights of his conception.[22] He makes a similar statement in discussing a composition he painted showing luminous angels appearing to Abraham, saying that, even though the image was extolled, his conception, which was so exalted that he does not know how he received the inspiration for it, outstripped his execution, perhaps due to the fact that in creating "new inventions and fantasies" he was "always seeking out the laborious and difficult in art."[23]

It must have been this drive to create "new inventions and fantasies" that inspired the *Pietà* Vasari executed for his friend Bindo Altoviti (fig. 6). Vasari writes that the painting shows a life-size Christ lying on the ground at Mary's feet, with:

> Phoebus in the air obscuring the Sun, and Diana that of the Moon. In the landscape, all darkened by that gloom, some rocky mountains, shaken by the earthquake that was caused by the Passion of the Savior, are seen shivered into pieces, and certain dead bodies of Saints are seen rising again. [24]

The subject of the *Pietà* does not require an eclipse, an earthquake, and the resurrection of the saints, but all are included here as part of a complex symbolism. The moon and its goddess Diana, along with the earthquake-torn mountains below them, symbolize the Old Testament, while Apollo and his sun, along with Jerusalem seen as a vision of ancient Rome, symbolize the New Testament. Taken together, these lights signify the importance of Christ, because just as the moon cannot be seen without the sun's light, the Old Testament cannot be understood until it is illuminated by the New. In addition to this complicated allegorical meaning, the sun and the moon allude to medieval images of the crucifixion.[25] Vasari seems to have been given advice on the invention of this work by Paolo Giovio, who came up with erudite subject matter that allowed for multiple associations and a variety of visual effects.

Thus, the landscape, with its combination of allegorical representations and uncommon lighting effects and its amalgam of mythological and religious imagery, was created by Vasari as a showpiece of his talents. His efforts apparently paid off, for Vasari reports the work pleased not only Michelangelo, but also Cardinal Alessandro Farnese, to whom it was shown by Altoviti and Paolo Giovio to advertise Vasari's skills.[26]

We have seen that Vasari conceives his *Nativity* as lit by Christ, angels, torches, the moon and the stars; composes his *Stigmata* on a cliff thrown into heavy shadow yet colorfully illuminated by Christ's multicolored radiance; and sets his *Pietà* in an earthquake-torn landscape in the ghastly dark of an eclipse, with Apollo and Diana partially obscuring the sun and the moon. The unusual, sometimes supernatural, lighting of all these works is designed to maximize the impact of bold, chiaroscuro effects on the figures and other elements of the painting, and yet in each of these, the *lumi fantastichi* are appropriate to, and can be seen to amplify, the Christian message of the works.

Again, one cannot help being struck by the fact that in describing the paintings discussed above—including an image of a life-size, nude Christ—Vasari spends no time discussing the creation of the figures. Instead, he is at pains to let the reader know how the images dazzled through their deployment of ingenious ornament, painted convincingly in appropriate settings. Perhaps Vasari takes the competent inclusion of important figures within these works as given, and thinks that his painterly talents were more in evidence in the strikingly lit background adornments. In assessing the relative merits of the different ages of painting, Vasari wrote that the works of the Second-Manner painters were "for the most part well-drawn and free from error."[27] It seems that in Vasari's age, it was through the pleasing accidents of color and light, not the eternal verities of form, that the painter could distinguish himself.

256

## Conclusion

In 1564, the Northern humanist Domenicus Lampsonius wrote to Vasari, saying that he learned Italian in order to read the *Lives of the Artists*, and that the book made him bold enough to try to paint in oils. He reports that he has made some progress painting nudes and draperies, but adds:

> I have not had courage enough to plunge deeper, as for example, to paint things more hazardous which require a hand more practiced and sure, such as landscapes, trees, waters, clouds, splendours, fires, etc. . . . although in these things, as also in inventions, up to a certain point, it is possible that . . . I could show that I have made some little proficiency by means of the reading.[28]

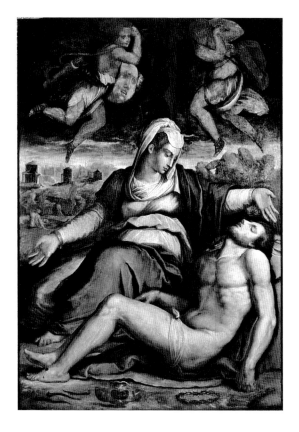

FIG. 6 Giorgio Vasari, *Pietà*, private collection.

It is generally assumed that his Northern biases caused Lampsonius to misread Vasari. Could it be, however, that Lampsonius has come away from the *Lives* with a correct understanding of Vasari's thoughts on the relative difficulties of painting?

While Vasari does not think fantastically lit settings are the highest aim of art, he does seem to believe that they are a very good way to highlight a painter's mental and manual powers. Vasari says that he always sought to create "something out of the ordinary" in his commissions, and his descriptions of his own paintings show that in pursuing this goal, he arrived at a formula that he believes combined all the aims of painting into one. He takes the painterly details of art, those vivid pleasures generally associated with small paintings from Northern Italy, Flanders and Germany, and includes them in large-scale public works. Often these pleasing details, as we have seen, are strong and unusual light sources which in some way further the content of a work through their symbolic meaning. In this manner, Vasari rehabilitates the colorful accidents of painting, occurrences that will no doubt most delight the viewers of his works, through their important context. We remember Annibale Caro suggesting that the multiple light effects in a complex allegory of night would be admired not just for their workmanship, but also for their conceptions. This dual aim seems to have been taken to heart by Vasari, a man who always sought to please his patrons as well as to promote himself.

I might, in closing, draw a parallel between Vasari's painting and his writing. *The Lives of the*

*Artists*, Vasari's written masterpiece, takes us on a journey from the *primi lumi* of painting to the divine light of Michelangelo. Along the way, the reader is led down a path more or less grounded in accurate information. Vasari's facts are adorned, however, with imagination and invention. His historical progression, as has been so amply demonstrated by Paul Barolsky, is illustrated, in the true sense of the term, by ornamental fictions that serve to cast another, perhaps more fanciful, but still revealing light on his subjects. In a similar manner, Vasari makes sure that his painted images hew closely to the accepted truth of their subject matter, but he does not allow this truth to strip his paintings of the brilliant marks of invention and virtuosity.

NOTES:

1. All references to translations of Vasari are from *Lives of the Painters, Sculptors and Architects*, 2 vols., trans. Gaston de Vere (1927; reprint New York, 1996). Here, the quotation is from de Vere, 2, 1029. All references to Vasari in Italian are from *Le opere di Giorgio Vasari, con nuove annotazione e commenti*, 9 vols., ed. Gaetano Milanesi (Florence, 1906).

2. Cited in Patricia Rubin, *Giorgio Vasari: Art and History* (New Haven: Yale University Press, 1995).

3. The *Life of Giotto*, see de Vere, 1, 101; Milanesi, 1, 379–80.

4. de Vere, 1, 254. We learn in Vasari's Preface to the Third Part that Second-Style painters "lacked . . . our great number and variety of bizarre fancies, loveliness of colouring, wide knowledge of buildings, and distance and variety in landscapes." 1, 618.

5. de Vere, 1, 742.

6. *Natural History*. vol. 9, trans. H. Rackham (Loeb Classical Library, 1968), 35.26.96.

7. *The Notebooks of Leonardo da Vinci*, vol. 1, trans. Edward MacCurdy (New York, 1958), 866.

8. de Vere, 1, 581.

9. de Vere, 2, 863; Milanesi, 7, 584.

10. Quoted in Walter S. Gibson, *The Mirror of the Earth: The World Landscape in the Sixteenth Century* (Princeton: Princeton University Press, 1989), 38.

11. de Vere, 2, 471; Milanesi, 6, 507.

12. G. P. Lomazzo, *Scritti sulle Arti*, ed. Roberto Paolo Ciardi (Florence, 1973–1974), 2. 194–95.

13. Liana Cheney, *The Paintings of the Casa Vasari* (Garland, 1985), 174–75.

14. de Vere, 2, 627.

15. de Vere, 2, 627–38.

16. de Vere, 1, 648.

17. de Vere, 1, 649.

18. de Vere, 1, 932.

19. de Vere, 1, 935–36, Milanesi, 5, 223. Figure 5, the *Circumcision* from the Detroit Institute of Art's collection, is generally thought to be the one that Vasari describes. If it is, however, Vasari is mistaken in his description—there are no torch-bearers, and what he calls the dawn "playing upon a most lovely landscape with a vast number of buildings" seems to be instead moonlight. It is possible that Vasari is conflating the Parmigianino *Circumcision* with the description of his own *Nativity* (fig. 1), which does display Christ's radiance, torches, and the dawn.

20. de Vere, 2, 1045.

21. Ugo Muccini, *Il Salone dei Cinquecento in Palazzo Vecchio* (Florence, 1990).

22. de Vere, 2, 1029.

23. de Vere, 2, 1031.

24. de Vere, 2, 1035.

25. Florian Härb, *Christie's Old Master Paintings*, January 27, 2000, Sale Catalog, 132.

26. de Vere, 2, 1035. In another instance of a work created to impress a sophisticated audience, Vasari painted an extraordinary portrait of the "beautiful youth" Alfonso di Tommaso Cambi in the guise of Endymion, the Moon's beloved. Vasari describes the nude Cambi's "...white form and the fanciful (*capriccioso*) landscapes all around, [which] have their light from the brightness of the Moon, which in the darkness of the night makes an effect passing natural and true, for the reason that I strove with all diligence to counterfeit the peculiar colours that the pale yellow light of the Moon is wont to give to the things upon which it strikes." (de Vere, 2, 1049; Milanesi, 7, 690).

27. de Vere, 1, 620.

28. de Vere, 1, 867.

# Giorgio Vasari's Studio,
# Diligenza ed Amorevole Fatica

LIANA DE GIROLAMI CHENEY

Hac sospite nunquam hos perisee,
Viros victos avt morte fatebor.

(While history lives, it would never be said
That artists' work has perished)[1]

Enkindled by the Virgilian motto from the *Aeneid* (Book VIII), Giorgio Vasari (1511–74) embroiders the inscription around the depiction of Fine Arts—Architecture, Sculpture and Painting—honored by Fame, in the Title Page from the second edition of the *Vite* (*Le vite de' più eccellenti pittori, scultori et architettori*, fig. 1).[2] Under this poetical spell, Vasari asserts the new status of the Cinquecento artist as himself, who is not simply a mere craftsman but a draftsman, a painter, an architect, and an art collector, as well as a writer. Thus, he embellishes the text of the 1568 edition of the *Vite* with several inventive additions, such as artists' portraits in woodcuts, including one of himself (fig. 2),[3] an elaborate frontispiece—designed as a cartouche with the coat-of-arms of the Medici family at the top, his self image in the center, and a view of Florence at the bottom (fig. 3)—and an inclusion of his autobiography or *vita* as manifestation of his role and talents.

FIG. 1 Giorgio Vasari, *Title Page*, woodcut, 1568 edition of the *Vite*.

259

FIG. 2 Giorgio Vasari, *Self-Portrait*, woodcut, 1568 edition of the *Vite*.

and the second as Duke of Florence and Siena;[6] a Preface to the Whole Work (*Proemio alle Vite*);[7] an Introduction to the Three Arts of Drawing: Architecture, Painting and Sculpture (*Introduzzione alle Tre Arti del Disegno cioè Architettura, Pittura e Scoltura* );[8] a Note to His Fellow Artists (*Agli Artefici del Disegno*);[9] and a Letter from the humanist Giovambatista Adriani to Giorgio Vasari (*Lettera di Messer Giovambatista di Messer Marcello Adriani a Messer Giorgio Vasari*).[10]

The second part of the *Giuntina* edition discusses Vasari's art theory and describes the lives of the artists. It consists of three sections. Each section, in turn, comprises two areas: a Preface (*Proemio*) and a collection of artists' biographies (*Vite*) organized historically.

In this essay, I examine the parallelism between the introductory paragraph to Vasari's *vita* and the Prefaces to the *Vite*, demonstrating the importance of Vasari's artistic creativity in relation to his literary accomplishments. In the introductory paragraph of his *vita*, Giorgio Vasari summarizes his artistic intentions, aesthetic theory, and historical view of art. Earlier in his writings, Vasari expounded them with some length in the prefaces, dedicatory letters, and technical manual of the *Vite*.[4]

Vasari wrote two editions of the *Vite*. One version was published by Lorenzo Torrentino, so called *La Torrentina* edition, in Florence in 1550 (fig. 4), and the second enlarged edition in 1568, also in Florence, by Giunti, and called *La Giuntina* edition (see fig. 1).[5] The latter edition is divided in two main parts. The first part is a preamble containing several items: two dedicatory letters from Vasari to Cosimo de' Medici, one as Duke of Florence,

FIG. 3 Giorgio Vasari, *Frontispiece*, woodcut, 1568 edition of the *Vite*.

260

Vasari's conception of art history reflects the structure of an organic scheme or historical progression. In the Second Preface, Vasari defines history as "the true mirror of human life."[11] This historical view is interpreted in the *Vite* in two separate ways: in the trio of Prefaces and the biographies of artists. The Prefaces present an almost cyclical view of history, determined by the laws of nature instead of by specific historical events, and the biographies explain the historical process in the evolution of each artist's accomplishments. Vasari visualizes the analogy of history with the mirror's reflection of human life in the Endpiece of 1550 (fig. 5). In the imagery, the elliptical composition resembles the shape of a mirror and the shape of the

FIG. 5 Giorgio Vasari, *Endpiece*, woodcut, 1550 edition of the *Vite*.

FIG. 4 Giorgio Vasari, *Title Page*, woodcut, 1550 edition of the *Vite*.

cartouche while the *mascheroni* and female herms simulate the Wheel of Fortune. Both structural aspects allude to the symbolic imagery depicted in the center of the composition—the Fine Arts. Located at the bottom of the design, dormant and recumbent figures are awakened by Fame's sonorous trumpet. These figures represent the deceased artists who have excelled in their artistic careers by "mirroring nature" (imitating nature). The enlivened depiction of the personifications of the Fine Arts allude to one or more of their artistic accomplishments finally recognized by the efforts of Vasari. The motif of the Wheel of Fortune signifies their artistic efforts brought to light, even if time has passed, by the publication of the *Vite*.

In the 1568 edition, Vasari creates a Title Page, with a more intricate frame design, by integrating the imagery of the Endpiece with the imagery of the Title Page

from the 1550 edition. (compare figs. 1 with 4 and 5) Furthermore, in the Title Page of the 1568 edition, Vasari substitutes the view of Florence found in the Title Page of the 1550 edition with an explanatory note that the edition contains portraits of the artists (*Co' Ritratti Loro*) (compare figs. 1 and 4). And, among other changes in the 1568 edition is the inclusion of a *Frontispiece* with Vasari's self-portrait and of the view of Florence (fig. 3).

In the 1568 edition, the center image of the Title Page has a square design rather than an oval shape. Inserted around the square are Virgilian inscriptions, as noted at beginning of this essay, asserting and reinforcing the significance of the artists' immortality (see fig. 1). The imagery of the 1568 edition is more complex than the imagery of the 1550 edition; for example, an energetic Fame blows vigorously her triple-trumpet, and numerous images depicting deceased artists arise from the ground (compare figs. 1 and 5).[12]

One of Vasari's purposes in writing the *Vite* is to provide a contextual history for Italian art, while presenting a manual for artistic practice, theory, and artist's behavior. These issues are interwoven into the Vasarian concept of "rebirth," which links the idea of artistic progress to the moral *exemplae* with which the *Vite* is replete. Vasari's idea of artistic progress is described by what he perceives as the inevitable pattern of change from imperfection to perfection in the arts.

There are two models that might help to explain Vasari's paradoxical cyclical view of art history. The first model is drawn directly from the cosmographical belief of the sixteenth century, and the second comes from the late eighteenth-century theory about food crises.[13]

Ptolemy's cosmographical theory introduces the idea of "epicycles" to account for the planet's changing position and imperfect cycles. In brief, the epicycle theory allows ancient astronomers to preserve the idea of a perfect circular motion while accounting for the strange position of the planets at certain times of the year. This theory was also accepted by Copernicus in 1543 with his publication of the *De revolutionibus*. I suggest that Vasari, with his classical training as well as his professional contact with the humanists of the time—Giovambatista Adriani, Vincenzo Borghini, Annibale Caro, and Paolo Giovio[14]—appropriates the epicycle theory to explain his history of art. For example, Vasari might view the history of ancient art as a large circle spanning small epicycles around it; these epicycles represent classical movements such as Greek, Hellenistic, Roman, and Renaissance. Thus Vasari's first stage of assimilating classical art would be a small epicycle of Hellenistic art. The second stage of classical appropriation would be another small epicycle as in Roman art. Vasari's third stage would appear to be "perfection" with the total assimilation of classicism with Renaissance art because it is the current epicycle. This theory allows for the assimilation of ancient art to continually improve and regenerate even *after* the Renaissance, just as Vasari historically noted that art has improved from antiquity *to* the Renaissance.

With this construct, Vasari might view the development of Renaissance painting as a large circle spanning small epicycles around it. These epicycles represent movements in painting such as Florentine or Venetian. Additional epicycles exist within the movements, for example, Giotto within the Florentine movement or Mantegna within the Venetian. Thus Vasari's First Age of painting with Giotto and Cimabue would be one small epicycle, and the Second Age would be another small epicycle with Masaccio and Mantegna. Vasari's Third Age would appear to be "perfection" with Leonardo, Raphael, and Michelangelo because it is the current epicycle.

However, the possibility exists for yet more epicycles after the age of Vasari. This construct would allow for art to improve continually, even after Michelangelo's death.

The second plausible explanation for Vasari's art theory can be deduced from the ideas of Thomas Malthus, who writes on population and food supply at the very end of the eighteenth-century. In *Essay on the Principle of Population* of 1798, Malthus suggests that wages, employ-ment, population, and the amount of food available are all subject to the laws of supply and demand (following Adam Smith). In reviewing the previous five and six centuries, Malthus con-cludes that population will grow until it outstrips the food supply, at which point famine, pesti-lence, and other natural calamities will reduce the population to a stable level (the Malthusian cycle). This cycle continues to repeat itself until there is some kind of technological break-through, which allows more food to be produced by the same amount of labor or until the pop-ulation can control its reproduction (through birth control, late marriage, or infanticide). The ironic aspect of Malthus's essay is that he is correct about this cycle of food and population until his own era.

Maybe Vasari thought of the history of art or classical ages of art, for example, in the Malthusian sense: that is, classical art was locked in a perpetual cycle of advance and decline from Antiquity (advance), Middle Ages (decline), and the Renaissance (advance or renewal), showing the way to a breakthrough that would forever change the prior boundaries (Middle Ages), and, at the same time, cycles parallel to those of classical art could be applied to the arts in the Renaissance until Vasari's generation. According to this Malthusian theory, painting, sculpture, and architecture transcend its former limitations in what Thomas Kuhn would call a "paradigm shift." The Malthusian cycle suggests a more linear view of art history, whereas the prior discussed theory (Ptolemy's epicycles) is circular. Perhaps Vasari, unsystematically, is applying complex laws of change in order to justify the impact of ancient art on Renaissance artistic conventions and mutation without reasoning out the paradox in his cyclical view.

In the Prefaces, however, Vasari clearly discloses the aims of the book; for example, in the Preface to the Whole Work, he explains the purpose for writing the *Vite*, "In honor, then, of those who are already dead, and for the benefit, for the most part, of all the followers of these three most excellent arts, Architecture, Sculpture and Painting, I will write the *vite* of the artists of each according to the times wherein they lived, step by step from Cimabue down to our own time."[15] The First Preface is a description on the history of ancient art appropriated from Adriani's letter. Vasari says, "at the beginning of these *vite* I spoke of the nobility and antiquity of these arts, in so far as it was then necessary for our subject, leaving on one side many things from Pliny and other authors."[16]

The Second Preface is a classificatory essay, paralleling the *vite* of artists with the evolu-tion of human life: for example, Vasari explains, "having made a distinction and division...into Three Parts, or we would rather call them Ages...now that we have weaned these three arts, to use such a fashion of speaking, and brought them through their childhood..."[17]

And, in the Third Preface, Vasari defines his aesthetic criteria for assessing the *vite* in rela-tion to the Cinquecento's theory of art. Vasari explains what he means by *perfetta regola dell'arte* (perfect rule of art) as the practice of five precepts in art, "*regola, ordine, misura, disegno* and *maniera*" (rule, order, proportion, drawing and manner or style)[18] and in particular, the "*bella*

*maniera*" or "*il più bello*" (the beautiful manner or the greatest beauty).[19]

In the three Prefaces (*Proemi*), Vasari establishes not only the historical scheme for the writings of the biographies but also the criteria he applies to the selection of the "most excellent" artists and the ways in which their works are judged. The main aspects of the criteria consists of the study of nature; the capturing of nature in art through its imitation; and art surpassing nature by improving on it or perfecting it, through canons of design (*disegno*). Vasari states: "For I know that our art consists first in the imitation of nature but then, since it cannot reach such heights unaided, in the imitation of the most accomplished artists.[20] The study of nature is only accomplished with design. For Vasari, design is an intellectual process: "the intellect sends ideas with judgment and the hand of the artists, through the study of art, express them. Accompanied by diligence (*diligenza*), the intellect and art amend all that is operable to perfection."[21] Through the assessment of *disegno* and *diligenza*, Vasari selects to write about the *vite* of only the "most excellent" artists.

Vasari's *vite* are short biographies of architects, painters, and sculptors of almost three centuries, with critical descriptions of their works. Vasari clearly states his quest in the Second Preface: "In my biographies, I have spent enough time discussing methods, skills, particular styles, and the reasons for good, superior, or preeminent workmanship."[22] Both the artists he chooses and the qualities that he praises in their works illustrate Vasari's view of art. Vasari begins the discourse with the earliest artists and discusses each artist according to his place in time until he reaches his time and his *vita*.

In his own *vita*, which only appears in the second edition of the *Vite*, Vasari briefly explains the purpose of writing his autobiography and articulates a historical construct and an aesthetic criterion as cited in the masterful introductory paragraph. By employing similar critical terminology such as "*diligenza, amorevole fatica, lavoro ed onore*," (diligence, loving effort, labor and honor), Vasari's begins his *vita* as follows. (To capture the true flavor of Vasari's description, the complete passage is cited.)

> Having discoursed hitherto of the works of others, with the greatest diligence (*diligenza*) and sincerity that my mind (*ingegno*) has been able to command, I also wish at the end of these my efforts (*fatiche*) to assemble together and make known to the world the works that the Divine Goodness in its grace has enabled me to execute; for the reason that, if indeed they are not of that perfection which I might wish, it will yet be seen by him who may consent to look at them with no jaundiced eye that they have been wrought by me with study (*studio*), diligence (*diligenza*), and loving labored efforts (*amorevole fatica*), and are therefore worthy, if not of praise (*onore*), at least of excuse; besides which, being out in the world and open to view, I cannot hide them.

Vasari's terminology in defining his artistic accomplishments allude to several meanings. For example, *lavoro* signifies hard work, a prescribed physical assignment, while *fatica* is the result of hard work by which the task is physically and intellectually well executed. *Lavoro* is the result of a prudent *fatica*. *Amorevole* alludes to the willingness of undertaking such artistic efforts. The signification of *amorevole* conjoins with the meaning of *diligenza* as an act of volition or an act of perseverance where the effective result of hard work is successfully manifested. For example,

Vasari's artistic efforts as a painter and architect as well as his historical endeavors as the writer of the *Vite* demonstrate the *diligenza* in his *amorevole fatica*.

Vasari continues in the ardent introductory paragraph to his *vita* to note:

> And since perchance at some time they might be described by some other person, it is surely better that I should confess the truth, and of myself accuse my imperfection, which I know only too well, being assured of this, that if, as I said, there may not be seen in them the perfection of excellence, there will be perceived at least an ardent desire to work well, great and indefatigable effort, and the extraordinary love that I bear to our arts. Wherefore it may come about that, according to the law, myself confessing openly my own deficiencies, I shall be in great part pardoned.

In this long introductory paragraph, Vasari further unfolds his visual *istoria* (history) in the description of his *vita*. His *amorevale fatica* (loving labored efforts) is manifested and explicated in several sections throughout the *Vite*. For example, first this distinction is explained in dedicatory letters, where he establishes the intention and need for this type of book. Vasari notes: "I am convinced that these my labors [writing the *Vite*] will delight those who are not engaged in these pursuits, and will both delight and help those who have made them a profession."[23] And "In short, how great have been therein my labor, expense, and diligence, will be evident to those who, in reading, will see whence I have to the best of my ability unearthed them."[24]

Vasari's *amorevale fatica* continues to unfold in the Preface to the Whole Work of the *Vite*. For example, his masterful opening of the *Vite* disguises his claim of inadequacy with the pen, "I was more fitted to wield the brush than the pen." With prudence, in the first sentences of the Preface to the Whole Work, he contours his ideal artist. (The complete passage is cited.)

> It was the wont of the finest spirits in all their actions, through a burning desire for glory, to spare no labour, however grievous, in order to bring their works to that perfection which might render them impressive and marvellous to the whole world; nor could the humble fortunes of many prevent their energies from attaining to the highest rank, whether in order to live in honour or to leave in the ages to come eternal fame for all their rare excellence. And although, for zeal and desire so worthy of praise, they were, while living, highly rewarded by the liberality of Princes and by the splendid ambition of States, and even after death kept alive in the eyes of the world by the testimony of statues, tombs, medals, and other memorials of that kind; none the less, it is clearly seen that the ravening maw of 'time' has not only diminished by a great amount their own works and the honourable testimonies of others, but has also blotted out and destroyed the names of all those who have been kept alive by any other means than by the right vivacious and pious pens of writers.[25]

Moreover, the subject of his *Vite* is the three fine arts—architecture, sculpture, and painting, as Vasari observes: "The sovereignty and nobility are not of architecture, which they have left on one side, but of sculpture and painting." However, the title of the first edition reflects the opposite, *Le vite de' più eccellenti architectti, scultori e pittori*. Whereas in his second edition of the *Vite*, Vasari alters the title of the book to reflect the primacy of painting,[26] *Le vite de' più eccellenti pit-*

*tori, scultori et architettori*. In this manner, Vasari enthrones painting as the preeminent art "because painting embraces the invention of history." In the *Vite*'s imagery there are different focuses as well. In the *Endpiece* of the 1550 edition, the personification of Architecture resides in the center of the composition in between Sculpture and Painting, and Fame, holding one torch and blowing one trumpet, descends toward her. Whereas in the 1568 edition, Fame is blowing a triple-trumpet towards Architecture, Sculpture, and Painting (compare figs. 1 and 5).

The second aspect of Vasari's *amorevole fatica* persists in the three Prefaces to the *Vite*, dealing with the following aspects of which are also cited in Vasari's introductory paragraph of his *vita*. For example, the First Preface explains the historical description of the arts, from antiquity to his modern times. The content of this Preface reflects the artistic evolution of Giovambatista Adriani's letter to Vasari on the History of Ancient Art. The Second Preface provides a classification of the *vite* connected with the cycle of life, birth, growth, and maturity. The Third Preface reveals the criteria necessary for an aesthetic judgment of the visual arts, such as rule, order, proportion, design, and manner (style). Following each preface is a description of the artist's biographies or *vite*. Here, Vasari unveils his history of art.

The third aspect of Vasari's *amorevole fatica* is to instruct his readers in the making of art in his extensive introduction to the *Three Arts of Design*. Unlike the previous *fatiche* based on historical and theoretical criteria, his third *fatica* focuses on the techniques of art. The conclusion to his *amorevole fatica* in the *Vite* is a letter to artists as well as to the reader, where Vasari hopes to have instructed, delighted, and honored his fellow artists as well as Art (as explained earlier in the dedicatory letter to Cosimo I). Vasari remarks: "Accept these my labors, therefore, with a friendly mind; whatsoever they may be, I have anxiously concluded the work to its close, for the glory of art, and to the honor of artists." Thus, Vasari's introductory paragraph to his *vita* begins with a powerful rhetorical statement composed of a series of aesthetic notions derived from his early writings in the *Vite*.

Moreover, with a Neoplatonic emphasis, Vasari starts his *vita* by thanking God, *La Divina Bontà*, for having provided him with *ingegno* (Neoplatonic *nous* or mind) for the creation of artistry. This invocation for divine inspiration is addressed as well in Vasari's opening remarks of the dedicatory letter of January 9, 1568, to Cosimo de Medici, Duke of Florence and Tuscany. Vasari writes: "Accept then, most Illustrious Excellency, this my book, or rather indeed your book, of the *Vite* of the craftsmen of design; and like the Almighty God, looking rather at my soul and at my good intentions than at my work, take from me with right good will not what I would which and ought to give, but what I can."[27] And in the Preface to the Whole Work in the *Vite*, Vasari also praises God as "Almighty God, who created the great body of the world, Our Father, first artist and divine architect of Time and Nature" ("*Altissimo Dio [che ha] fatto il grande corpo del mondo, Dio Padre primo artista e divino architetto del Tempio e della Natura*").[28]

Fitting with Renaissance Neoplatonism, artists envision themselves as part of divine creation.[29] Vasari's aesthetics[30] or visual sensations (feelings) and perceptions (recognition) are concerned with the nature of the beautiful as it exists in art and nature, as well as with the physicality and spirituality of beauty.[31] In accordance with the Neoplatonic theory of beauty, Vasari understands beauty to be a divine creation. "He (God) fashioned the first forms of painting and sculpture in the sublime grace of created things."[32] For Vasari, the physicality of beauty is per-

ceived in the painted image, and the spirituality of beauty is reflected in the evocation of the visual experience. His philosophy of art depends on the philosophical and poetical tradition of the Renaissance—in short, Marsilio Ficino's restatement of Neoplatonism.[33]

Similar to the prefaces of the *Vite*, Vasari gives shape to his *vita* by expounding critical principles.[34] For example, in the *Vite*, the first lines of his dedicatory letter to Duke Cosimo I diagram his project. Vasari recounts the story of those "who first revived the arts and then nurtured them to their current state of beauty and majesty."[35] And in his *vita*, Vasari comments:

> They [his works of art] might be described by some other person, it is surely better that I should confess the truth, and of myself accuse my imperfection, which I know only too well, being assured of this, that if, as I said, there may not be seen in them the perfection of excellence, there will be perceived at least an ardent desire to work well, great and indefatigable effort, and the extraordinary love that I bear to our arts.

Vasari also translates visually this ardent desire in his Title Pages of the *Vite*, in particular the 1550 image where the frame at the top is decorated with three burning lamps, and the design at the bottom resembles a sarcophagus, signifying the eternal flames that honor renown and deceased artists (compare figs. 1 and 4). This honorific sentiment is also expressed in the Endpiece of the *Vite* with the depiction of Fame blowing vigorously a trumpet, which alludes to the recall and resuscitation of artists' accomplishments from the past. Furthermore, in the Title Page Vasari transforms the verbal dedicatory letters in visual theatrical designs or *tableau vivant*. In the 1550 edition, the Title Page's design is in the shape of a tabernacle designed with a strong cornice, similar to a sarcophagus's lid, decorated with flaming vases. Two reclining putti on the festooned lintel arduously hold the Medici's crowned coat-of-arms and honorific necklace. Two caryatid figures depicting the personification of Fame and Mercury frame the theatrical tent or cloth of honor, containing the inscriptions of the title of the Vasari's book. The bases of the personifications contain their attributes and Medicean symbols, such as the *festina lente* (slowly in haste) impresa and the roster. Resting on a rectangular base, two putti hold the bottom of the illusionistic cloth of honor while unveiling a view of the city of Florence. The base or sarcophagus is decorated with a cartouche containing the date of publication of the *Vite*. The inscription reads:

> *Le Vite de' più eccellenti Architettori, Pittori, et Scultori Italiani, Da Cimabue insino a' tempi nostri: Descritte in lingua Toscana, da Giorgio Vasari Pittore Aretino. Con sua utile & necessaria introduzzione a le arti loro. In Firenze MDL.*

In the 1568 edition, the Title Page to the whole work is not only embellished with the imagery of the Fine Arts but also contains two additional Title Pages for volume one, two, and three of the *Vite* (see figs. 6 and 7). The frame decoration is consistent with all the three Title Pages, with the exception that the Title Page to the whole work contains the Fine Arts while the other two Title Pages contain a description of the content of the texts. For example, the Title Page to volume 1 of the book contains the following inscription (fig. 6):

> *Le Vite de' più eccellenti Pittori, Scultori, e Architettori. Scritte da M. Giorgio Vasari Pittore*

*et Architetto Aretino, di Nuovo dal Medesimo Riviste et Ampliate. Con I Ritratti Loro. Et con l'aggiunta delle Vite de' vivi, & de' morti dall'anno 1550 infino al 1567. Prima, e Seconda Parte. Con le Tavole ciascun volume, delle cose più Notabili, De' Ritratti, Delle Vite degli Artefici, et Dei Loughi dove sono l'opere loro. Con Licenza e Privilegio di N.S. Pio V. et Del Duca di Fiorenza e Siena. In Fiorenza, Appresso I Giunti 1568.*

The second Title Page of volumes 2 and 3 contains the following (fig. 7):

*Le Vite de' più eccellenti Pittori, Scultori, e Architettori. Scritte da M. Giorgio Vasari Pittore et Architetto Aretino, Secondo, et ultimo Volume della Terza Parte. Nel quale si comprendano le nuove Vite dall'anno 1550-1567. Con una breve memorio di tutti più ingegnosi Artefici che fioriscano al presente Nell'Academia del Disegno In Fiorenza, et per tutta Italia, et Europa & delle più importanti Opere loro. Et con una Descrizione de gl'Artefici Antichi, Greci & Latini, & delle più notabili memorie di quella eta, Tratta da I più famosi Scrittori. Con Licenza e Privelegio. In Fiorenza, Appresso I Giunti 1568.*

In the imagery of these Title Pages, there is a superimposition of two theatrical designs. Only the top and side frame of one of the back theatrical designs is visible. In a frieze format, two putti hold a large inscription of the book's title while two personification of learning, Mercury and History, hold the frieze. The front design contains the Medicean crowned coat-of-arms with the

FIG. 6 Giorgio Vasari, *Title Page, Part One and Two*, woodcut, 1568 edition of the *Vite*. (Photo: Author).

FIG. 7 Giorgio Vasari, *Title Page, Part Three*, woodcut, 1568 edition of the *Vite*. (Photo: Author).

honorific necklace held by putti. Below them, an extensive inscription explains the content of the book. The playful frame contains the attributes of the arts, palette, ruler, chisel and brush and mischievous putti. Below the inscription two harpies present a view of Florence with the date of publication.

The last section of the *Vite* contains a description about the Academy of Design founded by Vasari in 1562 and honored by the Duke of Florence.[36] For Vasari as well as for other Christian artists of the sixteenth century, God is not only the Divine Creator, but the Supreme Designer. In the language of Vasari, the word *disegno* is comprised of three segments: *di, segn,* and *o*.[37] The combination alludes to God as Designer. For example, when the first segment (*di*) and the third segment (*o*) are connected, they compose the word *Dio* or God's name. But when the second segment, *segn*, connects with the third segment, *o*, they constitute the word *segno* (sign or design). Thus, the word *disegno* embodies the name and artistic function of God. In his writings, Vasari is influenced by Thomas Aquinas's concept of God in *Summa theologiae*—God, as a creator, also 'designs' internally and externally—and Dante's notion of God as "Primo Fattore" (First Mover) in *Purgatorio*.[38]

In another passage, Vasari similarly alludes to the origin of the arts with God creating the most perfect form—the human figure.

> *Disegno* is the very soul that conceives and nourishes in itself all the parts of the intel-lect—already most perfect before the creation of all other things, when almighty God with his intellect forming man, discovered with the lovely invention of all things the first form of *scultura* and of *pittura*.[39]

For Vasari, *disegno* or *segno di Dio* exists as a cosmic creative force, impelling the intellect of *l'Altissimo Dio* to emanate inventions in the artist's mind. God's *invenzioni* (inventions) of the human form become the first form of sculpture and painting and the *vero esemplare* (true exam-ple) from which inventive ideas transform into artistic forms.[40] The triad of *disegno, invenzione* and *imitazione*—with *disegno* dominant—governs the first creation as in Vasari's *vite* as well as his *vita*.[41]

For Vasari, *disegno* is formulated in the intellect or *ingegno* or *invenzione* (invention), a high or great intelligence, talent, or resourceful imagination. In a particularly apt articulation in his *vita*, he fuses the concept of *ingegno* and invention. Vasari's comprehensive sense of *invenzione* as the ability to devise pictorial imagery emerges as his discourse progresses.[42]

In his *vita*, Vasari frequently refers to his new artistic creations as *invenzioni*. However, only once in the corpus of the *Vite* does Vasari attempt to define *invenzione* in the *vite* of the *prima età*.[43] Complementing his statement is the *paragone* that painting and sculpture are sisters, "that is, born of one father, *disegno*."[44] Vasari asserts that *invenzione* has always been held to be the *madre verissima* (true mother) of architecture, painting,[45] and poetry and of all the better arts (*arti*) and marvelous things made by humankind:

> Because [as Vasari writes] it is much appreciated by artists and displays the caprices and novelties of their fantasizing minds which discover the variety of things; the newness of these exalting always, with marvelous praise, all those who, exerting

themselves in honorable projects, with extraordinary beauty give form under covering and veiling shadow to the things that they make, sometimes praising others who have dexterity and sometimes blaming them without being openly understood.[46]

Vasari demonstrates the significance of drawing in the arts through his love of collecting artist's drawings. In 1528, when Vasari was only seventeen years of age, he began acquiring from his first teacher, Vittorio Ghiberti, drawings by Lorenzo Ghiberti (Vittorio's ancestor), Giotto, and others. To expand his collection of drawings, Vasari also visited other artists' workshops in Florence, buying sketches and drawings of their work. This compilation serves as Vasari's primary source for his seminal book, *Il Libro dei Disegni*. This collection of drawings occupies a pivotal position in the evolution of the history of drawing.[47]

Furthermore, consistent with his pedagogic intent, Vasari, in the introduction to his *vita*, refers to his ability to create works of art with *diligenza*, *fatica*, and *lavoro*. The Vasarian term *diligenza* derives from *De pictura* (On painting), where Leon Battista Alberti refers to diligence in relation to instruction on the working process. Alberti's discussion of practice emphasizes the virtue of diligence, "But [as Vasari notes] one should avoid the excessive scruples of those who, out of desire for their work to be completely free from all defect and highly polished, have it worn out by age before it is finished."[48]

Vasari parallels this sequence in discussing the completion of a painting, suggesting that "The work should be brought to perfection not with an effort of cruel suffering" ("*non con uno stento di passione crudele*") but with pleasure in the skill of the hand. Like Alberti, Vasari respects diligence, but only to the optimum point, where figures in the picture "appear alive and real" (*si appresentino vive e vere*), demonstrating the *ingegno* of the painter.[49]

Moreover, in several passages of the Second Preface, Vasari associates the meaning *diligenza* with the intellectual endeavors of history's writers, including himself as the writer of the *Vite*. In the introduction to his *vita* as well, Vasari defines his efforts in terms of diligence. He notes:

> With the greatest diligence (*diligenza*) and sincerity that my mind (*ingegno*) has been able to command, I also wish at the end of these my efforts (*fatiche*) to assemble together and make known to the world the works that the Divine Goodness in its grace has enabled me to execute.

In *Lo Zibaldone*, there is a folio containing Vasari's descriptions of several *invenzioni* of personifications or allegorical figures; among them is *Diligentia*. Vasari writes: "Diligentia is portrayed as a young person holding a flaming torch in a dark area, demonstrating that diligence is needed when dealing with difficult matters, whether in looking for or recovering them." Perhaps Vasari visualizes an aspect of the personification of *Diligence* in the burning lamp or eternal flames depicted in the frame of the *Vite*'s Title Page (fig. 4) and in the painting of *Apelle's Studio* in the Florentine *sala*, where allegorical figures holding torches greet models in the artist's workshop.

Vasari had every reason to be proud of himself as an artist and to write in the Preface of the *Vite*:

If my writing, being unpolished and as artless as my speech, be unworthy of your Excellency's ear and of the merits of so many illustrious intellects...let it suffice me that your Excellence should deign to approve my simple labor, remembering that the necessity of gaining for myself the wherewithal to live has left me no time to exercise myself with any instrument but the brush.

For Vasari, fame and achievement are indissolubly bonded. Fame should depend on achievement, which, in turn, merits fame, as illustrated in the frontispieces of the editions of the *Vite*. Fame, in the *Vite*, ranges from recognition and respect through the art of hard labor.[50] Vasari writes: "Labor...Low rank matters not: hard work and zeal bring work to a perfection that impresses all. Princes and States reward the living artist: tombs, memorials, and writings testify, after death." And in his *vita*, Vasari reflects on his own works. He observes: "There may not be seen in them the perfection of excellence, there will be perceived at least an ardent desire to work well, great and indefatigable effort, and the extraordinary love that I bear to our arts."

Vasari ascribes as motives for this labor on the part of artists, "a burning desire for glory," a wish "to live in honor," and a wish for "eternal fame." But eternal fame is impaired by the disappearance of the evidence. Therefore, only writings about the labors can salvage names and achievements for posterity. As Vasari notes in his *vita*: "I also wish at the end of these my efforts (*fatiche*) to assemble together and make known to the world the works that the Divine Goodness in its grace has enabled me to execute."

In the center of the ceiling of Chamber of the Fame, in his Aretine house, Vasari visualizes the concept of Fame by depicting the personification of Fame surrounded by the portraits of famous artists and personifications of the Fine Arts–Architecture, Painting, and Sculpture. In this imagery, Vasari reveals a personal and private interpretation of the importance for an artist to be honored, while in the *Vite*'s Endpiece of the 1550 edition (see fig. 5), and later in the *Vite*'s Title Page of 1568 (see fig. 1), he universalizes the importance for artists to achieve public and historical recognition.

Vasari articulates yet another concern for the artist who attempts to write history. He states: "With that accuracy and good faith which are essential for the veracity of history and of things written[51] as one who earns his living with a brush, however, his production with a pen is less refined than if he were a writer."[52]

Vasari's purpose in writing the *Vite* is twofold—to enlighten and delight the reader, practitioner, and enthusiast alike with a historical or chronological approach to the making or studying of art and to provide his fellow artists with a historical perspective, artistic guidance, and a record of their accomplishments for posterity.[53] These two significant issues are evident in his explanation of the concept of "rebirth," which combines progress and moral intention.[54] Vasari's idea of progress is described by the inevitable pattern of change from imperfection to perfection in the arts. And his moral intention is related to the Cinquecento's spirit of history[55] as Vasari writes, "having set out to write the history of distinguished artists in order to honor them and to benefit the arts to the best of my ability, I have tried as far as I could to imitate the methods of the great historians." And Renaissance Neoplatonic philosophy, which fulfills its real purpose in making individuals prudent and showing them how to live, as Vasari states,

"spirit of history fulfills its real purpose in making men prudent and showing them how to live, except for the pleasure it, brings in past events as though they were in the present."[56]

Moreover, Vasari's concern for historicity is revealed in a series of apologies addressing, for example, his inadequacy as a writer. Although he thanks his fellow artists and his readers for attending to the description of his artistic efforts, he apologizes for his imperfections, as he notes, "If indeed they are not of that perfection which I might wish." In his *vita* as well, Vasari likewise concludes the introductory paragraph with an apology: "myself confessing openly my own deficiencies, I shall be in great part pardoned."

But Vasari's masterful opening of the *Vite*—the first sentences of the Preface to the Whole Work attests to his artistic ability to memorialize the accomplishment of his fellow artists, since there are no proper historical records.[57] In his *vita*, after prefacing the purpose of his whole work, Vasari unveils the mastery of his art and his honorable achievements in the description of his paintings.

Vasari's tone of modesty changes from the first to the second edition of the *Vite* as exemplified by the ending paragraph of his *vita*, published in the second edition, where he humbly states, "And this is enough of talking about myself, who have worked hard for fifty-five years (here Vasari has forgotten his age; in reality he was a year older) and must continue to live so long as it shall please God, to His honor and in the service of my friends, as well and as long as I am able, in ease, and for the betterment of these most noble arts." This contrasts with the arrogant statement from the earlier Preface to the Second Edition, which says; "it is rather a lucky thing for many of these painters that through the beneficence of the Almighty, who gives life to all things, I have been spared long enough to rewrite nearly the whole of my book; for I have removed a great deal that had crept into it during my absence and have added many useful and important things that were lacking." Vasari reveals his understanding that artistic fame must be endowed with prudence, if posterity is to honor the artistic merits.

Undoubtedly to Vasari's surprise, his mortal fame is accomplished not as an architect or painter but as the historian of art, with the ability to collect the records of the great old masters who overcame the difficulties of drawing and perspective and whose genius triumphed in expressing the human nature and spirit. Although Vasari states in the *Vite* that he "was more fitted to wield the brush than the pen," today one may declare that Vasari was "fitted to wield the brush as well as the pen"!

NOTES

I wish to extend my appreciation to Profs. Andrew Ladis and Norman Land and to William U. Eiland, Director of the Georgia Museum of Art, for their generous invitation to participate in the historical event of *Reading Vasari: A Symposium in Honor of Paul Barolsky* at the University of Georgia in Athens (November 16–17, 2001), and to Anne Barriault and Prof. Jeryldene M. Wood. Furthermore, this essay is an expression of my gratitude to Paul Barolsky for his continuous contribution to the understanding of Giorgio Vasari as an individual, artist, writer and *uomo docto*.

1. Giorgio Vasari's *Le vite de' più eccellenti pittori, scultori e architettori* (Florence: Giunti, 1568). Explanatory note to the reader: in this essay, I refer to Vasari's corpus as *Vite*, to the biographies of the artists as *vite* and to Vasari's autobiography as *vita*.

2. This frontispiece depicts a flying Fame blowing a trumpet with three openings and holding a burning torch. Fame resurrects the deceased artists who have labored in architecture, sculpture, and painting. The arts are depicted by three personification of the Fine Arts, who reside on a higher plane. In the frontispiece of the 1550 edition of the *Vite*, Vasari depicted a reduced

version. See Patricia Lee Rubin, *Giorgio Vasari: Art and History* (London: Yale University Press, 1995), 222.

3. As Vasari states in the *Vite*, on September 20, 1567 he sent his own portrait to Venice. "I have this very day drawn my own portrait with the aid of a looking-glass. I drew it on wood, and if Messer Cristofano [sic Christopher Coriolanus, a Flemish engraver, who is preparing the blocks for the second edition of the *Vite*] in Venice only does it justice it will be quite a pleasing head, as I have made a good thing of it. I shall send it off to Venice this evening." See Robert W. Carden, *The Life of Giorgio Vasari* (London: Philip Lee Warner, 1910), 273.

4. The title of the 1550 edition is *Le vite de' più eccellenti architetti, pittori, et scultori italiani, da Cimabue insino a' tempi nostri nell'edizione per I tipi di Lorenzo Torrentino Firenze, 1550*. This earlier title is changed in the edition of 1568 to *Le vite de' più eccellenti pittori, scultori e architettori*. See the invaluable comparative study of Rossana Bettarini and Paola Barocchi on the 1550 and 1568 editions of Giorgio Vasari, *Le vite de' più eccellenti architetti, pittori, et scultori* (Florence: Sansoni, 1971–1986). Hereafter referred as Bettarini-Barocchi. For this note, see Bettarini-Barocchi I, xvii.

5. See Rossana Bettarini and Paola Barocchi on the 1550 and 1568 editions of Giorgio Vasari, *Le vite de' più eccellenti architetti, pittori, et scultori* (Florence: Sansoni, 1971–1986).

6. In the first dedicatory letter of 1550 also included in the 1568 edition, Vasari signs his name as *Giorgio Vasari, Pittore Aretino* (Aretine Painter) establishing his artistic status. While in the second letter, his fame is renown, and he only signs his name, *Giorgio Vasari*. See Bettarini-Barocchi, I, 1–5 and 6–7.

7. See Bettarini-Barocchi, I, 9–30.

8. See Bettarini-Barocchi, I, 31–172.

9. See Bettarini-Barocchi, I, 175–75.

10. See Bettarini-Barocchi, I, 179–227. In La Giuntina edition, Adriani's letter was placed by error after the Third Preface of the *Vite*.

11. See Bettarini-Barocchi, III, 3–20.

12. With the imagery, resurrected bodies, no doubt, Vasari is visually referring to his highly praised Michelangelo's *Last Judgment*.

13. I am grateful to the historian Prof. Chris Carlsmith from UMASS Lowell for this suggestion.

14. To assure accuracy in his writing style, Vasari consulted the current master of good literary style, Annibale Caro. See Bernard Degenhart and Annegrit Schmitt, "Methoden Vasaris bei der Gestaltung seines 'Libro'," in Wolfgang Lotz and Lise Lotte Moller, eds. *Studien zur Toskanischen Kunst: Festschrift Ludwig Heinrich Heydenreich* (Munich: Prestel-Verlag, 1964).

After Annibale Caro read a draft of the *Vite*, he made several stylistic recommendation to improve the "elegance" of writing. Specifically, Caro comments on Vasari's grammar in this manner: "Move the verbs from the end to the middle of your sentences . . . make sure you use the correct nouns." See Karl Frey, *Der literarische Nachlass Giorgio Vasaris* (Munich, 1923), 210. Vasari completed the *Vite* in July, 1547 and he took the manuscript to Rimini to have a copy made by Don Giammatteo Faetani, an Olivetan prior. For a literary relationship between Vasari and Faetani and possible influence on the style of the *Vite*, see Ugo Scoti-Bertinelli, *Vasari scrittore* (Pisa, 1905), 207–9.

Furthermore, Cardinal Alexander Farnese, Francesco Maria Molza, and particularly Paolo Giovio encouraged Vasari to travel throughout Italy in order to collect drawings and make notes on the paintings, sculptures, and edifices that he saw. Reluctant at first, but strongly encouraged by Giovio, Vasari relates in his *vita*, "I turned to my notes and memoranda, which I prepared even from my boyhood, for mine own recreation, and because of a certain affection which I preserved to the memory of the artists of the time." Vasari's ambitious project culminated in his writing of the *Vite*.

15. See Bettarini-Barocchi, I, Whole Preface.

16. See Bettarini-Barocchi, I, First Preface.

17. See Bettarini-Barocchi, III, Second Preface.

18. See Bettarini-Barocchi, IV, 4, where Vasari explains further what he means by the visual elements of art: *Rule*, then, in architecture, was the process of taking measurements from antiquities and studying the ground-plans of ancient edifices for the construction of modern buildings. *Order* was the separating of one style from another, so that each body should receive its proper members, with no more interchanging between Doric, Ionic, Corinthian, and Tuscan. *Proportion* was the universal law applying both to architecture and to sculpture, that all bodies should be made correct and true, with the members in proper harmony; and so, also, in painting. *Drawing* was the imitation of the most beautiful parts of nature in all figures, whether in sculpture or in painting; and for this it is necessary to have a hand and a brain able to reproduce with absolute accuracy and precision, on a level surface—whether by drawing on paper, or on panel, or on some other level surface—everything that the eye sees; and the same is true of relief in sculpture. *Manner* then attained to the greatest beauty from the practice which arose of constantly copying the most beautiful objects, and joining together these most beautiful things, hands, heads, bodies, and legs, so as to make a figure of the greatest possible beauty. This practice was

carried out in every work for all figures, and for that reason it is called the beautiful manner.

19. Vasari elaborates by stating: "La maniera venne poi la più bella dall'aver messo in uso il frequente ritrarre le cose più belle, e da quel più bello, o mani o teste o corpi o gambe, aggiugnerle insieme e fare una figura di tutte quelle bellezze che più si poteva, e metterla in uso in ogni opera per tutte le figure, che per questo si dice esser bella maniera." See Bettarini-Barocchi, IV, 3. Preface III.

20. Vasari-Milanesi, Preface I, 7. See Bettarini-Barocchi, I, 331 and 12, line 15, Vasari explains, "perche io sò, che l'arte nostra è tutta imitazione della natura principalmente e poi perche da se non può salire tanto alto delle cose che da quelli che miglior maestri di se giudica sonocondotte."

21. See Bettarini-Barocchi, I, 252. For Vasari's full passage, see 250–52.

22. Vasari-Milanesi, Preface II.

23. See Bettarini-Barocchi, I, 2–5.

24. See Bettarini-Barocchi I, 2–5.

25. See Bettarini-Barocchi, I , 9, citing the original: "Soleano gli spiriti egregii in tutte le azzioni loro, per uno acceso desiderio di gloria, non perdonare ad alcuna fatica, quantunche gravissima, per condurre le opere loro a quella perfezzione che le rendesse stupende e maravigliose a tutto il mondo; ne la bassa fortuna di molti poteva ritardare i loro sforzi dal pervenire a' sommi gradi, si per vivere onorati e si per lasciate ne' tempi eterna fama d'ogni rara loro eccellenza. Et ancora che di cosi laudible studio e desiderio fussero in vita altamente premiati dalla liberalita de' principi e dalla virtuosa ambizione delle republiche, e dopo morte ancora perpetuati nel cospetto del mondo con le testimonanze delle statue, delle sepulture, delle medaglie et altre memorie simili, la voracita del tempo nondimeno si vede manifestamente che non solo he scemate le opere proprie e le altrui onorate testimonanze di una gran parte, ma cancellato e spento i nomi di tutti quelli che ci sono stati serbati da qualunque altra cosa che dalle sole vivacissime e pietosissime penne delli scrittori."

26. The title of the 1550 edition, *Le vite de più eccellenti architetti, pittori et scultori italiani . . .* (see Bettarini-Barocchi, I, xvii, for full title of Torrentino edition), is changed in 1568 to *Le vite de' più eccellenti pittori, scultori e architettori.* But the sequence of the Introduction to the Three Arts–architecture, sculpture, painting is preserved.

27. Bettarini-Barocchi, I, 1–5.

28. Bettarini-Barocchi, I, 1–5.

29. Shrimplin, *Sun Symbolism and Cosmology in Michelangelo's Last Judgment*, 211–50.

30. The word aesthetic derives from the Greek *aisthesis*—sensation.

31. Philip P. Wiener, ed. *Dictionary of the History of Ideas* (New York: Scribner's Sons, 1974), vol. III, 510–12; Jayne, *Marsilio Ficino*, 89–91; and, Laura Vestra, "Love and Beauty in Ficino and Plotinus," 179–80.

32. Vasari-Milanesi, Preface I, 93.

33. Christos Evangeliou, "Koros Kalos: Plotinus on Cosmic Beauty and Other Beauties," paper read at *Neoplatonism and Western Aesthetics*, University of Crete, August, 1998, John Anton, "Plotinus' Conception of the Functions of the Artist," *Journal of Aesthetic and Art Criticism*, XXVI (Fall 1967), 91–101, and Liana De Girolami Cheney, *Botticelli's Neoplatonic Images* (Potomac, MD: Scripta Humanistica, 1993), 32–34.

34. In analyzing the Prefaces, one must keep in mind that the text of the 1550 edition contains fewer *vite*, thus revealing a sharper distinction between one cycle and another.

35. Bettarini-Barocchi, I, 1.

36. See Zygmunt Wazbinski, *L'Accademia Medicea del Disegno a Firenze nel Cinquecento: Idea e Istituzione*, 2 vols. (Florence: Leo S. Olschki Editore, 1997), 235–66 and *passim*; D. S. Chambers and F. Quiviger, eds. *Italian Academies of the Sixteenth Century* (London: Warburg Institute, 1995), in particular pp. 136–64; and Anton W. A. Boschloo, *et al, Academies Between Renaissance and Romanticism of Art* (Hague: SDU Uitgeverij, 1989), 14–33.

37. See Panofsky, *Idea: A Concept in Art Theory*, 88.

38. On Thomas Aquinas's concept of God in *Summa theologiae*, I, l–15, see Panofsky, *Idea: a Concept in Art Theory*, pp. 85–86. Also Federico Zuccaro elaborates on the concept of *disegno*. See also Dante's *Purgatorio* (X.vv.31).

39. Bettarini-Barocchi, II, 3.

40. Vasari's concept echoes that of Plato's *Timaeus*, which explains that the Creator made the world as a copy "of the unchangeable, eternal pattern (*paradeigma*). See Eden, 67. Vasari's specifics for the making of man (See Bettarini-Barocchi, II, 4) which follows Alberti's *De statua*: Vasari's "lump of clay (una massa di terra)" copies Alberti's "clod of earth"; Vasari's "adding and taking away" copies Alberti exactly.

41. Bettarini-Barocchi, II, 3–4.

42. In several *vite*, Vasari explains what he means by *disegno* and its application. For example, in 1568 edition on the *vita* of Orcagna, Vasari discusses how this sculptor acquires an interest in painting through the faculty of *invenzione* because wanting to make lovely groupings in his scenes, he devoted such study to *disegno* ("poi essendo disideroso, per fare vaghi componimenti d'istorie, d'esser abondante nell'invenzioni, attese con tanto studio al disegno"). See Bettarini-Barocchi, II, 217. In

the *vita* of Lippo, Vasari repeats more concretely the same intention on the importance of drawing in creating narrative scenes: "avendo egli *invenzione ne*l comporre le storie." See Bettarini-Barocchi, II, 298.

43. In the comment of painter Lippo (whose identity and oeuvre have never been established).

44. Bettarini-Barocchi, I, 26.

45. Note that for Vasari only the art of painting has both father and mother.

46. "Perciò che ella gradisce gl'artefici molto e di loro mostra i ghiribizzi e i capricci del fantastichi cervelli che gruovano la varietà delle cose; le novità delle quali esaltano sempre con maravigliosa lode tutti quelli che, in cose onorate adoperandosi, con straordinaria bellezza dànno forma sotto coperta ombra alle cose che fanno, talora lodando altrui con destrezza e talvolta biasimando senza essere apertamente intesi." See Bettarini-Barocchi, II, 297.

47. *Renaissance Drawings from Florence*, June 2001. National Museum Collection in Stockholm. More than 80 of these drawings are now in National Museum and are presented here for the first time as a single unit.

48. Alberti discusses sketching and squaring in Section 6.

49. See Bettarini-Barocchi, I, 116.

50. Vasari's notion of a painter's goal is not that different from that of Alberti: "the aim of the painter is to obtain praise, favor and good-will for his work much more than riches" (152). I disagree with Rubin's view that fame *per se* strongly motivated Vasari. A guiding premise of this paper is that Vasari valued art and artists, and that recompense and commemoration for his fame was earned through *amorevale fatiche*.

51. In her study of Cosimo Bartoli, great friend and admirer of Vasari, Judith Bryce reports on Vasari's determination to assure accuracy in the *Vite* and his impatience with Bartoli's procrastinations. See Judith Bryce, *Cosimo Bartoli: The Career of a Florentine Polymath* (Geneva, 1983), 68–69.

52. However, Vasari demonstrates his skill with pen, excusing himself for not having "greater power of delineating and shading (più forza di linearly e d'ombreggiarli)." See Bettarini-Barocchi, I, 3.

53. Wolfram Prinz, "I Ragionamenti del Vasari sullo Sviluppo e Declino delle Arti," in *Vasari storiografo e artista: Atti del Congresso Internazionale nel IV centenario della sua morte*, 857–66.

54. Vasari's idea of progress is described by the inevitable pattern of change from imperfection to perfection in the arts. And his moral intention is related to the Cinquecento's spirit of history, which fulfills its real purpose in making individuals prudent and showing them how to live. Mirollo, *Mannerism and Renaissance Poetry*, 9, sustains that Vasari's *Vite* "do not present a moral, social, or emotional justification for artistic activity."

Vasari's concept of "rebirth" strongly interrelates with the artist's response to nature. "In the origin of the arts was nature itself," he states, and "the arts of sculpture and painting were first derived from nature" (Preface I). According to Vasari, "rebirth" combines several issues. The study of nature is captured in the artist's design; the application of the design's canons contributes to the imitation and invention of nature; the birth, growth, and maturity of design creates a perfect art, thus the artist is able to perfect nature and surpassing it creation. Vasari evaluates these artistic accomplishments within his frame of historical progression, an organic scheme or cyclical evolution. These theoretical ideas are best articulated in Vasari's Prefaces to the *Vite*.

55. Vasari-Milanesi, Preface I, 24. For an opposite view, see *Mannerism and Renaissance Poetry*, 9, where Mirollo sustains that Vasari's *Vite* "do not present a moral, social or emotional justification for artistic activity."

56. Vasari-Milanesi, Preface I, 24. See Liana De Girolami Cheney, "Giorgio Vasari's Theory of Feminine Beauty," in *Concepts of Beauty in Renaissance* Art (London: Ashgate/Scolar Press, 1997), 180–90.

57. See Bettarini-Barocchi, I, 30.

'DELLE
# VITE DE' PIV ECCELLENTI
PITTORI SCVLTORI ET ARCHITETTORI
*Scrute da M. Giorgio Vasari*
PITTORE ET ARCHITETTO ARETINO.

Secondo, et vltimo Volume
della Terza Parte.

*Nel quale si comprendano le nuoue Vite,
Dall anno 1550 al 1567.*

Con vna breue memoria di tutti i piu ingegnosi
Artefici che fioriscano al presente
NELL'ACADEMIA DEL DISEGNO
In Fiorenza, et per tutta Italia, et Europa, &
delle piu importanti Opere loro.

*Et con vna Descrizione de gl'Artefici Antichi,
Greci & Latini, & delle piu notabili
memorie di quella età,*

*Tratta da i piu famosi Scrittori.*

❧

CON LICENZA E PRIVILEGIO.

IN FIORENZA Appresso i Giunti. 1568.

# The Delight of Art:
# Reading Vasari against Himself

DAVID CAST

The subject of this essay is pleasure or, for reasons grounded in the language of the Renaissance, what may be more appropriately referred to here as delight, the art of delight, the delight in art, or, from the title of a recent book, what might even be called the scandal of delight.* And this delight, however more precisely it can be defined, will be recognized from Vasari and from the text of *Le Vite*, from where, if read in a certain way, we can begin to understand what this notion meant to him and the place it occupied within the language and the accounts of art in Florence and Rome during his time.

The text of *Le Vite* has several aspects: as Fréart de Chambray so nicely put it, that Vasari was at once historiographer and panegyrist, writing history and biography; he also laid out a set of critical and historical values in the several prefaces to establish the grounds for his praise of those who were all his contemporary painters and predecessors for two or three ages, to quote Fréart again. Vasari's method was one of synthesis and co-ordination, unalienated, as Michael Baxandall once provocatively described it. And if such a way of writing was standard in all humanist practice, here in this narrative the relationship between the parts—that of history and of judgment—was particularly close. As ever, in the facts it recounted, history was taken to be true; but its language like that of poetry was always figurative—and this would distinguish it from mere chronicle. Vasari's narrative is concerned with persuasion and the establishing of certain moral claims that were then taken to be proven in the record of the examples laid out. Thus, to cite the obvious instance, Vasari, on writing about Michelangelo within the narrative in *Le Vite*, not only recorded that he worked on certain projects at certain times but also, and most importantly, why he was the greatest of the artists at that time. His works, as Vasari could add in the ringing conclusion to the first account of him in the Preface to the Third Part of this history, transcended and eclipsed those of every other artist, living and dead.

Yet, if Vasari's prefaces and biographies served each other so well, I would like to emphasize a distinction beyond any differences in language. Much about the authorship of the parts of *Le Vite* has been made of this: but there is a particular contrast in the evidence offered about the topic of delight and the many responses to it in the culture of Florence and Rome. The point can be put directly: in the Prefaces, Vasari advanced a description of art that did not openly acknowledge the delight of art; yet in the more discursive narratives of the Lives, recording the

277

facts of the responses to art, Vasari included evidence about delight—whether acknowledged openly or not, and about forms of attention paid to it, which are of a kind with such responses. Also, beside any of the more practical reasons that Vasari may have had for taking on the task of writing this text—and here his hopes of professional advancement were high—he hoped to contradict an ever-growing account of art there that allowed just such an idea of delight. This is an essential point; in making certain claims as he did about art, he was arguing not only for his particular account, which he could directly encourage, but he was also arguing against another that said something different about the essential nature of art, which he would not encourage directly. If we imagine Vasari arguing against an account that encompassed the notion of delight more fully, we can also see that this was a form of attention encouraged by certain practices—such as conversation, history, and biography—that flourished within the culture of the Renaissance and of humanism and indeed suggested such a way of responding to art. Hence in the Prefaces, where Vasari is scrupulous and careful, no mention is made of such delight; but throughout the rest of *Le Vite*, there is a much fuller record of this form of attention and of all the other intellectual and social practices that served to encourage it.

The first point is clear: within the account of art in the Third Preface, where he speaks of the great advances of the arts of architecture, painting, and sculpture, Vasari lists rule (*regola*), order (*ordine*), proportion (*misura*), draughtsmanship (*disegno*), and manner or style (*maniera*). Perhaps delight might be included within the idea of style; and certainly when Vasari came to speak here of the Leonardo, he took note of what he called the divine grace of this work, a phrase certainly acknowledging just such a possibility. But he did not speak openly here about delight, suggesting rather an account set around reason and proposing that art, in representing the properties of the divine world, was to be recognized essentially for its value as a truth. But beyond rule, order, and proportion, he listed also design and style. Despite what they may refer to elsewhere, these two properties are a part of reason or of ethics: design being here the process of representing the judgments made by an artist about art, style a description of the moral process involved in making a representation in relation to other representations. But, as ever, beside such an account of art, there was also always history and the rich and fuller narrative of the Lives; and there Vasari wrote of so many more ways to recognize in people's responses the idea of delight: Pope Innocent III delighted in building; Pandolfo Malatesta, even when young, took delight in everything connected with drawing; the style of Taddeo Zuccaro pleased the Duke of Guise, and a certain prior of the Gesuati clearly delighted in art. And many other examples acknowledge the various responses to art based on the idea of delight—and quite different from phrases elsewhere that took art to have its value merely as truth or as a model of an epistemology. [1]

But what was this delight and how could it be so spoken about? For the humanists of the Renaissance it was clear, whatever else might be said, that delight could be part of rhetoric, which was always to be defined as having as its purpose three tasks—to teach, to persuade, and to delight. Such an account, which goes back past Aristotle to Eratosthenes, came to be used also to describe poetry, which, as Horace put it, was to teach and to delight. Here delight was part of persuasion, a faculty recognized as concerned both with reason and the power to move the emotions. And in this sense all art, even as grand and public a form as history painting,

might, as Vasari acknowledged, be described, like poetry, to include delight in its rhetorical pro-gram. But this raised questions; for if, as in antiquity, rhetoric was to be taken always as a pub-lic response to things, rational judgment being in this sense public and exercised, as Aristotle had said, in the realm of citizenship, delight is a more private emotion, far from any such public role. Delight, like the taste to the tongue, whether bitter or sweet, is intimate and partic-ular, as Virgil had said of pleasure in a famous verse, or as Savonarola, quoting him, put it more directly, if with an echo also of Plato here—one person may prefer the sweet, another the bitter.[2]

The distinction here between private and public could also be defined, at that moment, in the contrast of the piazza, the public space, and the palazzo, a more private, even intimate space. Vasari borrowed this imagery from Humanism, where the public site was taken to be the true source of values, realized in common and in unison, even if the palace, the more private space, was now the center of authority, the site of the gracious Duke who alone could give the arts the full honor to sustain them. Vasari drew upon both the public and the private in his arguments. Thus when he described how the best art is made, he might, as when he talked of Michelangelo, say much about the solitude necessary for the artist. Yet at another moment, he would criticize Pontormo at San Lorenzo, for working in too stringently private a space, producing then a work that was not comprehensible. Then again, to define the final worth of something, he might turn to what was he called the judgment of the piazza, and indeed there are some very complex sto-ries here, especially about Michelangelo and sculpture by Bandinelli. Yet at another moment, calling into doubt the opinion of the general public, he would make clear the differences in judg-ment between those who knew something about art, and those who did not. And then, when-ever he wished to talk most grandly about Giotto or Leonardo or Michelangelo, he would pick up both parts of this account—and this pattern in describing responses can be traced back to Alberti—and speak of qualities in the work of these artists that delighted everyone who looked at it but were recognized also by those who truly knew what good art was. The climax of such rhetoric was Michelangelo; when the great fresco of the *Last Judgment* was finally unveiled it caused wonder and astonishment not only to Rome but to the whole world and then, as ever, to all artists—and their judgment was obviously particular—and to Vasari who was, as he said, stupified by what he saw when he came down specially from Venice to see it. [3]

This is delight itself, and within Vasari's history, the record of such a response to art was also filled out by other terms—wonder, surprise, astonishment, and private responses which, like delight, were registered always within the public realm. In defining the nature of any form of this delight, difficulties will always arise; indeed, as Gilbert Ryle once said of pleasure, it is not a technical notion, but merely the record of a mood or activity that is enjoyed. But perhaps here it is enough to imagine it as akin to what Walter Pater once referred to as idea of art for its own sake—before he spoke of art for art's sake—a form of attention, as the language of the Renaissance allows us to say, better referred to as an artistic rather than an aesthetic attention, since, as history can show, such aesthetic attention can on occasion be directed also to what is not art. Needless to say these terms, if now familiar, were not available for Vasari to use. Thus, the word "aesthetic" did not appear until the end of the eighteenth century and Francesco Milizia and Ermes Visconti; the phrase "work of art" did not appear until the time of Antonio

Labriòla and Pascoli, since in the Renaissance the word "art" itself means "work." The phrase "art for art's sake" did not appear until the 1920s in the writings of Ardengo Soffici, an admirer, appropriately enough, of Benedetto Croce. But we can stay with the simple "delight"— recognizing as we do that if, by its nature, it is private—within the narrative of humanism, it was recognized in its public face in actions and in the narrative of public affairs. This might be true of single actions, as when Annibale Caro noted once Duchess Vittoria Farnese's delight in a particular design, which prompted her to commission a similar design for herself. Or, within his general narrative, Vasari could easily write of Giotto making a painting that was much lauded—a form of delight—or of Masaccio winning praise for a certain picture, or of Leonardo executing a marvelous and beautiful painting at S. Maria delle Grazie. All such examples led to further commissions and to all the many works of art—made by these artists with such judgment—that made their lives and achievements worthy of being written about.[4]

About delight, at that moment of language, more can indeed be said. Delight is not pleasure; and if on occasions the two might become synonymous—as when Dante once spoke of Epicurianism as delight and pleasure—here we might wish to follow Lorenzo Valla, when he noted that pleasure, as opposed to such delight, was concerned always more with the idea of transcendence. Here delight is to be taken to refer to something more direct, the response perhaps noted by Caro when he spoke of a certain such delight in reading a Latin and an Italian text, comparing them, focusing on them, carefully yet enjoyably.[5] And attention, implied by such an idea of delight—and here the work of Robert Gaston is very apposite—can refer to a certain focus, encouraged within the institutions of the culture, or, as we might also say, an attention towards particular possibilities within works of art now the focus. Always, in the language of the Renaissance, there were different possible objects of attention, even to God, as one writer might say, or to Fame, as Petrarch wrote, or, of course, to the affairs of the heart, as Francesco da Barberini noted, which he said were especially pertinent to women. Thus Vasari could talk of attending to art and in many different ways; Francia, even when a mere goldsmith, attended to painting when he was in Bologna; Giuliano da Sangallo attended much to drawing; Aristotile da Sangallo gave attention to the cartoon of the Battle of Cascina; and Raphael, when he was in Florence, gave greater such attention to the works of Masaccio, Leonardo, and Michelangelo, from which, as Vasari added, his work improved strikingly.[6]

The idea of delight depended on attention, recorded now as public action and leading then to fame—the praise of artists. Such praise, as Vasari knew, was the proper attribute always of virtue and, as now a fact of public action, was to be used at each moment in the moral narrative of his history, confirming the achievements of the artists, whether of the first period or the second or then of the third, where worked the masters of the modern age who, in all the ways Vasari could recount, surpassed those before them. But if this was one language to use, there was another, that of wonder or amazement or marvel. This, to quote the humanist Cristoforo Landino, was also an essentially private response, powerful always, exceeding our faculties, as Aristotle had said. And yet it was this language that came often to refer to what might be called the artifice of art, the art in the art. Hence Vasari speaks of the marvel of the simplicity and loveliness to be seen in the face of Our Lady in a cartoon by Leonardo, or of the miraculousness of a painting Raphael did for Leonello da Carpi of Meldola, or then of the miraculousness again of

the first 'Pietà' of Michelangelo, a formless block of stone reduced to a perfection that nature is scarcely able to create in the flesh. This also applied to the responses to art; for example, it was marvelous to see in Giotto the bearing of the draperies and the grace and vivacity of the heads; the consuls of the cloth guild, if after initial hesitations, were amazed at Donatello's statue of St. Mark; people ran, as if mad, to look on the new and lively beauty of the paintings by Francia and Perugino, as if they would never see the like again; and the master of Perino del Vaga—and here Vasari was speaking even of an artist—was amazed at his first attempts at art. There are other examples: Francia felt great wonder when he saw the painting of St. Cecilia by Raphael, and you could only look with wonder and surprise at the figure of St. George by Pisanello. Often also this was the response of those who knew most about art; hence Ristoro d' Arezzo, writing even as early as 1282, could say that the ignorant would not recognize what the old Aretine vases were but connoisseurs looking at them—and famously this is the first use of such a word in Italian—would be amazed.[7]

There is a certain point here about the history of language. The words that Vasari used in his narrative—praise, attention, delight, marvel, and so forth—can occasionally be found in earlier texts as reflections, whether understood as such, of the classical tradition of such honors.[8] But in these earlier passages, these words cannot carry the same meaning; for humanism, in making such attention a part of public activity, could come to invest its language with far more significance than ever possible, where the fact of such attention was not, in this way, acknowledged as part of a larger cultural practice, which would give each term in this language a far greater force. And if then we think more widely about the status of art in these years, such attention could be seen to work in a particular context: within the capitalism of the early Renaissance, as Robert Goldthwaite has suggested, there was a process, at once religious, at once epistemological, by which the continuous presence of images within the culture constructed the idea of a visual world that could exist on its own terms, as such calling for a particular attention, a reality between the world of man and that of God. Later in the culture—as we might say even about the text Vasari wrote— certain particular practices were added that encouraged in all their differing ways attending to art: the idea of conversation (and think here of the story of how this whole enterprise was conceived of in the house of Cardinal Alessandro Farnese); the idea of history, which is what the enterprise of this conversation turned into; and then biography, which is what this call for history became, those biographies of all the best painters, sculptors, and architects.

Such practices as these were but the last sign of the idea now of an attention to art. There was conversation; and if this was a particular convention now—and here Castiglione's comments about talking show how important this convention was—so also, if gradually, there developed a more general intellectual context in which to understand what it might be. Here Aristotle was the source; for if in his account of knowledge there was theory, to be balanced by practice, within the category of this practice, a distinction then existed between productive knowledge, that is, a knowledge dependent, as in the realm of artists, on skill (*techne*), and then practical wisdom (*phronesis*)—the world of the gentlemen. One form of such knowledge is about making things, the other about what might be called 'as if 'to make things. And if this was a contrast or a distinction within practice, it allowed a passage from making to one of thinking, of

making, where conversation—and then a certain attention to art— could be held in common and shared. The same was possible within the idea of history where now, within Humanism, it had become possible to make a work of art a phenomenon of history, with properties—be these imitation or the representation of judgment—that are particular to it, and have then a history, acknowledged and attended to. And then finally, as Paul Barolsky has so often shown, in biography, under the guise of all the apparently fabulous or invented stories, or in the plays with names and characters, Vasari had opportunity, within these last forms of Humanism, to define a set of judgments about the works of these artists, recognized now always as things made. Thus poetry, *poesis*, is made, as GianMaria Filelfo put it, pulling up the Greek term. So then are made all the works of visual art, as Giannozzo Manetti had said, by the intelligence of man being this his, "buildings, paintings, sculptures, all the arts..."[9]

It was in these many varied ways that in *Le Vite*, whether openly or not, Vasari calls upon the institutions of Humanism, so many of which invited and encouraged, in both practice and theory, a certain form of attending to art. Yet, if so, Vasari wished to counter the consequence of such attention, that is, this idea of delight, as private and powerful as it was, by what he wrote of art. Something of the same program was implied within the prescriptions of the *Accademia del Disegno*, founded first in 1562 and then re-established a year later, where once again, and in the terms we have suggested here, the idea of art was brought back to a more public space. Perhaps here this move accorded well with the idea of culture that from the 1550s Cosimo I was so clearly concerned with in Florence. And, as Randolph Starn, Michel Plaisance, and Karen-Edis Barzman have noted, there is a parallel here in language; if Cosimo I was to be called the master and father of his country, so then *disegno* also, and as powerfully, was taken to be the father of art, as Vasari so clearly said. There is more to be said about this new academy but, in the end, the idea of the academy was at once more flexible and more powerful. For if in part it was a reflection of political and cultural authority, it became in time an institution, as Paul Duro has said of the later French Academy, that enjoyed such authority in itself, rather than reflecting the social or ideological underpinnings that were there when it was first established.[10]

These are very brief comments, taken from a certain interpretation of the text. Yet I have many scholarly debts here; to Nancy Streuver and her study of history and rhetoric and politics; to Fritz Schalk and his account of the humanist audience; to Peter Platt and his recent volume on marvels; to John Martin and his re-examination of the ideal of the individual in the Renaissance; and then to James Hankins, in his account of Renaissance philosophy. And here I was especially struck by the temper of a remark that he once made about philosophy in the Renaissance: that if, by the end of this moment, certain modern questions were brought up as part of the intellectual geography of the culture, then, he added, the answers do not seem to us equivalently modern. Here Hankins was thinking about such subjects as fact-value distinctions or the embeddedness of thought in language. But I would like to extend this characterization to problems more of art and see Vasari, like Castiglione or even Machiavelli, standing at the conclusion of an certain intellectual tradition and coming to the edge of certain questions, arranged around the idea of delight of art that, in the end, he could not bear to think of openly. The art of the Renaissance was so clearly delightful to so many, and astonishing, a marvel, a wonder. And if indeed the history of art has often and so clearly acknowledged something of

this—exemplified by much of what we say of Mannerism— the situation appears differently in what I have suggested here. Vasari was caught in an intellectual and political context where he could both speak for and against such a possibility, enjoying the fruits of such attention, yet when speaking of art itself, worrying about it. Two possibilities here may result: that such an argument may give us other ways of thinking about visuality or what could also be called the discursive determinations of vision, then and there in the Renaissance, at the moment when Vasari put his brushes aside and set pen to paper to write what he did; or, if not this, perhaps the argument may direct us to notions within Vasari's text, now read newly.

Perhaps I should end this discussion by referring to three passages about art—one about poetry and two about the visual arts. All of which, if different in form, refer to just this language of delight or wonder, there in the Renaissance. The first of these texts is not generally known to historians of art; the second is more familiar since it was quoted, if in passing, by Martin Wackernagel in his account of the world of Renaissance art; and the third was discussed very fully and richly by David Summers in his account of the artistic language of Michelangelo.

One: a remark by Petrarch, a letter of the 1330s written from Avignon to a old friend, Tomaso Caloiro, about eloquence. Here he talks of himself in solitude and of the pleasure he gets from certain familiar and famous words, spoken out loud, which indeed help his own writing. "The salutary words of poetry, that fall tenderly upon my ears," he says, working "by arousing in him through the power of an unusual sweet temptation to reread them." This is standard perhaps. But then he adds that "they [the words] gradually flow forth and transfigure my insides with hidden darts." This is a powerful, even strange phrase, for it too comes from antiquity, but it speaks of a very particular, even disturbing response to art. [11]

Two: a very striking image from a sermon by Savonarola on the psalm, *Quam Bonus* (Psalm 133), delivered in Santa Maria del Fiori in 1493. Savonarola says that love, that is to say Divine Love, is like a painter, a good painter, whose paintings "so please men that in looking at them, they remain suspended, and some times in such a state that they seem in ecstasy and beyond themselves, forgetting themselves." This is the wonder we have heard about as a fact of life, but seen here by Savonarola, strangely perhaps, as something favorably comparable to Divine Love. [12]

And three: a passage by Benedetto Varchi, delivered as part of Michelangelo's funeral in 1564, where Varchi uses words of extraordinary force to describe what he felt when responding to Michelangelo's art; "that he was unique, so new, so unusual, so unheard of all in all centuries that I for myself do not just admire, do not just wonder, am not just astonished and amazed, and almost reborn, but my pulse trembles, all my blood turns to ice, all my spirits are shocked, my scalp tingles with a most sacred and never before felt horror to think of him." This too is strangely powerful language, Petrarchan psychology, as Summers has said, pushed to the verge of the sublime, perhaps to the limit of the aesthetic response, even before there were aesthetics. At which point we can call the words of the great critic Count Leonardo Cicognara, thinking in the early nineteenth century of the effect of the work of Michelangelo. For him it was sublime, "as indeed the sublime of Burck (sic) in his treatise," and to make this all the more explicit, he turned to all the then familiar images of the sublime, "the precipitous torrents, the lonely forests, the menacing storms, the sweet melancholy of the starry night, the placid smile of

nature, the fresh dawn of the morning, the purple haze of the misty sunset." This was perhaps where the Renaissance was moving in its attention to art, even if at the end, it was never able to take the last, fateful step.[13]

NOTES

This text is the outline of a longer study on Vasari that I have been busy with for several years, always with the gracious encouragement of Paul Barolsky; it is deeply pleasant to be able to contribute to such a volume in his honor. The text here is essentially that of the lecture I gave at the conference, organized by Andrew Ladis in Athens, Georgia, in November, 2001.

I keep the notes to a minimum, listing here in order of publication the general texts on which I have based my work; G. Ryle, *Dilemmas*, Cambridge, 1954; F. Schalk, *Das Publicum in italienschen Humanismus*, Krefeld, 1955; N. J. Bialostocki, "The Power of Beauty: a Utopian Idea of Leone Battista Alberti," in *Studien zur Toskanischen Kunst: Festschrift für Ludwig Heinrich Heydenreich*, Munich, 1964, 13–19; N. Streuver, *The Language of History in the Renaissance*, Princeton, 1970; C. O. Brink, *Horace on Poetry: the Ars Poetica*, Cambridge, 1971; M. Plaisance, "Une première affirmation de la politique culturelle de Cosimo Ier (1540–42)," in *Les écrivains et le pouvoir en Italie a l'époque de la Renaissance*, no. 2, Paris 1973, 361–438; M. Baxandall, "Doing Justice to Vasari," *Times Literary Supplement*, 1 February 1980, p. 111; D. Summers, *Michelangelo and the Language of Art*, Princeton, 1981; M. Wackernagel, *The World of the Florentine Renaissance Artist* (1938), trans. A Luchs, Princeton, 1981; A. Danto, "Art, Evolution and the Consciousness of History," in *Journal of Aesthetics and Art Criticism*" 44, 1986, 30; H. Belting, *The End of the History of Art?*, Chicago, 1987; R. Gaston, "Attention and Inattention in Religious Paintings of the Renaissance," in *Renaissance Studies in Honor of Craig Hugh Smyth*, ed. A. Morrogh, F. Superbi Gioffredi, P. Morselli, E. Borsook, Florence, 1988, vol. 2, 253–75; R. Starn, L. Partridge, *Arts of Power: Three Halls of State in Italy, 1300–1600*, Berkeley, 1992; R. A. Goldthwaite, *Wealth and the Demand for Art in Italy: 1300–1600*, Baltimore, 1993; J. Hankins, "Review of B.P. Copenhaver, C. B. Schmitt, *Renaissance Philosophy*, Oxford, 1992," in *Renaissance Quarterly* 47, 1994, 639–41; P. L. Rubin, *Giorgio Vasari: Art and History*, New Haven, 1995; C. Hope, "Can you trust Vasari?", in *New York Review of Books* 42, 1995, 10–13; D. Donoghue, *Walter Pater: lover of strange souls*, New York, 1995; W. Steiner, *The Scandal of Pleasure: Art in an Age of Fundamentalism*, Chicago, 1995; P. Duro, *The Academy and the Limits of Painting in Seventeenth Century France*, Cambridge, 1997; P. G. Platt, *Reason Diminished: Shakespeare and the Marvellous*, Lincoln (Ne), 1997; *Public and Private in Theory and Practice*, ed. J. A. Weintraub, K. Kumar, Chicago, 1997; J. Martin, "Inventing Sincerity, Refashioning Prudence: the Discovery of the Individual in Renaissance Europe," *Journal of the History of Ideas* 102, 1997, 1309–42. B. Dziemidok, "Controversy about the aesthetic nature of art," *British Journal of Aesthetics*, 28, 1988, 1–17; H. Lausberg, *Handbook of Literary Rhetoric* (1973), ed. D. E. Orton, R. D. Anderson, Leiden, 1998; K–E Barzman, "The Accademia del Disegno and Fellowships of Discourse at the Court of Cosimo I de Medici," in *The Cultural Politics of Duke Cosimo I de' Medici*, ed. K. Eisenbichler, Aldershot, 2001, 177–88. Part of this material here was sketched out in two earlier articles: "Reading Vasari again: history, philosophy," *Word & Image* 9, 1993, 29–38; "Vasari on the Practical," in *Vasari's Florence: Artists and Literati at the Medicean Court*, ed. P. Jacks, New York, 1998, 70–82. In quotations I use the edition of Vasari by Gaetano Milanesi, referred to here in citations as VM.

1. For these phrases about delight and art see: "si dilettò molto di fabricare" (Pope Innocent III) *VM* 1, 276: "che ancor giovanetto si dilettava assai delle, cose del disegno" (Malatesta), *VM* 2, 223; "onde vedute dell' opere e piaciutagli la maniera" (Zuccaro), *VM* 7, 86; "un priore del medesimo convento degl'Ingesuati, che si dilettava dell'arte" (Gesuati), *VM* 3, 574; and for delight noted by Vasari of other matters see "dilettosi costui in modo dell'alchimia" (C. Rosselli), *VM* 3, 190;" si dilettò di vestir bene" (Signorelli), *VM* 3, 695: The comment on Leonardo's style reads: "con buona regola, miglior ordine, retta misura, disegno perfetto, e cosi à punto come elle sono e grazia divina. . . ." *VM* 4, 11.
2. The comment of Savonarola, referring to Virgil *Eclogues* 2.65 "trahit sua quemque voluptas" is to be found in *Girolamo Savonarola: Prediche sopra l'Esodo*, ed. GP. G. Ricci, Rome, 1956, vol. 2, 59: "ognuno e tirato da quella cosa che dentro sente che lo diletta, e della alter cose non cura. Ognuno ha diversi gusti; chi vuole del dolce e chi vuole del brusco"; for such a contrast between bitterness and sweetness, see Plato *Theaetetus*,

159D. The comment by Vasari on history painting is to be found in his letter to Varchi in P. Barocchi, *Scritti d'arte del Cinquecento*, Milan, 1971–74, vol. 1, 498–99; "tanto più vedendo questo secol d'oggi ripieno di tanti ornamenti nelle figure e nell' alter appertenenze, delle quale mi par, quando un pittore ne sia privo, e della invenzione, d'ogni cosa madre onoranda, la quale con dolci tratti di poesia, sotto varie forme vi (con)duce l'animo e gli occhi prima a maraviglia stupenda."

3. The comment on the *Last Judgment* reads: "la scoperse . . . con stuporette maraviglia di tutta Roman, anzi di tutto il mondo; ed io che quell'anno andavi a Roma per vederla . . .ne rimasto stupito. . . .," *VM* 2, 215; for these stories about Michelangelo, and his use of the phrase, "il lume della piazza," see *VM* 7, 280; and Bandinelli in public with his statue of Hercules and Cacus, see *VM* 6, 147; for Vasari on solitude, see P. Barocchi, *Giorgio Vasari: La Vita di Michelangelo*, Milan-Naples, 1962, vol. 4, 1859, and then on Pontormo, E. Ciletti, "On the Destruction of Pontormo's frescoes at San Lorenzo and the possibility that parts remain," *Burlington Magazine* 121, 1979, 765–70 and Cast, *op cit.*, (1993), 37, note 11 with a comment on the terms piazza, palazzo, sometimes referring to an idea of every part of the city, as in L. Strozzi, *Le vite degli uomini illustri della Casa Strozzi*, ed. P. Stromboli, Florence, 1892, 107: " Paolo Vettori e Antonio Francesco deli Albizzi . . . comiciarono . . . a parlare largamente per la piazza e in palagio . . . ."

4. For these passages, speaking of public recognition see: "dipinto in una tavola un Crocifisso grande . colorito a tempera, che fu allora molto lodato," (Giotto) *VM* 1, 387; "gli acquisto non piccola lode," (Masaccio) *VM* 2, 290; "fece un Cenacolo, cosa bellissima e maravigliosa" (Leonardo) *VM* 4, 29. For the story of Vittoria, see Caro, "Ho nuova de la signora duchessa che l'impresa le piace, e che mi manderà il ricamatore per metterla in opera," A. Caro, *Lettere familiare*, ed. A. Greco, Florence, 1957–61, vol. 1, 275.

5. For Valla on pleasure, see *Lorenzo Valla: de Vero falsoque bono*, trans. A.K. Hieatt, M. Lorch, New York, 1977, bk. 3, chap. 9, 266, "neque ego video quid interest inter 'voluptatem' e 'delectationem', nisi quod voluptas delectationem vehementem utique significant.....nam ea duplex: altera nunc in terries, altera postea in celis . . . ."; and for Caro on delight, *Delle lettere familiari del Commandatore Annibal Caro*, Padua, 1742, vol 2, 443; "un certo diletto che ho trovato in far pruova di questa lingua con la latina . . . ."

6. For Vasari and notes on attention, see; "attendendo dunque, mentre stava all'orefice, al disegno" (Francia), *VM* 3, 534; "mentre che Giuliano attendeva al disegno," (Giuliano da Sangallo), *VM* 4, 268; "ma non las-ciando per ciò Bastiano di attendere al detto cartone" (Sangallo), *VM* 6, 433; "e quelle che vide nei lavori di Lionardo e Michelangelo lo feciono attendere maggiormente agli studi," (Raphael), *VM* 4, 326. And for the other objects; "ogni ora si pareva a loro brieve per attendere a Dio." *Della imitazione di Cristo*, Modena, 1844, 28; to fame "qual donna attende a gloriosa fama," *Petrarch's Lyric Poems*, ed. R. Durling, Cambridge (Ma.), 1976, no 261; and to the affairs of the heart, "le femmine hanno ignannato Salamone, Aristotile, Sansone, Davit, Ansalon e molti altri, e non attendono ad altro che a pigliar cuori," *Francesco da Barberino, Reggimento e costumi di donna*, ed. G. E. Sansone, Turin, 1957, 214.

7. For the passage from Landino, *Disputationes camaldulenses* (1475), as in E. Garin, *Prosatori latini del Quattrocento*, Milan-Naples, 1952, 744: 'admiratio . . . autem stupor dicitur, qui ex eius rei perceptione provenit quae nostram facultatem excellat . . ."; and for the passages in Vasari, "per veder le maraviglie di Lionardo, che ne fecero stupire tutto quel popolo . . ." (Leonardo), *VM* 4, 38; "il quale fu miracolossimo di colorito e di bellezza singulare" (Raphael), *VM* 4, 348; "che certo è un miracolo che un sasso, da principio senza forma nessuna, si sia mai ridotto a quella perfezione, che la natura a fatica suol formar nella carne" (Michelangelo), *VM* 7, 151; "perchè, oltre alla bellezza dei panni, e la grazia e vivezza delle teste, che sono miracolose, vi è . . ." (Giotto), *VM* 1, 392; "e così fatto, la turò per quindici giorni, e poi senza altrimenti averla tocca, la scoperse, riempiendo di maraviglia ognuno . . ." (Donatello), *VM* 2, 403; "ed I popoli nel vederla corsero come matti a questa bellezza nuova e più viva . . ." (Francia, Perugino), *VM* 4, 11; "ma tanto fu lo stupore che e'ne ebbe, e tanto grande la maraviglia" (Francia), *VM* 3, 546; "e per dirlo in una parola, non si può senza infinita maraviglia, anzi stupore, contemplare quest'-opera fatta con disegno, con grazia e con giudizio straordinaria" (Pisanello), *VM* 3, 10; and for Ristoro d'Arezzo, *Libro della composizione del mondo*: testo italiano del 1282, Milan, 1864, 256, bk. 7, chap. 4; "e di queste vasa...nella quale erano scolpiti sì naturalmente e sottili cose, che li conoscitori, quando le vedevano, per lo grandissimo diletto ratieno, e vociferano ad alti, e uscieno di sè, e diventavano quasi stupidi, e li non consenti la voleano spezzare e gittare . . . ."

8. For several such prehumanist passages using this language, see most easily E. F. van der Grinten, *Elements of Art Historiography in medieval texts: an analytic study*, The Hague, 1969, 62–64 and especially p. 137, no. 247, a text of 1274, referring to the Coronation of Edward Ist, the *Cronica maiorum et vicecomitum Londiniarum* :"quod oculi infra illas intrantium et tantam pulchritudinem intuentium, plenius deliciis et

gaudio repleantur..."

9. For these passages, see for Filelfo, A. Solerti, *Le vite di Dante, Petrarca e Boccaccio*, Milan, 1903, 177–78, "Est hoc poieo, unde dictus est poietes, hoc, inquam, piieo, unde dictus est poeta. Verbum, quo rem aeque fieri declaretur, ac nos dicimus creare, quod est aliquid novi conficere. Quare Graeci documt – in principio fuisse Deum poetam coeli et terrae – nos creatorem ipsum fuisse interpretamur." And for Manetti, *Gianozzo Manetti: De Dignitate et excellentia hominis*, ed. E. R. Leonard, (Cornell Unpubl. Diss.), 1964, bk.3, 113; "nostra namque, hoc est humana, sunt quoniam ab hominibus effecta cernuntur: omnes domus, omnia oppida, omnes urbes, omnia denique orbis terrarum edificia . . . nostre scientie . . . ."

10. For this language see design as the father of the arts, "padre delle arti nostre," in VM 1, 168, to be compared with the phrase that Cosimo is "di quest'arti.....padre, capo, e guida e corretore . . . Reynolds, *The Accademia del Disegno in Florence, its Formation and Early Years*, Ph.D.diss. Columbia University 1974, 222. Design might also be described as the mother of the arts, perhaps calling on the metaphor of succor, as in Vasari, "e perché il disegno è madre di ognuna di queste arti . . .", in Barocchi, *ed. cit.* 497.

11. For this see *Petrarca: Le familiari*, ed. V. Rossi, Florence, 1933–42, vol 1, 45–48, esp. 48; "quod nunquamprofecto consequerer, nisi verba ipsa salutaria demulcerent aures, et me ad sepius relegendum vi quadam insite dulcedinis excitantia sensim illaberentur atque abditis aculeis interiora transfigerent...".

For the phrase "demulcere aures" see Aulus Gellius 3. 13. 5.

12. For this see: "l'amore è come un dipintore. Un buono dipintore, se e'dipigne bene, tanto delettano gli uomini le sue dipinture, che nel contemplarle rimangon sospesi, e qualche volta in tal modo che é pare che e'sieno posti in estasi a fuora di loro, a pare che e' si dimentichino di loro medesimi," "Sopra il salmo "Quam Bonus," in *Sermoni e Prediche di F. Girolamo Savonarola*, Prato, 1846, vol. 1, 434–35.

13. For this see B. Varchi, *Orazione funerale . . . fatta e recitata. . . .nell'essequie di M. Buonarroti*, Florence, 1564, 8; "che io per me (e cosi credo che faccino tutti gli altri; non solo che habbiano fior d'ingegno, ma che non machinò affato del senso comune) non pure ammiro, non pure stupisco, non pure strabilio, e trasecolo, e quasi rinasco; ma mi tremano tutti i polsi, mi s'agghiacciano tutti i sangui, mi si raccapricciano tutti glispiriti, mi s'arricciano di dolcissimo, e mai più non sentito horroe turri i capelli à pensarlo . . ."; and for the remark of L. Cicognara, *Storia della scultura*, Prato, 1825, vol. 5, 145: "si può francamente asserire, che lo stile del Bonarroti è sublime, ma di un tal genere di sublime fatto soltanto per risvegliare quel magico senso di orrore elevato, secondo cui fu definito il sublime da Burck nel suo trattato, il quale lo ravvisò più tra le cupe valli, i precipitosi torrenti, le solitarie foreste, le minacciose procelle, di quello che nelle soavi melanconie di stellate notti, nel sorriso placido della natura, nel fresco albeggiar del mattino, o fra le porpore del vaporoso tramonto . . . ."

# Select Bibliography

Ackerman, James S. "Notes on Bramante's Bad Reputation." In *Studi bramanteschi*. Rome, 1974.

*The Age of Correggio and the Carracci: Emilian Painting of the 16$^{th}$ and 17$^{th}$ Centuries* Pinocoteca nazionale di Bologna, exhibition catalogue. Washington, D.C.: National Gallery of Art, 1986

Alberti, Leon Battista. *On Painting*. Rev. ed. Translated with introduction by John R. Spencer. New Haven: Yale University Press, 1966

Alpers, Svetlana. "Ekphrasis and Aesthetic Attitudes in Vasari's Lives." *Journal of Warburg and Courtauld Institutes* (1960): 190–215

Apfelstadt, Eric C. "The later sculpture of Antonio Rossellino." Ph.D. dissertation, Princeton University, 1987

Armenini, Giovanni Battista. *De' veri precetti della pittura*. Ravenna, 1587

Andreani, Laura, ed. 'I documenti', Appendix I. in *La Cappella Nova o di San Brizio nel Duomo di Orvieto*. Edited by Giusi Testa. Milan, 1996

Ashby, Thomas, Jr. "Sixteenth-century drawings of Roman buildings attributed to Andreas Coner," *Papers of the British School at Rome* II (1904)

Baglione, Giovanni. *Le Vite di pittori, scultori ed architetti dal Pontificato di Gregorio XIII del 1572. In fino a tempi di Papa Urbano VIII nel 1642*. Introduction by Valerio Mariani. Rome: Calco-offset, 1935

Baldini, Umberto. "Contributi all'Angelico: il trittico di San Domenico di Fiesole e qualche altra aggiunta." In *Scritti di storia dell'arte in onore di Ugo Procacci*, ed. Maria Ciardi Duprè dal Poggetto et al. 2 vols. Milan: Electa, 1977, 1: 236-46

Bambach, Carmen C., Hugh Chapman, Martin Clayton, and George R. Goldner. *Correggio and Parmigianino: Master Draughtsmen of the Renaissance*. London: British Museum Press, 2000

Barkan, Leonard. "'Living Sculptures': Ovid Michelangelo and *The Winter's Tale*," *ELH* 48 (1981): 646

Barkan, Leonard. *Unearthing the Past: Archaeology and Aesthetics in the Making of Renaissance Culture*. New Haven: Yale University Press, 1999

Barnes, Bernadine. *Michelangelo's Last Judgment: The Renaissance Response*. Berkeley: University of California Press, 1998

Barocchi, Paola. *Scritti d'arte del Cinquecento*. Milan and Naples: R. Ricciardi, 1971–77

Barocchi, Paola. *Studi Vasariani*. 3 vols. Turin: Giulio Einaudi, 1984

Barocchi, Paola, ed. *Trattati d'arte del cinquecento fra manierismo e controriforma*. Bari: Gius. Laterza e Figli, 1960

Barolsky, Paul. *The Faun in the Garden*. University Park, PA: The Pennsylvania State University Press, 1994

Barolsky, Paul. *Giotto's Father and the Family in Vasari's Lives*. University Park, PA: The Pennsylvania State University Press, 1992

Barolsky, Paul. *Infinite Jest*. Columbia: University of Missouri Press, 1978

Barolsky, Paul. "Michelangelo's Erotic Investment." *Source* 11 (1992): 32–34

Barolsky, Paul. *Michelangelo's Nose*. University Park, PA: The Pennsylvania State University Press, 1990

Barolsky, Paul. "Michelangelo's Self-Mockery." *Arion* (Spring 2000): 167–74

Barolsky, Paul. "Vasari and the Historical Imagination." *Word & Image* 15 (1999): 286–91

Barolsky, Paul. *Walter Pater's Renaissance*. University Park: The Pennsylvania State University Press, 1987

Barolsky, Paul. "What Are We Reading When We Read Vasari?" *Source* 22 (Fall, 2002): 33–35

Barolsky, Paul. *Why Mona Lisa Smiles and Other Tales by Vasari*. University Park, PA: The Pennsylvania State University Press, 1991

Barolsky, Paul, and Anne Barriault. "Botticelli's Primavera and the Origins of the Elegiac in Italian Renaissance Painting." *Gazette des Beaux Arts* (September 1996): 63–70

Barriault, Anne B. *Spalliera Paintings of Renaissance Tuscany*. University Park, PA: The Pennsylvania State University Press, 1994

Bartoli, Lorenzo. "Rewriting history: Vasari's *Life of Lorenzo Ghiberti*." *Word & Image* 13 (1997): 245–52

Barzman, Karen-edis. "The Accademia del Disegno and Fellowships of Discourse at the Court of Cosimo I de Medici." In *The Cultural Politics of Duke Cosimo I de' Medici*. Edited by K. Eisenbichler. Aldershot: Ashgate Publishing Limited, 2001

Barzman, Karen-edis. *The Florentine Academy and the Early Modern State: The Discipline of "Disegno."* Cambridge: Cambridge University Press, 2000

Baxandall, Michael. "Doing Justice to Vasari." *Times Literary Supplement.* 1 Feb 1980: 111

Belting, Hans. *The End of the History of Art?* Translated by Christopher S. Wood. Chicago: University of Chicago Press, 1987

Bertelli, Carlo. "'Architecto doctissimo.'" In *Bramante e la sua cerchia a Milano e in Lombardia 1480-1500*. Edited by Luciano Patetta. Milan, 2001

Berti, Luciano. "Miniature dell'Angelico (e altro)." *Arte acropoli* 2 (1960): 277–308; 3 (1963): 1–38

Bialostocki, Jan. "The Power of Beauty: a Utopian Idea of Leone Battista Alberti." In *Studien zur Toskanischen Kunst: Festschrift für Ludwig Heinrich Heydenreich*. Munich: Prestel-Verlag, 1964

Bjurström, Per. *Italian Drawings from the Collection of Giorgio Vasari*. Stockholm: National Museum, 2001.

Boase, T. S. R. *Giorgio Vasari: The Man and the Book*. A. W. Mellon Lectures in the Fine Arts, 1971, The National Gallery of Art, Washington, DC. Bolligen Series 35. Princeton: Princeton University Press, 1979.

Boccaccio, Giovanni. *De mulieribus claris*. In *Opere di Giovanni Boccaccio*. Edited by Cesare Segre. Milan: Mursia, 1978

*Boccaccio on Poetry*. Edited by Charles G. Osgood. Princeton, 1930; Indianapolis: The Bobbs-Merrill Company, Inc., 1956 .

Borghini, Raffaello. *Il Riposo*. Florence: Tip. G. Marescotti, 1584

Borsook, Eve. *The Mural Painters of Tuscany*. Oxford: Clarendon Press, 1980

Borsi, Franco. *Bramante*. Milan: Electa, 1989

Borsi, Stefano. "La vita di Bramante di Giorgio Vasari." In *Bramante e Urbino, il problema della formazione*. Rome: Officina, 1997, 130–56

Borsi, Stefano. *Polifilo architetto, cultura architettonica e teoria artistica nell'Hypnerotomachia Poliphili di Francesco Colonna (1499)*. Rome: Officina, 1995

Boschloo, Anton W. A. et al. *Academies Between Renaissance and Romanticism of Art*. Hague: SDU Uitgeverij, 1989

Boyle, M. O'Rourke. "Gracious Laughter: Marsilio Ficino's Anthropology." *Renaissance Quarterly* 52 (1999)

Bramante, Donato. *Sonetti e altri scritti*. Edited by Carlo Vecce. Rome: Salerno Editrice, 1995

*Bramante milanese e l'architettura del Rinascimento Lombardo*. Edited by Christoph L. Frommel, Luisa Giordano, and Richard Schofield. Venice: Marsilio, 2002

Brandt, Kathleen Weil-Garris. "'The Nurse of Settignano:' Michelangelo's Beginnings as a Sculptor." In *The Genius of the Sculptor in Michelangelo's Work*. Montreal Museum of Fine Arts, 1992

Brink, C. O. *Horace on Poetry: the Ars Poetica*. Cambridge: Cambridge University Press, 1971

Bristow, Robert. *Robert Browning*. New York and London: Harvester Wheatsheaf, 1991

Brock, Maurice. *Bronzino*. Translated by David Poole Radzinowicz and Christine Schultze-Touge. Paris: Flammarion; London: Thames and Hudson, 2002

Brown, Allison. "Cosimo de' Medici's Wit and Wisdom." In *Cosimo `il Vecchio' de' Medici, 1389-1464*. Edited by F. Ames-Lewis. Oxford: Clarendon Press, 1992

Browning, Elizabeth Barrett. *Casa Guidi Windows*. Edited by Julia Markus. New York: Browning Institute, 1977

Browning, Robert. *Dramatic Lyrics and Romances*. London: Edward Moxon, 1845

Browning, Robert. *Selected Poetry*. Edited by Daniel Karlin. Harmondsworth: Penguin Classics, 1989

Bruschi, Arnaldo. "Identità di Bramante '...al mondo huom singulare....'" In *Donato Bramante, ricerche, proposte, riletture*. Edited by Francesco Paolo di Teodoro. Urbino: Accademia Raffaello, 2001

Bryce, Judith. *Cosimo Bartoli: the Career of a Florentine Polymath*. Geneva, 1983.

Buonarroti, Michelangelo, *Il Carteggio di Michelangelo*. 5 vols. Edited by P. Barocchi and R. Ristori. Florence, 1965–83

Butcher, S.H. *Aristotle's Theory of Poetics and Fine Arts*. London: Macmillan, 1911

Bynum, Caroline Walker. "Wonder." *The American Historical Review* 102 (1997): 1–26

Caglioti, Francesco. "Bernardo Rossellino a Roma: Stralci del carteggio mediceo (con qualche briciola sul Filarete)," *Prospettiva* 64 (1991): 49-59, and " Tra Giannozzo Manetti e Giorgio Vasari," *Prospettiva* 65 (1992): 31–43

Canedy, Norman W. *The Roman Sketchbook of Girolamo da Carpi*, Studies of the Warburg Institute. Edited by E.H.Gombrich. Vol. 35. London and Leiden: The Warburg Institute, University of London, and E. J. Brill, 1976

Cantaro, Maria Theresa. *Lavinia Fontana Bolognese, "pittura singolare."* Milan: Jandi Sapi Editore, 1989

Carden, Robert W. *The Life of Giorgio Vasari*. London: Philip Lee Warner, 1910; Yale University Press, 1965

Cantatore, Flavia. "Francesco di Giorgio nella trattistica rinascimentale." In *Francesco di Giorgio architetto*. Edited by L. Bellosi and M. Tafuri, Milan: Electa, 1993, 382–83

Cast, David. "Reading Vasari again: history, philosophy." *Word & Image* 9 (1993): 29–38

Castiglione, Baldassare. *The Book of the Courtier*. Translated by G. Bull. Rev. Ed. London: Penguin Classics, 1976

Cavallucci, C.I. *Notizie storiche intorno alla R. Accademia delle Arti del Disegno in Firenze*. Florence: Tipografia del vocabolaria, 1873

Cellini, Benvenuto. *Sopra i principii e 'l modo d'imparare l'arte del disegno*, in *La Vita di Benvenuto Cellini*. Edited by

A. Rusconi and Valeri. Rome: Societa editrice nazionale, 1901

Cennini, Cennino. *The Craftsman Handbook: 'Il Libro dell'Arte'*. Translated by Daniel V. Thompson, Jr. New York: Dover Publications, Inc., 1960

Chambers, D. S. and F. Quiviger, eds. *Italian Academies of the Sixteenth Century*. London: Warburg Institute, 1995

Cheney, Liana De Girolami. "Giorgio Vasari's Theory of Feminine Beauty." In *Concepts of Beauty in Renaissance Art*. London: Ashgate/Scolar Press, 1997

Cheney, Liana. *The Paintings of the Casa Vasari*. New York: Garland, 1985

Choulant, Ludwig. *History and Bibliography of Anatomic Illustration*. Chicago, 1920.

Clements, R. J. *The Poetry of Michelangelo*. New York: New York University Press, 1965

Cohen, Charles. *The Art of Giovanni Antonio da Pordenone: Between Dialect and Language*. Cambridge: The University Press, 1996

Collobi, Licia Ragghianti. *Il Libro de' Disigni del Vasari*. 2 vols. Florence, 1974

*The Complete Poems of Michelangelo*. Translated by J. F. Nims. Chicago and London: University of Chicago Press, 1998

Condivi, Ascanio. *Michelangelo: Life, Letters, and Poetry*. Translated by George Bull. Oxford and New York, 1987

Condivi, Ascanio. *The Life of Michelangelo*. Translated by Alice Sedgwick Wohl, edited by Helmut Wohl, 2nd ed. University Park, PA: The Pennsylvania State University Press, 1999

Condivi, Ascanio. *Vita di Michelangnolo Buonarroti*. Edited by Giovanni Nencioni. Florence: Studio per edizioni Schelte, 1998

Corsaro, A. "Michelangelo, il comico e la malinconia." *Studi e problemi di critica testuale* 49 (1994): 97–119

Cropper, Elizabeth. *Pontormo, Portrait of a Halberdier*. Los Angeles: Getty Museum, 1997

Cruciani, Fabrizio. *Il Teatro del Campidoglio e le feste Romane del 1513, con la ricostruzione* architettonica del teatro di Arnaldo Bruschi. Milan: Il Profilo, 1968

Danto, Arthur. "Art, Evolution and the Consciousness of History." *Journal of Aesthetics and Art Criticism* 44 (1986)

Degenhart, Bernhard and Annegrit Schmitt, "Methoden Vasaris bei der Gestaltung seines 'Libro'." in *Studien zur Toskanischen Kunst: Festschrift Ludwig Heinrich Heydenreich*. Edited by Wolfgang Lotz and Lise Lotte Moller. Munich: Prestel-Verlag, 1964

DeGrazia, Diane. Introduction to *Correggio and His Legacy*. Washington, D.C.: National Gallery of Art, 1984

Della Casa, Giovanni. *Galateo*. Translated by K. Eisenbichler and K. R. Bartlett. Toronto: Center for Reformation and Renaissance Studies, 1986

Dempsey, Charles. "Some Observations on the Education of Artists in Florence and Bologna During the Later Sixteenth Century." *Art Bulletin* 62 (1980): 552–69

*Diario Fiorentino: 1405-1439*. Edited by Roberta Gentile. Roma: De Rubeis, 1991

Donoghue, Denis. *Walter Pater: Lover of Strange Souls*. New York: Knopf: Distributed by Random House, 1995

Dziemidok, B. "Controversy about the aesthetic nature of art." *British Journal of Aesthetics* 28 (1988): 1-17

Eisler, Colin. "Every Artist Paints Himself: Art History as Biography and Autobiography." *Social Research* 54 (1987): 73-99

Ekserdjian, David. *Correggio*. New Haven and London: Yale University Press, 1997

Elam, Caroline. "`Ché ultima mano!': Tiberio Calcagni's Marginal Annotations to Condivi's *Life of Michelangelo*." *Renaissance Quarterly* 51 (1998): 475–97

Enggass, Robert and Jonathan Brown, *Italy and Spain 1600-1750: Sources and Documents*. New Jersey: Prentice-Hall, 1970

Feinberg, Larry J. with Karen-edis Barzman. *From Studio to Studiolo: Florentine Draughtsmanship Under the First Medici Grand Dukes*. Allen Memorial Art Museum Oberlin College and Seattle, 1991

Fenton, James. *Leonardo's Nephew: Essays on Art and Artists*. Chicago: University of Chicago Press, 1998

Ferretti, O. P., Ludovico. "Intorno alla tomba del B. Angelico alla Minerva." In *Atti del Congresso nazionale di studi romani*. Ed. Congresso nazionale di studi romani. 2 vols Rome: Istituto di studi, 1929, 1: 560-64

*Filarete's Treatise on Architecture, being the Treatise by Antonio di Piero Averlino, known as Filarete*. Translated with introduction by John Spencer. 2 vols. New Haven: 1965

Fiocco, Giuseppe. *Alvise Cornaro, il suo tempo e le sue opera*. Vicenza: N. Pozza, 1965

Francesco di Giorgio Martini. *Trattati di architettura, ingegneria, e arte militare*. Edited by Corrado Maltese and transcribed by Livia Maltese Degrassi. 2 vols. Milan: Il Polifilo, 1967

Frank, Mitchell B. "The Nazarene *Gemeinschaft*: Overbeck and Cornelius." In *Artistic Brotherhood in the Nineteenth Century*. Edited by Laura Morowitz and William Vaughan. Aldershot: Ashgate Publishing Limited, 2000

Fermor, Sharon. *Piero di Cosimo: Fiction, invention, and fantasia*. London: Reaktion Books Ltd, 1993

Frey, Karl. *Der literarische Nachlass Giorgio Vasaris*. 3 vols. Munich: Georg Müller, 1923

Fumi, Luigi. *Il Duomo di Orvieto e i suoi restauri*. Rome: Tipografia vaticana, 1891

Gaston, Robert. "Attention and Inattention in Religious Paintings of the Renaissance." In *Renaissance Studies in Honor of Craig Hugh Smyth*. Edited by A. Morrogh, F. Superbi Gioffredi, P. Morselli, and E. Borsook. 2 vols. Florence: Giunti Barbèra, 1988

Garzelli, Annarosa. *Miniatura Fiorentina del Rinascimento, 1440-1525*. 2 Vols. Firenze: Giunta regionale Toscana & La Nuova Italia Editrice, 1985

Gere, J.A. *The Life of Taddeo Zuccaro by Federico Zuccaro from the collection of the British Rail Pension Fund.* Sotheby's, 11 January 1990

*The Genius of the Sculptor in Michelangelo's Work* Montreal: The Montreal Museum of Fine Arts, 1992

Geronimus, Dennis. "The Birth Date, Early Life, and Career of Piero di Cosimo," *Art Bulletin* 82 (March 2000): 164–70

Gibson, Walter S. *The Mirror of the Earth: The World Landscape in the Sixteenth Century* Princeton: Princeton University Press, 1989

Gilbert, Creighton. "Fra Angelico's Fresco Cycles in Rome: Their Number and Dates." *Zeitschrift für Kunstgeschichte* 38 (1975): 245–65

Giusti, Giuseppe and Gino Capponi, *Dizionario dei Proverbi Italiani.* Milan: Veronelli, 1956

Gizzi, Corrado, ed. *Signorelli e Dante.* Milan: Electa, 1991

Goldstein, Carl. "Rhetoric and Art History in the Italian Renaissance and Baroque," *Art Bulletin* 73 (1991): 646

Goldstein, Carl. "Vasari and the Florentine Accademia del Disegno," *Zeitscrift für Kunstgeschichte* 38 (1975): 145–52

Goldthwaite, Richard A. *Wealth and the Demand for Art in Italy: 1300-1600.* Baltimore: The Johns Hopkins University Press, 1993

Gombrich, Ernst. *Symbolic Images, Studies in the Art of the Renaissance.* London: Phaidon, Distributed by Praeger, 1972

Gould, Cecil. *The Paintings of Correggio.* Ithaca, NY: Cornell University Press, 1976

Grant, W. Leonard. *Neo-Latin Literature and the Pastoral.* Chapel Hill: University of North Carolina Press, 1965

Grinten, Ernst F. van der. *Elements of Art Historiography in medieval texts: an analytic study.* The Hague: Nijhoff, 1970

Hall, Marcia. *After Raphael: Painting in Central Italy in the Sixteenth Century.* Cambridge: Cambridge University Press, 1999

Hanafi, Zakiya. *The Monster in the Machine: Magic, Medicine, and the Marvelous in the Time of the Scientific Revolution.* Durham: Duke University Press, 2000

Hartt, Frederick. *History of Italian Renaissance Art.* 2nd ed. Englewood Cliffs: Prentice Hall, Inc., 1979

Herrmann-Fiore, Kristina. "Il tema 'Labor' nella creazione artistica del Rinascimento." In *Der Künstler über sich in seinem Werk,* Edited by Matthias Winner. Weinheim: VCH, 1992

Hersey, George L. *Alfonso II and the Artistic Renewal of Naples 1485-1495.* New Haven: Yale University Press, 1969

Hill, George F. *A Corpus of the Italian Medals of the Renaissance before Cellini.* 2 vols. London: British Museum, 1930

Hirsh, Edward. *How to Read a Poem.* New York: Harcourt Brace and Company, 1999

Holderbaum, James. "A Bronze by Giovanni Bologna and a Painting by Bronzino." *Burlington Magazine* 98 (1956): 441

Holmes, Megan. *Fra Filippo Lippi. The Carmelite Painter.* New Haven: Yale University Press, 1999

Hood, William. *Fra Angelico at San Marco.* New Haven: Yale University Press, 1993

Hope, Charles. "Can You Trust Vasari?" *The New York Review,* 5 (October 1995): 10–13

Jack, M. A. "The Accademia del Disegno in Late Renaissance Florence," *The Sixteenth Century Journal* 7 (1976): 3–20

Jacks, Philip, ed. *Vasari's Florence.* Cambridge: Cambridge University Press, 1998

Jacobs, Fredrika H. "(Dis)assembling: Marsyas, Michelangelo, and the Accademia del Disegno," *Art Bulletin* 84 (2002): 426–48

James, Clifton. "Vasari on Competition," *Sixteenth Century Journal* 27/1 (1996): 26–28

James, Sara Nair. *Signorelli and Fra Angelico at Orvieto: Liturgy, Poetry, and a Vision of the End Time.* Aldershot: Ashgate Publishing Limited, 2003

Janitschek, Hubert. "Das Capitolinische Theater vom Jahre 1513." *Repertorium für Kunstwissenschaft* 5 (1882)Kallab, Wolfgang. *Vasaristudien.* Edited by J. von Schlosser. K. Graeser and G. B. TeubnerLeipzig and Vienna, 1908

Kanter, Lawrence B. "The Illuminators of Early Renaissance Florence." In *Painting and Illumination in Early Renaissance Florence 1330-1450.* Edited by Laurence B. Kanter et al. New York: The Metropolitan Museum of Art, 1994.Kemp, Martin, ed. *Leonardo On Painting.* Translated by M. Kemp and M. Walker. New Haven: Yale University Press, 1989.

Kemp, Martin. "'Ogni dipintore dipinge se': A Neoplatonic Echo in Leonardo's Art Theory?" In *Cultural Aspects of the Italian Renaissance: Essays in Honour of Paul Oscar Kristeller.* Edited by C. Clough. Manchester: Manchester University Press; New York: A. F. Zambelli, 1976.

Kennedy, William. *Jacopo Sannazaro and the Uses of the Pastoral.* Hanover and London: University Press of New England, 1983.

Kent, Dale. *Cosimo de' Medici and the Florentine Renaissance. The Patron's Oeuvre.* New Haven: Yale University Press, 2000.

Kidwell, Carol. *Sannazaro and Arcadia.* London: Gerald Duckworth & Co. Ltd., 1993.

King, Catherine. "Looking a Sight: 16th-Century Portraits of Women Artists." *Zeitschrift fur Kunstgeschichte* 58/3 (1995): 400-1.

Klapisch-Zuber, Christiane. *Women, Family, and Ritual in Renaissance Italy.* Translated by Lydia G. Cochrane. Chicago: University of Chicago Press, 1985.

Kris, Ernst and Kurz, Otto. *Legende vom den Kunstler.* Vienna: Krystall-Verlag, 1934.

Ladis, Andrew. "Perugino and the Wages of Fortune," *Gazette des Beaux-Arts* 131 (1998): 221–34.

Lambert, Ellen Zetzel. *Placing Sorrow: A Study of the Pastoral Elegy Convention from Theocritus to Milton.* Chapel Hill: The University of North Carolina Press,

1976.

Land, Norman E. "Giotto as an Ugly Genius: A Study in Self-Portrayal." *Explorations in Renaissance Culture* 23 (1997): 23-36.

Landucci, Luca. *A Florentine Diary from 1450-1516.* Translated by A. de Rosen Jervis. New York: E.P. Dutton and Company, 1927.

Landucci, Luca. *Diario Fiorentino dal 1450-1516.* Edited by I. del Badia. Firenze: G. C. Sansoni, 1883.

Leonardo da Vinci, *Trattato della Pittura.* Milan: TEA, 1995.

Leonardo da Vinci *Trattato della Pittura.* Edited and translated by Martin Kemp and Margaret Walker. New Haven: Yale University Press, 1989.

*Leonardo on Painting.* Edited by M. Kemp. New Haven: Yale University Press, 1989.

Leskey, Albin Leskey, *A History of Greek Literature.* Translated by James Willis and Cornelis de Heer. New York: Thomas Y. Crowell Company; Great Britain: Methuen & Co. Ltd., 1966.

Magagnato, Licisco. *Teatri Italiani del Cinquecento.* Venice: N. Pozza, 1954.

Mahon, Denis. *Studies in Seicento Art and Theory.* London: The Warburg Institute, 1947.

*The Major Poems of Jacopo Sannazaro.* Translated by Ralph Nash. Detroit: Wayne State University Press, 1996.

Malvasia, Carlo Cesare. *Felsina Pittrice. Vite de' pittori Bolognesi.* Bologna: Arnaldo Forni Editore, 1841.

Manetti, Antonio. *The Life of Brunelleschi.* Introduction, Notes and Critical Text Edition by Howard Saalman. Translated by Catherine Enggass. University Park, PA: The Pennsylvania State University Press, 1992.

Martin, J. "Inventing Sincerity, Refashioning Prudence: the Discovery of the Individual in Renaissance Europe." *Journal of the History of Ideas* 102 (1997): 1309-42.

Martines, Lauro. "The Italian Renaissance Tale as History." In *Language and Images of Renaissance Italy.* Edited by A. Brown. Oxford: Clarendon Press, 1995.*Masterpieces of Renaissance and Baroque Sculpture from the Palazzo Venezia.* Exhibition catalogue. Athens, GA: Georgia Museum of Art, 1996.

McIver, Katherine. "Maniera, Music and Vasari," *Sixteenth Century Journal* 28/1 (Spring 1997): 52.

Mendelsohn, Leatrice. *Paragoni: Benedetto Varchi's "Due Lezzioni" and Cinquecento Art Theory.* Ann Arbor: UMI Research Press, 1982.

Metternich, Franz Graf Wolff. "Bramante, Skizze eines Lebensbildes," Römische Quartalschrift 63 (1968): 1–28.

Miller, J. Hillis, *The Disappearance of God: Five Nineteenth-Century Writers.* Cambridge, MA: The Belknap Press of Harvard University Press, 1963.

*Miniatura del '400 a San Marco dalle suggestioni avignonesi all'ambiente dell'Angelico.* Edited by Magnolia Scudieri et al. Florence: Giunti, 2003.

Nagel, Alexander. *Michelangelo and the Reform of Art.* Cambridge: Cambridge University Press, 2000.

Nelson, Jonathan, ed. *Suor Plautilla Nelli (1523-1588). The First Woman Painter of Florence.* Proceedings from the symposium, Florence and Fiesole, May 27, 1998. Fiesole: Edizione Cadmo, 2000.

*The Notebooks of Leonardo da Vinci.* Edited by E. MacCurdy. 2 vols. New York: Reynal & Hitchcock, 1938.

Ovid. *The Erotic Poems.* Translated by Peter Green. London: Penguin Books Ltd, 1982.

Ovid. *Metamorphoses.* Edited by G.P. Goold. 2 vols. Cambridge, MA and London: Harvard University Press, 1984.

Ovid. *Metamorphoses.* Translated by Rolfe Humphries. Bloomington and London: Indiana University Press, 1955.

*The Oxford Classical Dictionary.* Ed. N.G.L. Hammond and H. H. Scullard. Oxford: Clarendon Press; London: Oxford University Press, 1970.

Panofsky, Erwin. *Studies in Iconology.* New York: Harper & Row, 1972.

Parker, Deborah. *Bronzino: Renaissance Painter as Poet.* Cambridge: Cambridge University Press, 2000.

Pater, Walter, *The Renaissance,* ed. Adam Philips. Oxford and New York: Oxford World Classics, 1998.

Pelta, Maureen. "Antonio Allegri da Correggio," *Encyclopedia of the Renaissance.* Vol. 2. New York: Charles Scribner's Sons in association with the Renaissance Society of America, 1999.

Pelta, Maureen. *Form and Convent: Correggio and the Decoration of the Camera di San Paolo,* Ph.D. dissertation. Bryn Mawr College, 1989.

Perlingieri, Ilya Sandra. *Sofonisba Anguissola: The First Great Woman Painter of the Renaissance.* New York: Rizzoli, 1992.

Pilliod, Elizabeth. *Pontormo, Bronzino, Allori: A Genealogy of Florentine Art.* New Haven: Yale University Press, 2001.

*Pittura di luce. Giovanni di Francesco e 1'arte fiorentina di metà Quattrocento.* Edited by Luciano Bellosi. Milan: Electra, 1990.

Plaisance, M. "Une première affirmation de la politique culturelle de Cosimo Ier (1540-42)." In *Les écrivains et le pouvoir en Italie a l'époque de la Renaissance.* No 2. Paris, 1973.

Pliny the Elder. *Natural History.* Bk. 35. London: Penguin Classics, 1991.

Poliziano, Angelo. *Detti piacevoli.* Edited by Tiziano Zanato, Rome: Istituto della enciclopedia italiana, 1983.

Pope-Hennessy, John. *Italian Renaissance Sculpture, Introduction to Italian Sculpture.* 4th ed. Vol. 2. London: Phaidon Press, 1996.

Prinz, Wolfram. "I Ragionamenti del Vasari sullo Sviluppo e Declino delle Arti." In *Vasari storiografo e artista: Atti del Congresso Internazionale nel IV centenario della sua morte.* Florence: Istituto nazionale di studi sul Rinascimento, [1976].

Prinz, Wolfram. "Vasaris Sammlung von

Künstlerbildnissen, mit einem kritischen Verzeichnis der 144 Vitenbildnisse in der zweiten Ausgabe der Lebensbeschreibungen von 1568."
*Mitteilungen des Kunsthistorischen Institutes in Florenz*, Supp. to vol. 12 (Florence, 1966).

*The Renaissance from Brunelleschi to Michelangelo: The Representation of Architecture*. Edited by H. Millon and V. Magnago Lampugnani. London: Thames and Hudson, 1994.

Rio, Alexis-François. *De l'art chrétien*. 3 vols. Paris: L. Hatchette, 1861.

Ripa, Cesare. *Iconologia*. Padua: Pietro Paolo Tozzi, 1603 and 1611.

Robertson, Charles. "Bramante, Michelangelo and the Sistine Ceiling." *Journal of the Warburg and Courtauld Institutes* 49 (1986): 91-105.

Romano, Giovanni. "Correggio in Mantua and San Benedetto Po," in *Dosso's Fate: Painting and Court Culture in Renaissance Italy*. Edited by Luisa Ciammitti, Steven F. Ostrow, and Salvatore Settis. Los Angeles: The Getty Research Institute for the History of Art and the Humanities, 1998.

Romei, Danilo. "`Bernismo' di Michelangelo." In *Berni e berneschi del Cinquecento*. Florence: Edizioni centro, 1984.

Rowland, Ingrid D. *The Culture of the High Renaissance: Ancients and Moderns in Sixteenth-Century Rome*. Cambridge: Cambridge University Press, 1998.

Rubin, Patricia Lee. *Giorgio Vasari: Art and History*. New Haven: Yale University Press, 1995.

Sacks, Peter M. *The English Elegy*. Baltimore and London: The Johns Hopkins University Press, 1985.

Sangiorgi, Fert. *Bramante 'hastrubaldino': Documenti per una biografia bramantesca*. Urbino: Fermignano, 1970.

Santagostino Barboni, Anna. "Il Giudizio Universale del Beato Angelico per la chiesa del monastero camaldolese di S. Maria degli Angeli a Firenze." *Memorie domenicane* 9 (1989): 255–78.

Satkowski, Leon. *Giorgio Vasari, Architect and Courtier*. Princeton, N.J.: Princeton University Press, 1994.

Scaglia, Giustina, ed. *Francesco di Giorgio. Traduzione di Vitruvio (Vitruvio Magliabechiano)*. Documneti indediti di cultura Toscana 6. Firenze: L. Gonnelli, 1986.

Schalk, Fritz. *Das Publicum in italienschen Humanismus*. Krefeld: Scherpe-Verlag, 1955.

Scher, Stephen K. ed. *The Currency of Fame: Portrait Medals of the Renaissance*. New York: Harry N. Abrams, Inc, Publishers in Association with the Frick Collection, 1994.

Schlegel, Ursula. "Observations on Masaccio's Trinity Fresco in Santa Maria Novella," *Art Bulletin* 45 (March 1963): 19-33.

Schultz, Anne Markham. The Sculpture of Bernardo Rossellino and his Workshop. Princeton: Princeton University Press, 1977.

Schultz, Bernard. *Art and Anatomy in Renaissance Culture*, Studies in the Fine Arts, Art Theory 12. Ann Arbor: UMI Research Press, 1985.

Schnapp, J. T. "Machiavellian Foundlings: Castruccio Castracani and the Aphorism." Renaissance Quarterly 45 (1992): 665.

Scorza, R. A. "Vincenzo Borghini (1515–1580) As Iconographic Adviser." Ph.D. Thesis, Warburg Institute, University of London, 1987.

Scoti-Bertinelli, Ugo. Giorgio *Vasari, scrittore*. Pisa: Nistri, 1905.

*Scritti sulle Arti*, ed. Roberto Paolo Ciardi. 2 vols. Florence: Marchi and Bertolli, 1973-74.

Seymour, Charles. *Sculpture in Italy: 1400-1500*. The Pelican History of Art. Harmondsworth: Penguin Books, 1966.

Sheard, Wendy Stedman and John Paoletti, eds. *Collaboration in Italian Renaissance Art*. New Haven and London: Yale University Press, 1978.

Smyth, Craig Hugh. *Bronzino as Draughtsman: An Introduction*. Locust Valley, New York: J. J. Augustin, 1971.

Sohm, Philip. *Style in the Art Theory of Early Modern Italy*. Cambridge: Cambridge University Press, 2001.

Speroni, Charles. *Wit and Wisdom of the Italian Renaissance*. Berkeley: University of California Press, 1964.

Steiner, Wendy. *The Scandal of Pleasure*, Chicago: University of Chicago Press, 1995.

Struever, Nancy C. *The Language of History in the Renaissance*. Princeton: Princeton University Press, 1970.

Summers, David. *Michelangelo and the Language of Art*. Princeton: Princeton University Press, 1981.

Testa, Giusi, ed. *La Cappella Nova o di San Brizio nel Duomo di Orvieto*. Milan: Rizzoli, 1996.

Thode, Henry. Michelangelo und das Ende der Renaissance. 3 vols. Berlin: G. Grote, 1903-1912.

Ticciati, G. "Storia della Accademia del Disegno," *Spigolatura Michelangiolesca*. Edited by P. Fanfani. Pistoia: Fratelli Bracali, 1876.

Varchi, Benedetto. *Della Generazione de'Mostri* in *Opere*. 2 vols. Trieste: Sezione letterario-artistica del Lloyd austriaco, 1858–1859.

Giorgio Vasari's *Le vite de' più eccellenti pittori, scultori e architettori*. Florence: Giunti, 1568.

Vasari, Giorgio. *La Vita di Michelangelo nelle redazioni del 1550 e del 1568*. Edited by Paola Barocchi. Milano and Napoli: Riccardo Ricciardi, 1962.

Vasari, Giorgio. *Le vite de' più eccellenti architetti, pittori, et scultori*. Edited by Rossana Bettarini and Paola Barocchi. 6 vols. Florence: Sansoni, 1966-1987.

Vasari, Giorgio. *Le vite de' più eccellenti pittori, scultori et architetti, pittori, et scultori italiani, da Cimabue insino a' tempi nostri nell' edizione per i tipi di Lorenzo Torrentino, Firenze 1550*. Edited by L. Bellosi and A. Rossi. Turin: Einaudi, 1986.

Vasari, Giorgio. *Le vite de' più eccellenti pittori, scultori, ed architettori*. Edited by Enrico Bianchi. 7 vols. Florence, 1930.

Vasari, Giorgio. *Le Vite de' più eccellenti architetti, pittori, ed scultori italiani, da Cimabue, insino a' tempi nostril*. 2 vols. Florence, 1550; Reprint, Turin: Einaudi Tascabili, 1991.

Vasari, Giorgio. *Le vite de' più eccellenti pittori, scultori ed architettori*. Edited by Gaetano
 Milanesi. 9 vols. Florence, 1875-1885; Reprint, Florence: G. C. Sansoni Editore, 1981.

Vasari, Giorgio. *Lives of the Painters, Sculptors, and Architects*. Translated by Gaston du C. de Vere with an Introduction and Notes by David Ekserdjian. Harmondsworh: Penguin, 1996.

Vasari, Giorgio. *Lives of the Most Eminent Painters, Sculptors, and Architects*. Translated by Gaston du C. de Vere. Introduction and notes by David Ekserdjian. 2 vols. New York: Alfred A. Knopf, 1996.

Vasari, Giorgio. *Lives of the Artists*. Translated by George Bull. Harmondsworth: Penguin Books [1965], 1976.

Vasari, Giorgio. *Lives of the Artists*. Translated by George Bull. Vol. 2. Middlesex: Penguin Books, 1987.

Wackernagel, Martin. *The World of the Florentine Renaissance Artist*. Translated by A Luchs. Princeton: Princeton University Press, 1981.

Waldman, Louis Alexander. "Fact, Fiction, Hearsay: Notes on Vasari's Life of Piero di Cosimo," *Art Bulletin* 82 (March 2000): 171–79. Wallace, William E. "Instruction and Originality in Michelangelo's Drawings." In *The Craft of Art: Originality and Industry in the Italian Renaissance and Baroque Workshop*. Edited by A Ladis and C. Wood. Athens, GA and London, 1995.

Wazbinski, Zygmunt. *L'Accademia Medicea del Disegno a Firenze nel Cinquecento*. 2 vols. Florence, 1987.

Wazbinski, Zygmunt. *L'Accademia Medicea del Disegno a Firenze nel Cinquecento: Idea e Istituzione*. 2 vols. Florence: Leo S. Olschki Editore, 1997.

Weintraub, Stanley. *Whistler: A Biography*. New York: Weybright and Talley, 1974.

Westfall, Carroll William. *In This Most Perfect Paradise. Alberti, Nicholas V, and the Invention of Conscious Urban Planning in Rome, 1447-55*. University Park, PA: The Pennsylvania State University Press, 1974.

Williams, Robert. "Notes by Vicenzo Borgherini on Works of Art in San Gimignano and Volterra: a Source for Vasari's 'Lives'," *Burlington Magazine*, 127 (January 1985): 17–21.

Williams, Robert. "Vincenzo Borghini and Vasari's *Lives*." Ph.D. Thesis. Princeton University,1988.

Williams, Robert. *Art, Theory, and Culture in Sixteenth-Century Italy: From Techne to Metatechne*. Cambridge: Cambridge University Press, 1997.

Wind, Barry. *A Foul and Pestilent Congregation: Images of "Freaks" in Baroque Art*. Aldershot: Ashgate Publishing Limited, 1998.

Woods-Marsden, Joanna. *Renaissance Self-Portraiture: The Visual Construction of Identity and the Social Status of the Artist*. New Haven: Yale University Press, 1998.

Zander, Giuseppe. "Il Vasari, gli studiosi del suo tempo e l'Architettura antica." In *Il Vasari storiografo e artista*, Atti del Congresso Internazionale nel IV Centenario della Morte. Arezzo-Firenze, 2-8 September 1974. Istituto Nazionale di Studi sul Rinascimento. Palazzo Strozzi. Firenze: Istituto Nazionale di Studi sul Rinascimento , [1976], 333–50.

Zöllner, F. "'Ogni pittore dipinge sé.' Leonardo da Vinci and 'Automimesis'." In *Der Künstler über sich in seinem Werke*. Edited by M. Winner. Weinheim: VCH, 1992.

Zuraw, Shelley E. "Mino da Fiesole's Lost Design for the Facade of Santa Maria del Fiore." In *Santa Maria del Fiore. The Cathedral and Its Sculpture*. Acts of the International Symposium for the VII Centenary of the Cathedral of Florence, Florence, Villa I Tatti, 5–6 June 1997. Edited by Margaret Haines (Fiesole: Cadmo, 2001), 79-93.

Zuraw, Shelley E. "The Sculpture of Mino da Fiesole (1429–1484)," Ph.D. dissertation, Institute of Fine Arts, New York University, 1993.

293

# Index